KU-481-842

MASTERPIECES
MEDIEVAL ART

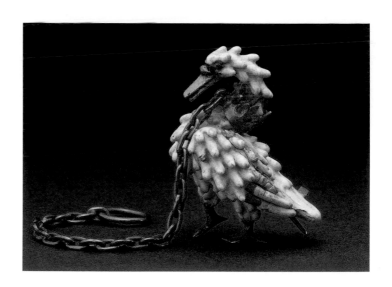

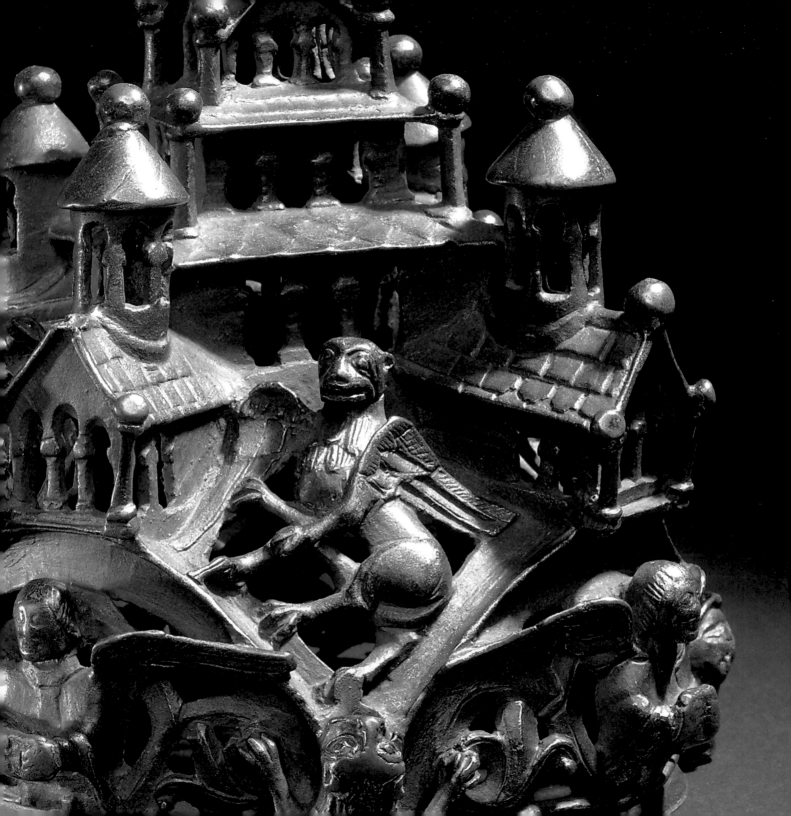

MASTERPIECES
MEDIEVAL ART

JAMES ROBINSON

With contributions by Silke Ackermann, Barrie Cook,
Catherine Eagleton and Beverley Nenk

THE BRITISH MUSEUM PRESS

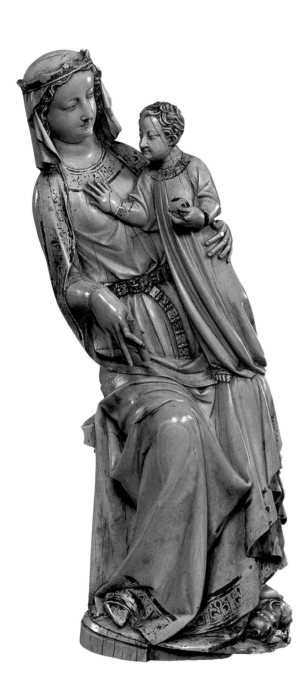

For Jill and Paul Ruddock

© 2008 The Trustees of the British Museum

James Robinson has asserted the right to be identified
as the author of this work

First published in 2008 by The British Museum Press
A division of The British Museum Company Ltd
38 Russell Square, London WC1B 3QQ

www.britishmuseum.org

A catalogue record for this book is available from the
British Library

ISBN 978-0-7141-2815-3

Designed by Janet James in Minion and Frutiger
Printed in Singapore by CS Graphics PTE Ltd
Map drawn by David Hoxley

HALF-TITLE: The Dunstable Swan Jewel, France or
England, around 1400 (*see* pp. 172–3)
FRONTISPIECE: Censer cover (detail), probably England,
around 1150–75 (*see* pp. 32–3)
LEFT: Ivory figure of the Virgin and Child, Paris,
about 1330 (*see* pp.116–17)
RIGHT: Limoges casket with the Adoration of the Magi,
Limoges, France, early 13th century (*see* pp. 138–9)
FAR RIGHT: The Shield of Parade, Flanders or Burgundy,
late 15th century (*see* pp. 168–9)

CONTENTS

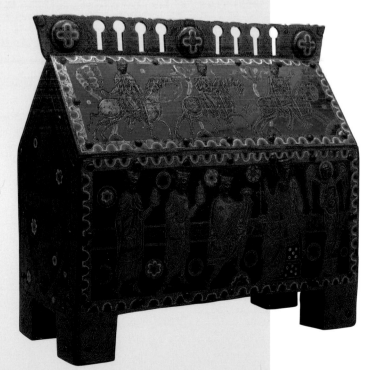

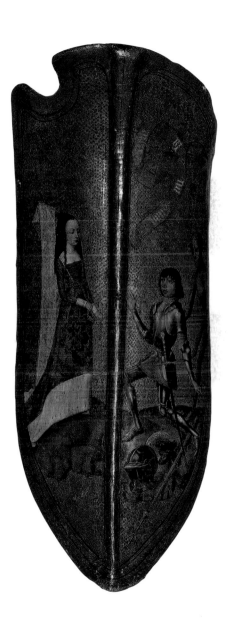

PREFACE

The widespread survival of medieval monuments and institutions is a lasting testimony to the glory of an age that saw great technical, intellectual and social innovation. This book examines the material culture of a period that saw the early incarnation of modern foundations such as Parliament, universities, hospitals, banks and civic halls. The cultural legacy of the Middle Ages extends to the widespread translation, circulation and preservation of classical texts on which much Renaissance thought depended. However, little appreciation of the great originality of the medieval achievement was made before the eighteenth and nineteenth centuries, when some of the finest collections of medieval art were amassed. It is to this collecting enthusiasm that the British Museum owes many of its splendid medieval masterpieces.

A number of the objects featured in this book are justly famous: the Royal Gold Cup, the Holy Thorn Reliquary, the Citole, the Noah Cameo, the St Stephen's Chapel wall paintings, the St Eustace head reliquary – the list is long and impressive. But many others will be new to most readers and are presented here for the first time in a fully colour-illustrated survey of the medieval collection. The book is divided into a sacred and a secular section, along with a shorter, third section that explores the transmission of ideas and influences in the medieval world. A number of sub-themes are explored within these sections but each object is set firmly into its immediate context so that any single entry can be read and enjoyed at random. Close scrutiny of these marvellous works is encouraged by the text and supported by dramatic photographic details.

The selection of objects reflects the full scope of the British Museum's medieval collection, which combines items of immense artistic worth with archaeological assemblages rich in historical significance. Glittering jewels are placed alongside humbler badges made of lead, which nevertheless convey the technical expertise of the metalsmith. The vast medieval ceramic collections are represented by extensive tiled pavements and other individual tiles decorated with delicately drawn narratives. The museum's related collection of world-famous medieval coins is used selectively in each section to amplify specific themes. As manuscript illumination falls outside the remit of the British Museum, a short introduction to each section of the book is illustrated with a manuscript selected from the British Library as an acknowledgement of the shared collecting history of the two institutions. Sculpture too is only briefly touched

upon here; together with stained glass and textiles it forms an important part of the collections of the Victoria and Albert Museum in London.

The book covers the period from around 1050 to 1500, with the exception of a few earlier Byzantine objects. The juxtaposition of Byzantine ivories, icons and reliquaries with material from Western Europe conveys points of both similarity and departure between the two cultures. The tremendous importance of the Byzantine capital, Constantinople, which served as a meeting point of East and West and saw the fusion of classical, Islamic, Italian and Slavic influences, provides a perfect perspective from which to discover the widest context of the medieval world. The Byzantine material has been deliberately interspersed with objects from Western Europe in order to make explicit the connections between them. The role of imagery as an aid to prayer is shared by the Orthodox and Latin Churches, and is intimately linked to the veneration of relics and the worship of saints. Reliquaries made to house the relics of Christ and the saints are very well represented in the British Museum's collection. Two pieces from the outstanding Waddesdon Bequest are featured for their special merit: a casket depicting scenes from the martyrdom of St Valérie, which is one of the Museum's finest examples of Limoges enamel, and the jewel-studded Holy Thorn Reliquary, among the world's rarest and most fabulous instances of the enamelling technique *émail en ronde bosse*.

Jean, duc de Berry, commissioned both the Holy Thorn Reliquary and the Royal Gold Cup, another of the world's unique treasures. The cup, featured on the cover of this book, is truly without parallel. Regarded with extreme suspicion when it appeared on the Paris market in 1883, its genuine worth was ultimately understood by Sir Augustus Wollaston Franks, one of the Museum's greatest curators and benefactors. It was bought in 1892 for the then princely sum of £8,000, which Franks raised partly from his own funds, partly from donations and partly from an appeal to the Treasury. This earned the cup the distinction of being the first art object to be bought for the nation by the nation. Its iconography relates to the legend of St Agnes, and yet it was made in the form of a secular drinking cup. At a stroke, this illustrates how the division of sacred and secular material had little relevance in the medieval world, where the seamless integration of devotional imagery into everyday life is surely one of the defining characteristics of the period.

ACKNOWLEDGEMENTS

A publication of this scope places a heavy reliance on the work of many generations of the Museum's medievalists. My most immediate debt is to Neil Stratford and John Cherry, whose wide-ranging publications have informed almost every page. A very warm acknowledgement is due additionally to John Cherry for reading the whole transcript. I benefited greatly from the encouragement and understanding of two successive keepers, Leslie Webster and Jonathan Williams. Two editors also contributed their skill and expertise: initially Nina Shandloff steered the structure of the book, while Felicity Maunder took charge of the final critical months of its delivery. Her sensitive editing of the text has vastly improved its readability. The writing, meanwhile, would have been almost impossible without remote computer access and Stuart Mann's dedicated help.

Generous support came from the contributing authors, Silke Ackermann, Barrie Cook, Catherine Eagleton and Beverley Nenk. I am also grateful to Thom Richardson of the Royal Armouries, Chris Entwistle and Barry Ager for checking entries that fall within their areas. Equally, Aileen Dawson, Ian Jenkins and Dora Thornton have provided highly valued advice. Conservators Fleur Shearman and Michelle Hercules ensured that specific objects were at their most photogenic. Saul Peckham's superlative photography is undoubtedly a great strength of the book and is shown to wonderful effect by the insightful design of Janet James. Credit for the images also falls to Isabel Assaly and Axelle Russo, who cheerfully controlled a constantly shifting list of photographic requests. High production values were maintained by Melanie Hall and by Laura Lawrence's copy-editing.

On a more personal level, I would like to thank Claude Badion for his great forbearance. My very dear friend Maureen Greenwood sadly died before the book was completed but the humour and care that she exercised during its authorship means that a special part of it will always belong to her.

The book is dedicated with thanks to Jill and Paul Ruddock for their desire and commitment to see one of the finest medieval collections in the world enjoy the profile it deserves.

Isle of
Lewis

Trondheim

NORTH
SEA

BALTIC SEA

Moscow

Copenhagen

Dublin

York

Hamburg

Danzig

London

Amsterdam

Berlin

Warsaw

Canterbury

Brussels

Prague

Paris

Cologne

ATLANTIC
OCEAN

Limoges

Buda Pest

Santiago de Compostela

Bordeaux

Milan Venice

BLACK SEA

Avignon

Siena

Sofia

Constantinople

Madrid

Rome

Thessaloniki

Naples

Granada

Athens

MEDITERRANEAN SEA

Palermo

CRETE

Jerusalem

0 500 miles
0 800 km

I DEVOTIONAL ART

Detail from the Sherbourne Missal, showing Noah's Ark and the initial 'P'. Sherbourne, Dorset, *c.* 1399–1407. British Library, Add. 74236, p. 16.

In the late eleventh century the late medieval Church was transformed by a period of intense reform brought to fruition by Pope Gregory VII (r. 1073–85). A consolidation of papal power was combined with a genuine desire for spiritual renewal. The reform was to have far-reaching political implications, reflected partly by the rise in the importance of bishops. It also saw a resurgence in the monastic ideal. The established religious orders, represented by the reformed Benedictines at Cluny in Burgundy, met with the emergence of a rival order of monks more attuned to the spirit of Gregorian reform. The Cistercians, founded in the late eleventh century, were characterized by their austerity and their desire for solitude. Their monasteries were in remote locations where the monks worked the land to support the community. The secluded Byland Abbey in Yorkshire thrived on its production of wool, which financed splendid tiled pavements in the thirteenth century and a glazing scheme in its cloister in the fifteenth century.

The inclination towards greater comfort was at odds with the abbey's founding principles. The celebrated Cistercian St Bernard of Clairvaux (1092–1153) famously disliked the grotesques and animal forms that decorated religious buildings, which he considered both a distraction from piety and a monstrous expense. Thus Cistercian monasteries developed a sober style of architecture in contrast with that of their Cluniac cousins. St Bernard's reservations did not extend to all aspects of the decorative arts and the Cistercians were renowned for the quality of their manuscript illuminations. The Benedictines too were responsible for producing works of outstanding artistic merit, such as the magnificent Sherborne Missal, painted in the early years of the fifteenth

century. The pages of the Missal delight in every detail and serve as a revealing record of the status of Sherborne's abbot, Robert Brunying, who appears constantly throughout the manuscript. Monasteries achieved great wealth from the endowments of land, which gradually placed them in the position of feudal landlords. In addition, a number of monasteries were positioned strategically along major pilgrim routes or were the focus of pilgrimage themselves.

Shrines attracted donations according to the fame of their saint and the quality of their relics. Canterbury and Cologne vied for third place as a destination of penitential pilgrimage in Europe behind Rome and Santiago de Compostela. However, the Holy Land was the ultimate goal for pilgrims, who flocked there to experience the very landscape associated with the life of Christ. Access to these holy sites was ensured by the success of the First Crusade in 1099. The crusaders set in motion a steady supply of relics, which enriched the shrines of Western Europe. The miracle-working powers of relics were essential to a shrine's success as cures were sought for every known ailment. The process of miracle working, whereby divine will was conveyed by proximity to a sacred relic, became ever more complex as images of Christ, the Virgin and saints were also credited with miracles.

The concept of miracle-working images may have been inspired by Byzantine icons, credited with powers of healing or with defensive success in battles. The use of images as intensifiers of devotional experience is central to late medieval worship. However, the notion was not always a comfortable one, as popular practices occasionally veered perilously close to idolatry. This was particularly pertinent in the Byzantine world where religious icons were suppressed from 730 until 843. Lingering sensitivities about idolatrous effigies meant that Byzantine art did not develop a tradition of religious statuary, unlike the West, where miracle-working images and statues were enthusiastically adopted at a vast number of shrines, especially from the twelfth century. In northern Europe in particular, from the fourteenth century, the use of such images was met with growing distaste; ultimately, the agents of the sixteenth-century Reformation sought to dispel the practice with the widespread destruction of religious imagery.

THE BORRADAILE TRIPTYCH

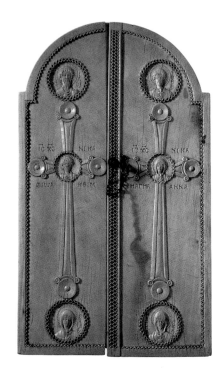

10th century

Constantinople
(modern Istanbul, Turkey)

Bequeathed by Charles Borradaile

HEIGHT: 27.8 cm
WIDTH: 32.7 cm

P&E 1923,1205.1

Three-panelled altarpieces, known as triptychs, were often designed to be portable for the purposes of private devotion. This outstanding example, made of elephant ivory, was clearly the result of a commission from someone of great wealth and refinement. The central scene shows the Crucifixion with the archangels Michael and Gabriel, the Virgin and St John the Evangelist, while the wings are carved with the figures of saints. Four standing saints are arranged in two registers on each wing, with the half figure of another saint above. All are identified by inscriptions in Greek: from the top left, St Kyros; St George and St Theodore Stratilates; St Menas and St Procopius; and, on the right, St John; St Eustathius and St Clement of Ankyra; St Stephen and St Kyrion.

The figures in the central panel are not identified in this way. Instead a quotation from the Gospel of St John is placed beneath the arms of the cross; it reads, 'Behold thy Son; Behold thy Mother' (John 19:26–7), the phrase by which Christ committed the Virgin Mary to the care of St John. In this way the artist makes explicit the emotional content of the work, which relies for its power on an understanding of the incarnation through Christ's family relationships; Christ was born of the Virgin Mary and suffered for the sins of mankind. The emphasis, however, is not entirely on suffering. Although the Virgin and St John grieve and Christ inclines his head to his sorrowful mother, he stands rather than hangs on the cross. His body is upright and unblemished. When the wings are closed, the meaning of this depiction is made apparent. A cross decorates each wing and carries an inscription in Greek that means 'Jesus Christ is victorious'. The Byzantine perception of Christ from the earliest times tended to focus squarely on the notion of Christ as victor. The fondness for military saints, as seen on the wings of this triptych, reinforced the vision of a militant Christianity. The closed wings, however, also give additional support to the theme of the incarnation. Each cross is placed between two portrait busts, St Basil and St Barbara on the left, and St John the Persian and St Thekla on the right. At the centre of the crosses are representations of the Virgin's parents, St Joachim and St Anna, thus emphasizing Christ's human ancestry.

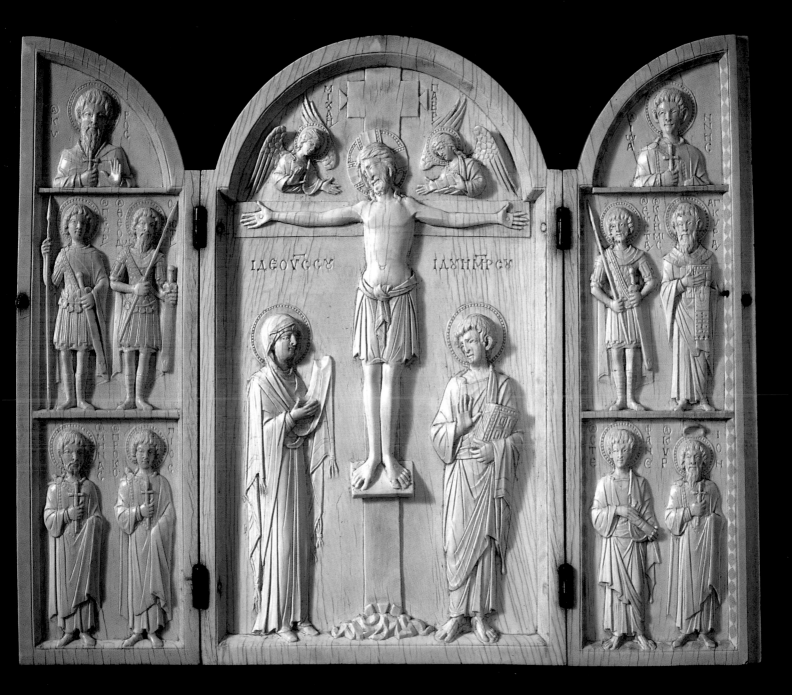

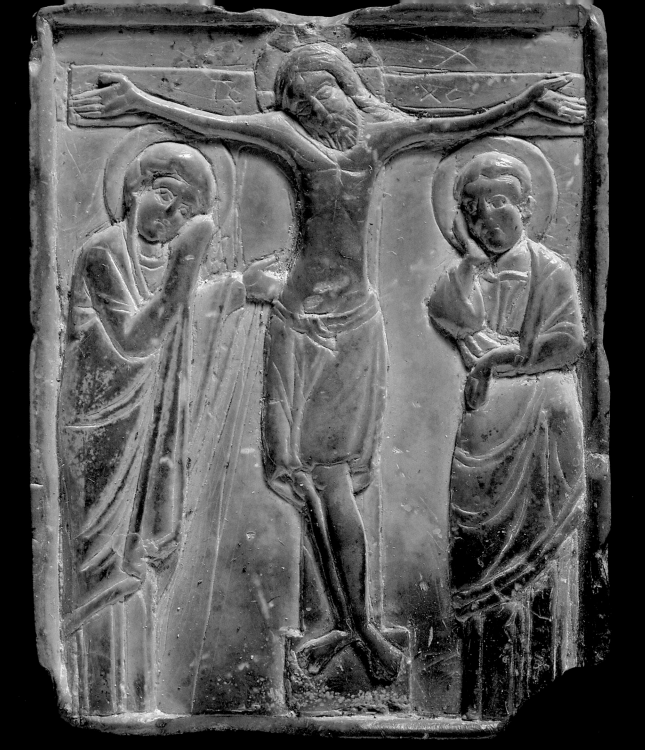

STEATITE PLAQUE WITH CRUCIFIXION SCENE

Steatite, commonly known as soapstone, is a soft, metamorphic rock. It was carved by Byzantine artists to create stone icons, many of which were collected by pilgrims as small, portable devotional works and were used as amulets. The inviting, tactile quality of the stone, along with its softness, has contributed to loss of detail on this piece, which has been rubbed smooth from constant use. It shows an emotionally laden and physically constricted Crucifixion scene. The arms of Christ's cross push against the edges of the composition; his head is bent by the pressure of the design to emphasize the expression of pain; and the Virgin and St John press against an unrelenting border, which compels them to observe the horror of crucifixion. Both figures raise a hand to their cheeks in a recognized gesture of grief. The Virgin extends her left arm and appears to touch the body of Christ in a movement that seems to be unique in Byzantine Crucifixion scenes. It recalls but does not replicate the pose of the Virgin and Child Hodegetria ('she who shows the way'; see pp. 48–9) and may perhaps serve as a poignant visual reminder of Christ's infancy.

The figure of Christ, sinuous and graceful, is appropriately dominant, and the only one named in a rudimentary inscription on the arms of the cross. His halo retains traces of gilding, suggesting that the plaque was originally embellished with at least a selective application of gold. Stylistically the carving belongs to the Palaeologan period, which saw intense political vulnerability and yet great artistic achievement.

Late 13th century
Byzantine
HEIGHT: 59 cm
WIDTH: 47 cm
P&E 1972,0701.1

ICON WITH ST JOHN THE BAPTIST

Around 1300

Constantinople
(modern Istanbul, Turkey)

Purchased with the aid of the
Art Fund, British Museum
Publications Ltd. and Stavros
Niarchos, Esq.

HEIGHT: 25.1 cm
WIDTH: 20.2 cm

P&E 1986,0708.1

Icons that show the single figure of a saint are often termed 'portrait' icons to distinguish them from others offering narratives. The power of this superlative portrait of St John the Baptist in his role as prophet lies in its immediacy and in a certain illusionistic quality, which makes the figure appear to protrude from the panel. This effect is achieved partly from the depth of modelling lent to his features and to the richly layered draperies that cover his form and partly from the way that the panel itself is worked. The panel has a raised border, which appears to contain the image of the saint but does not quite. Sections of his sleeves, the finger of his right hand raised in benediction and part of his halo are painted on the raised area creating the impression that he is stepping forward into the viewer's space. The intentness of St John's gaze contributes substantially to the directness of the depiction and invites a certain intimacy which, combined with the small scale of the icon, might suggest that it was painted for the purposes of private devotion in a domestic or monastic setting.

St John's identity and his status as the last of the Old Testament prophets is conferred by the scroll that he holds in his left hand and by the inscriptions that are painted to either side of his halo. On the left he is described in Greek as 'St John' and on the right as 'the Forerunner' to Christ ('o Prodromos'). Other, more discreet visual clues to his identity are apparent in the flames of his unkempt hair, which lick elegantly at the gilt background. This is a conventional allusion to his life as a hermit, which is given further expression by the hint of a camel-hair shirt visible at the neck of his red tunic. The saint's wild aspect is tamed here and instead he conveys qualities of grace and wisdom in a manner resembling depictions of Christ.

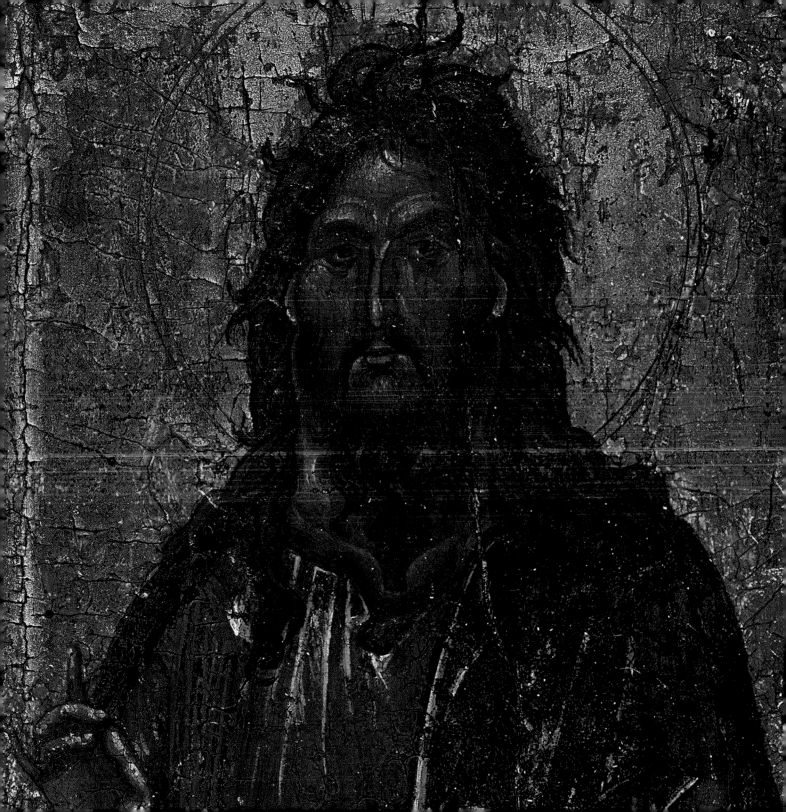

ICON WITH FOUR CHURCH FEASTS

This icon's delicate beauty is achieved by the careful handling of vibrant, expensive pigments and the considered application of gold leaf. It was almost certainly intended to be viewed at near proximity and was probably used by a monk or a priest. Stylistically it compares with wall paintings in the church of St Nikolaus Orphanou in Thessaloniki and may have been painted by an artist from that city. It represents four scenes connected with Christ's incarnation: the Annunciation, the Nativity, the Baptism of Christ and the Transfiguration, events which were celebrated as important feasts in the liturgical calendar.

At top left is the Annunciation, in which the Virgin is shown disturbed while spinning thread by the sudden arrival of the archangel Gabriel, his diaphanous drapery billowing around him. The emphatic use of white highlights brings Gabriel's right thigh forward and fixes him in a physical space by creating a sense of recession from one leg to the other. In the Nativity, the Virgin is placed centrally, the Christ child in the manger close to her side. Above this the Annunciation to the Shepherds takes place, while below, Joseph is seated to the right of two midwives who wash the infant Christ. The two scenes in the bottom register relate events that reveal the divinity of Christ. At left Christ is baptized in the river Jordan by John the Baptist, witnessed by three angels. At bottom right is the Transfiguration, a difficult theme for artists to portray since it demands an expression of otherworldliness in the treatment of Christ. Gospel accounts tell how he ascended a mountain with Peter, James and John and was transfigured so that his garments appeared supernaturally white and his face shone. The three apostles witnessed Christ in conversation with the prophets Moses and Elijah and heard a voice from heaven declare, 'This is my beloved son, in whom I am well pleased; hear ye him' (Matthew 17:5), echoing the statement made at the Baptism (Matthew 3:17). This moment is shown here, with the apostles falling prostrate in fear. Christ is disproportionately large, hovering above them in a disc with gold rays supported by Moses and Elijah. He is dressed not in white but in a silvery grey robe made luminous by bright white highlights. It is unlike any other garment represented and was clearly conceived to contrast with the rich colours that dominate the rest of the composition.

Around 1310–20

Constantinople (modern Istanbul, Turkey) or Thessaloniki, Greece

HEIGHT: 38.8 cm
WIDTH: 25.6 cm

P&E 1852,0102.1–2

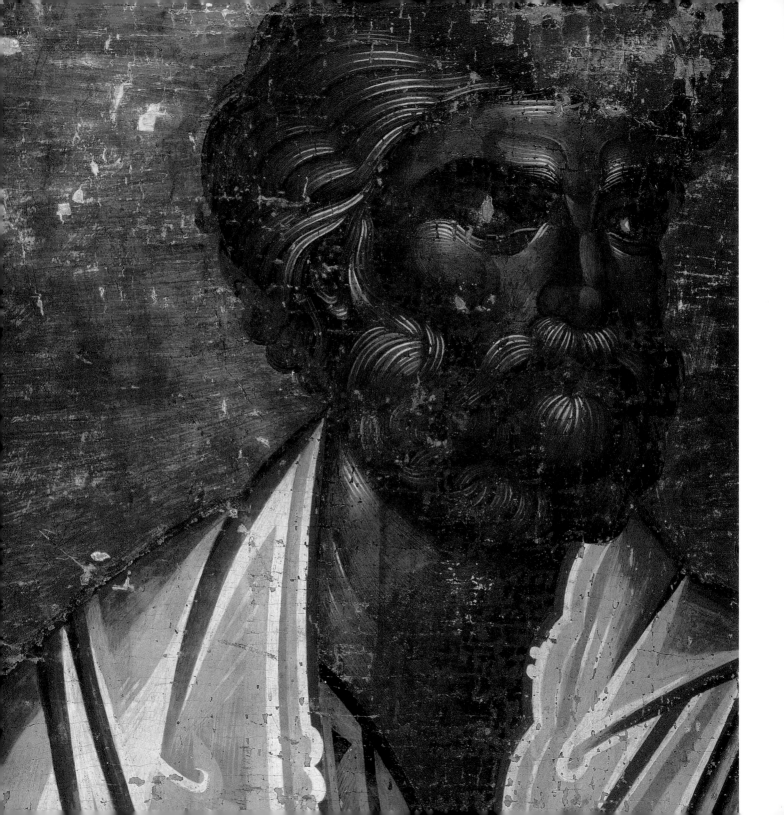

ICON WITH ST PETER

Representations of St Peter usually show him as a venerable figure with white hair and beard, the most senior of the apostles. This was the custom in both the Latin west and the Orthodox east and became one of the indicators of his identity. The convention is particularly helpful when there is no visible iconographic symbol to guide the onlooker, as in this portrait icon. However, the icon offers an additional clue in the scroll that the saint holds. It is painted with text in Greek taken from the first Epistle of St Peter:

> Beloved I beseech you as aliens and exiles to abstain from the passions of the flesh that wage war against your soul

This message combined with a portrait type dressed in apostolic robes secures the identification of the saint as Peter.

The treatment of the head of St Peter is very detailed, with modulated skin tones and carefully textured hair and beard. It contrasts with the rather generalized rendering of his robes, painted in confident, broad strokes with emphatic bands of light and shade. This technique is ideally suited for a large-scale figure designed to be visible from a distance. Significantly the icon is only a fragment of its original size. It has been cut down on at least three of its four sides and was probably intended as a half-figure representation. Since the icon's current dimensions are not insubstantial, this would suggest that it was intended originally to function as a prominent piece of public devotional art. No expense was spared on the execution of the icon, which is painted on cedar and backed extensively with high quality gold leaf. Such materials were worthy of a painter of great skill and the icon's style has invited comparison with that of the artist responsible for the mosaics and wall paintings of the Chora monastery in Istanbul (now the Kariye Camii). In the original composition the text that St Peter carries would have been more prominent, its call for celibacy having a particular resonance with a community of monks.

Around 1320

Constantinople
(modern Istanbul, Turkey)

HEIGHT: 68.7 cm
WIDTH: 50.6 cm

P&E 1983,0401.1

LITURGICAL COMB

Ritualistic cleansing and grooming was a fundamental part of the medieval Liturgy. In some instances it was prompted by a concern to prevent the contamination of the sacrament. Consequently the hair of the celebrant was combed to remove stray hairs, skin flakes or lice, all of which posed a potential hazard. Combs were also used ceremonially in the anointment of a bishop at his ordination. This intricately carved double-sided comb is of sufficiently high quality to suggest that it may have been used in just such a context. It carries an inscription on one side, which offers some affirmation that it was used for religious purposes. The inscription has not been satisfactorily read but it contains the Latin word for God, 'DEVS' (with an inverted 'V'), followed by the sacred monogram for Christ, 'IHC'. These small clues are valuable since the subject of the carving seems entirely secular.

The comb is divided into three openwork sections. Only half of the left panel survives, but it promises to mirror the intertwined tendril design of the right side. In the centre, the same tangled mass surrounds two male adversaries. One stands, though only half visible, in full armour. He appears every inch the Norman knight and closely resembles the figures of warriors embroidered into the famous Bayeux tapestry. His opponent, or victim, is unarmed and lies in a contorted pose, grasping helplessly at the shield of his attacker. The significance of this scene is not clear, although combat scenes are a recurring motif in Romanesque art, and it may not be intended to impart any specific meaning. The three panels are divided by two vertical bands, which are carved with lion masks and interlace decoration. At the complete end there is a suspension loop, which emanates from the mouth of another grotesque and suggests that the comb might have been worn.

The calibre of the carving is combined with a raw material of extreme rarity and suggests that this was an object of high status. It is carved from elephant ivory, which was unavailable in Europe from about the ninth until the thirteenth century, for reasons yet unknown. Instead walrus tusks were used for the majority of ivory carvings that survive from this time.

Late 11th century
England or Wales
LENGTH: 22.3 cm
WIDTH: 13 cm
P&E 1856,0623.29

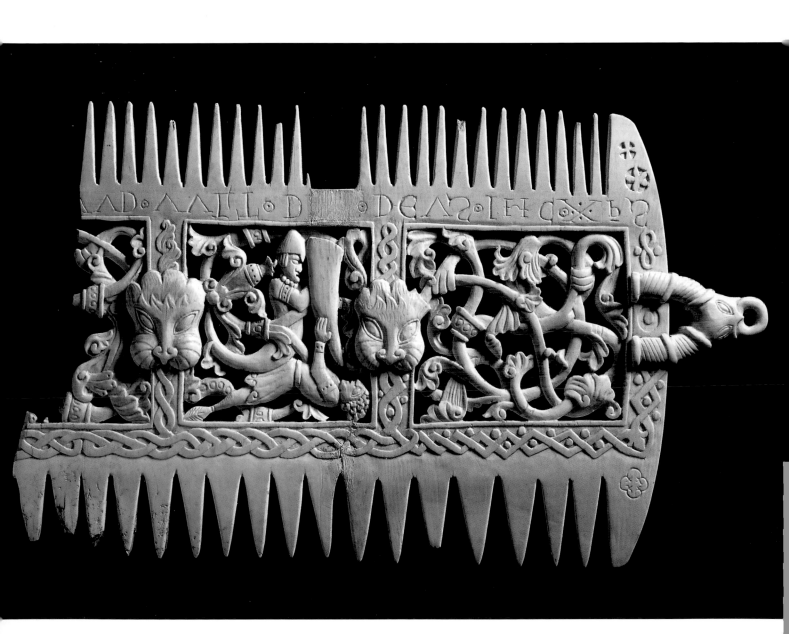

SILVER-GILT CHALICE

In 1229 William de Blois, Bishop of Worcester, issued a statute stipulating that every church in the diocese should have two chalices, one made of silver for the celebration of Mass and one made of pewter for burial with the priest at his funeral. The importance of the metal used in the manufacture of chalices stemmed from sensitivities about the Eucharist, as only gold and silver were considered appropriate to receive the blood of Christ during Mass. The sacred symbolism with which these materials were imbued came from their extreme expense and rarity, but also from the Bible. Psalm 12, verse 6 establishes a connection between the divine and the purity of metal: 'The words of the Lord are unalloyed: / Silver refined in a crucible, / Gold purified seven times over.'

A number of gold chalices are known to have existed from entries in Church inventories but the most numerous survivals are in silver. Their preservation is in part due to Episcopal burial practices. Although unconsecrated pewter chalices were considered suitable for priests' graves, the status of bishops and archbishops often resulted in silver chalices being buried with them. Occasionally these were filled with wine and placed upright alongside the body of the bishop.

This chalice is the finest piece of medieval church plate in the British Museum's collection. Much of its gilding is original and is applied to the vessel with discrimination around the rim of the foot, the twisted knop and the lip and interior of the bowl. The effect is restrained, balanced and elegant. The decorative focus is on the stem with its elaborate knop peppered with tiny punches in narrow bands within its deeply recessed grooves. Two more densely punched bands form collars around the stem above and below the knop. The same ornamental detail is applied to the foot between the large, smooth areas of scalloping.

The chalice belongs to a small category of survivals that includes two from Scandinavian burials. Chalices from Børsa in Norway and Dragsmark in Sweden are thought to be English by comparison. Interestingly, two English goldsmiths, Walter of Croxton and Edward of Westminster, are known to have worked in Norway in the second quarter of the thirteenth century and testify to the international nature of the medieval artisan.

Around 1250

England

Purchased with the aid of the Art Fund

HEIGHT: 14 cm
DIAMETER: 12.7 cm (bowl)

P&E 1968,1206.1

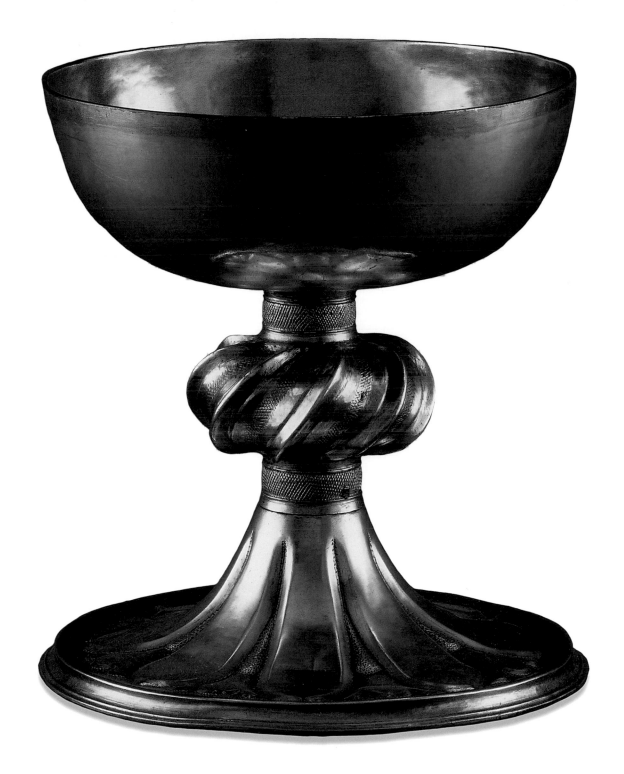

SILVER-GILT AND ENAMEL CHALICE

The goldsmiths of Siena won prestigious commissions and considerable fame with their use of translucent enamel on liturgical plate. A chalice produced for Pope Nicholas IV between 1288 and 1292, presented by him to the basilica of S. Francesco in Assisi, where it remains, set the standard in Italy throughout the fourteenth and for much of the fifteenth century. It served, not surprisingly, as a prototype for this example in the shape of the bowl and the construction of the stem, knop and foot decorated with translucent enamel plaques.

The size and success of the Sienese goldsmith industry is documented by the preservation of around fifty names associated with the craft. Many of these names appear on works they produced, by no means standard practice in the Middle Ages. This chalice is inscribed '*Tondinus e Andreia me fecit*' ('Tondino and Andrea made me') on the base of the stem. This relates to Tondino di Guerrino and Andrea Riguardi, who are known to have worked together between 1322 and 1328. It has been suggested that the presence of two names in such inscriptions indicates a division of labour between the goldsmith and the enameller.

This expensive chalice is made entirely of gilt silver and uses a profusion of enamel plaques. The bowl sits on six enamelled roundels with representations of birds; birds also decorate the spaces above and below the knop. Much of the enamel is lost or has deteriorated, making it difficult to identify the figures enamelled on the roundels set into the knop: there appear to be three male saints, two female saints and a seraph. The highly ornamental foot has six sexfoil plaques set between leaves in relief. They represent the Crucifixion, the Virgin Mary and St John with St Peter, an unknown abbot and St Francis, who adopts a pose on one knee with his arms outstretched indicating that he is about to receive the stigmata, which the seraph in the knop above is positioned to deliver.

Around 1322–8

Siena, Italy

Acquired with a donation from the Art Fund

HEIGHT: 20.5 cm

P&E 1960,1203.1

CHALICE

From the end of the thirteenth century the production of chalices in Siena appears to have formed part of a well-regulated industry. Mass production was facilitated by the lingering popularity of a form of chalice that remained current from the end of the thirteenth well into the fifteenth century. Component parts, particularly the translucent enamel plaques that decorated the stem and foot of the chalice, could be stockpiled and used at will.

We know from documentary records the names of many goldsmiths, each of whom seems to have offered a range of products adaptable by price. At the top end of the market chalices were made of gold or silver-gilt and were heavily decorated with translucent enamel plaques (see pp. 26–7). Cheaper models used gilt-copper alloy for the stem and knop, into which were inserted silver plaques with translucent enamel. A still cheaper alternative is represented by this chalice. It retains a silver-gilt bowl, since this was considered mandatory for the reception of the Eucharist, but its gilt-copper-alloy stem is decorated with two bands of champlevé enamel in green and white. Only its knop receives the iridescence of six translucent enamel medallions. The distressed state of the enamel makes it very difficult to decipher which figures are represented, but they are all likely to be saints. An inscription placed above the foot ascribes this piece to Goro di Ser Neroccio. That Goro made grander chalices is apparent from another example that bears his name in the Bargello Museum, Florence. Despite the adjustments in price and quality, when new and freshly gilded this chalice would have appeared almost as splendid as its more expensive counterparts.

Around 1414–56
Siena, Italy
HEIGHT: 18.8 cm
P&E 1886,0619.2

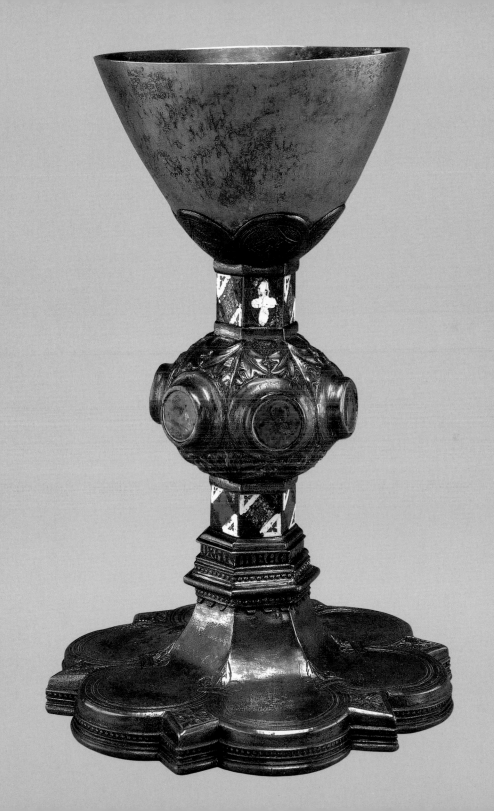

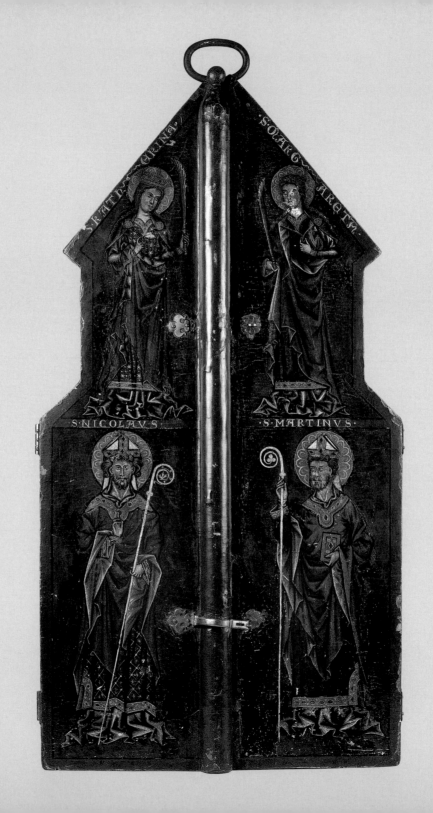

PAINTED WOODEN ALTARPIECE

When open, this altarpiece forms a three-panelled unit known as a triptych. It was designed to accommodate carvings, which would have been exposed only on feast days. When acquired by the British Museum it contained a series of ivories detailing the birth and Passion of Christ, which are now considered to be of eighteenth- or nineteenth-century date. The apocryphal history of the altarpiece relates how it was given by a pope to an emperor in the mid-fourteenth century; then in the fifteenth century it was presented by an empress to a convent, where it remained until the turbulent Napoleonic period, at which time it fell into private hands. None of these details has been corroborated. However, despite its potentially fanciful past and the question mark placed over the authenticity of the ivories it contained, a scientific examination of the painted surface, combined with its stylistic qualities, indicate that the altarpiece was made in the thirteenth century in the area that now constitutes southern Germany.

The style of painting is known as *Zackenstil* or 'jagged style', which describes a specifically Germanic development in painting, stained glass and manuscript illumination. It is defined by the treatment of the figures' drapery, in which the fabric seems to assume a life of its own and does not relate to the anatomy it covers. The unmistakably jagged edges of the hemlines on the four figures that decorate the closed wings of the altarpiece convey precisely what *Zackenstil* represents. The figures depict Sts Katharine (top left), Margaret (top right), Nicholas (bottom left) and Martin (bottom right), all of whom are identified by an inscription on the red border beneath their feet. *Zackenstil* was inspired by Byzantine art and fused with French Gothic to create a unique and elegant visual idiom. The stylistic similarities between the altarpiece and south German manuscript illumination are borne out by the method of execution. Analysis has revealed that a type of ink, rather than the more customary charcoal, was used to draw the figures, which were then 'coloured in' with paint. The altarpiece was an expensive commission and uses valuable vermilion and azurite pigments. However, some consideration of cost was taken into account as beneath the vermilion there is a layer of red lead and the azurite is similarly combined with a cheaper blue pigment.

Around 1250
Germany
HEIGHT: 94 cm
P&E OA.1343

CENSER COVER

The use of incense in religious services has an ancient origin, ratified by Christians from Old Testament references in the Book of Exodus (30:1–10) and in Psalms (141:2), where incense is used as a metaphor for prayer. Censers were perforated and swung from chains to increase the flow of incense and to provide ventilation for better burning. The celebrated authority Theophilus describes how best to model a censer in the third book of his twelfth-century text *De diversis artibus* ('On the Diverse Arts'). In his account, he cites the Heavenly Jerusalem as an appropriate model for the form of a censer. The notion of the Heavenly Jerusalem derives from a passage in Revelation (21:1–27) and had a huge influence on medieval Christian perceptions of the Kingdom of God, which was visualized in strongly architectural terms.

This censer cover, though missing its bottom half, is among the finest surviving examples of Romanesque bronze casting. It closely follows the recommendations set down by Theophilus in its arrangement of towers and gables on a circular base. The central tower is built in three storeys with four projecting gables issuing from each corner. Theophilus also advises ornamenting the censer with figures of prophets, apostles and angels as appropriate occupants of the celestial sphere. In keeping with this suggestion, within the space between each gable is the symbol of an evangelist: the winged man for Matthew, the lion for Mark, the ox for Luke and the eagle for John. Angels with open books are accommodated beneath arches that spring from the base where they are joined by half figures of lions. The lions rest their paws on luxuriant leaves, their mouths open to take the chains that would have connected the two halves of the censer for suspension. When new, the censer was gilded to resemble gold, the material believed to constitute the walls of heaven.

About 1150–75

Probably England

Bequeathed by Robert John Steggles through Miss E.R. Steggles

HEIGHT: 12.9 cm

WIDTH: 12.4 cm

P&E 1919,1111.1

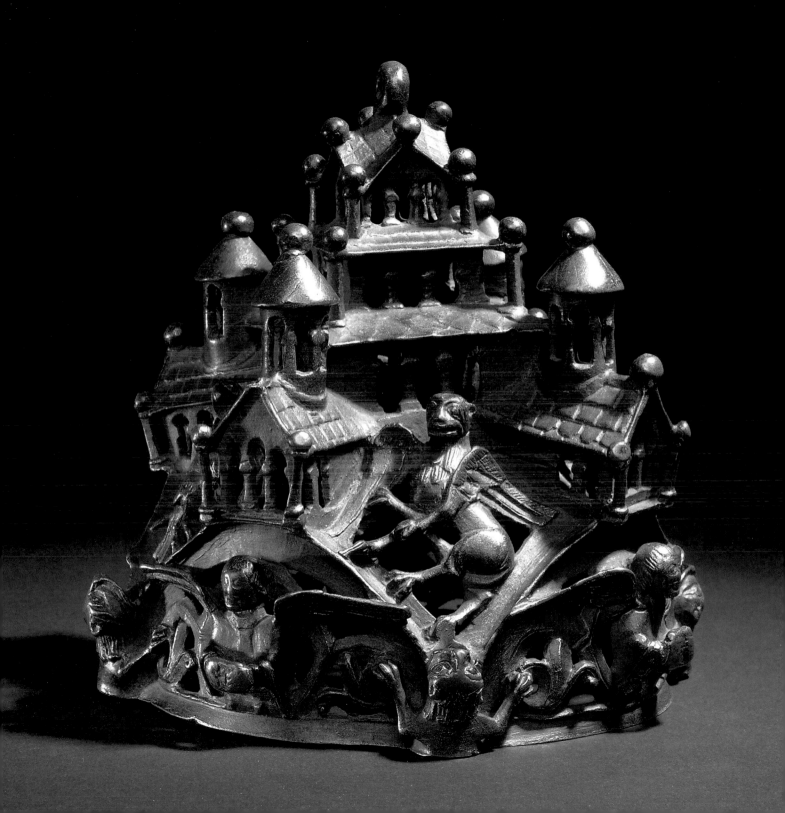

IVORY FLABELLUM HANDLE

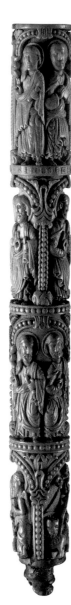

Around 1175–1200
France or England
LENGTH: 20.3 cm
P&E 1856,0623.30

The flabellum was a fan that was used to keep flies away from the Eucharist during the celebration of the Liturgy. The fans were made of parchment which was painted and were held by highly ornate handles sometimes crafted from ivory. This section of a handle may have been designed to hold a flabellum in place or it may have formed part of a much longer staff or rod. It is hollowed out and has one end adapted into a screw-thread for attachment to another section. Although it relates closely to several other pieces to be found in the Victoria and Albert Museum, London, the Metropolitan Museum of Art, New York, the Musée du Louvre, Paris, and the Bargello Museum, Florence, all considered to be by the same hand, they are not thought to belong to the same object.

The miniature detailed carving is arranged with remarkable precision around the narrow circumference of the handle. The figure groups are set in three registers of four and placed in pairs within beaded arcades. The twelve figures represent the apostles, although only St Peter is unambiguously identifiable from the three keys that he holds. Beneath the apostles are the four symbols of the evangelists, the voids above and around them filled with finely carved foliage. A certain dynamism is given to the carving by the adjustment in orientation from one register to the next as the apostles are seen either face on or in profile, depending on where the eye falls. The rich complexion of the piece is achieved by the deeply incised lines that animate the fluttering folds of the drapery and by a degree of undercutting which throws some figures into high relief. Though small in scale, the handle section corresponds convincingly to more monumental sculpture, such as that found on the lavabo of Much Wenlock in Shropshire. The similarity of treatment shown by the Much Wenlock reliefs has led to suggestions that the ivory may have been made in England. Recent work on the Paris piece, however, proposes an origin in Plantagenet France.

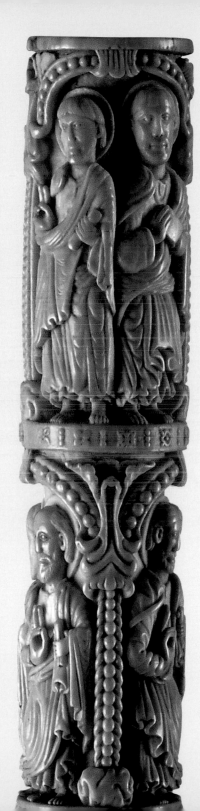
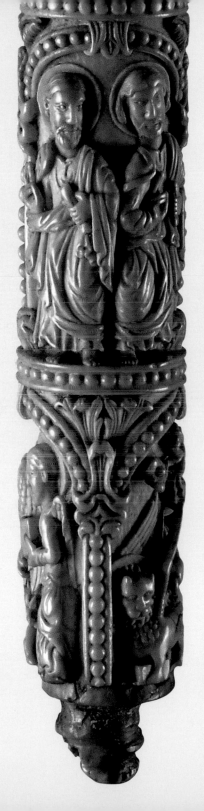

35

ALTAR CRUET

15th century

England

Accepted by HM Government
in lieu of inheritance tax

HEIGHT: 8.3 cm

P&E 2007,8047.1

Medieval altar cruets were characteristically diminutive. Their size reflected the small quantities of wine used by the celebrant in the Mass prior to the Reformation. The changes in liturgical practice prompted by religious reform saw the replacement of the miniature cruets with more modish and doctrinally acceptable flagons. Silver cruets appear never to have been made in large quantities, the vast majority being crafted from pewter. The regulations that governed chalice manufacture did not apply to cruets since they were used to contain the Eucharistic wine prior to consecration (see pp. 24–5 and 308–9). Those that existed in silver were inevitably destined to be melted down. As a consequence, medieval silver altar cruets are astonishingly rare throughout Europe. This cruet is the earlier of only two English examples known to survive; the other is owned by the Church of St Peter Port, Guernsey. Its history is unknown until about 1887 when it was bought from a pawnbroker in Rochester by Mr William Ball. It remained in private hands until it was acquired by the British Museum in 2007.

Cruets were always used in pairs, one to contain water and the other to contain wine. The contents of the two cruets were mixed in the chalice at Holy Communion for purification purposes but also in response to a passage in the Gospel of St John, which describes the fatal wound dealt to Christ on the cross: 'But one of the soldiers with a spear pierced his side, and forthwith came there out blood and water' (John 19:34). The contents of the two vessels had to be readily identifiable and different systems were devised to offer guidance. Some cruets were made of rock crystal and set into silver mounts, their transparency making the contents visible. Other sets might combine one gilt piece with a plain partner. By far the most common way of distinguishing between the cruets was by engraving the lids with the letters 'A', to represent the Latin word for water (aqua), and 'V', for wine (vinum). This example was made to contain water and carries the letter 'A' on a medallion set into the lid, which was originally enamelled.

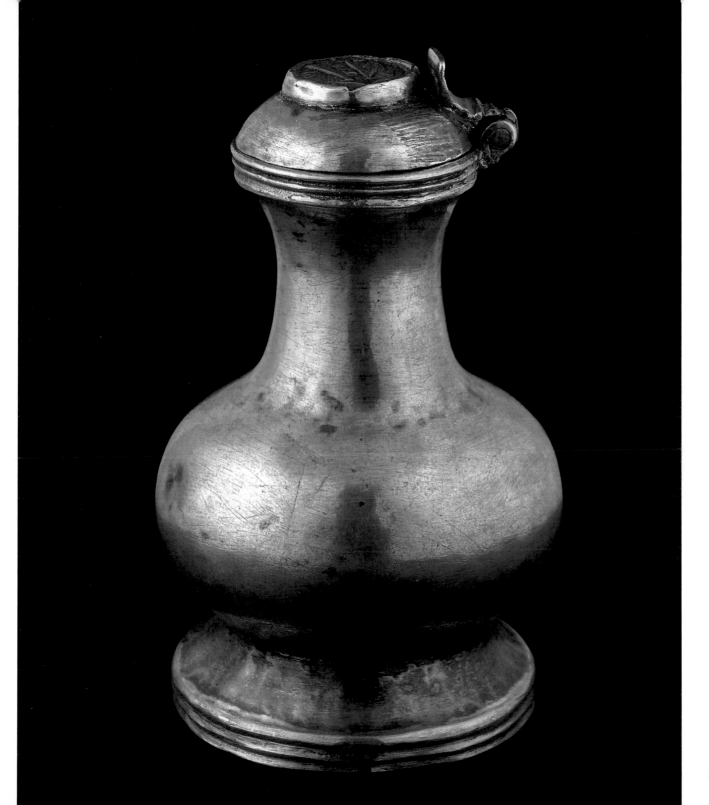

LEAF FROM AN IVORY DIPTYCH

About 1280–1300

Paris, France

HEIGHT: 22.2 cm

WIDTH: 10.6 cm

P&E 1943,0401.1

The corresponding left wing to this panel survives in the Walters Art Museum, Baltimore. It shows the Flagellation of Christ (bottom) and the Crucifixion (top), scenes that precede those represented here, the Deposition from the cross (top) and the Entombment (bottom). These episodes from Christ's Passion were selected intentionally for their pathos. The dramatic climax is the Entombment, the emphasis being placed on the human vulnerability of Christ. When the two leaves are placed together, the narrative flows in a beautifully balanced way from one panel to the other through the connected scenes of Crucifixion and Deposition. As it falls from the cross, Christ's body is supported by Longinus, the Roman centurion who pierced Christ's side with a lance. His identity is made clear in the Crucifixion group on the Baltimore panel where his lance is shown leaning against his shoulder as he receives the revelation of Christ's divinity.

In the Deposition scene, Longinus is helped in his task by the Virgin Mary and St John the Evangelist, who both take one of Christ's hands in their own, wrapped in the folds of their robes. A young boy struggles with pliers to extract the nails which still fix Christ's feet firmly to the cross. This figure is dramatically undercut so that he stands out in high relief from the background. Christ's left arm is given a similar treatment, which heightens the sculptural quality of the piece. The lack of the surrounding architectural canopies that frame the action of later ivory carving provides the composition with greater clarity and strength. The scenes are divided by an economically arranged band of rosettes and set against a starkly plain background. The plainness of the background was originally broken by a diapered pattern, the vestiges of which can still be seen.

Shadows of painted decoration are also evident on the side of the sarcophagus in the Entombment scene. Christ is gently lowered into it by two male figures who hold the corners of the shroud while a third tenderly anoints his chest. The Virgin Mary observes the ritual, her hands clenched in grief. The carver has demonstrated an awareness of perspective in his treatment of this group, especially in the placement of Christ's body, turned by the shroud bearers to face the viewer. In this way, the onlooker is invited to share in the scene of intense lamentation.

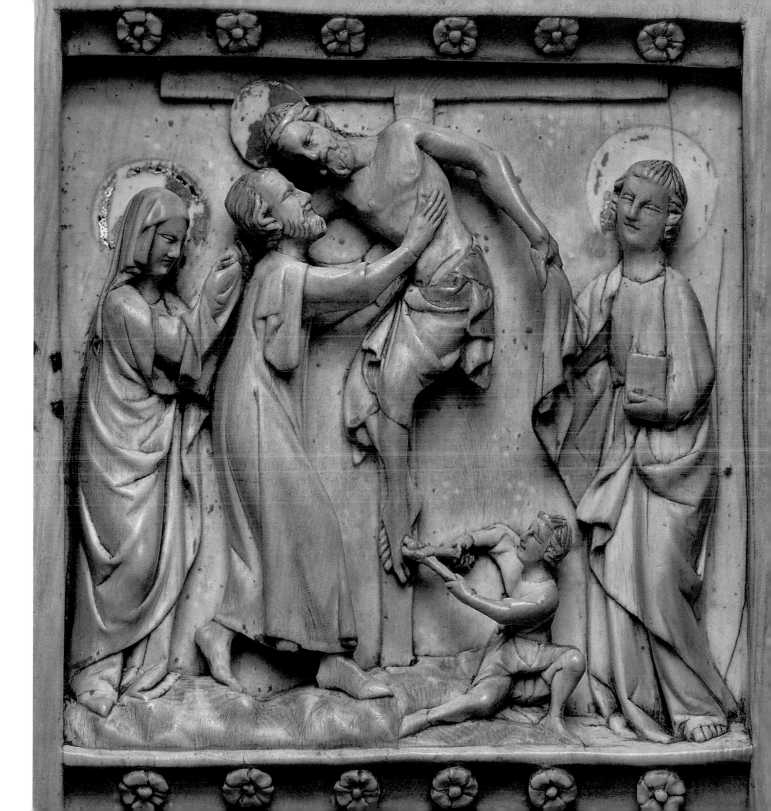

CRUCIFIXION FIGURE OF THE DEAD CHRIST

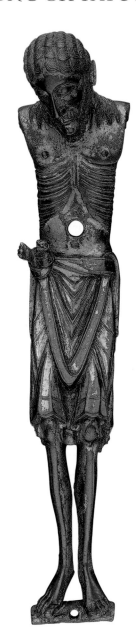

This figure of Christ is one of the most beautiful surviving bronzes of its period. It was made at a time when enormous changes were occurring in representations of Christ on the cross. Contemporary and earlier depictions tended to show the crucified Christ as a victorious force. He is frequently crowned, not with thorns, but with an imperial crown and dressed in robes fit for a king. He stands rather than hangs on the cross and his eyes are open, his head erect. However, in the twelfth century there was an increasing interest in conveying a sense of incarnation; that Christ was God made man and that he died to cleanse mankind of sin. It is the frail humanity of Christ that is developed in this image. The emphasis is on death, with the clear message that Christ had to die for the salvation of mankind.

The artist who made this figure achieves the psychological shift in how Christ is perceived by a radical remodelling of the body. The emaciated figure is designed to provoke sympathy with Christ's suffering. The ribcage is exposed and exploited as much for its emotional resonance as for its decorative qualities. The legs are very thin; the arms, though now missing, were most likely disproportionately long to emphasize the weight of the dead body hanging on the cross. The head of Christ is bent and his heavy-lidded eyes are closed. Symmetry, surface pattern and texture give dignity to the image and demonstrate the Romanesque artist's excitement in the emotional power of decorative detail. This fine level of modelling can be seen in the treatment of the hair and the beard, with its double row of curls. The emphatic V-folds in the drapery are echoed in the mirror image formed by his ribcage. The whole composition is perfectly controlled and harmoniously balanced. As well as being of outstanding quality, the Christ figure is much larger than the great majority of Romanesque bronzes. A similar figure exists in the Musée des Beaux-Arts in Angers. This example was formerly at Le Mans, also in northern France, which might suggest a possible area of origin.

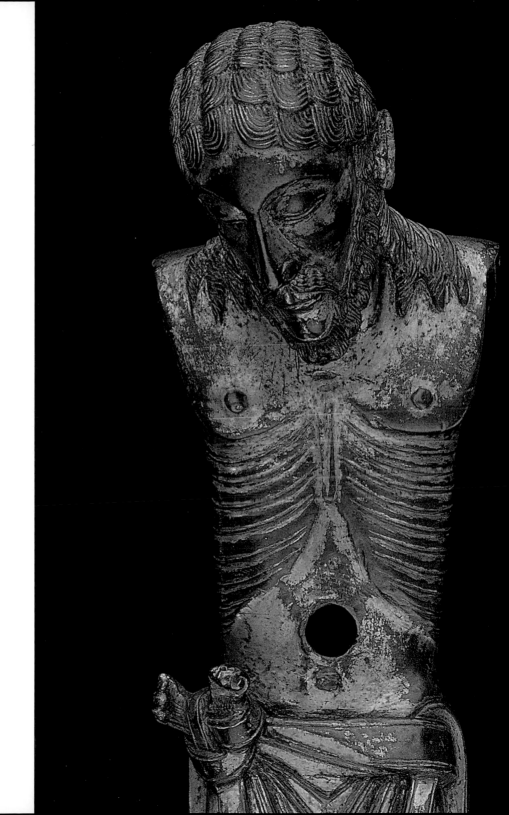

About 1100

Probably made in Anjou, France

Purchased with the aid
of the Art Fund

HEIGHT: 27.2 cm

P&E 1965,0704.1

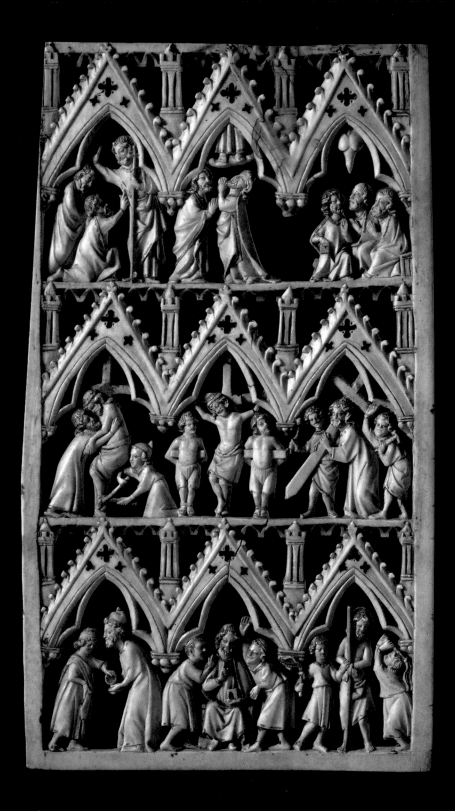

OPENWORK IVORY PANEL OF THE PASSION OF CHRIST

This panel relates to a body of ivory carvings known as the Soissons group. The term derives from a diptych in the Victoria and Albert Museum, London, which is said to have come from the Abbey of St Jean des Vignes at Soissons. Although the ivories are more likely to have been made in Paris or the northern Île-de-France, they all share certain defining characteristics. Their subject matter is usually the Passion of Christ, which is arranged in architectural compartments in units of three; the panels are divided into three horizontal registers, each of which incorporates three scenes. The British Museum ivory is unusual in that it is a single, openwork panel that was probably designed to be placed against a ground of gold leaf. It presents an abbreviation of the 'Soissons' model and edits significant scenes such as the Betrayal of Christ in favour of simplicity, symmetry and number significance. The application of the unit of three is carried rigorously into each individual episode, which contains just three figures. The only conspicuous exception is the first scene, at bottom left, which shows Judas accepting the bribe to betray Christ. Given the strict adherence to three-figure compositions, the void between Judas and his briber must surely be significant, and may indeed indicate the invisible omnipresence of God, who witnesses all things.

The 'Soissons group' ivories also share certain narrative interests. They read in a sinuous manner that connects one scene effortlessly to the next. The Bribing of Judas, the Mocking of Christ and the Flagellation occupy the bottom register, moving on to the register above in a right-to-left sequence with the Carrying of the cross, the Crucifixion and the Deposition. The top register flows on naturally in the conventional left-to-right fashion and shows the Doubting of St Thomas, the Ascension and the Descent of the Holy Spirit. The selection and arrangement of the scenes has also allowed the artist to make interesting vertical juxtapositions; for example, Joseph of Arimathea's tender embrace as he takes Christ's body from the cross is contrasted with Judas's lack of loyalty, below, and St Thomas's lack of faith, above.

Around 1260–80

Paris, France

HEIGHT: 22.5 cm

P&E 1856,0623.43

IVORY PIETÀ

Developments in personal devotion in the fifteenth century led to an increasing enthusiasm for small-scale, intimate works to assist in meditation on the mysteries of Christ's Passion. This miniature ivory carving incorporates two key episodes from Christ's life to guide the viewer in contemplation of the consequences of sin and the value of prayer. On the front is a compelling representation of the dead Christ held in the arms of his grieving mother.

This apocryphal scene, thought to have occurred after the removal of Christ's body from the cross, originated in thirteenth-century Germany. Known as a Pietà, from the Latin 'pietas' ('piety' or 'pity'), it takes for its inspiration representations of the Virgin and Child. The Virgin is seated with her knees apart but instead of supporting the standing figure of the infant Jesus on one knee, she bears the lifeless corpse of her grown son across her lap. This iconographic reference, with some poignancy, combines one of her greatest joys (the Nativity) with her principal sorrow (the Crucifixion). Christ is shown completely rigid from death, his emaciated, naked body in stark contrast to the voluminous robes of the Virgin, as she cradles him in her arms. Although much of the polychromy is not original, it is quite likely that it covers areas of paint applied when the carving was first made. The white body of Christ was undoubtedly designed to stand out against a deeply coloured background.

Although Christ's suffering is central to the scheme, the key to its meaning almost certainly lies with the figure of the Virgin Mary. As the mother of God, prayers to the Virgin Mary were believed to hold particular currency and prayers before an image of the Pietà carried an indulgence, or remission of sin. Appropriately, the reverse of this ivory is carved with a scene of intense prayer, known as the Agony in the Garden, and shows Christ kneeling in supplication. It relates how, when Christ asks the apostles Peter, James and John to pray with him, they fall asleep and he is left alone to plead that he may be released from the ordeal that he is to face. The Agony is the opening episode of the Passion of Christ, the consequence of which is given such graphic form in the Pietà.

15th century
Germany
Given by William Maskell
HEIGHT: 6.6 cm
P&E 1856,0623.153

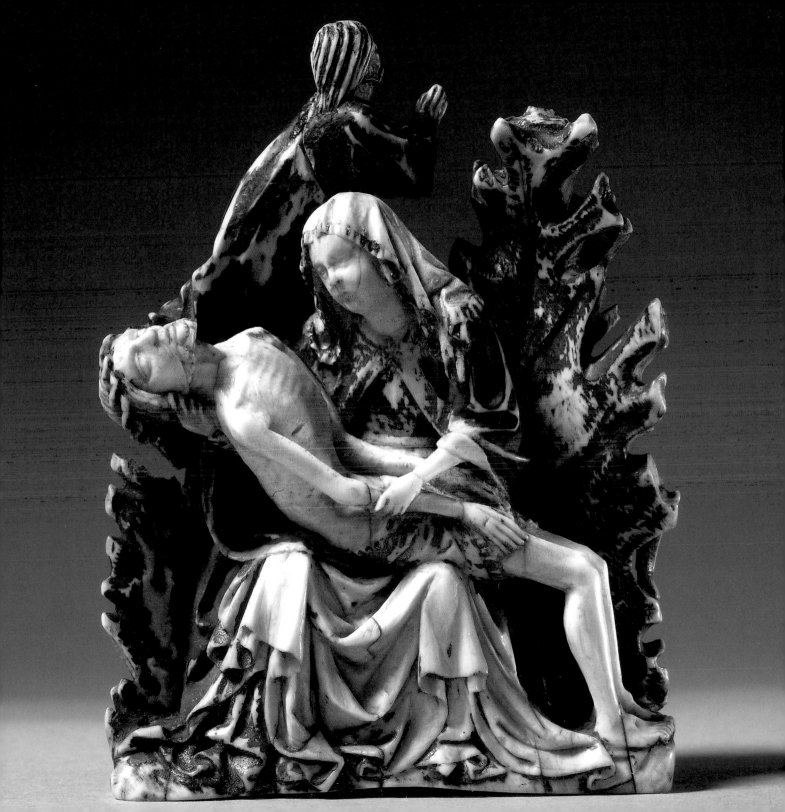

ENAMEL CRUCIFIX

The original appearance of this outstanding cross can be determined by comparison with another in the Cleveland Museum of Art, Ohio, which is extremely close in execution and design. The celebrated Spitzer Cross is a pivotal point of reference for a number of Limoges crosses made around the same period. It too is a fragmentary survival, but the plaques that formed the front of the cross survive in their entirety and provide guidance for the iconographic scheme that once surrounded this striking figure of Christ crucified. Four plaques are missing, which would have formed terminals to each arm of the cross. To the left and right there would have been the customary representations of the Virgin and St John. Above the titulus, the plaque that spells out an abbreviated form of Christ's name at the top of the cross, there is the half-length figure of an angel. This would have been surmounted by another plaque enamelled with a second angel, while at the bottom, beneath the damaged white spot of enamel that signifies the skull of Adam, a further plaque probably carried a depiction of St Peter. When complete the enamels would have decorated a wooden core along with an equivalent number of enamel plates on the back.

The areas of damage do little to diminish the impact of this forceful image. Christ's gleaming white body appears almost cadaverous, the lines that divide his lean body and define his musculature creating the impression of a skeleton. The left side of his ribcage is punctured with a patch of red enamel that illustrates the fatal wound to his side administered by the centurion Longinus. His face, however, is not leached of colour, and his eyes remain open and alert. This is a Christ unvanquished by death. Four nails attach him to the cross on which he appears to stand. The body, though contorted, is not convulsed with pain but is arranged rather in a sinuous symmetry of form, which is highly stylized. This treatment extends to the careful arrangement of the three heavy locks of reddish-brown hair which are spread out on each shoulder. The sophistication and refinement of this cross earns it a place alongside a number of high-quality champlevé enamels that were produced in local workshops to furnish the Abbey of Grandmont near Limoges, many under Plantagenet patronage, particularly that of Henry II.

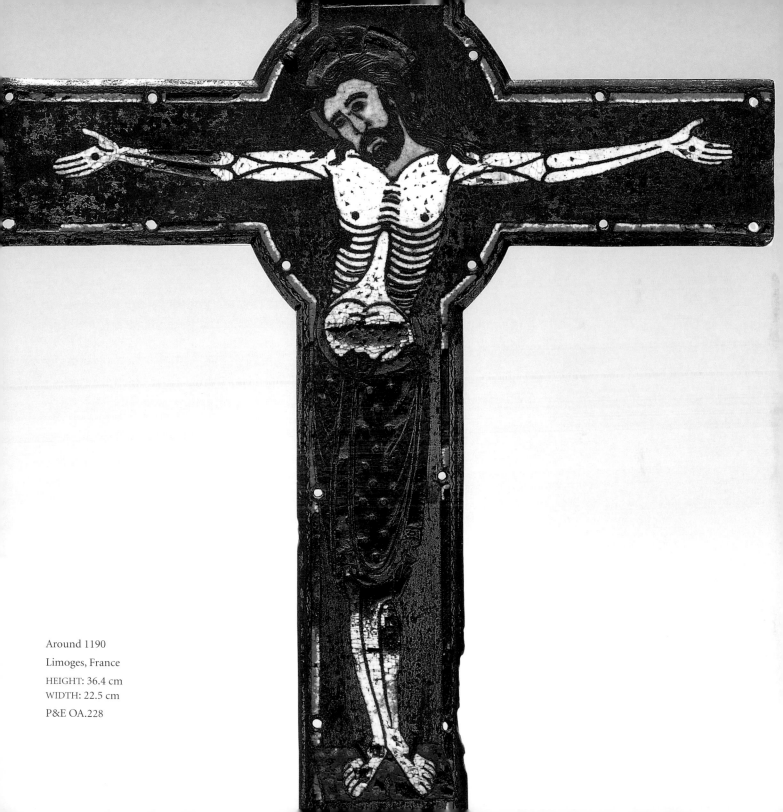

Around 1190

Limoges, France

HEIGHT: 36.4 cm

WIDTH: 22.5 cm

P&E OA.228

ICON WITH THE TRIUMPH OF ORTHODOXY

Around 1400

From Constantinople
(modern Istanbul, Turkey)

Purchased with the aid
of the Art Fund (Eugene
Cremetti Fund)

HEIGHT: 39 cm
WIDTH: 31 cm

P&E 1988,0411.1

In AD 730 the Emperor Leo III forbade the use of icons by the Orthodox Church. His decision was the result of a long-standing doctrinal debate between theologians on the idolatrous nature of images in devotional practice. The judgement was not universally popular and the controversy continued to rage until the regency of the Empress Theodora, who in AD 843 reinstituted icons in Orthodox worship. She is represented in the upper register of this icon, crowned and dressed in red and gold, beside her infant son, Michael III. They stand to the left of a depiction of an icon of the Virgin Hodegetria to commemorate the overthrow of Iconoclasm, a victory that became known as the Triumph of Orthodoxy, celebrated on the first Sunday in Lent. The Virgin Hodegetria was an appropriate symbol of this event since it was believed to have been painted from life by St Luke the Evangelist. The notion of St Luke as a painter was crucial to the argument of the iconophiles that icons had existed virtually since the incarnation. The Hodegetria is usually interpreted as 'she who shows the way', a reading explained by the gesture of the Virgin, who points towards the Christ child.

The icon is densely populated by the heroes of Orthodoxy, among them St Methodosios, who was Patriarch of the Orthodox Church in AD 843. He appears richly vested for Mass and stands with three monks to the right of the Hodegetria. Beneath them are eleven figures, each associated with the defence of icons. Not all are readily identifiable but their names were read out at the service that marked the restitution of icons when images such as this were kissed with due reverence by the congregation. Prominent among them is St Theodosia who, according to legend, was martyred for protecting the icon of Christ Emmanuel that adorned the Chalke Gate of the Imperial Palace. She holds a representation of the icon as an attribute. Another icon of Christ Emmanuel is held by two male saints, probably St Theophanes the Confessor and St Theodore the Studite.

This is the earliest known treatment of the subject, which occurs rarely in icon painting. Its relevance in the late fourteenth and early fifteenth centuries can only be surmised from the volume of church councils convened in this period with the deliberate intention of defining and asserting the values of Orthodoxy.

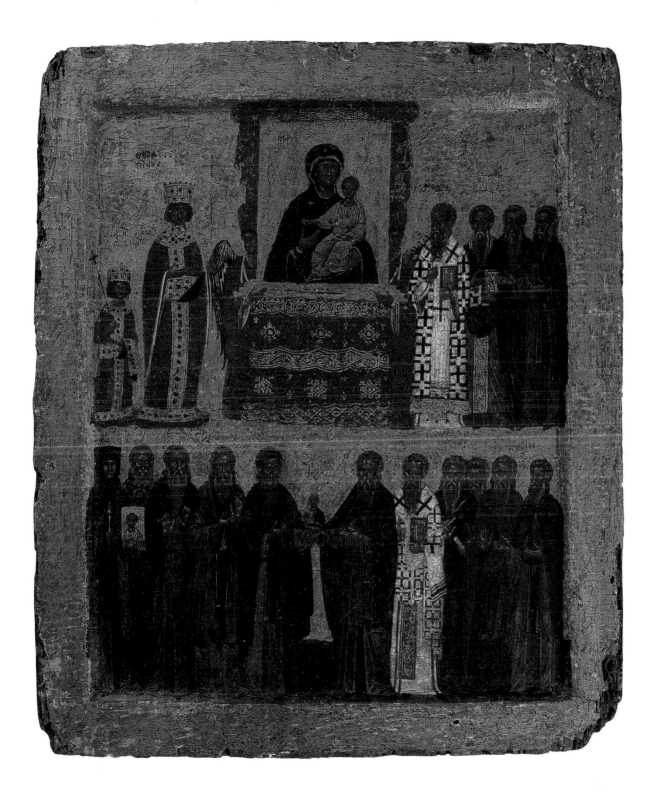

HEAD AND FOOT FROM A CRUCIFIXION CORPUS

Around 1130

England

All Hallows Church, South Cerney, Gloucestershire

HEIGHT OF HEAD: 14.5 cm

HEIGHT OF FOOT: 12 cm

P&E 1994,1008.1 & 2

Images of the crucified Christ, which adorned every church in medieval Europe, acted to reinforce the central tenets of Christian belief: that Christ as God incarnate died to redeem man of original sin and was resurrected. Christ was conventionally represented as victorious over death, often wearing the crown of a king rather than a crown of thorns, with his eyes open. In the twelfth century a change occurred, with Christ increasingly shown lifeless on the cross to engender an appreciation of his suffering and sacrifice. Monumental crucifixions carved from wood were traditionally positioned prominently above the high altar for maximum impact. The scale of these two fragments makes questionable their suitability as part of a large Crucifixion. When whole, the figure from which they came would measure only about eighty centimetres in length, but, mounted on a cross and with the accompanying figures of the Virgin Mary and St John, the sculpture must have had undeniable presence.

That the fragments survive at all is a miracle. They were found in 1915 preserved in a wall of All Hallows Church in South Cerney, Gloucestershire. The damp had taken its toll and the rest of the figure had disintegrated before discovery. In all likelihood it was concealed there to protect it during the Reformation, when such images were banned in England. The head and foot exist now as frighteningly fragile shells, the wood having rotted away inside and the exterior held together by gesso and paint. Their eloquence, however, is undiminished. Together they offer a vision of both torture and tranquillity. The foot is clenched in great pain to convey the horror of crucifixion, its surface punctured by a hole for the nail that fixed it to the cross. The lids drawn over the large eyes of the head speak unambiguously of death. The gently mournful downturn of the mouth is framed by the drooping moustache and the curls of the beard to provide greater definition. The elongated features and the careful arrangement of the curls of Christ's hair and beard show restraint in the treatment of the figure and endow it with great dignity.

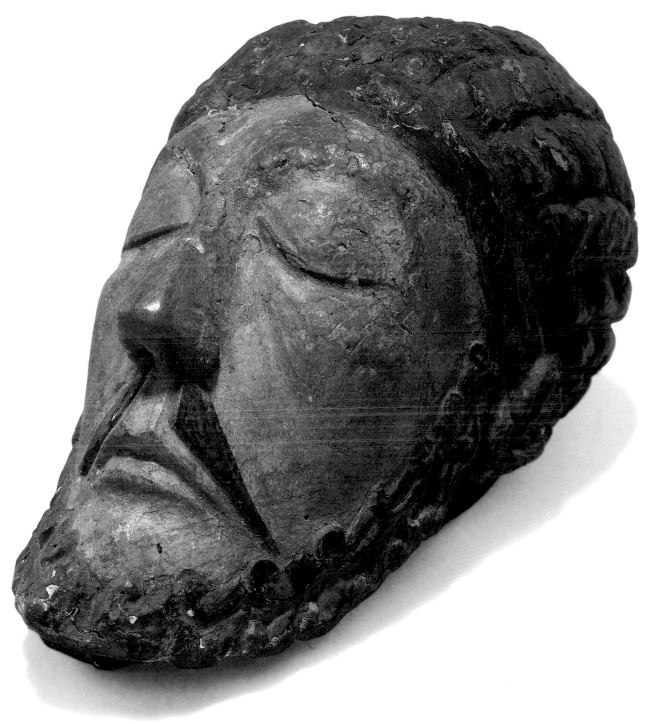

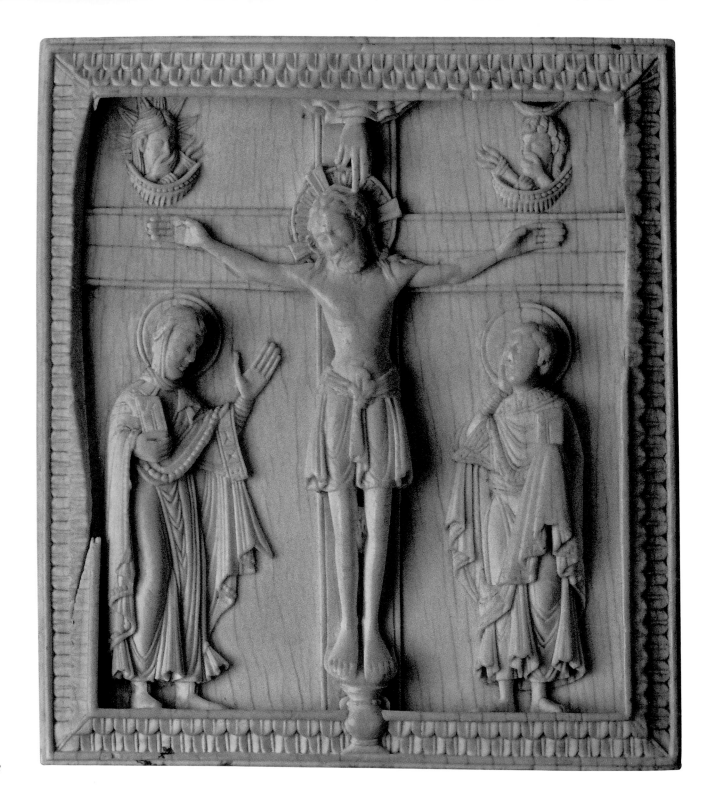

IVORY PANEL SHOWING THE CRUCIFIXION

The dimensions and border decoration of this ivory panel suggest that it was probably intended to furnish a book cover. It resembles Ottonian and Carolingian ivories that were put to the same purpose and shares with them a common source of inspiration in Byzantine art and iconography. It carries a wonderfully lucid, economically rendered depiction of the Crucifixion. The cross extends into the ornamental border in a way that suggests its infinite reach. Christ is arranged on the cross in an almost perfectly symmetrical manner, apart from the inclination of his head towards his mother. He appears victorious over death, serene and untroubled by bodily pain. As with some Byzantine representations of the Crucifixion, no attempt is made to signify the nails that attached him to the cross (see pp. 12–13, 14–15).

Christ is flanked by figures of the Virgin Mary and St John the Evangelist, both of whom hold books in one hand. With her other hand the Virgin indicates towards Christ, in the manner of a Virgin Hodegetria (see pp. 48–9), and St John clasps his cheek in a conventional attitude of grief. They are dressed in fine robes heavily layered and beautifully textured with simulated embroidery on cuffs and hemlines. Above Christ's head, the hand of God issues from a cloud, and above the two arms of the cross are two miniature busts contained within beaded crescents. They represent the sun (left) and the moon (right). Both raise one hand to their mouths in a gesture of inconsolable grief and carry burning torches in the other. The figure of the sun has rays emanating from its head and that of the moon wears a crescent. The presence of these two personifications refers to Gospel accounts of the Crucifixion, which describe darkness descending prior to the death of Christ (Mark 15:33; Matthew 27:45; Luke 23:44–5).

Around 1100

Belgium or Germany

HEIGHT: 11.5 cm

WIDTH: 10.1 cm

P&E 1856,0623.24

ALABASTER OF THE FLAGELLATION OF CHRIST

Late 15th century

England

HEIGHT: 43.2 cm

WIDTH: 27.4 cm

P&E 1891,0521.1

The episode from the Passion of Christ known as the Flagellation or scourging was taken from Gospel accounts, which relate how Pilate, submitting to the will of the multitude, condemned Christ to be crucified in favour of the criminal Barabbas: 'Then released he Barabbas unto them: and when he had scourged Jesus, he delivered him to be crucified' (Matthew 27:26). The scene is given summary treatment in the Gospels, but was developed by alabaster carvers and other artists as a gruesome manifestation of the inhuman cruelty inflicted on Christ prior to his crucifixion.

The intimate relationship between English alabasters and medieval drama is undoubtedly evident in a series of panels that explore the subject. The common source for details not given in the Gospels was almost certainly *The Golden Legend*, written around 1260 by the Franciscan Jacobus de Voragine, which had an enormously influential effect on the visual and dramatic art of the medieval period. One singular aspect shared by the majority of the carvings depicting this scene is the way in which Christ's tormentors grip their scourges with both hands to deliver their blows with extra force. A number also include the additional feature of the cord being tightened around Christ's wrists by one of the soldiers; in this instance, he has dropped his scourge to the ground and uses both hands to pull on the rope. To give additional strength to his efforts he presses his weight on to his bent right knee, which rests on a raised point in the ground. More unusual is Christ's gesture of benediction, which occurs rarely in other examples and is used to show his capacity for forgiveness. The panel bears a number of points of excellence in its execution, design and preservation. It is characterized by a degree of legibility and symmetry shared by few other pieces. The two scourges raised in absolute synchronization above Christ's head find further balance in the arrangement of Christ's right leg, which mirrors that of the soldier who attacks him from behind. The surviving polychromy and gilding appears to be completely original and include touches such as the darkened faces of the soldiers, to express their villainy. Noteworthy also is the use of colour to achieve greater symmetry; the hair colour of the soldiers is juxtaposed for a considered and effective result.

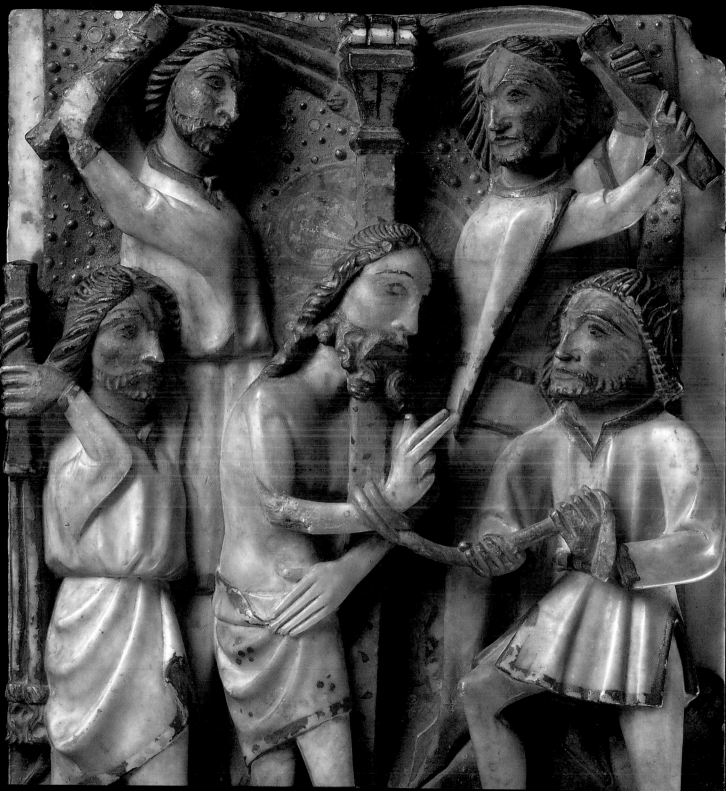

STONE CAPITAL WITH SCENES FROM THE LIFE OF ST PETER

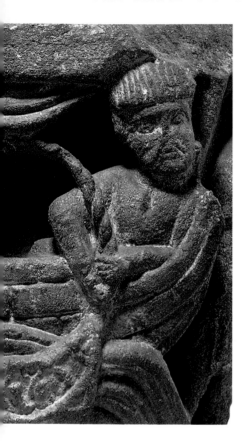

A fifteenth-century charter in the British Library describes how in 1077 William of Warenne and his wife, Gundrada, founded Lewes Priory in Sussex. It recounts how, while on a pilgrimage to Rome, William and Gundrada were delayed in Burgundy and enjoyed the hospitality of the abbey of Cluny. They had for some time considered establishing a religious order close to their home at Lewes and the favourable impression they formed of the monks at Cluny prompted them to decide that it should be a Cluniac order. The priory they founded at Lewes was only the second Cluniac house in England. However, it was destined to become the senior Cluniac house in the country and the richest post-conquest foundation in the south. From its inception, the generosity of William and Gundrada enabled the priory to embark upon an ambitious building scheme, its church designed in close reference to the abbey church at Cluny. The most sacred part of the building, the east end, was completed between 1088 and 1095 and the nave was completed by 1122. It is to this later period that the St Peter capital belongs.

The capital is intended to be seen in the round. Each of its four faces is carved with a scene from the life of St Peter. The first scene shows Peter and his brother Andrew in a small boat hauling in a net, heaving with fish. This establishes the narrative background for the next episode in which Peter and Andrew leave their nets and follow Christ. The remaining two surfaces concentrate on Peter's ministry. In a scene taken from the Acts of the Apostles (3:1–17) Peter, clearly holding his attribute of a key, is shown with the lame man he has healed at the gate of the Temple. The final carving is a church essentially representing Christ's statement, 'Thou art Peter and upon this rock I will build my Church' (Matthew 16:18). The choice of subject matter may have been determined by the fact that the mother house at Cluny was dedicated to St Peter.

About 1125–50

From Lewes Priory, Sussex, England

HEIGHT: 25.2 cm
WIDTH: 28.2 cm

P&E 1839,1029.43

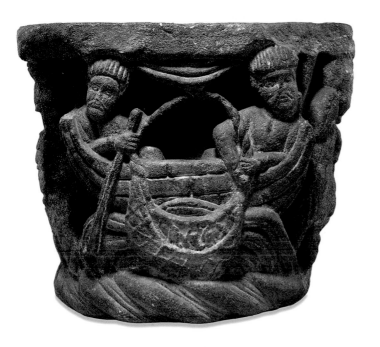
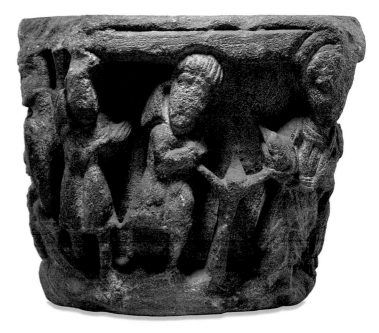
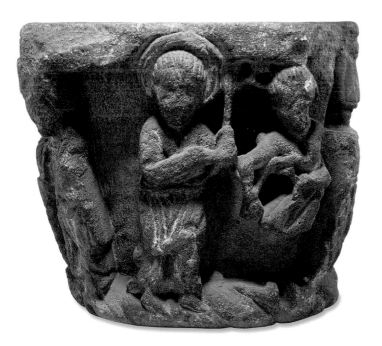
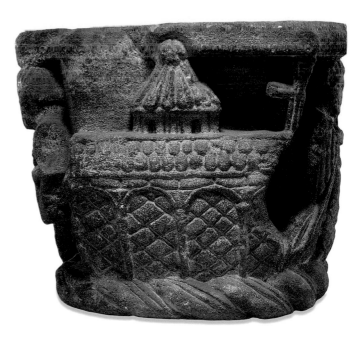

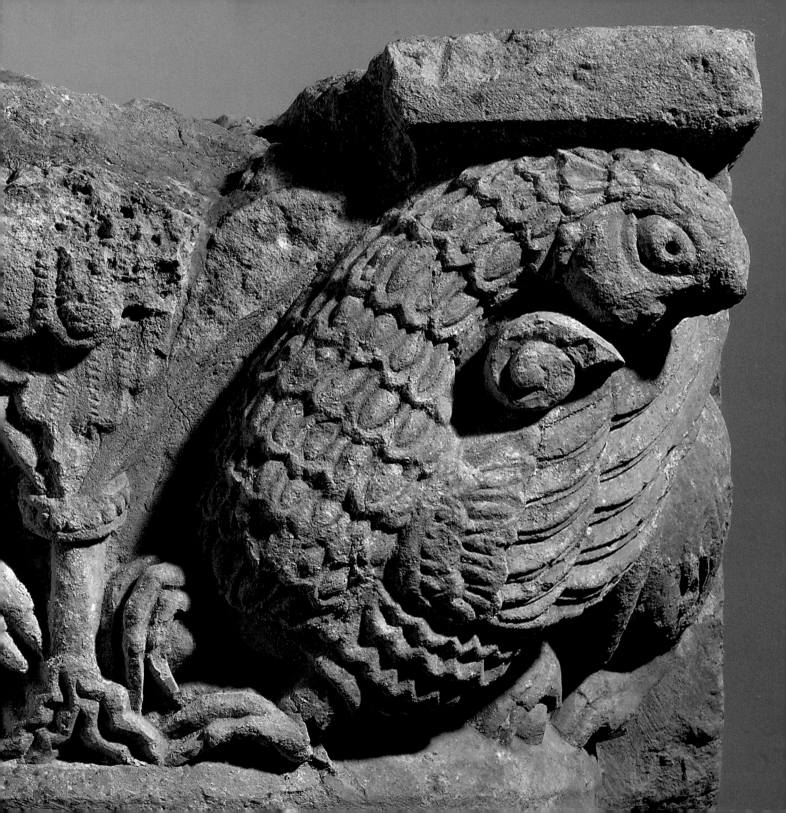

CARVED STONE CAPITAL

The ancient history of this capital is unknown but it came to light in the early 1980s in the garden of a local house in Lewes, East Sussex. It is carved from Caen stone, imported from Normandy, and is of a sufficiently high artistic standard to suggest that it belonged to an institution of some prominence. Extensive remains from the site of Lewes Priory offer points of stylistic comparison that indicate that it may have originated there. Furthermore, Caen stone was used on the site from around the mid-twelfth century. Lewes Priory was an enormously wealthy Cluniac monastery founded by the influential Norman baron William de Warenne and his wife Gundrada in 1077. The priory was dissolved in November 1537 and was demolished for redevelopment as a stately manor owned by Thomas Cromwell, one of the principal agents of the Dissolution. Thereafter, like many of its sister institutions, it found its stone gradually pilfered for reuse in the immediate vicinity. The common practice of reusing monastic stone to build walls elsewhere might account for the displacement of this splendid capital from the site of the priory.

The capital would have decorated the top of a respond, or half column, usually backed against a wall to support the arch around a doorway. It is carved with the figures of two beasts: on the left, a lion, and on the right, a griffin. Some damage has occurred to the capital, resulting in the loss of the lion's face and the griffin's beak. However, the surviving detail is remarkably well preserved, with a crispness and angularity that betrays little evidence of exposure to the elements. This is particularly the case with the claws of the lion and the talons of the griffin. The carver has respected the different natures of the two creatures by conveying the impression of densely layered plumage for the griffin while the lion's mane hangs in heavy curls across its smooth coat.

About 1150–75

From Lewes, East Sussex, England

Given by Mr Mervyn Ralph Corfield

HEIGHT: 34.4 cm
LENGTH: 58.6 cm
WIDTH: 47.3 cm

P&E 2004,0801.1

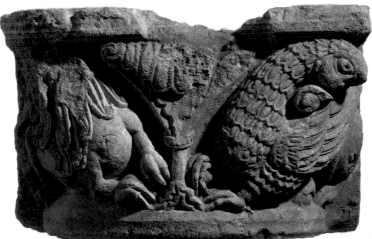

BRONZE SEAL-DIE OF INCHAFFRAY ABBEY

Inchaffray Abbey was a house of Austin Canons founded by Gilbert, Earl of Strathearn, in 1200. It was dedicated to St John the Evangelist, whose imagery decorates this finely engraved seal-die. Bronze was the preferred medium for seal-dies due to its hardness, which allows for a higher definition of engraving and greater resilience in repeated use. By the mid-thirteenth century the business of monastic administration had become enormously complex. Seals, appended to documents, provided a means of validating legal documents most usually relating to issues of land disposition. Double-sided seals, produced by dies such as this, were attached to strips of parchment or laces made of silk inserted into slits at the end of the document. The wax was softened, sandwiched between the two parts of the die and squeezed into the engraved surfaces by the action of a seal-press or a small roller. In order to perform this process, the backs of the dies were made flat and the projecting pegs of one side fitted into loops on the other to prevent any slippage.

It was common practice for institutions to represent themselves on their seals with reference to their dedicatory saint. In this instance, Inchaffray chose to show St John the Evangelist on both sides of its seal. On the front, St John stands within an architectural canopy meant to signify the abbey. He is represented greater than life-size, almost as large as the abbey church itself, as he gathers his robes into elegant folds in one hand, supporting a book, and holds the palm of martyrdom, or a large quill pen, in the other. On the reverse of the seal, within an elaborate octofoil, is a richly plumed eagle with a nimbus. The eagle is the symbol of St John the Evangelist, its symbolism made clear here by the scroll it holds in its claws, which cites the opening words of the Gospel according to St John: 'I. PRINCIPIO. ERAT. VERBV' ('In the beginning was the word').

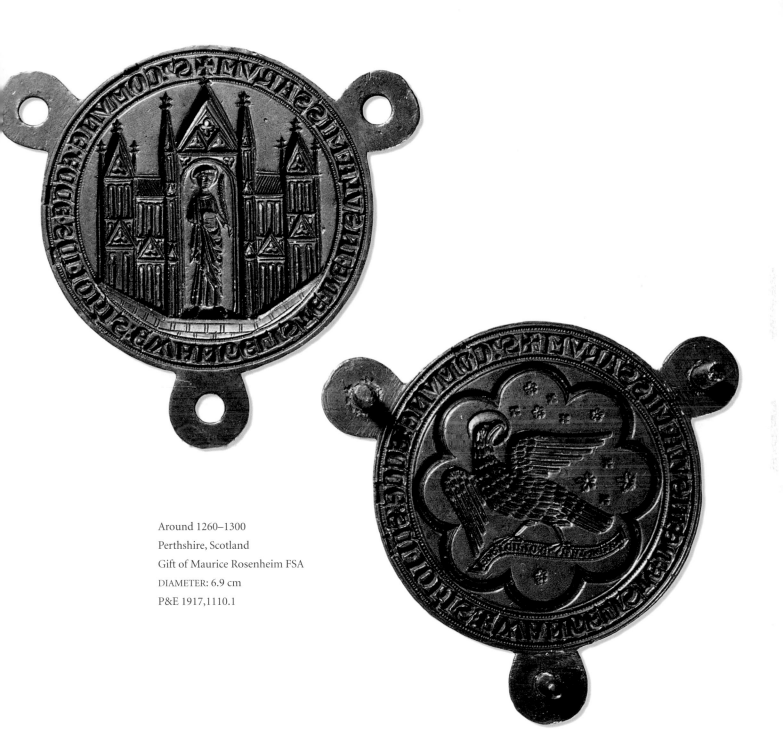

Around 1260–1300

Perthshire, Scotland

Gift of Maurice Rosenheim FSA

DIAMETER: 6.9 cm

P&E 1917,1110.1

BYLAND ABBEY TILES

Elaborate mosaic pavements were created at a number of Cistercian monasteries in northern England and southern Scotland during the thirteenth century. The spectacular effect of these huge complex floors was achieved by the arrangement of ceramic tiles of various shapes – each glazed a single different colour – in abstract geometric patterns. At Byland Abbey, as at many monasteries, the tiled floors covered vast areas of the abbey church. The architectural stonework of many of the steps inside the church was specially rebated to take the tiles, suggesting that the mosaics were intended as a major element of the appearance of the interior. This integration of tiles into the stone fittings of the building indicates that the tilers and masons probably worked closely together on the design.

The Byland mosaic panel is arranged in concentric bands, each separated by a ring of narrow, yellow-glazed tiles. The panel has been reassembled from tiles found loose on the site, probably from the north transept, and is based on surviving areas of re-set tiles in the chapels of the south transept. The tiles were originally glazed either yellow or green. The pavement has become worn and damaged over time, resulting in the appearance of white, pink and grey colours on the tiles where the slip or clay fabric has been exposed.

Mosaic pavements were probably introduced into northern England from French or German Cistercian houses with comparable floors, and the tilers who created them are likely to have been Cistercian monks or lay brothers. Manufacture of mosaic tiles of this type is dated broadly to the period 1220–70, and Byland may have been the first abbey to be paved. The monastic milieu of both production and use contrasts with the contemporary development of tiled pavements in southern England, which relied primarily on royal patronage.

Probably first half of 13th century
Byland Abbey, North Yorkshire
Acquired with the aid of
the Art Fund

LENGTH: 195 cm
WIDTH: 126 cm
P&E 1947,0505.6339–6772

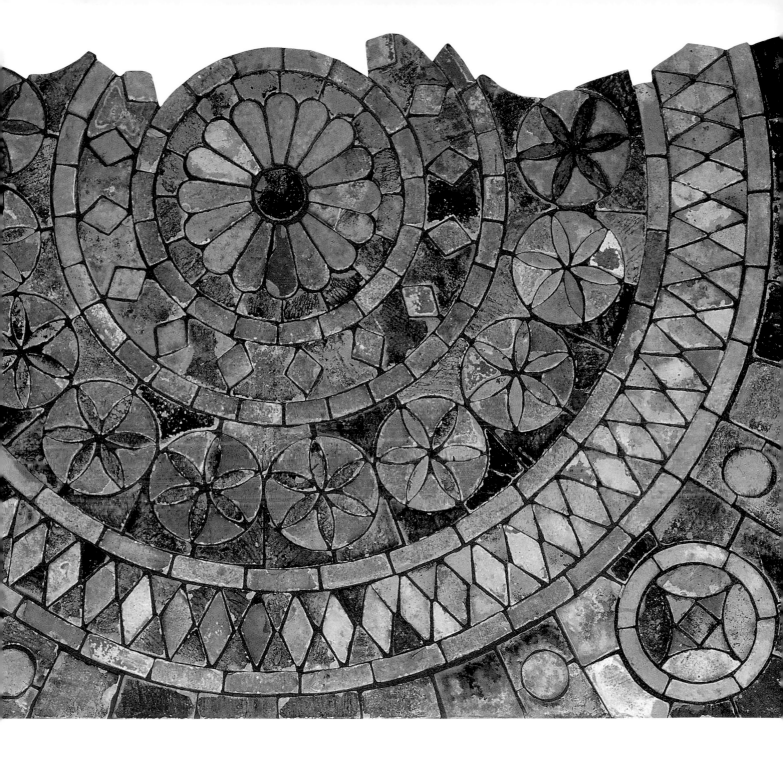

SILVER BRACTEATE PFENNIG OF AGNES II VON MEISSEN, ABBESS OF QUEDLINBURG

There were many powerful women in the medieval world. Women's right to inherit and transfer power and property varied over time and across regions, but nowhere was it negligible. Misogynistic language, especially in theological and philosophical literature, did not overpower the realities of family and dynasty. While there could be restrictions over their control of their own fates, wives, widows, sisters and daughters all had rights and expectations which, given the correct personality or set of circumstances, could often ensure their status. When and how powerful women were depicted in visual media echoes this ambivalence.

Coinage design is one such arena, indeed probably the one with the widest circulation among the largest group of people. Although images of female rulers were not common, they did arise when it fitted the local tradition of coinage design, as in Castile, Naples and Cyprus. The only long-running series of female rulers on coins occurred in Germany from the eleventh century as a consequence of the existence of wealthy female religious communities with the right to mint their own coins. These included Herford, Gandersheim and Essen, but the most prominent was probably Quedlinburg. The abbey was created by St Matilda, widow of the German king Henry the Fowler, and was a long-standing centre of imperial power under the Ottonian emperors. In 994 Emperor Otto III gave the convent the right to hold markets, levy local taxes and mint coins.

The abbey housed unmarried daughters and widows from royal and noble families leading a godly life, although they did not take formal vows and were not part of one of the great monastic orders. The abbesses of Quedlinburg were always members of the greatest families of Germany: the imperial house itself or the major lords of the region of Saxony. They were women used to the exercise of power and were often able to use their family ties to support the abbey's control over the city of Quedlinburg, against the rivalry of its rich urban elite. They also depicted themselves on their coinage. Abbess Agnes II was a member of the family of the powerful margraves of Meissen; she is shown here demurely cloaked and holding a bible and cross, but seated on an impressive throne.

1184–1203
Quedlinburg, Germany
DIAMETER: 4 cm
CM 1848,0310.84

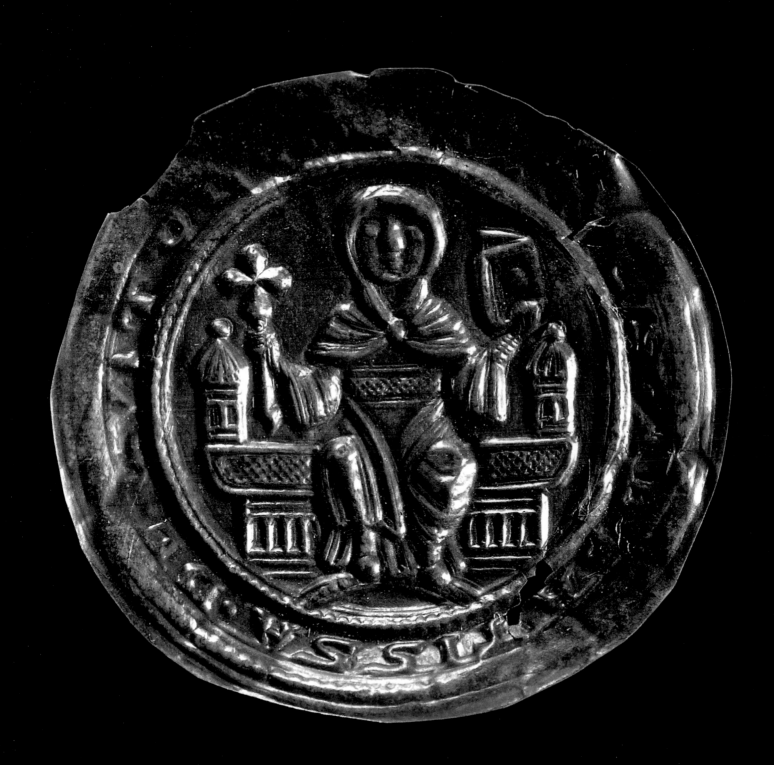

FRONT OF AN ENAMELLED ALTAR CROSS

About 1160–70

France or Belgium

HEIGHT: 37.2 cm

WIDTH: 25.6 cm

P&E 1856,0718.1

The significance of the cross is possibly one of the most unchanging aspects of Christian belief. Its representation, however, has been subject to an infinite variety of treatments since the dawn of Christianity. The plaques on the front of this elaborately decorated altar cross do not, significantly, show the Crucifixion at all, nor is there any space for the attachment of a figure of Christ. Instead the richly enamelled scenes reveal the mysteries of the Crucifixion through Old Testament typologies and symbolism. Although this object was undoubtedly made to commission for someone of sufficiently high status and learning to understand the allusions, the medieval mind was schooled in a system of image interpretation that rendered such schemes readily understandable. For instance, the Old Testament story in which Abraham is asked by God to sacrifice Isaac, his only, beloved son, was understood by a medieval Christian audience to prefigure the sacrifice of Christ, the son of God.

The plaques here develop a system of cross and Crucifixion symbolism through the choice of subject matter or through simple repetition of the motif. At the centre Jacob blesses the sons of Joseph and forms a cross with his arms. Above this scene Moses and Aaron are shown the brazen serpent on its column, which resembles Christ on the cross, the true deity. To the left the scene of Elijah and the widow of Sarepta includes the image of a cross formed from the two sticks she holds. The right plaque portrays the Passover, where the slaughtered lamb is understood to be a symbol for the sacrifice of Christ, the Lamb of God. The bottom plaque shows two spies returning from the Promised Land bearing a colossal bunch of grapes which, through Eucharistic allusion, signifies the blood of Christ.

Although no explicit representation of the cross occurs in the imagery of the plaques, interestingly the matching plaques that would have decorated the reverse of the altar cross survive in the Kunstgewerbe Museum, Berlin. The scenes depicted on those plaques amplify the cross imagery on the British Museum piece by relating the legend of the discovery of the True Cross by the Empress Helena. The sophistication of this compact but dense iconographic scheme might suggest that the cross the plaques furnished was intended to hold a relic of the True Cross.

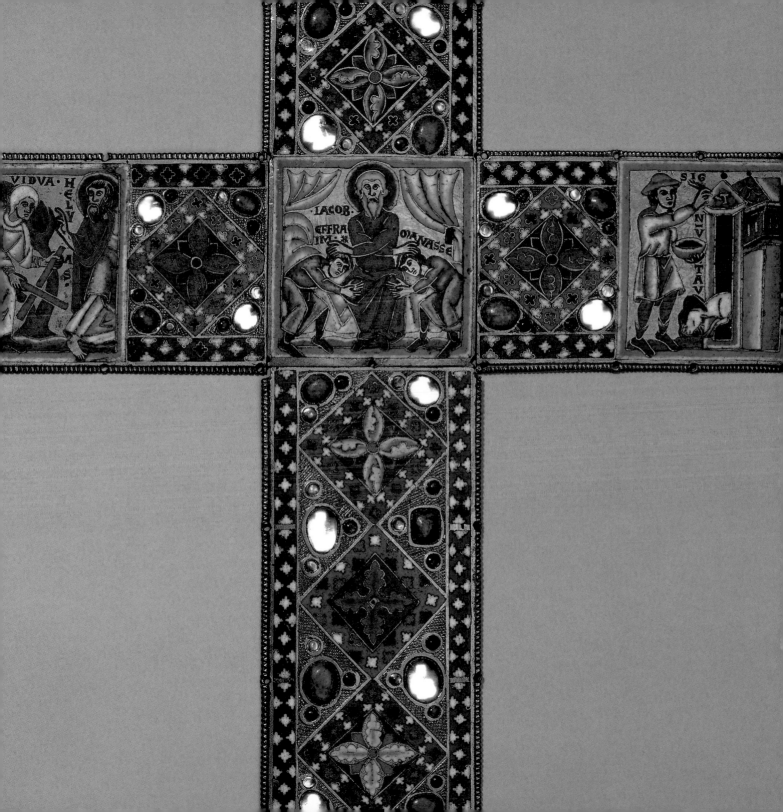

VIDVA · HELV... ...S.

IACOB · EFFRA... IM · O... ANASSE

SIG... ...NI · V... ...TAV

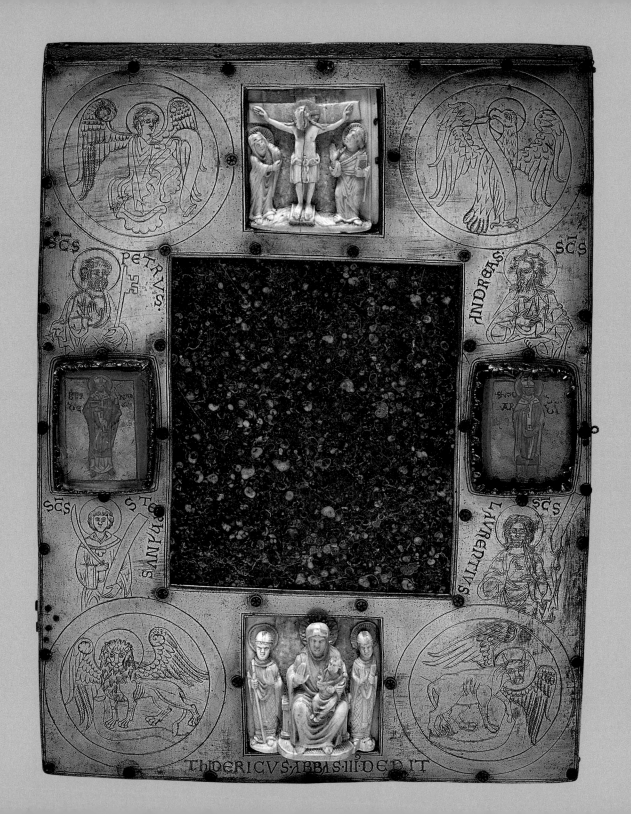

PORTABLE ALTAR

About 1200

Hildesheim, Germany

HEIGHT: 35.4 cm

WIDTH: 25.1 cm

P&E 1902,0625.1

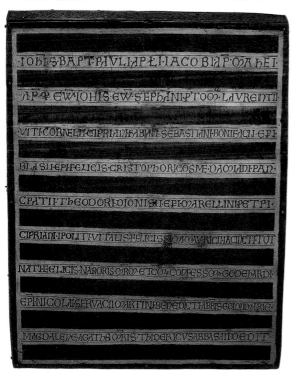

Portable altars were used to celebrate Mass in areas without consecrated spaces. The notion of consecration, of creating a sacred space separate from daily reality, was of integral importance in the performance of Christian ritual. An altar was an essential part of this process. The nature of the portable altar was infused with sacred significance. Central to its construction was the altar stone, which was endowed with its own symbolic power. Exotic stones and marbles from the Holy Land were especially valued for this purpose. The stone that furnishes this portable altar is a type of oolitic limestone that was chosen because of its resemblance to porphyry.

The altar stone is set into an engraved copper-gilt surround, itself attached to a wooden core by small silver pins, the heads of which are decorated with niello rosettes. Carved walrus ivory panels showing the Crucifixion (above) and the Virgin and Child between two bishop saints (below) provide a point of contrast with the flat linearity of the engraving. They are balanced by two pieces of painted vellum placed beneath convex crystal covers either side of the altar stone. On the left is a representation of St Bernard of Hildesheim and on the right St Godehard, in whose name the abbey of Godehardiklosters at Hildesheim was dedicated. An inscription beneath the Virgin and Child ivory identifies the patron of the altar as Abbot Theodoric III, who was at Godehardiklosters between 1181 and 1204.

Images of saints adorn the altar in abundance; engraved roundels showing the symbols of the four evangelists are accompanied by half-figure representations of the saints Peter, Andrew, Stephen and Lawrence and decorate the entire surface. Also, it actually contains the remains of saints, physically reinforcing its sacredness. On the reverse, in a long inscription separated by bands of brown varnish, are the names of forty saints whose relics are contained in a cavity beneath the altar stone.

RING ENGRAVED WITH THE FIVE WOUNDS OF CHRIST

Devotion to the blood and wounds of Christ was one of the hallmarks of late medieval piety. Prompted by a desire to provoke greater sympathy with the sufferings of Christ, images of the disembodied wounds became a universally recognizable symbol of the consequences of sin. They were often combined with half-figure representations of the risen Christ standing in the tomb and surrounded by the instruments of the Passion. Known as the Man of Pity or the Man of Sorrows it is the central image on the band of this gold ring. The largest wound inflicted on Christ was the mortal wound to his side delivered by the centurion Longinus, which pierced his heart and released him from his suffering. It is shown here next to the figure of Christ, spurting drops of blood, which were originally enamelled red. Each wound is described as a well to express the Eucharistic concept of drinking Christ's blood for the redemption of the soul. English inscriptions on the ring identify 'the well of pity, the well of mercy, the well of grace, the well of everlasting life'. The lengthy inscriptions dictate the ring's form and their language shows an increasing interest in using the vernacular for devotional purposes, established in the fourteenth century by mystics such as Richard Rolle, Walter Hilton and Julian of Norwich, all of whom also employed graphic images of Christ's suffering in their texts.

The English inscriptions are accompanied by others in Latin on the interior of the hoop, all inlaid with black enamel. They explain the significance of the imagery: 'the five wounds of God are my medicine, the holy cross and passion of Christ are my medicine. Caspar, Melchior, Balthazar, ananyzapta tetragrammaton.' Image and word combine to offer the wearer salvation and comfort. The healing power of Christ's blood is described alongside the use of popular amuletic charms. The names of the three kings, Caspar (sometimes Jasper), Melchior and Balthazar, were widely believed to have magical properties, as were the words 'tetragrammaton', used to express the unwritable name of God in Jewish belief, and 'ananyzapta', which was invoked as protection against epilepsy. The ring, undoubtedly used as a devotional tool, clearly also functioned as an amulet.

Late 15th century

England

Bequeathed by Augustus Wollaston Franks

HEIGHT: 1.55 cm
DIAMETER: 2.7 cm

P&E AF.897

PELICAN BROOCH

The symbolic significance of the pelican was developed in medieval Bestiaries, books that contained images of real and mythical animals accompanied by a moralizing text. The bird was compared with Christ on a number of levels, principally because it was believed to resuscitate and nourish its young with its own blood. It was thus given a strong Eucharistic dimension and enjoyed great popularity as a symbol of Christ's sacrifice.

The cabochon ruby set into the breast of this small gold pelican brooch signifies the blood it sheds from its self-inflicted wound. The pelican stands on a scroll, which extends beyond the full expanse of its outstretched wings. On one side a tiny pelican is perched to receive the blood and on the other is an inscription of uncertain meaning, formed from the letters y, m, t and h. In the centre, set into a high collet, is a single diamond. From the scroll hang the remains of five suspension elements, including two pins that were probably meant to hold pearls. The brooch is finely modelled and richly textured in an attempt to convey a naturalistic impression of feathers. The back is also worked, although it was never intended to be visible. Documentary sources bear witness to the extensive fashion for small animal-shaped brooches from the late fourteenth to the mid-fifteenth century. Valentina Visconti, who married Louis de Valois in 1389, brought with her from Milan a pelican brooch enamelled in white with a ruby in its breast and four pearls, presumably suspended. The device of the ruby to signify blood remained in vogue long into the fifteenth century. In 1447 Duke Amadeo VIII of Savoy commissioned thirteen pelican brooches as New Year gifts for his family. Each one was made of gold and set with a ruby.

Around 1420–50

Belgium or France

Given by Sir Augustus Wollaston Franks

HEIGHT: 2.5 cm

WIDTH: 3.7 cm

P&E AF.2767

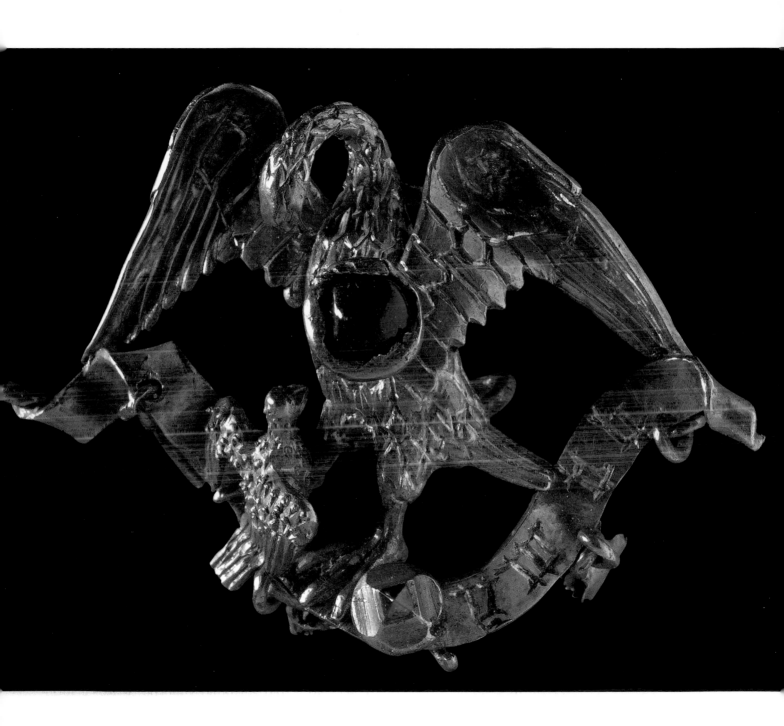

RELIQUARY HEAD OF ST EUSTACE

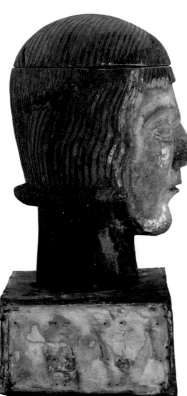

Around 1180–1200

Basle, Switzerland

HEIGHT: 33.5 cm
WIDTH: 17 cm
DEPTH: 15.6 cm

P&E 1850,1127.1

In the 1830s political agitation resulted in the sale of a substantial part of the magnificent Cathedral Treasury at Basle. This reliquary was one of several outstanding objects that subsequently appeared on the open market. Although known as the reliquary head of St Eustace since at least 1477, when it was described as such in an inventory, upon examination its contents were found to include the relics of several different saints along with nine unlabelled skull fragments. The skull fragments were the first to be encased, and, given the form of the reliquary, they are likely to have been the relics that dictated its shape and possibly its name if they were believed to be those of St Eustace. According to legend, St Eustace was a Roman general who converted to Christianity after a miraculous vision: when out hunting he saw a stag, which carried between its antlers an image of the crucified Christ. He and his family were later martyred for their faith.

The reliquary has two parts: a core carved from sycamore, which accommodated the relics in a cavity beneath its skull, and a silver-gilt cover. The cover seems to have been applied a little later than the manufacture of the wooden head, which it resembles closely but not precisely. It was possibly designed as a means of embellishing the earlier wooden reliquary, which provided a support for the application of the thin, repoussé metal sheets. The result is a much more imposing, idealized image. The less oval, more angular face with its smaller chin, wider mouth and eyes gives a dimension of austere authority that is lacking in the more diminutive features of the wooden model. A diadem encircles the head to give an extra expression of grandeur. Its frame of filigree coils is decorated with sixteen various settings, including amethyst, carnelian, rock crystal, chalcedony, pearl and glass. The settings show a liberal use of recycled Roman glass and gems, confirming both that medieval craftsmen often exploited existing supplies of Roman glass and the value that was placed upon ancient Greek and Roman gems in the medieval period. The pedestal on which the metal head stands was also set with a profusion of glass and gems, though only two Roman glass pastes survive. Its four sides are mounted with twelve figures within arches, each cast from the same die and probably intended to represent the twelve apostles.

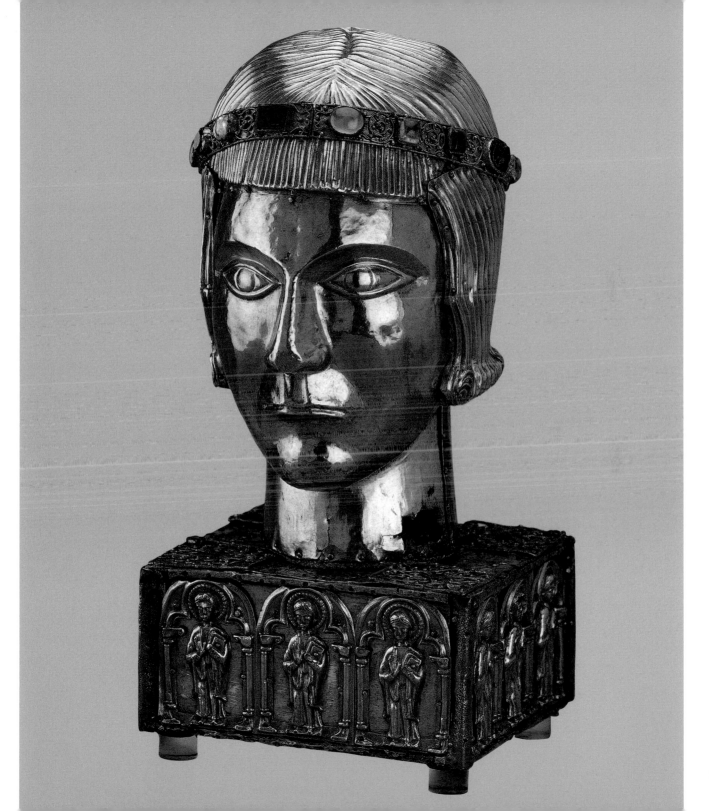

RELIQUARY PENDANT

The collection and presentation of relics in the medieval period are well documented and supported by the survival of a vast range of reliquaries. These were devised to accommodate the sacred relic in an appropriate setting and so were often constructed of precious metal, richly embellished with enamels or jewels. Multiple relics might share a single container, as is the case with this gold reliquary pendant. The origins of its relics are itemized in an abbreviated Latin inscription, which runs around the edge of the reliquary. This is very difficult to read but includes references to Jesus Christ, St Ninian and St Andrew. The relics were set into a base-plate secured to the back of the pendant by the action of a nut, which was screwed down at the top. At the centre of the arrangement is a cavity for a piece of the True Cross. Once the back was in place, the relics were effectively concealed. Their presence was indicated by the inscription but equally by a simple wooden cross set into a gold surround amid pearls which form the pendant's front. The pearls are sewn to their base with gold wire loops and are magnified by the domed rock crystal that covers them. Vestiges of two suspension rings remain, which suggest that the reliquary was either worn around the neck or hung close to a shrine or altar.

St Ninian's name appears first in the inscription after that of Christ, making him the principal saint among those listed. He, along with St Andrew, had strong Scottish associations and was venerated at the Cathedral of Galloway at Whithorn. Other saints listed on the reliquary might also include St Fergus and St Margaret, an interpretation that strengthens the Scottish connection, along with St Norbert of Xanten. St Norbert founded the Premonstratensian order of Canons Regular and his inclusion would be appropriate given that the Cathedral of Galloway was under Premonstratensian rule. The local associations suggested by the inscription have led to a conviction that the pendant belonged to a bishop of Galloway in the thirteenth century.

About 1200
Scotland
Purchased with the aid
of the Art Fund
DIAMETER: 5 cm
P&E 1946,0407.1

RELIQUARY PENDANT

The powers attributed to relics relied on their proximity to the person soliciting help. Pilgrims were encouraged to press themselves against shrines in the hope that they would be imbued with the miracle-working agency of the saint. Those fortunate enough to own a sacred relic might set it within a pendant or a ring to ensure close physical contact. The immediacy underlying this belief permeated late medieval piety, which relied increasingly on mystical contact with Christ and the saints, achieved through contemplation and the wearing of relics. Descriptions of personal reliquaries proliferate in household accounts, wills and inventories of the late fourteenth and fifteenth centuries, when the fashion for wearing such items was at its peak.

This heavy gold pendant was owned by a person of some wealth. It has a removable back-plate, which is held in place by hinges on each side secured by retractable pins. On the reverse is a depiction of a standing archbishop saint, very probably St Thomas Becket, who holds a cross-staff in one hand and extends a blessing with the other. On the front is a representation of St John the Baptist, who holds a book in his left hand supporting the Agnus Dei (Lamb of God), to which he indicates with his right index finger. Both figures are placed between two white roses. Most of the enamel that originally decorated this piece is now lost, but where it remains it achieves some subtlety of modelling, particularly in the billowing robes of the archbishop and the hair and beard of the Baptist. Black enamel is used for the inscription on the front, which reads '*A mon derreyne*', a phrase that has been interpreted as 'at my death'. Tears, which were also once enamelled in black, are arranged on the sides and base of the reliquary either as a symbol of mourning or in sympathy for the suffering of Christ. St John the Baptist was an important funerary saint and is invoked frequently in wills and tomb imagery. He also appears conspicuously in Last Judgement iconography and was, therefore, an appropriate saint to call upon in death.

Late 15th century

England

Given by Sir Augustus Wollaston Franks

HEIGHT: 5 cm
WIDTH: 4.2 cm

P&E AF.2765

GOLD AND ENAMEL RELIQUARY PENDANT

The front plate of this multilayered reliquary pendant has been replaced by a simple frame, which surrounds a depiction of St Demetrios recumbent in his tomb (left). The frame is engraved with an eighteenth-century Cyrillic inscription, which states that the pendant was once owned by St Kethevan, a Georgian queen executed by Shah Abbas I in 1624 for refusing to convert to Islam. It was doubly valued at this time both as a possession of the holy martyr and, according to the inscription, as a receptacle for a fragment of the Holy Cross. However, it was almost certainly made originally to contain a relic of St Demetrios. The missing cover is likely to have held a representation of the military saint, executed in cloisonné enamel, to correspond exactly with the depiction of St George on the back (right). St George looks towards his sword, which is raised against his shoulder on the left. He is named in an inscription that reads in Greek from the point of the sword downwards. The surrounding inscription of Greek letters against a brilliant blue background reads, '[The wearer] prays that you will be his fiery defender in battles', reinforcing the military character of this sacred jewel.

A further inscription, which runs around the rim of the reliquary, proclaims 'Anointed with your blood and myrrh'. The inscription relates to the shrine of St Demetrios at Thessaloniki, which was celebrated for the sweet-smelling oil that oozed from his tomb. This reliquary was probably made in Thessaloniki to furnish the cult of the saint and may have been worn by a wealthy military patron. The rectangular panel that accommodates the image of St Demetrios lifts up to reveal a secondary, repoussé figure of the saint in plain gold. The figure of St Demetrios in his tomb appears to be modelled on representations of Christ in the Holy Sepulchre that appeared on the seals of the Grand Masters of the Knights Hospitallers of Jerusalem and on the lead ampullae collected by pilgrims. The image probably travelled to Thessaloniki through the agency of pilgrims returning from the Holy Land.

13th century

Thessaloniki, Greece

Acquired with donations from the Art Fund and O.M. Dalton

DIAMETER: 37.5 cm

DEPTH: 10.5 cm

P&E 1926,0409.1

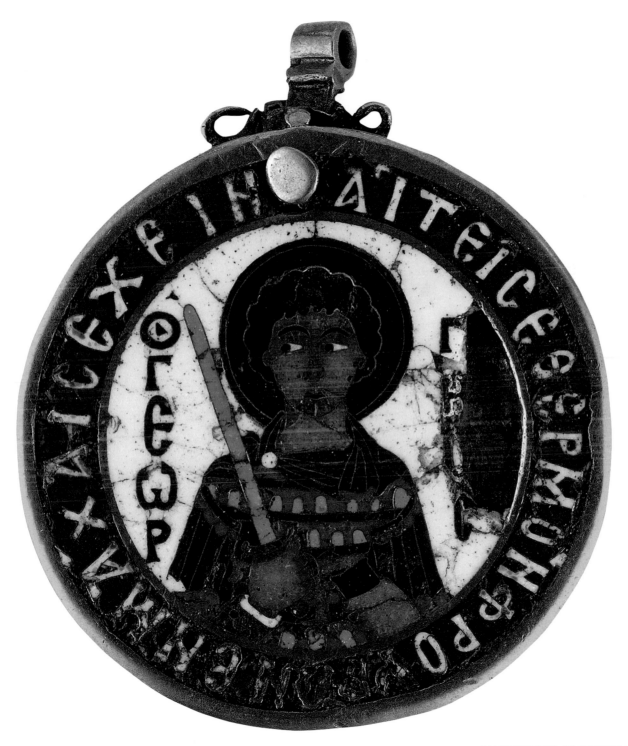

GOLD AND ENAMEL RELIQUARY CROSS

An astonishing survival, this reliquary cross is said to have been found on the site of the Great Palace of Constantinople. Even more remarkably it retains its original chain, which extends to over sixty centimetres in length and is threaded through a large, heavily beaded suspension loop. The cross was made to be worn around the neck and was probably intended to carry a relic of the True Cross. It is enamelled in a style of 'sunken' enamel that became current from the middle of the tenth century onwards and is distinctive for the bold silhouette of colour it forms against a bare metal background. A plentiful supply of gold and the ready availability of recyclable glass from the tesserae that made up mosaics placed Byzantine enamellers in a natural position of strength, from which they excelled. The enamel of this cross is laid in small cells made up of thin strips of gold soldered together in a technique known as cloisonné.

The front of the cross is missing its enamelled plate and is now empty. However, the standard iconography of such crosses suggests that it certainly once contained a representation of the crucified Christ with busts of the Virgin and St John the Evangelist on the arms. The design on the reverse echoes this arrangement by placing the Virgin between two saints, Basil the Great at left and Gregory Thaumaturgus at right. All are identified by inscriptions, which are incised into the gold and filled with enamel. The Virgin stands with her hands open at her chest in a pose that indicates prayer. Her dominant position on the cross is a suitable indication of her importance in Byzantine devotion.

Early 11th century

Constantinople
(modern Istanbul, Turkey)

HEIGHT: 6.1 cm
WIDTH: 3 cm

P&E 1965,0604.1

RELIQUARY PENDANT OF THE HOLY THORN

The exterior of this devotional jewel gives little indication of its true mystery. A chunk of amethystine crystal has been cleft in two and hinged to create the covers of a miniature book, the pages of which are crafted in gold and enamel. Three of the four surfaces, revealed when the pendant is open, are enamelled in a technique known as *basse-taille*, where the enamel is laid in shallow fields to allow the reflective surface of the metal to shine through, creating a jewel-like appearance. The fourth surface, a piece of painted vellum held beneath a thin sheet of crystal, lacks the brilliance of the enamel. The crystal cover was designed to protect the vellum but it may also have been intended to give the matt complexion of the paint greater lustre and the appearance of hardness, effectively simulating the other enamelled surfaces. In time, however, the paint has faded and the effect has diminished. A secret compartment lies beneath the painted vellum. It is divided into seven parts, the central one containing a thorn said to come from Christ's crown of thorns.

The scenes represented on the enamel are drawn from the life of Christ, with one exception. The first leaf shows the Virgin and Child enthroned. Beneath this image of celestial majesty two terrestrial royals, a king and his queen, kneel as supplicants. The king is barefoot, perhaps as a sign of his humility, or possibly in imitation of Louis IX, St Louis of France, who embarked on a pilgrimage to the Holy Land barefoot. Louis's collection of sacred relics was justly famous and included the crown of thorns. The French royal provenance of this jewel makes it likely that the thorn it contains was taken from this crown. Given the date of the piece and its production in the workshops of the Parisian goldsmiths, the king and queen are likely to be Philip VI (r. 1328–50) and his wife, Jeanne de Bourgogne.

The other scenes do not appear in strict narrative order: the Presentation in the Temple is above the Flight into Egypt; the Nativity is above the Annunciation to the Shepherds; the Deposition is above the Crucifixion. This sequencing probably indicates that the reliquary was meant to be read from bottom to top, making the final scene the Deposition from the cross. The miracle-working relic contained within acted to affirm Christ's resurrection and victory over death.

Around 1340

Paris, France

Given by George Salting

LENGTH: 3.8 cm

P&E 1902,0210.1

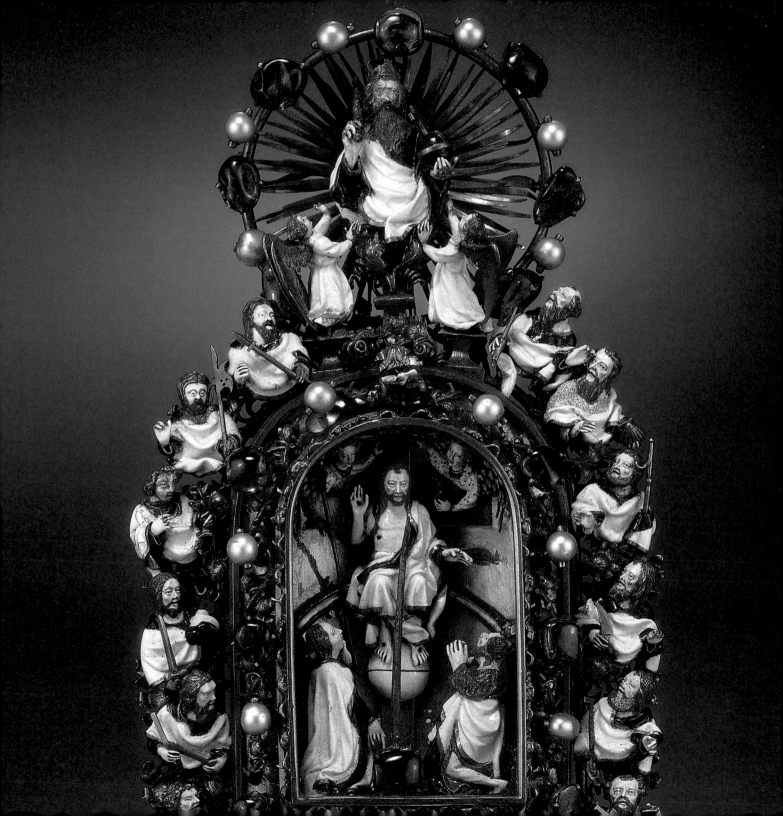

HOLY THORN RELIQUARY OF JEAN, DUC DE BERRY

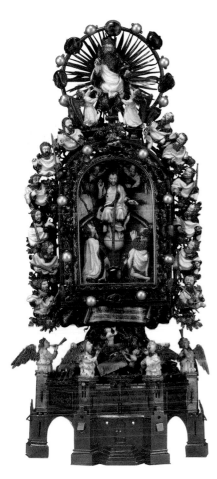

About 1400–10

Paris, France

Bequeathed by Baron Ferdinand de Rothschild

HEIGHT: 30.5 cm

P&E Waddesdon Bequest 67

In 1239 Louis IX of France acquired the sacred relic of the crown of thorns for 135,000 livres, an amount equal to more than half the annual expenditure of the realm. Its inestimable value had not diminished by the time Jean, duc de Berry (1340–1416), commissioned this opulent reliquary to contain just one of its thorns. The attribution of the reliquary to the duc de Berry comes from two enamelled plaques set into the turreted base, which incorporate his heraldry.

The reliquary represents a dramatic Last Judgement. At its centre, behind a crystal cover, the holy thorn is mounted on a large sapphire. Rising above the thorn is the figure of Christ between the Virgin Mary and St John the Baptist. Around the outside an arrangement of the apostles culminates in a figure of God the Father, supported by angels, within a burst of golden rays. At the base the dead emerge from their tombs, beckoned by trumpeting angels. Above them, at a point directly beneath the thorn, a Latin inscription reads, 'This is a thorn from the crown of Our Lord Jesus Christ'. The poses of the apostles, the angels and the recently risen dead bring an element of agitation to the composition, which contrasts with the more static scene around the thorn. The costumes and complexions of each figure are rendered in *émail en ronde bosse*, a type of enamel developed in the fourteenth century, which could be fused on to three-dimensional forms. Throughout, colour is used in a very considered way. The dominant colours are white and gold but a controlled use of red includes the alternation of rubies and pearls around the central compartment. A single sapphire interrupts this rhythm, placed above the head of God the Father to echo that beneath the thorn. The terrestrial sphere is identified by a swathe of verdant green enamel.

The reverse was also originally enamelled and is decorated with images that support the principal theme. At the top, the Passion of Christ is alluded to in a representation of the handkerchief of St Veronica, while death and judgement are signalled by the figures of St Christopher and St Michael on two doors that conceal a second compartment. St Michael's role in the Last Judgement was well established (see pp. 128 and 156); St Christopher protected against sudden death, a plight that might prevent the correct preparation for salvation.

GABLE-END OF A SHRINE WITH ST ODA

The rich natural resources of the area demarcated by the rivers Meuse and Rhine, in what constitutes part of modern-day France, Belgium and Germany, gave rise to a long-standing and influential metalworking tradition. Characterized by the term 'Mosan', the products of the region are celebrated for their artistic merit and technical excellence. The form of this reliquary is dictated by the house-shaped shrines that were customary all over Europe. At some point it was separated from its shrine and converted to its present use. In the centre, named by an inscription, stands the figure of St Oda. She holds a book in her left hand and curls the fingers of her right hand to hold an object, which is now missing but is likely to have been a cross or a staff. St Oda's life and miracles were recorded in the thirteenth century, when she was associated particularly with the Virtues of Religion and Almsgiving. She is supported by the same figures on this relief, identified by the words 'Religio' (left) and 'Elemosina' (right). The Virtues are shown in lower relief than St Oda, who is given prominence by her size and placement under a large rock crystal, and by the embellishment given to her dress. St Oda's gown has distinctive ornamental plaques attached by silver hooks to her hem, sleeves and waist. Each is decorated with *vernis brun*, a type of brown varnish that was particularly favoured by the Mosan goldsmiths at this time. The haloes of the three females are treated in the same way to create a warm contrast with the metal. An outer border of intermittently placed enamel plaques creates added vibrancy with a carefully juxtaposed palette of colours.

A corresponding gable-end exists at the Walters Art Museum, Baltimore, showing Christ between two beasts in reference to Psalms 90:13. Both ends probably came from St Oda's twelfth-century shrine at Amay. They were transformed into reliquaries around the middle of the thirteenth century, when the practice of displaying relics became widespread. At this time the inner border was remodelled to accommodate relics beneath horn covers. Each relic is identified by a vellum tag, including one of St Elizabeth of Thuringia. Since she was canonized in 1236, the gable-ends could not have been converted before this date.

About 1170

Belgium

HEIGHT: 58 cm

WIDTH: 37.5 cm

DEPTH: 4.5 cm

P&E 1978,0502.7

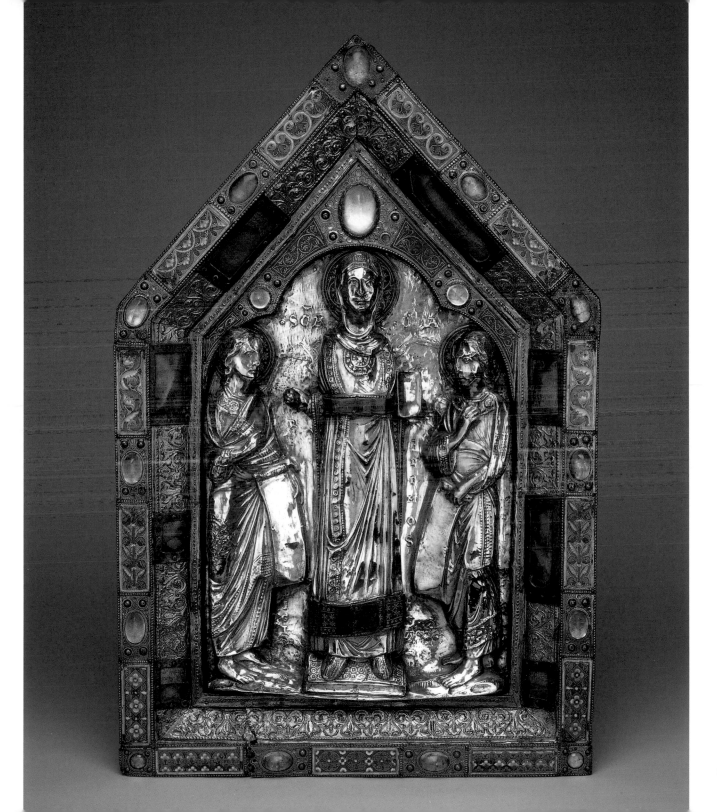

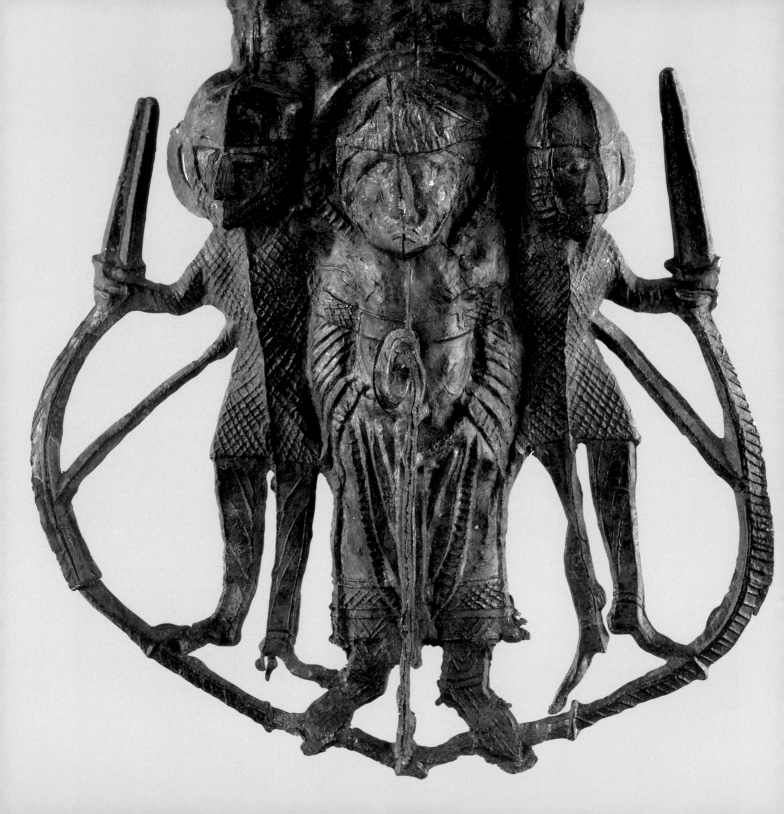

AMPULLA WITH THE MARTYRDOM OF ST THOMAS BECKET

About 1170–1200

England

HEIGHT: 10 cm

WIDTH: 8.7 cm

DEPTH: 2.8 cm

P&E 1921,0216.62

St Thomas Becket's shrine at Canterbury Cathedral was a magnet for the devout, the curious and the sick throughout Europe. The miracle-working properties of 'Canterbury water', credited with curing a multitude of ailments, were established very soon after the saint's martyrdom. The mix of holy water with a drop of Becket's blood was initially distributed in wooden or ceramic containers sealed with wax, similar to those that had long served pilgrims to the Holy Land. However, at Canterbury a new technology was developed whereby large numbers of ampullae could be produced cheaply from a lead–tin alloy, cast in moulds. Canterbury also proved innovative and imaginative in the forms of ampullae it sold, some of which were very elaborate.

This complex example made from a five-part mould has on its front a high-relief representation of Becket between two knights. The two suspension loops by which it was worn around the neck of its owner are visible to the right and left of the knights' heads. A depiction of the saint's martyrdom decorates the reverse, showing Becket kneeling at prayer with his back to a single assailant, who deals the deadly blow with his sword. The scene is contained within a pointed oval frame inspired by contemporary seals. The resemblance to a seal is heightened by the legend that surrounds the image, an abbreviation of the Latin phrase 'OPTIMVS EGRORVM MEDICVS FIT THOMA BONORVM' ('Thomas is the best doctor of the worthy sick'). The seal imagery is an implicit way of authenticating the ampulla's contents, in the same way that a seal would render a document legally valid. It also acts as a disclaimer, suggesting that if a pilgrim did not prosper from the water's miraculous qualities, the fault lay not in the water but in the pilgrim's lack of worthiness.

Through the production of souvenirs, shrine-specific forms became attached to certain pilgrim destinations, a phenomenon expressed at the end of the twelfth century by the French hagiographer Garnier: 'People bring a cross back from Jerusalem, a Mary cast in lead from Rocamadour, a leaden shell from St James; now God has given St Thomas this phial . . . In water and in phials he has the martyr's blood taken all over the world to cure the sick.'

WALRUS TUSK RELIQUARY

Between about the ninth and the thirteenth centuries, walrus tusks were an expensive commodity in a period when they were used as a substitute for elephant ivory. The high value of this piece is reinforced by the richness of the carving that decorates it and by the fact that it was kept and converted to a reliquary two hundred years after it was made. Its original purpose is unknown but its proportions make it distinctly possible that it was used as the leg of a piece of furniture, most probably a chair or a throne. It consists of a complete walrus tusk, the dimensions of which suggest that it came from a female walrus. The male tusk can grow up to a metre in length, whereas the female tusk is shorter and less curved. A certain amount of curvature in this tusk would have been corrected in the carving, but even taking this adjustment into account it is remarkably straight and well suited to the task of a leg support.

Each of the four sides of the tusk is decorated with a convoluted design of vegetal scrolls, from which emerge a number of quadruped beasts. The carving closely resembles panels of decoration on the backs of the seated figures among the Lewis chessmen (pp. 278–9) and dates from roughly the same period, around the middle of the twelfth century. At some point in the fourteenth century the conversion occurred whereby a cavity was cut into the top end, sealed by a hinged cover and locked with a pin. The cover was set with crystal as was the bottom end. The mounts are silver-gilt and engraved with scrolls occupied by hybrids, in the fourteenth-century style. Another crystal is set into the tusk about a third of the way down and evidence suggests that a fourth might once have balanced this at a proportionate distance, since an area of the tusk has suffered some disturbance at the appropriate point. The investment in silver-gilt mounts and huge hog-back crystals for its later embellishment indicates that this intricate work of art was placed in a context equally as luxurious as the one for which it was initially intended.

Mid-12th century;
silver-gilt mounts, 14th century

Scandinavia

LENGTH: 44.7 cm
WIDTH: 5.8 cm
DEPTH: 3.2 cm

P&E 1959,1202.1

ST CONALL CAEL'S BELL SHRINE

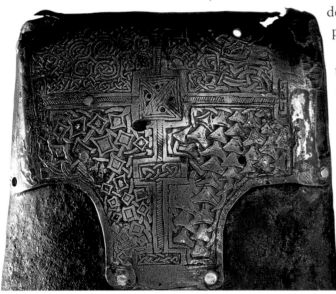

Over the course of time it was not unusual for the sacred relics of saints to receive intermittent embellishment. Thus a humble iron bell, said to have been owned by St Conall Cael in the sixth century, received a decorative brass plate some three hundred years after it was made and was encased in an elaborate cover in the fifteenth century. The brass plate that was applied to it around the year 1000 is wonderfully ornate. It covers most of the surface of the bell and is decorated with native Irish and Viking interlace designs picked out with a black inlay.

The fifteenth-century bell shrine, or reliquary, provided the corroding iron with greater protection. It follows roughly the shape of the bell but has a steeply gabled roof which is divided into three panels with representations of God the Father in the centre, the Virgin and Child to the left and St Michael to the right. The three figures are suggestive of scenes of the Last Judgement in which St Michael weighs the souls of the dead as God sits in judgement and the Virgin intercedes. Below them, on the front of the cover, hangs the figure of the dead Christ suspended on the cross. His emaciated arms are unnaturally long to emphasize the weight of his body on the cross. They form a Y-shape, beneath which stand the figures of the Virgin Mary and St John the Evangelist. Christ's feet hover above a large rock crystal, which divides the figures of two unidentifiable saints. The reverse is engraved with representations of the twelve apostles and the symbols of the four evangelists.

Each of the figures on the front of the bell shrine has been worn smooth from the constant touch of pilgrims who came to worship at St Conall's well on the island of Inishkeel. Pilgrims visiting the shrine believed that to drink water from a sacred bell would cure sickness.

7th–9th century (bell); late
10th–11th century (brass mount);
15th century (shrine)

Inishkeel, County Donegal, Ireland

Given by Sir Augustus
Wollaston Franks

HEIGHT: 17 cm
WIDTH: 12.8 cm

P&E 1889,0902.22 & 23

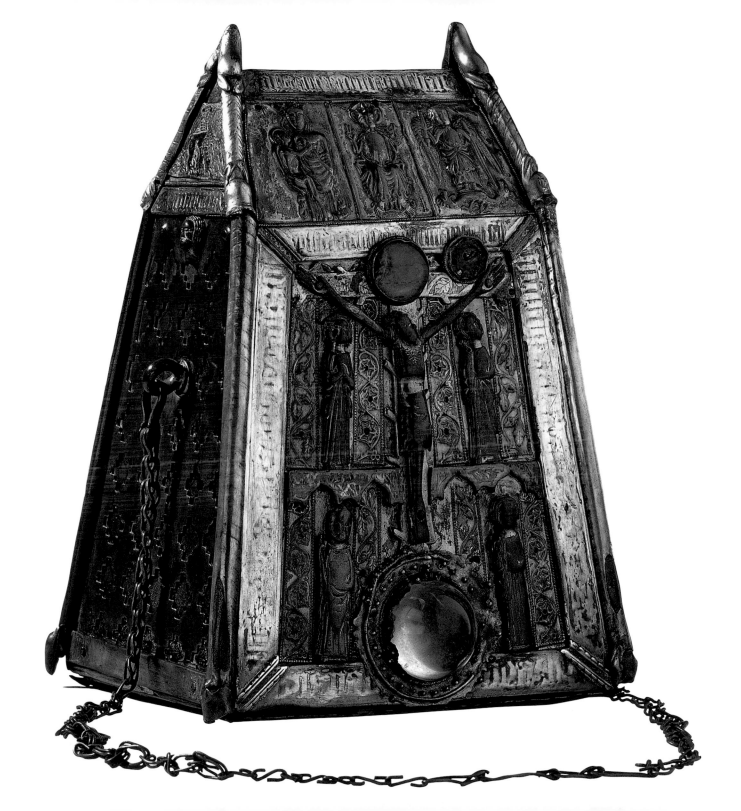

RELIQUARY CASKET OF ST VALÉRIE

Around 1170–72

Limoges, France

Bequeathed by Baron Ferdinand de Rothschild

HEIGHT: 15.4 cm
LENGTH: 23.6 cm
WIDTH: 11.6 cm

P&E Waddesdon Bequest 19

From its inception the cult of St Valérie was imbued with a sense of civic identity. According to legend, Valérie was a citizen of Limoges and the first Christian martyr of Aquitaine. Consequently, when Eleanor of Aquitaine sought the investiture of her son Richard Lionheart as Duke of Aquitaine, it is likely that she invoked the assistance of the saint: significantly, the ring of St Valérie was worn by Richard at the investiture ceremony in 1172. This astonishing reliquary casket from Limoges dates from the same period and may have been made as a consequence of Plantagenet ambition.

All four sides of the casket are richly enamelled with, on the back, roundels containing fabulous hybrid beasts, lions and eagles, and on each side an angel swinging a censer. Its dense colours are designed to stand out boldly against the tooled and gilded background. The main focus is the front, which tells the story of the martyrdom of St Valérie, who glides through her ordeal in a striking robe of blue decorated with white spots. St Valérie was the orphaned daughter of the Roman prefect of Aquitaine and was betrothed to his successor, Stephen. She was converted to Christianity by St Martial whereupon she pledged her virginity to Christ and renounced her vow to marry. Stephen, on hearing this news, instantly condemned her to death. What followed is depicted here. The first scene in the lower register shows Valérie being simultaneously sentenced and led off for execution. The epitome of masculine power, Stephen sits with his legs apart, indicating his judgement with a pointed finger. Valérie's execution is witnessed by the people of Limoges; the sword falls and Valérie catches her head in her own arms. In the upper register, Stephen sits back in his throne in an introspective manner and raises a thoughtful hand to his brow as he hears the news, in stark contrast with the expression of determination and strength in the scene immediately below. The executioner, forewarned of his imminent death by Valérie, explains the prediction to Stephen and is struck dead by a bolt of lightning. The same storm cloud with its jagged red edges supports an angel who emerges to offer guidance to Valérie's headless corpse. Valérie proceeds to seek the blessing of St Martial, who is celebrating Mass, and kneels before him to present him with her head.

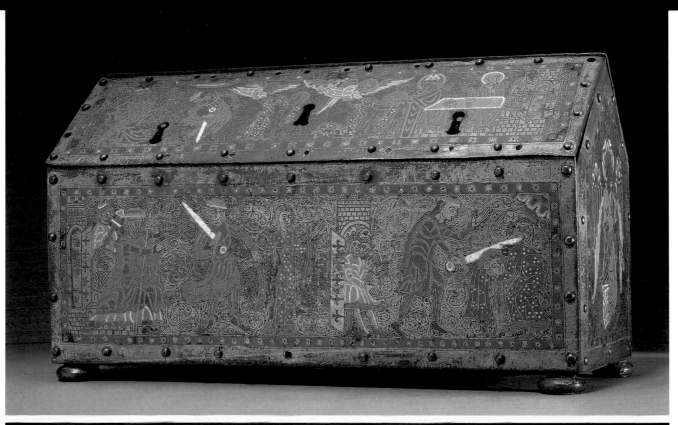

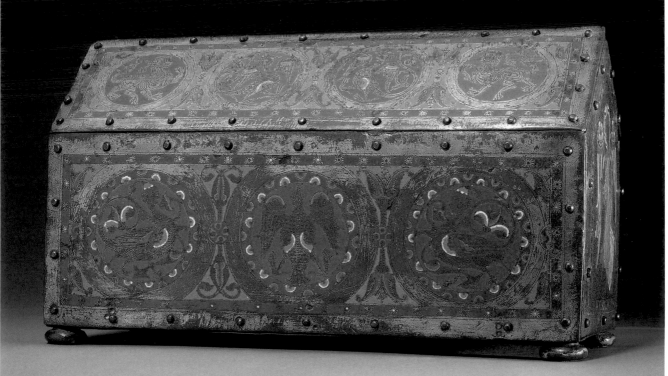

SILVER-GILT FIGURE

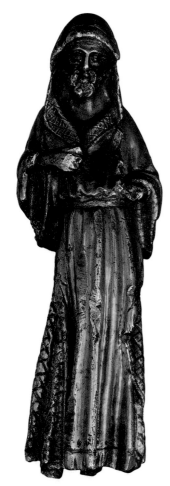

Around 1275–1310

England or France

Acquired with donations from
the British Museum Friends
and the Art Fund

HEIGHT: 4.6 cm

P&E 2000,1101.1

The ravages of the sixteenth-century Reformation and the seventeenth-century civil war, with their associated acts of iconoclastic vandalism, have left only partial remains of a rich medieval English past. Of particular interest to the iconoclasts of the sixteenth century were the well-endowed churches and monasteries, many of which were the focus of pilgrimage and home to shrines and treasuries of immense wealth. The agents of the Reformation were so thorough in their task that very few examples of fine metalwork in silver or gold survive. That this tiny figure escaped destruction may be a direct consequence of its diminutive proportions. Breaking up metal objects was the most practical way of transporting them to be melted down; chalices were usually crushed for this purpose. It is likely that the figure formed part of a much larger and elaborate object from which it was wrenched and then lost in transit. It is very suggestive of the small figures that occupy the architectural canopies of reliquaries and shrines, croziers and book covers. The fact that it is modelled in the round suggests that its reverse was also viewable. On the back is a loop for attachment, although the principal means of fixing the figure seems to have been by soldering its feet to a base. When it was separated from its setting, its feet were left behind.

The figure is of the highest quality and refinement, with a subtlety of expression difficult to achieve on such a small scale. It is likely to have been made in France, or in England under French influences, or by à French goldsmith working in England. The identity of the figure is difficult to deduce since it has lost whichever attribute it once carried, along with its left hand. The hooded gown, strictly frontal pose and the natural emphasis given by the sway of the body to whatever was held in the left hand are very suggestive of representations of prophets, who usually signal towards a scroll or a book. The Ormesby Psalter at the Bodleian Library, Oxford, dates from the early fourteenth century and is illuminated with prophets gesturing in this way.

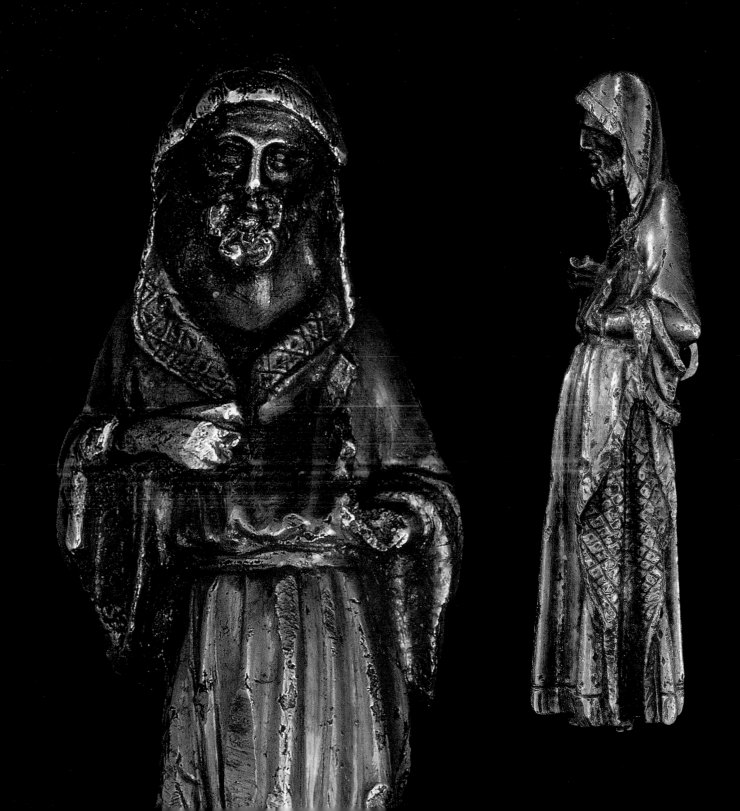

CROZIER HEAD FROM THE WORKSHOP
OF HUGO D'OIGNIES

Croziers serve as the ceremonial staff of office for bishops. Their form is derived from pastoral symbolism commonly used in the Gospels to express spiritual care and was designed deliberately to resemble a shepherd's crook. The spiritual dimension of a bishop's crozier was often expressed through lavish embellishment, which set it above the humble nature of the shepherd's staff and made it worthy of the service of God. The crozier head was usually the main focus for this type of aggrandizement and numerous examples survive carved from ivory or crafted from enamelled copper alloy that testify to the practice. The wooden rods onto which they were mounted have been invariably lost. Few croziers achieve the outstanding level of decorative impact that distinguishes this example. It combines gilt-silver with bronze, gems, nielloed plaques and rock crystal to create a rich display. The surface is alive with abundant forms drawn from nature, particularly vine leaves, a well-recognized symbol of regeneration and the Eucharist. A lizard, or two-legged serpent of the type occasionally used to denote Satan, crawls up the shaft of the crozier and cranes its neck towards the luxurious, floriated crook.

The crozier head's superlative qualities and combination of materials suggest that it may have been produced by the workshop of a goldsmith known as Hugo d'Oignies (active 1187–1228). Hugo was one of a number of goldsmiths who signed their work and a significant number of objects are attributable to him. He was an Augustinian Canon at a priory in Oignies in the province of Namur in Belgium. He produced notable pieces of precious metalwork including elaborate reliquaries designed to accommodate the relics collected by his prior, Jacques de Vitry. Hugo belonged to a metalworking tradition established in the Meuse valley from the end of the tenth century, known as Mosan. He is generally considered a great innovator through his exceptional ability to create filigree of great finesse and through his absorption of sculptural motifs drawn from architecture. Consequently he is thought to have been responsible for introducing the Gothic aesthetic to the Mosan metalworker's craft.

About 1225–50
Belgium
HEIGHT: 15.7 cm
P&E 1898,0521.1

THE HENRY OF BLOIS PLAQUES

Around 1150

Probably made in England

Gift of the Revd George Murray on behalf of the late Revd Henry Crowe

LENGTH: 17.8 cm

WIDTH: 9 cm

P&E 1852,0327.1

Henry of Blois (*c*. 1090–1171) was the Bishop of Winchester and the brother of King Stephen. At once prince, bishop and warrior, he was enormously wealthy, famously learned, a patron of the arts and a collector of classical antiquity. The enamel plaques pay tribute to another of his characteristics, that of diplomat. The lengthy Latin inscription that surrounds the image of the censing angels describes the peace of England as being dependent on him. Henry was instrumental in negotiating the succession of Henry II and intervened in the acrimonious dispute between the king and Thomas Becket.

The plaques are concave, made of copper inlaid with champlevé enamels and gilded. Given their outstanding quality, the reference to England in the inscription and the personal association with Henry, there is every possibility that they were made in England by a major Mosan goldsmith. The splendour of these two plaques has diminished slightly due to the loss of gilding. However, the colours of the enamels are astonishing and reveal the skilful use of a restricted palette to create a work of great harmony.

When the plaques were acquired by the British Museum, they were joined together as a dish. This was clearly not their original form as an examination of the inscription demonstrated. The two inscriptions were probably not meant to be read in close proximity and are composed in different verse forms. It is not entirely obvious what type of object the plaques were designed to ornament. The censing angel on the left carries what appears to be a chalice or a bowl in one hand. In representations of the Crucifixion, angels are often depicted collecting the blood from the wounds of Christ in chalices, which might indicate that the plaques originally adorned a large crucifix. The nature of the inscriptions, which place such emphasis on the act of giving, endow Henry's depiction with the quality of a donor portrait in which case he should be holding a representation of the gift he is making. The object that Henry grasps in both hands resembles the top of an altar and may be his gift. Altars were commissioned at vast expense and were often inlaid with exotic marbles or semi-precious stones.

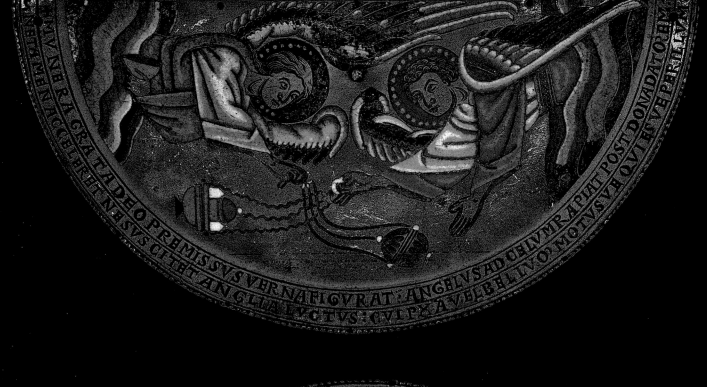

IN TERRA GRATA DEO PREMISSVS VERNA FIGVRAT: ANGELVS AD OBLVM RAPIAT POST DONA DATORE · NOLI EVM ACCELERA TENERIS VT TET AN GLIA LVCTVS: CVI PY A VEL B ELIV O MOTVS H VS VPERIT VM

ARS AVRO GEMORS Q PRIOR PRIOR OMNIBVS AVTOR ◦ DONA DAT HENRICVS VIV IS IN BREDEO
VBENTE PAR BM EMVSISTMAR QVO CEPRIOREM: FAMA VIRIS MO. ES CON CILIANT SVPERIS ◦

· HENRICVS · · EPISCOP ·

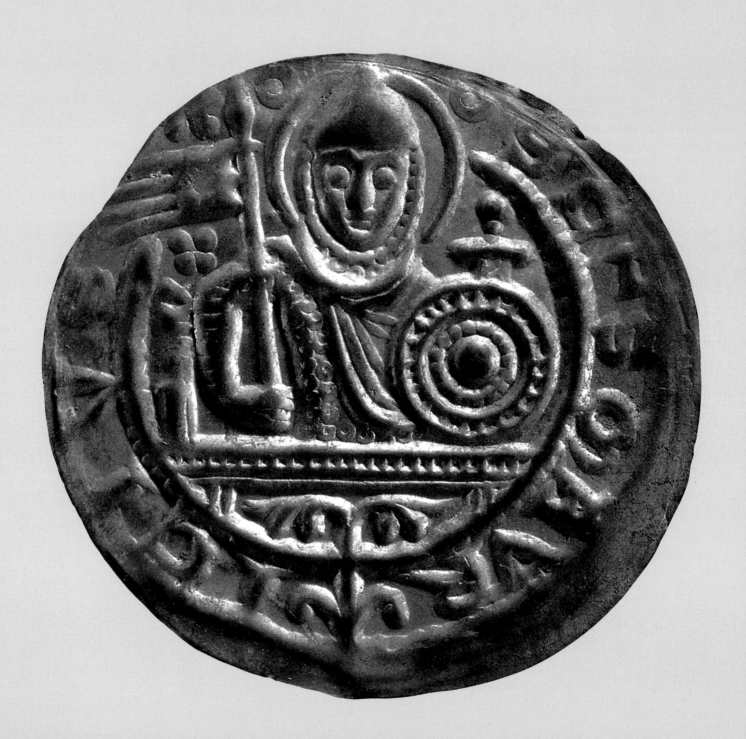

SILVER BRACTEATE PFENNIG OF WICHMANN VON SEEBURG, ARCHBISHOP OF MAGDEBURG

In the early Middle Ages many religious leaders gained the right to strike their own coinage. In Germany the Holy Roman Emperors used churchmen to settle and organize wide territories, encouraging them with land grants and the right to have mints and markets, and many German bishops and archbishops became important territorial princes. By the late eleventh century ecclesiastical coinage dominated German currency.

The only coins made at this time were silver pennies or pfennigs. During the twelfth century these took an unusual form in parts of north-eastern Germany. Normal two-sided pfennigs were replaced by thinner, broader ones, known today as bracteates, with a single design in the positive on the front and in the negative on the back. Being fairly large, they could carry quite elaborate designs; they also show great variety as their fragility meant they were often replaced in recoinages.

The bishops and archbishops who issued coins employed a wide variety of designs. The most common subject was the patron saint of the diocese's cathedral and city. In the Middle Ages the patron saint was an important identifying figure for urban and religious centres, and the saint took the place of a king or prince as a focus for loyalty and identification. Therefore images of St Ambrose in Milan, St John the Baptist in Florence and St Maurice in Magdeburg were widely familiar, not least because of their usage on coins that passed through everyone's hands.

In AD 961 the Emperor Otto I transferred the relics of the popular soldier–saint Maurice to the archbishopric of Magdeburg. Maurice was the leader of the legendary Theban Legion, a wholly Christian unit of Roman soldiers supposedly martyred in the third century. This coin names the saint and depicts him in the characteristic garb of mail and helmet, holding a soldier's clock, shield and his famous lance, identified with the weapon that pierced Christ's side on the cross.

The military nature of St Maurice on the coin well reflects the personality of its issuer. Archbishop Wichmann was a theologian by training but proved a major political and military figure, enlarging his diocese and improving its economy. He was an indefatigable upholder of the Emperor Frederick I Barbarossa, and led many of his supporting armies.

1152–92
Magdeburg, Germany
DIAMETER: 2.8 cm
CM 1881,0804.29

IVORY TRIPTYCH WITH THE ARMS OF JOHN DE GRANDISSON

John de Grandisson rose to prominence under the papal court at Avignon, where he was ordained Bishop of Exeter by Pope John XXII in 1327. He travelled to England the following year and remained devoted to his diocese until his death in 1369. Grandisson had a fondness for displaying his coat of arms, which he emblazoned on a number of gifts to Exeter Cathedral. Occasionally, they appear twice on the same object, as in the case of this ivory. They can be seen occupying the spandrels above the heads of St Stephen and St Thomas Becket in the lower register of the wings.

The triptych is one of three ivories owned by the British Museum that bear the arms of Grandisson. They are unique in that they are the only known ivories to be carved with the arms of their patron. This piece is carved from a substantial elephant tusk, which allows a remarkable degree of high relief in the central panel. The resulting depth and shadow lend emphasis to the most important scenes, the Coronation of the Virgin and the Crucifixion. The arches that frame the two scenes are adapted for the action they contain. The top half is divided into two ogee arches, occupied by the figures of the Virgin and God the Father; the bottom half is spanned by a single ogee, which gives prominence to the figure of Christ on the cross. A sense of symmetry and space is created to either side of the cross as the Virgin swoons to the left and the grief-stricken St John turns to the right.

The saints on the wings are those to whom Grandisson paid especial devotion: Peter and Stephen at left and Paul and Thomas Becket at right. The arrangement of the standing saints on the wings of the triptych may reflect Grandisson's awareness of Italian art, which he possibly acquired in Avignon. They are much more characteristic of Italian trecento painting than of French ivory carving, the most obvious source of inspiration for English artists working in ivory.

About 1330–40

England

HEIGHT: 23.8 cm

WIDTH: 20.5 cm

P&E 1861,0416.1

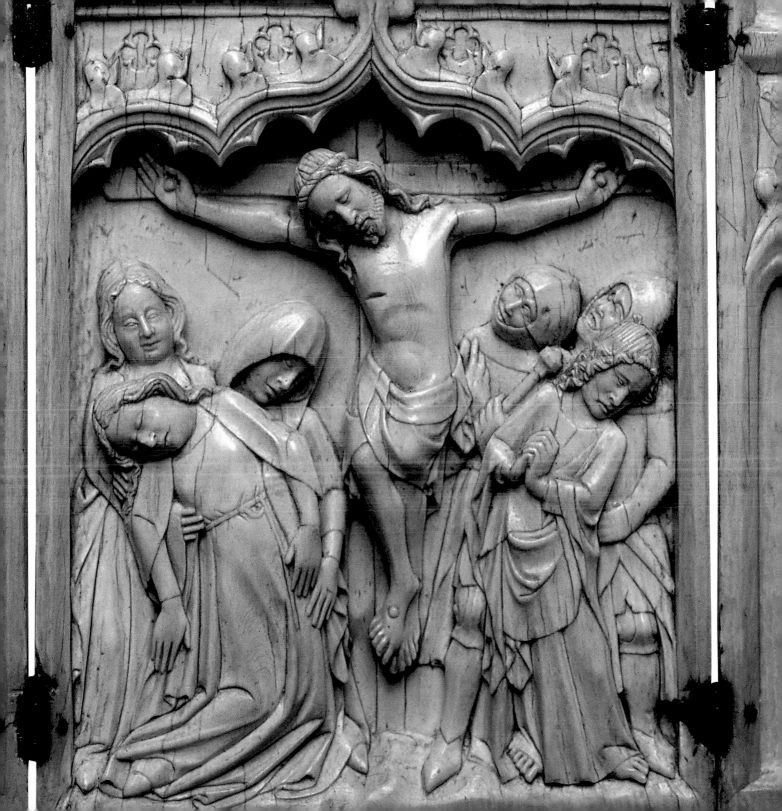

MONUMENTAL BRASS OF AN UNKNOWN BISHOP

About 1345–50
France or Flanders
LENGTH: 68 cm
WIDTH: 57.5 cm
P&E 1853,0221.1

The original dimensions of this fragment from a monumental brass would have reflected the full-length representation of a bishop surrounded by architectural elements and a dedicatory inscription. What survives is highly ornate and of exceptional quality. It was collected by the famous Victorian architect Augustus Welby Northmore Pugin, and inspired many of the brasses that he designed. It depicts the head of a bishop resting on a sumptuous cushion engraved with scrolling foliage and butterflies. He wears a richly jewelled mitre and holds a crozier containing an Agnus Dei (Lamb of God) in its crook. He is placed within a crocketed canopy, above which, in an architectural structure resembling a shrine or chapel, stand four saints against stained-glass windows and two angels. They are arranged on steps that culminate in a representation of Abraham holding in a napkin to his breast the naked, mitred soul of the deceased. This image of Abraham, taken from the parable of the rich man and Lazarus in the Gospel of St Luke (16:22), was widely used, particularly in funerary monuments, as a way of expressing the resting place of the righteous after death.

The saints standing above the bishop are beautifully rendered and reveal an artist as comfortable in detailed, small-scale draughtsmanship as in the larger, broader treatment of monumental figures. They depict, from left to right, St John the Evangelist, St Peter, St Paul, and another male saint with a sword, possibly St Matthew. Each adopts a different pose and adds a degree of animation to the design as they sway gently from the hip to display subtly modulated drapery. The architecture they inhabit would have extended down both sides of the panel to contain as many as eight other figures, bringing the total to an apostolic twelve. A notion of how the original brass might have looked is offered by an engraving of the brass of Jean de Blangy (d. 1345), formerly in the Chartreuse in Paris. This is close enough in some details, for instance in the design of the mitre, to suggest that it may be the very monument to which this fragment once belonged, although other elements are missing, such as the Agnus Dei that occupies the crozier. At the very least it offers convincing evidence of the date for this brass and may suggest that it too was made in France.

SEAL-DIE OF CHICHESTER CATHEDRAL

The depiction of Chichester Cathedral on this early thirteenth-century silver seal-die has caused some confusion. The lettering of the legend indicates a date for the engraving which is later than that suggested by the style of the building. The archaic architecture is close to the type of wooden structure favoured by the Anglo-Saxons, and, indeed, the treatment of the roof conveys the impression of thatch or shingle. It has been proposed that the die was copied from an earlier existing seal, although this cannot be proved. It is also possible that it represents a notional ideal. The stars to either side of the elaborately tiered tower must surely have some significance, while the inscription 'TEPLV IVSTICIE' ('Temple of Justice') beneath the cathedral implies that it is being accorded special, perhaps symbolic, status. Meanwhile the distinctive structure of the tower resembles early thirteenth-century censers, which were modelled to emulate the Heavenly Jerusalem (see pp. 32–3).

The legend reads '+ SIGILLVM : SANCTE : CICESTRENSIS : ECCLESIE', meaning 'seal of the holy church of Chichester'. It was designed for the use of the dean and chapter as a communal seal and, as such, would probably have been subject to close measures of security. Seals in the medieval period represented spending power and were mostly employed for the disposition of property. The seal might be locked in a chest with more than one lock and the keys held by several members of the community. Matthew Paris relates how at St Albans during the abbacy of John de Cella (1195–1214) the common seal of the abbey was stolen by one of the monks, who used it to seal a false charter. Likewise, in 1266, the prior of Durham Cathedral was discovered to have used the common seal to embezzle the priory's wealth.

The quality of the seal-die's engraving and the use of silver are commensurate with its status as a cathedral seal. The engraving of the masonry and the texture of the roof surface are especially noteworthy, as is the impressive rendering of the detached circular western tower on the left. On the reverse is an exuberant foliate handle that was soldered on separately, above which is a small, neat cross that served in the sealing process to ensure that the seal-die was the right way up.

Around 1220

England

LENGTH: 8.4 cm
WIDTH: 6.3 cm

P&E 1923,1015.1

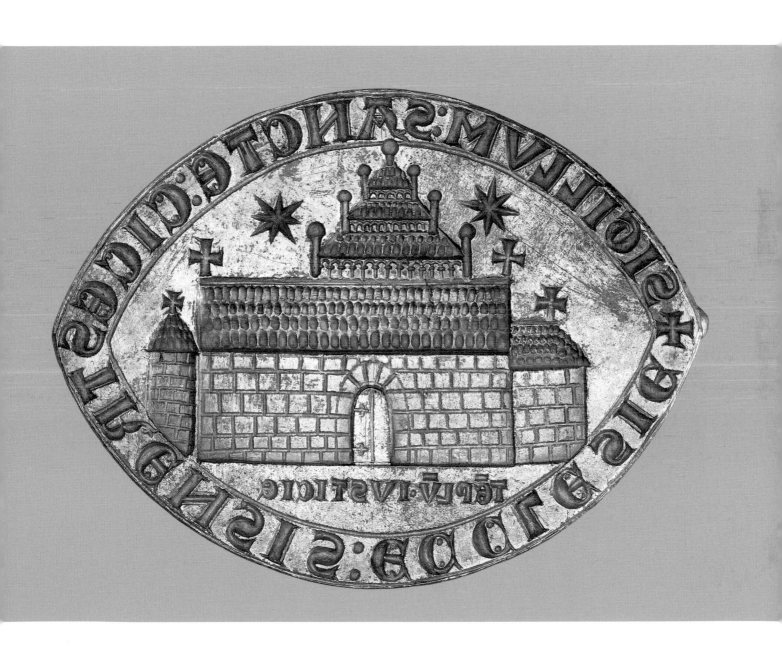

ALABASTER PANEL OF THE MARTYRDOM OF ST THOMAS BECKET

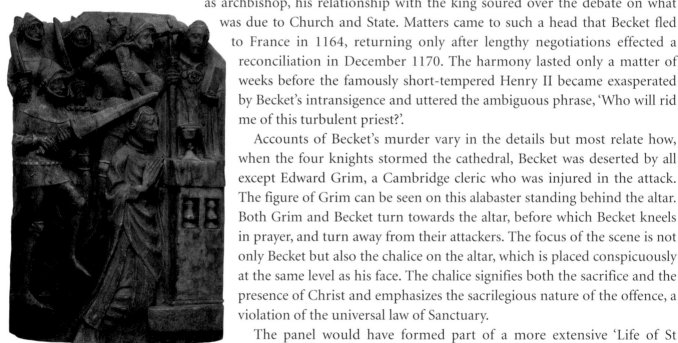

About 1450–1500

England

HEIGHT: 37.2 cm

WIDTH: 25.1 cm

P&E 1890,0809.1

The fateful events of the night of 29 December 1170 are depicted on this alabaster panel. It shows the brutal martyrdom of Thomas Becket at the hands of four knights in the nave of Canterbury Cathedral, under implicit or mistaken instruction from Henry II. Born around 1118, Becket had been a favourite of Henry II and rose to prominence first as Chancellor, the highest position in royal administration, and then as Archbishop of Canterbury, the highest position in the country, apart from that of king. Upon his appointment as archbishop, his relationship with the king soured over the debate on what was due to Church and State. Matters came to such a head that Becket fled to France in 1164, returning only after lengthy negotiations effected a reconciliation in December 1170. The harmony lasted only a matter of weeks before the famously short-tempered Henry II became exasperated by Becket's intransigence and uttered the ambiguous phrase, 'Who will rid me of this turbulent priest?'.

Accounts of Becket's murder vary in the details but most relate how, when the four knights stormed the cathedral, Becket was deserted by all except Edward Grim, a Cambridge cleric who was injured in the attack. The figure of Grim can be seen on this alabaster standing behind the altar. Both Grim and Becket turn towards the altar, before which Becket kneels in prayer, and turn away from their attackers. The focus of the scene is not only Becket but also the chalice on the altar, which is placed conspicuously at the same level as his face. The chalice signifies both the sacrifice and the presence of Christ and emphasizes the sacrilegious nature of the offence, a violation of the universal law of Sanctuary.

The panel would have formed part of a more extensive 'Life of St Thomas', which would have been painted, polished and gilded and set into a painted wooden surround. The Lives of the Saints was the principal subject matter of the alabaster carvers in the later years of the fifteenth century. At this time the panels also became more densely populated. Note here how little space is left vacant as the figures crowd together in a tightly packed unit.

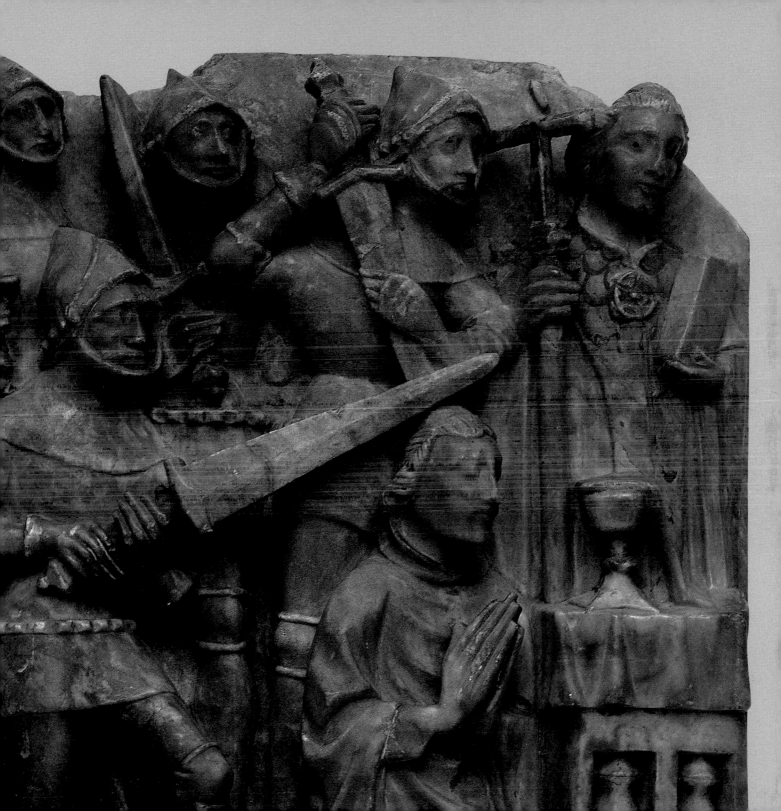

PILGRIM SOUVENIR SHOWING THE BUST OF BECKET

Becket's cult sprang up spontaneously and almost immediately after his murder (see pp. 112–13). The monks of Canterbury appreciated very quickly that the site of this sacrilegious crime would attract the devout in large numbers and they made suitable provision for the pilgrims. Canterbury was among the first of the pilgrim destinations in the late twelfth century to develop a market for souvenirs. These were endowed with a more sacred quality than those for sale at tourist destinations today and often also served as evidence that a penitential pilgrimage had been made. However, they were marketed at Canterbury in a way that seems precocious to modern observers, with specific badges, ampullae or plaques being introduced to commemorate key events. Thus in 1220, when Becket's relics were translated from the crypt to a splendid new shrine at the time of the saint's silver jubilee, badges representing the shrine were designed for sale. In or around 1320 the cathedral launched a range of plaques and badges showing a bust of Becket to celebrate his third jubilee. The image seems to have been drawn from a famous reliquary head containing fragments of Becket's skull and housed in a chapel close to the shrine, a choice perhaps prompted by the fact that in 1314 the cathedral's prior, Henry of Eastry, decided to enrich the reliquary and had the head encrusted in gold, silver and precious stones. The head, long since lost, was an established attraction for pilgrims and generated generous offerings.

The souvenirs were mass produced from a lead–tin alloy, cast in moulds. The moulds might be engraved to a high standard and could produce stunning results. This fragmentary devotional plaque representing the reliquary head is arguably one of the finest to survive. It was originally contained within an elaborate architectural frame and stood upon a delicate trellis of vine leaves. In what seems to be a customary feature of the design, the face is modelled in high relief, although the neck and shoulders are flat, giving the face an arresting presence, strengthened by the steadfast gaze that Becket directs to the onlooker. The standard features of a stern expression, the shadow of a moustache and a characteristic hairstyle are well illustrated here. The consistency of the representation between the badges has led to the conviction that they were made in imitation of the bejewelled reliquary head.

Around 1320
Canterbury, England
HEIGHT: 8.8 cm
WIDTH: 4.5 cm
P&E 2001,0702.1

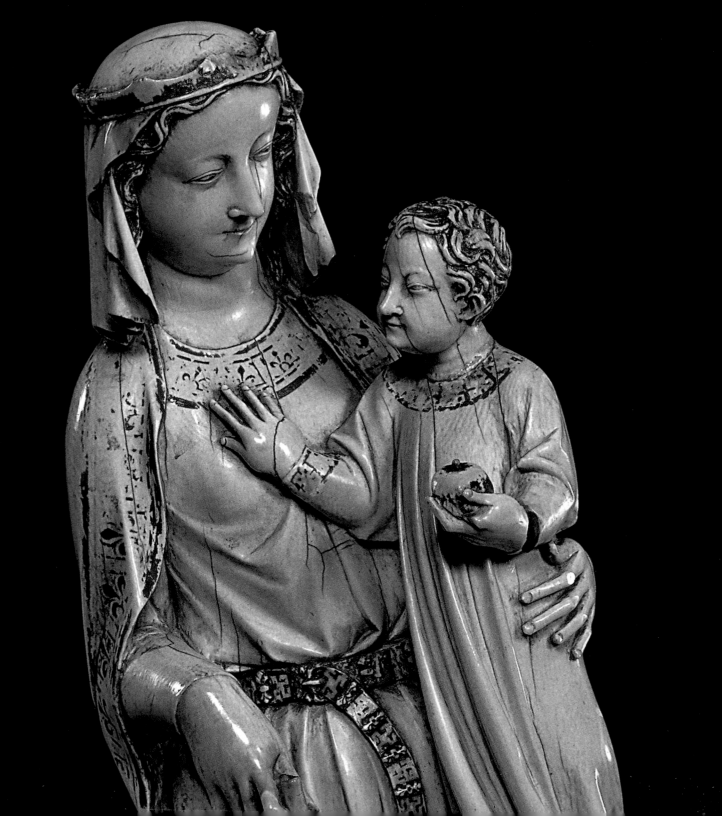

IVORY FIGURE OF THE VIRGIN AND CHILD

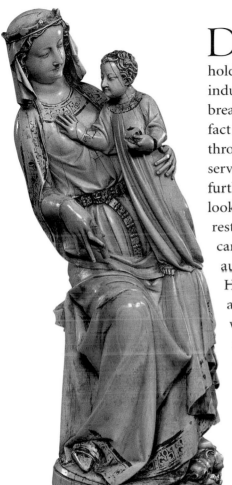

Depictions of the Virgin and Child from the thirteenth century onwards drew increasingly on the tenderness between mother and child. Here the Virgin holds the Christ child securely around his waist and smiles at him with all the indulgence natural to a mother. He stands on her lap, pressing one hand to her breast and holding an apple in the other. Ostensibly a childhood treat, the apple in fact has much greater symbolic resonance as a reminder of the origins of sin, through Eve's temptation, and thus of the necessity for Christ's incarnation. It also serves as an orb to signify that Christ is ruler of the universe. His omnipotence is further demonstrated by the demon trampled underfoot by the Virgin. This sorry looking, floppy-eared dragon is relegated to the position of obedient lapdog as it rests its chin on its paws. In this way it contributes to the courtliness of the carving, which possesses an exaggerated grace designed to appeal to aristocratic audiences. The Virgin's anatomy is deliberately elongated to evoke elegance. Her long fingers extend naturalistically around the body of Christ but are arranged in a much more artful way about the vessel in her other hand, which was probably meant to contain a lily, the symbol of the Virgin. The fashionably mannered pose achieves dizzying emphasis by the natural curvature of the elephant tusk, which sends the Virgin swaying back on her throne.

The refinement of the figure is achieved also by the selective application of gilding and paint to highlight details of the draperies. Although the colour that survives is likely to be nineteenth-century, it appears to cover areas that were previously painted since traces of original polychromy remain underneath. The natural qualities of elephant ivory were appreciated in the medieval period and colour was generally used sparingly for the hems and linings of garments or for the lips and eyes of figures.

About 1330

Paris, France

Accepted by
HM Government
in lieu of tax

HEIGHT: 33.5 cm

P&E 1978,0502.3

THE TRING TILES

About 1330

England

Purchased with the aid
of the Art Fund

LENGTH: 32.5 cm
WIDTH: 16.2 cm
DEPTH: 3.5 cm

P&E 1922,0412.1–8

Christ's life and ministry is recounted in the four Gospels attributed to the evangelists, Matthew, Mark, Luke and John. Other ancient accounts of Christ's life, considered apocryphal, though not attracting the sanction of the Church, were used to embellish elements of the Gospel story felt to be lacking in detail. Apocryphal stories based on the dream of Pilate's wife, for instance, or the forging of the nails for Christ's crucifixion were incorporated into medieval mystery plays and were an integral part of the imaginative religious experience.

One of the most frustrating absences in the Gospels is the early years of Christ's life. Christ is encountered as an infant and then later as an adolescent disputing with the doctors of the law in the Temple but no mention is made of his upbringing or his relationship with his parents. As the cult of the Virgin Mary blossomed, an interest in the Holy Family and the young Christ also grew. The Tring Tiles are remarkable survivals, which document this devotional curiosity.

The tiles are part of a much larger scheme, now lost. The scenes are arranged in pairs in a composition that resembles a modern-day comic strip. Christ is represented at play, working in the fields or in the carpenter's workshop, at school and, occasionally, in trouble. The stories struggle to come to terms with the notion of a child at once human and divine. The scenes at play often result in a fatality. In one episode Christ's solitary game of making pools on the banks of the river Jordan is disturbed by a bully who destroys them: the bully promptly falls down dead. Likewise, when a fellow pupil jumps on Christ's back in a playful attack, he is struck down. In both cases instant death is shown by the figures being flipped upside down. Not surprisingly, parents in the neighbourhood are reluctant for their children to play with Christ, often implementing extreme measures to prevent his contact with them. One parent shuts his son up in a tower but Christ miraculously pulls him through the lock. Others hide their children in an oven only to find them transformed into pigs when they open it. In every instance the intercession of the Virgin sees the return to normality. The culmination of the series, the only scene which occupies a full tile, is Christ's first official miracle at the wedding feast at Cana.

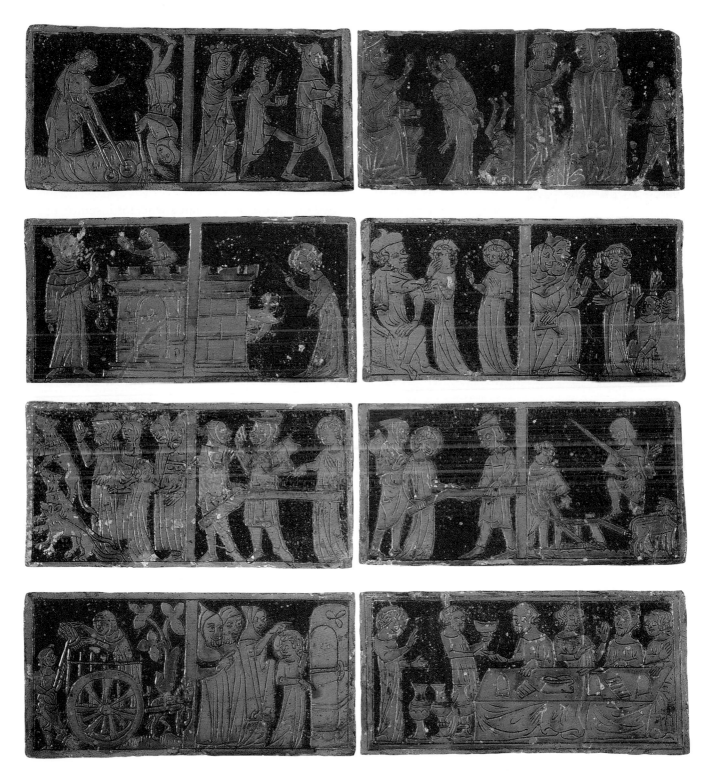

EMBROIDERED PANEL WITH SCENES FROM THE LIFE OF THE VIRGIN

The medieval textile industry was extremely important and produced garments of inconceivable luxury in huge quantities. English expertise in textile production became world famous through the export of embroidered fabrics known as *opus anglicanum* (English work). It is famously recorded that Pope Innocent IV (1243–54) was so impressed by the vestments of English ecclesiastics at the court of Rome that he ordered sets for himself. However, commissions commanded high prices since embroidery was much more time-consuming than, for instance, wall painting or panel painting.

This panel of *opus anglicanum* probably formed part of a vestment worn during the celebration of Mass. It is embroidered with three scenes from the Life of the Virgin, each one contained within a five-cusped arch supported by slim colonnades. Within the spandrel of each arch is the half figure of an angel who observes the scene below. On the left is the Annunciation. The archangel Gabriel approaches the Virgin with the news that she has been chosen to be the mother of God. A scroll unfurls from his hands with the customary salutation taken from the Gospel of St Luke (1:28), 'Ave Maria, Gracia Plena' ('Hail Mary full of Grace'), as the Virgin raises her hand in surprise. The second scene is the Visitation, when the Virgin receives news that her cousin Elizabeth, the mother of John the Baptist, is also miraculously with child. The next scene survives only partially but shows the Virgin recumbent on a bed with the infant Christ in her arms and an ass seated at a manger. This represents the Nativity, which is likely originally to have been the central scene of five.

The embroidery consists of gold and silver threads and coloured silks on a linen base. When new, the colours would have been much more vivid and the background details would have had greater lustre. The background is decorated with a series of interlocking roundels showing rampant lions amid vine scrolls. The vine imagery serves as an allusion to the Eucharist and as a reminder of Christ's sacrifice.

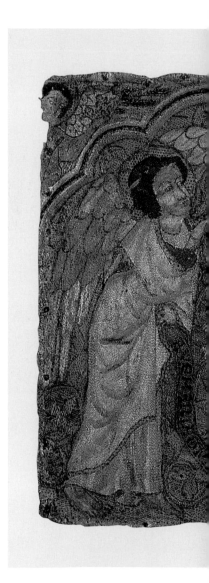

About 1310–40 England

Bequeathed by the Condesa de Valencia de Don Juan

LENGTH: 53.5 cm WIDTH: 24 cm

P&E 1919,0305.1

KNIFE HANDLE WITH THE TREE OF JESSE

The Book of Isaiah (11:1) states, 'And there shall come forth a rod out of the stem of Jesse, and a branch shall grow out of his roots'. This verse was translated in visual terms quite literally into a family tree of Christ, connecting him with the royal house of David, the son of Jesse. A detailed genealogy was provided principally by the Gospel of St Matthew (1:1–16). The Virgin Mary usually figures conspicuously in these representations as the ultimate shoot borne by the tree. This connection may spring from the similarity in Isaiah's prophecy when translated into Latin between the words 'virga' (rod) and 'virgo' (virgin).

The knife handle makes little attempt to distinguish the individual generations, although some of the figures may have had their names painted on the scrolls that they hold. There is evidence that the knife was treated to take either colour or gilding. It is carved from boxwood and was probably used as a hunting knife. Its use might explain the presence of an enigmatic interloper in the scene. A solitary, uncrowned figure occupies a space next to Jesse and carries a falcon on his fist. Jesse, often shown recumbent, is depicted here seated in a domestic chair, resting with his head in his right hand. His left arm encircles the trunk of a tree, which rises from his breast. The treatment of the theme is compact and energetic. The scrolling branches extend around the surface of the knife handle to contain a cast of celebrated biblical characters who sit, stand or swing from its support. David stands to the left of Jesse and is identified by the harp that he plays. To the right of the Virgin is an exuberant character with long, flowing hair and a sword in an elaborately engraved sheath. This might indicate Solomon, son of David, in reference to his famous act of judgement. If this is the case, his distance from David would suggest that the carver was not interested in representing the generations in the correct order or may not have been familiar enough with the genealogy. Two figures are not accommodated by the branches of the tree but squirm rather uncomfortably on the projections at the base of the knife. Both are crowned and of uncertain significance. They may represent unjust kings, frequently shown trodden underfoot in representations of Vices and Virtues.

Late 15th or early 16th century
England
LENGTH: 11.6 cm
P&E 1925,0507.1

IVORY PANEL SHOWING THE FUNERAL OF THE VIRGIN

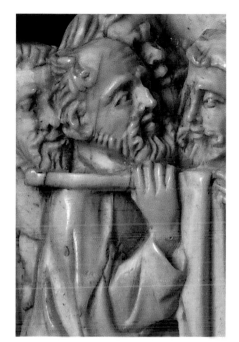

The fate of the Virgin Mary is not recounted in the Gospels. However, apocryphal sources compiled in *The Golden Legend* by the Dominican friar Jacobus de Voragine around 1260 recounted the Virgin's last days. Aching to join her son in heaven, the Virgin is visited by an angel bearing a palm branch from Paradise, who informs her that she will die in three days' time. All the apostles are miraculously transported to her so they can officiate at her funeral, which occurs at the appointed hour. The Virgin is placed on a bier borne by Sts Peter and Paul and led by St John, who carries the palm branch. It is this event that is depicted on this small fragment from the right wing of an ivory diptych. The left wing, showing scenes from the Life of the Virgin, is in Berlin. Prior to the funeral, the Virgin expresses concerns that the Jews may attempt to destroy her body. The ivory fragment delivers the next episode in the sorry tale of the Jew who tried to upset the funeral bier, only to find that his hand withered and stuck to it. He is shown here suspended from the fabric covering the bier, wriggling in distress. He is only released from his torment when he acknowledges Christ as the son of God born of a virgin. This element of sensational anti-Semitism is not uncharacteristic of medieval apocryphal stories.

The carving has been ascribed to the prolific Master of Kremsmünster, who was active in the area of the middle Rhine towards the end of the fourteenth century. His *œuvre* has been identified by comparison with a definitive work in the Abbey of Kremsmünster, Austria, and is recognized for high-quality, dramatic, crowded compositions. Astonishingly in this instance all twelve apostles are accommodated beneath six arches, along with four citizens of the town, a soldier who seems to be barring entry and, of course, the Jew, who is carved in low relief against the bier. The curly-haired, cherubic St John who leads the procession is a firm favourite of the Master of Kremsmünster and is one of his signatures on this piece.

Late 14th century

Germany

Accepted by HM Government in lieu of tax

HEIGHT: 7.7 cm

WIDTH: 12.1 cm

P&E 1978,0502.5

ENAMEL PLAQUES WITH THE VIRGIN AND ST JOHN

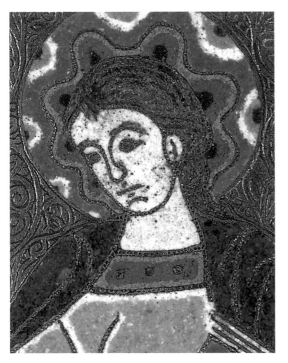

Around 1170–90
Limoges, France
HEIGHT: 21.7 cm
WIDTH: 10 cm
P&E 1850,0722.5 & 6

Along with the image of Christ on the cross, the figures of the Virgin Mary and St John the Evangelist frequently form the nucleus of Crucifixion groups. The closeness of their relationship to Christ – Mary as mother and St John as the youngest of the apostles, considered to be especially loved by Christ – greatly heightened the pathos of the event. These enamel plaques were designed as terminals to the arms of a cross, the original proportions of which have been calculated between 120 and 160 centimetres in length. Such a monumental scale was not unknown among the crucifixes produced in Limoges, though none survives. Other mounts from the cross that these plaques decorated exist at the Metropolitan Museum of Art, New York, and the Vatican Museum, Rome. The first shows two censing angels and would have been positioned at the head of the cross; the second is a representation of Adam emerging from his tomb, which would have furnished the foot.

Each of the plaques has the same decorative border of interlace and a densely patterned background engraved with scrollwork, termed vermiculé. This is skilfully executed and heavily gilded so that the figures contrast boldly against it in blocks of colour. The enameller has manipulated his medium with great control in the flamboyant haloes that surround the heads of the saints, the three-quarter view of the Virgin Mary and the delicately drawn feet of the evangelist, one of which intrudes gently into the deep blue of the border. The Virgin stands with her arms apart in a gesture that indicates prayer. She is depicted turning to face a central point. St John inclines his head in the same direction. Their orientation makes it clear that their original function was to flank a figure of Christ. The ambition of the original composition, in terms of scale and artistic accomplishment, surely must have secured the crucifix a position among the first order of achievement in the late twelfth-century workshops of Limoges.

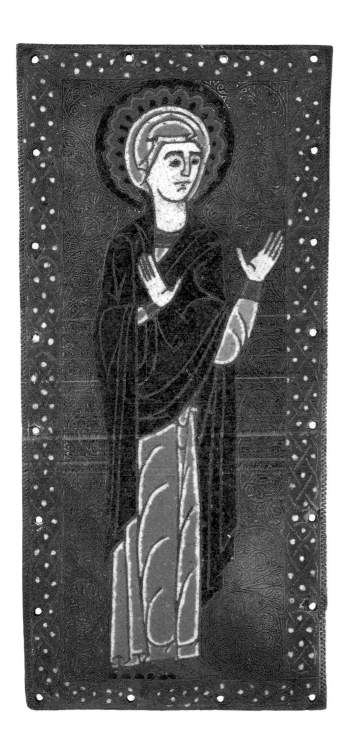
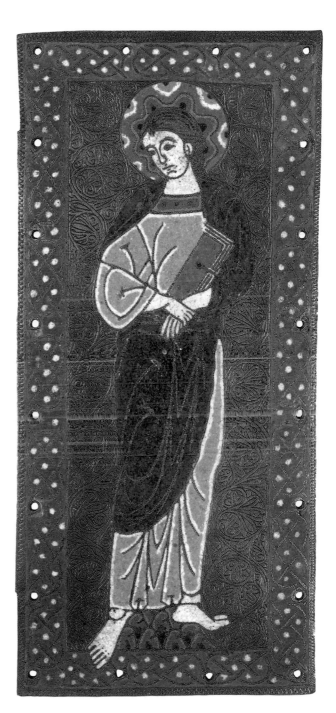

LIMOGES CROZIER

Around 1225–50

Limoges, France

LENGTH: 34 cm

WIDTH: 17.5 cm

P&E 1854,0410.1

A large number of enamelled croziers survive from the workshops of Limoges in south-west France. The majority of them fall into specific groups defined principally by the decoration that fills the space created by the curvature of the hook. This is most frequently occupied by vegetal motifs (as here) or by figures representing the Annunciation, the Coronation of the Virgin, Christ in Majesty with the Virgin, Adam and Eve, or St Michael slaying the dragon. The dominant themes, therefore, relate to the Virgin Mary, with an accompanying interest in the notion of sin and judgement. The Virgin was seen as the new Eve, equipped through her great virtue to assist in the absolution of original sin as the mother of Christ. Her subsequent role in the remission of sins was as the principal intercessor between mankind and God. The archangel St Michael, who expelled the forces of Satan from Paradise, was an established figure in Last Judgement iconography, where he is seen weighing the souls of the dead to gauge the level of sin before admission to heaven or consignment to hell. The survival rate of Limoges croziers is determined by the fact that many of them were interred with the ecclesiastics who owned them. Their subject matter might even suggest that many were made specifically as funerary items.

This crozier appears to be unique in that it does not correspond closely to any of the purely 'vegetal' group and because the dominant design on the hook is a Latin inscription in large red letters. The inscription invokes both the Virgin Mary and the Last Judgement and so provides a thematic link with the figurative types. It reads on the front 'REGINA ANGLORV IN DIE' and on the reverse 'IVDICII MISRERE MEI', which translates as 'Queen of Angels have pity on me in the day of judgement'. Other croziers with inscriptions generally relate to scenes of the Annunciation and offer the explanatory verse, taken from the archangel Gabriel's salutation, 'Ave Maria gracia plena' ('Hail Mary full of grace'). The unusual quality of this crozier has prompted the suggestion that it may have been adapted to suit the taste of a foreign client. It may certainly have been made to commission, perhaps with the deliberate intention of it furnishing a grave.

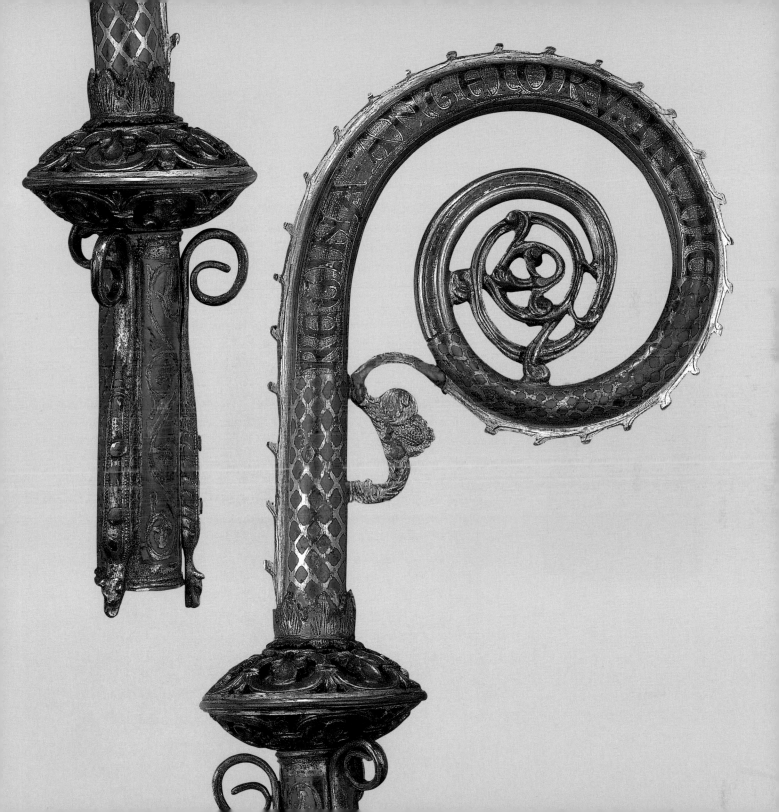

VIRGIN AND CHILD ENTHRONED

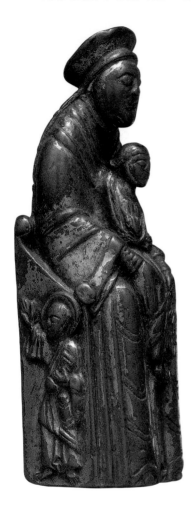

The view taken by prominent Church theologians of the eleventh and twelfth centuries that the birth of Christ would not have been possible without the Virgin Mary gave great impetus to her cult. Her relationship to Christ placed her in a unique position as an intercessor on behalf of mankind and devotion to her as an agent of salvation became an established creed, with the Benedictine abbot Guibert de Nogent famously remarking that it would be impossible for Christ to refuse his mother any wish. The Virgin gradually accumulated a wide variety of roles that were duly expressed in her iconography. A number of medieval litanies refer to her in Latin as 'Sedes Sapientiae' ('the Seat of Wisdom'), and it is this aspect of her character that is developed in this gilt-copper-alloy figure.

The Seat of Wisdom refers to the Virgin as the bearer of Christ both in the womb and in her lap as an infant. Its imagery loosely derives from comparisons between the Virgin and the throne of Solomon (1 Kings 10:18–20; 2 Corinthians 9:17–19). Representations of the subject are characterized by their emphatically frontal pose and by the attitude adopted by Christ, who appears upright, entirely cognizant and usually in the act of extending a blessing. Here Christ makes a sign of benediction with his right hand and in his left hand holds a book, an attribute of the wisdom he embodies. The extremely frontal quality of the composition is given greater strength by the rigorous symmetry that governs it and by the strong verticality provided by the slim, centrally placed figure of Christ. Christ is held firmly between the Virgin's two hands, which are placed on his knees in a strictly identical fashion to suggest that she is presenting him to the viewer. Despite its small scale, the figure conveys both monumentality and solemnity. It was manufactured by the lost-wax technique of bronze casting, whereby a clay core was covered by a layer of modelled wax and then encased in further layers of clay before molten metal was poured in to take the place of the wax. Once extracted from its casing, the hard metal could then be engraved and polished to achieve a high degree of finish. The precise function of this Virgin and Child is not known, but it resembles the figures that decorate the feet of Romanesque crosses.

Around 1150

Germany

HEIGHT: 11.2 cm

P&E 1878,1101.89

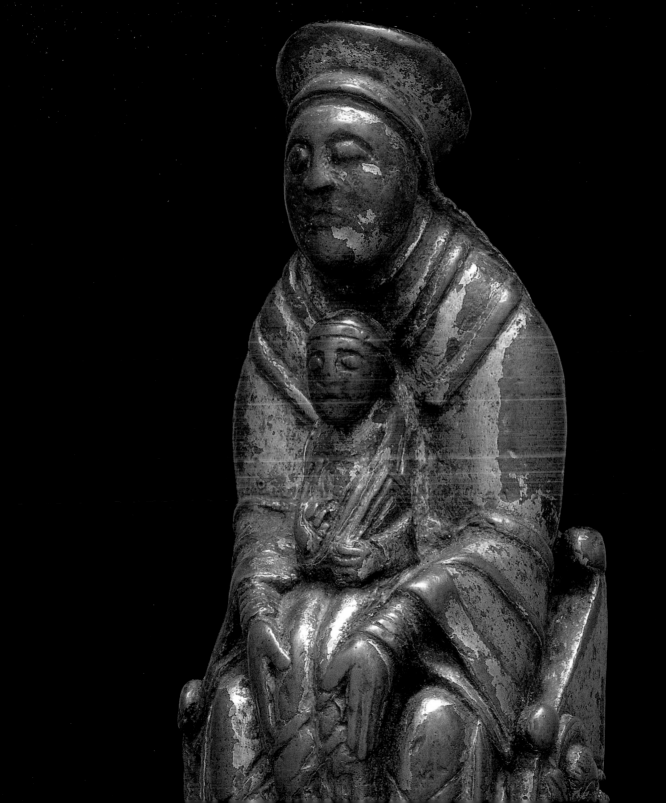

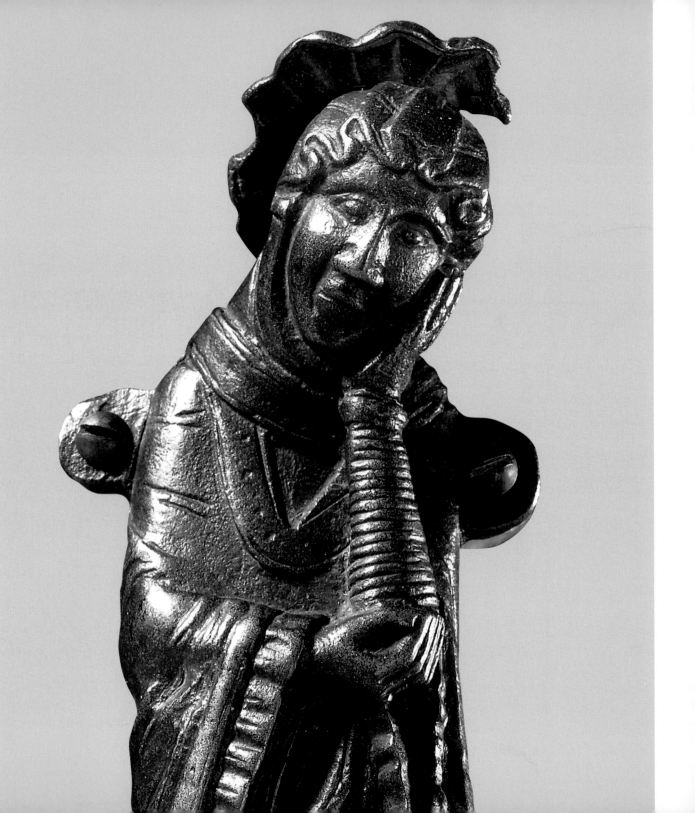

BRONZE FIGURE OF THE MOURNING VIRGIN

The Virgin Mary is traditionally depicted in Crucifixion scenes standing on the right-hand side of Christ. The corresponding space to Christ's left is usually occupied by St John the Evangelist, for whom Christ was believed to feel particular tenderness. This small figure of the Virgin was designed as part of a Crucifixion group and has four protruding pinholes to attach it to a flat surface, perhaps the arm of a large cross or the side of a reliquary. The presence of the Virgin at the Crucifixion was one of the emotional fillips that artists used to provoke religious empathy. Although the gesture she adopts is restrained, she communicates sorrow through the gentle incline of her head, which she supports in her left hand, while cradling her elbow in her right hand. This posture was easily recognizable to a medieval audience and is employed to interesting effect by the queens of the Lewis chess pieces (see pp. 278–9).

The Virgin's static pose, expressive of concentrated grief, is enlivened by the depth and volume of her robes, which are arranged in layers of rippling folds. The bronze-caster's love of pattern is apparent in the scalloped halo that crowns her head and the curling folds of her veil that frame her mournful face. The area around her chest and shoulders is left relatively plain, broken only by the heavily ribbed sleeve, which is raised by the action of her left arm. However, below the elbow the frilled cuffs of her wide-sleeved overmantle give way to layers of drapery, which fall in voluminous folds to her feet. Affinities between this piece and certain Scandinavian survivals, most particularly the retable from the church of Sahl in Denmark, have been remarked upon and may help confirm the oral tradition that the figure was found in the north of England in the nineteenth century before being committed as a gift to Ushaw College, Durham.

Late 11th or early 12th century
England
HEIGHT: 10.8 cm
P&E 1968,0707.1

IVORY FIGURE OF ST MARGARET

Tales of virgin martyrs who repel the amorous advances of prominent pagans and refuse to recant their faith were inspired by the persecutions of the early Christians. Saints such as Katharine, Barbara, Agnes and Margaret all shared the same fate, with varying details, and enjoyed enormous popularity in the late medieval period. St Margaret's origins were believed to be at Antioch, where she was the Christian daughter of a pagan priest. She refused the attentions of the Roman prefect Olybrius whereupon she was denounced as a Christian and tortured before her death by decapitation. As part of her ordeal, Margaret is swallowed by the devil in the form of a dragon. The devil, however, finds it difficult to digest the holy virgin, who invokes the name of the cross and bursts out of his belly. It is this fantastical episode that is captured by the ivory carver. The figure conforms to a conventional depiction of the scene that shows St Margaret emerging not from the creature's stomach but from its back. The dragon's open mouth reveals a portion of her gown that it has not yet swallowed. The whole dramatic episode is characterized by an ease and serenity that is conveyed as much by the motionless action of the dragon as by St Margaret's graceful poise as she rises from the demon with her hands joined in confident prayer. As a consequence of her safe passage through the belly of the dragon, Margaret became the patron saint of midwives and women in labour.

The carver has shown great skill in handling his raw material. He works convincingly within the constraints caused by the curvature of the elephant tusk, the original lines of which culminate in a point above St Margaret's head. Microscopic analysis has revealed traces of original polychromy that show that he has also applied gilding to disguise naturally occurring cracks in the ivory, which was highly prized for its lustrous sheen and flawlessness.

About 1325–50

Paris, France

HEIGHT: 14.5 cm

P&E 1858,0428.1

THE ADORATION OF THE MAGI BY TILMAN RIEMENSCHNEIDER

Around 1505–10

Germany

Given by the Revd George Murray on behalf of the Revd H. Crowe

HEIGHT: 110 cm

WIDTH: 57.8 cm

P&E 1852,0327.10

Tilman Riemenschneider (*c.* 1460–1531) was a successful and prolific artist whose long career saw him set up an accomplished workshop that produced carvings principally in wood but also in alabaster, sandstone and marble. He settled in 1483 in Würzburg, Franconia, where he quickly became established so that by 1485 he was a burgher of the city and conferred with the title 'Master', a distinction that enabled him to employ apprentices and market his works under his own name. A number of important commissions followed in Würzburg and the surrounding area. In 1505 he was asked to furnish the Marienkapelle in the city of Rothenburg with an altarpiece of St Anne, from which this Adoration of the Magi is thought to come. It has suffered considerable damage along its left side, probably as a result of its removal from the Marienkapelle, which was destroyed in 1810. The hands of the standing magus are missing but were undoubtedly carved in the round and inserted separately. The third magus is absent and must have occupied a space at the left, beyond the current frame.

Riemenschneider frequently referred to the printed works of Martin Schongauer (*c.* 1450–91) for inspiration in his designs and the arrangement of this Adoration appears to have been based on an engraving by Schongauer dated 1482. However, Riemenschneider's manipulation of his medium provides an entirely different experience, which reflects the public and monumental nature of the commission. His fluency with perspective and relief allows the carving to achieve maximum visibility, assured not through the application of paint but by the action of light and shadow. Many of Riemenschneider's works were conceived as monochrome and were highlighted only by minimal touches of paint to areas such as the lips and eyes. His delight in his material is manifest in details such as the joined hands of the kneeling magus and the knot that gathers his robes around his waist. They offer individual points of excellence in a composition that compels the eye to travel from one surface to the next in an essentially emotional journey.

RELIQUARY CASKET WITH THE ADORATION OF THE MAGI

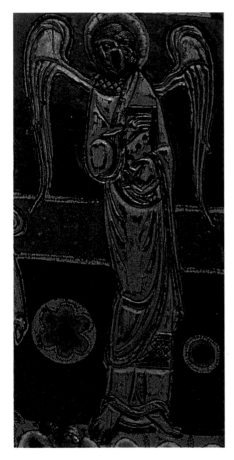

Early 13th century

Limoges, France

HEIGHT: 18.3 cm
LENGTH: 20.1 cm
DEPTH: 8.9 cm

P&E 1855,1201.8

The Gospel of St Matthew is the only one that mentions the wise men or magi who came from the east to witness the birth of Christ (2:1–12). There is no reference to their number, their country of origin, their names or the gifts they made: all these details were supplied by later commentators. The legendary relics of the three magi were translated from their shrine in Milan to Cologne by the Emperor Frederick I Barbarossa in 1164. Despite the lack of scriptural backing, a phenomenally successful cult was established at Cologne, where the relics were housed in a shrine made by Nicholas of Verdun, the foremost goldsmith of his day. Cologne was one of the four major penitential pilgrimage destinations in Europe, the others being Santiago de Compostela, Rome and Canterbury. Its importance was due in part to its strategic position on the Santiago pilgrimage routes and to the activities of German merchants who broadcast its fame.

The international nature of the cult is reflected in a number of reliquary caskets made in Limoges that take as their subject matter the Adoration of the Magi. This beautifully engraved example arranges the journey of the magi across its roof. The first figure is shown pressing forward as his horse gathers speed and he turns to indicate the star with some urgency to his companions. On the chest the three magi stand before the enthroned Virgin and Child as Christ extends his blessing and accepts the gifts of gold, frankincense and myrrh. The significance of each gift was felt to be three-fold. Gold was offered to relieve the Virgin's poverty, as a tribute to Christ as king of the Jews and as a symbol of love; frankincense was intended to dispel the odour in the stable, to signify sacrifice and to serve as a symbol for prayer; and myrrh was given to strengthen the child's limbs, for the burial of the dead (in a premonition of Christ's sacrifice) and as a symbol for the mortification of the flesh. Significantly, Joseph does not feature in the event. He occupies an ambivalent position in Nativity iconography, attracting little attention until the thirteenth or fourteenth century. His logical place here is taken by an angel, in elegant contrapposto, who holds a book and turns to observe the scene.

GLENLYON BROOCH

This brooch's impressive size endows it with considerable impact. Not only is it large but it is given extraordinary depth by the height of its gem settings and the richness of its decoration. Its extensive diameter makes necessary the use of two pins to secure it to a garment and a central bar has been inserted to accommodate the pin rests. This is studded with pearls, one placed at either end and a series of six (one is missing) arranged around a large garnet in the middle. The two rectangular fields with hollow cells placed either side of the central setting were probably designed to house coloured glass. The frame of the brooch operates as a series of undulating surfaces, the highest points of which are set with freshwater pearls, amethysts and rock crystals.

This is one in a series of Scottish brooches of similar proportions, the significance of which remains largely unknown. A number of them have close associations with ancient Scottish families; this particular brooch takes its name from Glenlyon, the family seat of the Campbells. That the brooch may have had amuletic meaning is supported by the use of gems and crystals, which were believed to have magical properties in the Middle Ages, and by the inscription engraved on the reverse, which reads 'Caspar Malchior Balthazar Consumatum'. This is a citation of the names of the three magi followed by a quotation in Latin of the last words spoken by Christ, according to the Gospel of St John (19:30): 'Consumatum est' ('It is finished').

Although neither the names nor the number of the magi are recorded in the Gospels, by the late Middle Ages the names attributed to them were credited with prophylactic power and were inscribed on a number of different items such as rings, brooches and cups. They were spoken as a popular charm against epilepsy, and, according to a sixteenth-century English document, they were invoked to recover lost property: 'Take virgine wax and write upon yt Jasper + Melchior + Balthazar + and put it under his head to whom the good pertayneth and he shall knowe in his sleape wher the thinge is become.'

Early 16th century
Scotland
DIAMETER: 14 cm
P&E 1897,0526.1

ICONOGRAPHIC FINGER RING

Large numbers of rings engraved with images of saints were produced in England from the fifteenth century until the Reformation. They vary hugely in quality and were seemingly mass manufactured in bronze, silver and gold for a burgeoning market in ready-made items sold by goldsmiths in jewellery shops. Termed iconographic rings because of the images they bear, they frequently carry fashionable French mottoes and may have been exchanged as marriage rings or New Year gifts. Their customary form is a cabled hoop, often engraved with sprigs of foliage, which may incorporate an inscription either on the decorated external or the smooth internal surface. A double- or triple-faceted bezel normally accommodates the depiction of two or three saints. In some instances, an Annunciation scene may cover the whole bezel. The Annunciation is one of the few narrative scenes from the Gospels that decorates with any regularity the bezels of these rings, which are quite often crudely engraved. The lack of precision in the engraving was compensated for by a display of coloured enamels. Remarkably few rings retain their enamel, partly because many of those surviving were found as random losses in the ground and the enamel has decomposed. Where it does remain, the palette tends to consist of vibrant reds and greens with black and white.

This ring, found at Sleaford in Lincolnshire, is an outstanding example. Its dimensions are impressive and allow a fuller treatment of narrative than is usually possible. Furthermore, very little of its enamel has been lost. Only black enamel is used, with the deliberate effect of making the scenes strikingly legible. The ring operates as a form of micro-art, and is incredibly detailed in its treatment of five different episodes. The Annunciation shows the figure of the Virgin startled by the arrival of the archangel Gabriel; the Nativity expresses the vulnerability of the Christ child but delights equally in the decorative effect of the tiles on the stable roof; the Resurrection shows Christ stepping from his tomb, decorated with small niches on its side; in the Assumption the Virgin is borne aloft by four angels who encircle the scene; and in the Ascension Christ is propelled heavenwards with such force that only his feet emerge from a cloud, to the complete amazement of the attendant apostles.

15th or early 16th century

England

Acquired through the Treasure Act with a donation from the British Museum Friends

HEIGHT: 0.8 cm

DIAMETER: 2.2 cm

P&E 2004,0202.1

Around 1160–70

Probably Germany

Given by Sir Augustus
Wollaston Franks

HEIGHT: 5.5 cm (St John); 5.6 cm (others)
WIDTH: 10.4 cm (St John); 11.2 cm (others)
P&E 1888,1110.3–6

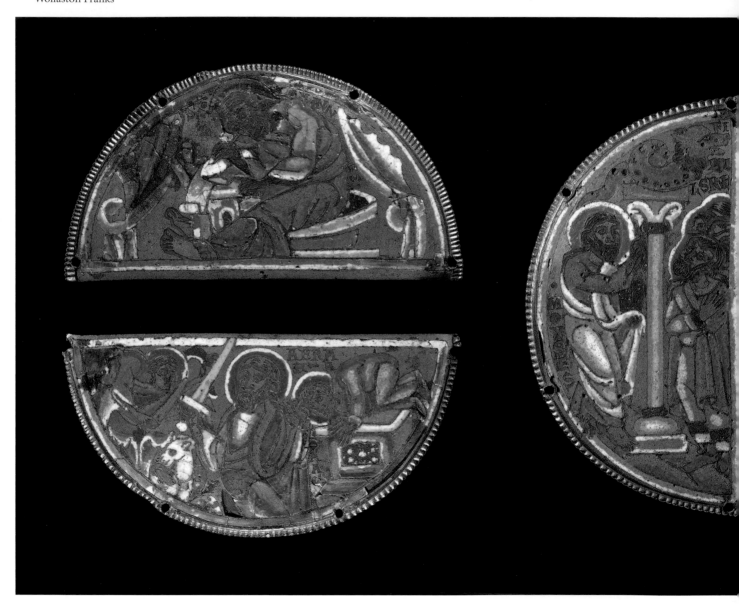

FOUR ENAMEL PLAQUES

The enamellers of the Mosan region in the Meuse valley, which includes parts of modern-day France, Belgium and Germany, enjoyed a short peak of prolific activity around 1140–80. They prospered from the presence of raw materials and the patronage provided by rich ecclesiastical foundations. The collection history and style of these four plaques unite them and may indicate that they originate from the abbey at Prüm in Germany.

Three of the plaques depict scenes from the Old Testament and undoubtedly come from the same object. The fourth, which is smaller with slight differences in the details of its enamelled margin and beaded border, shows St John the Evangelist, and is likely to come from a different, though related item. Semicircular plaques were frequently combined around a square central section to form a specific type of pendant reliquary known as a phylactery. Enamel plaques were attached to the front of a wooden core, the reverse of which was covered with plates that were either engraved or decorated with *vernis brun* (see pp. 88–9). Old Testament scenes were often understood by a medieval audience to refer to the Passion of Christ. In this scheme, the sacrifice of Isaac parallels that of Christ, as attested to in the celebration of Mass. The connection is made clear by the placement of Isaac upon an altar as Abraham clutches him by the hair and raises his sword to kill him. The scene of Moses and the brazen serpent was understood as an antitype for Christ on the cross (see pp. 66–7), while the marking of the Tau on the foreheads of the righteous had similar significance. The three were probably arranged, with a fourth plaque now at Trier but formerly at Prüm, around a relic of the True Cross concealed by an enamel of Christ. The plaque of St John the Evangelist corresponds closely to two plaques of St Mark and St Luke at Nürnberg and may, with a missing plaque of St Matthew, have surrounded a central image of Christ in majesty. The two phylacteries were perhaps conceived as a double commission.

ENAMEL PLAQUE WITH SAMSON

Samson's escape from the Philistines at Gaza is related in Judges 16:1–3, where he is described leaving the city at midnight, taking the city gates with him. Typologically the event was understood in the Middle Ages as a prefiguration of Christ's Harrowing of Hell, when Christ rescued from torment the souls of biblical characters such as Adam and Eve and Abraham, an episode believed to have taken place between the time of the Crucifixion and the Resurrection.

This plaque relates to four others by the same hand, probably designed to decorate a single substantial piece of liturgical furniture, perhaps a shrine or an altarpiece. Two of the plaques, now in the Metropolitan Museum of Art, New York, show the Nativity and the Annunciation to the Shepherds; a third, at the Musée d'Art et d'Archéologie, Moulins, depicts Joseph bearing a taper and two doves as part of a more extensive scene of the Presentation in the Temple or the Purification of the Virgin; the fourth, now lost but previously in the Czartoryski Collection at Goluchów Castle, Poland, was a representation of the Ascension of Christ. The Samson plaque is the only one to take its subject from the Old Testament and must surely have functioned as one of an elaborate sequence of type and antitype taken from the Bible.

All the plaques are the same size and made of gilt-copper alloy, with an equal number of pinholes for attachment to the object they originally ornamented. They exhibit strong stylistic and technical similarities. The enameller shows great proficiency for adventurous perspective, indicated here by the towers of Gaza contained within the city walls. Details of the architecture are ambitiously picked out with red granules of enamel fired with blue and turquoise to create a mottled appearance simulating marble or porphyry. This is pierced by a deep blue enamel to give the impression of a dark void behind the lunettes of the wall and towers and to show the gaping hole left in the door as Samson steals away with the gates. Even more breathtaking is the combination of different coloured enamels within a single field to give a bold, geometric pattern to Samson's leggings. The engraving is of a comparably impressive quality clear in the subtly modelled features of Samson's face and beard and the rich layers of his heavy tresses.

Around 1170–80

Mosan

Given by Sir Augustus Wollaston Franks

HEIGHT: 10.7 cm
WIDTH: 11.2 cm

P&E 1888,1110.2

IVORY TABLEMAN SHOWING SAMSON AT THE GATES OF GAZA

The figure of Samson, like that of Hercules (see pp. 298–9), provided a paragon of male virtue and virility, which held an obvious attraction for the noblemen who played the game of tables. This boardgame resembled backgammon and is known to have been popular in military circles and among the crusaders. Thirty pieces were required for a game of tables; one side was left plain and the other distinguished by the application of red pigment or by being subjected to smoke, which turned the ivory brown. A number of tablemen that take Samson as their subject have survived, bearing witness to the appeal held by his story. The heroic figure of Hercules, also seen by Christian commentators as a prefiguration of Christ, is used on a correspondingly significant number of tablemen and this has led to suggestions that the two superheroes may occasionally have formed opposing sides in single sets.

This extraordinary piece, made from walrus ivory, demonstrates the skill of the carver in the degree of undercutting that is achieved and in the dynamic representation of the biblical hero. Samson is shown seizing the gates of the city of Gaza. His long hair flies away in heavy locks as he pulls at the remaining gate and his cloak and tunic express the force of the movement in their agitated hemlines. Meanwhile the Philistines are asleep within the city walls, unaware that their plan to capture Samson has failed (Judges 16:1–3). Samson's escape from Gaza was linked typologically in the Middle Ages to Christ's Harrowing of Hell and the Resurrection (see pp. 146–7).

Around 1125–75

Cologne, Germany

DIAMETER: 4.8 cm

P&E 1857,0917.1

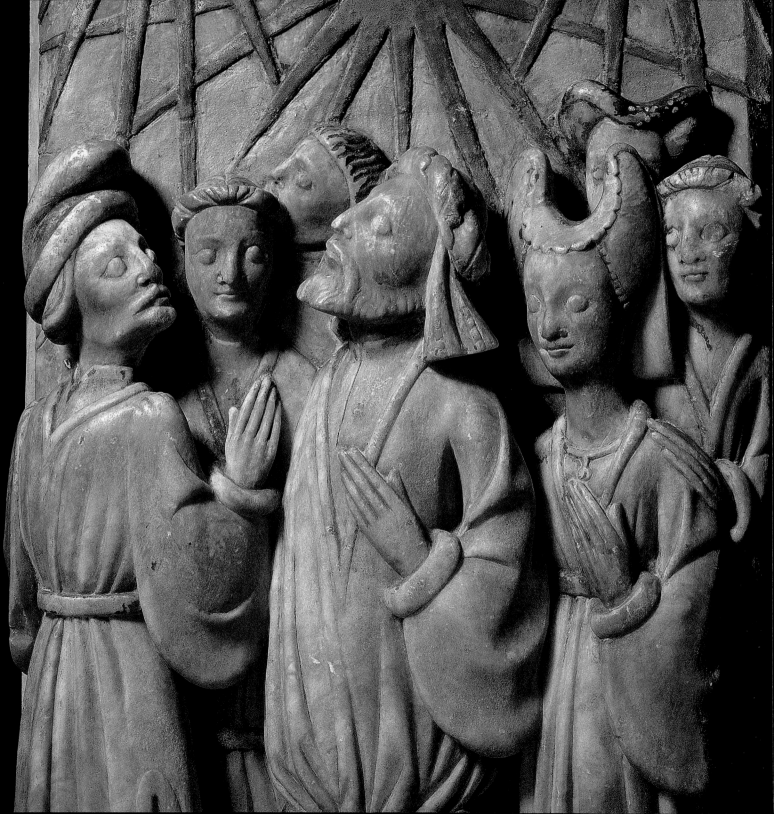

LAST JUDGEMENT ALABASTER

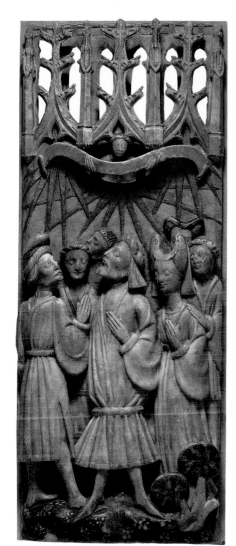

About 1420–60

England

Given by Max Rosenheim through the Art Fund

HEIGHT: 60.5 cm

P&E 1910,1208.2

In the late medieval period Doom paintings were a dominant feature of most churches. They consisted of a figure of Christ in majesty, often seated on a rainbow, meting out judgement to the souls of the deceased. The dead were shown emerging from their tombs whereupon they were seized by devils and dragged into the jaws of hell or were summoned by angels to the gates of heaven. Such paintings were customarily positioned on the west wall above the door to the church so that the departing congregation were reminded of the penalties of sin.

However, Doom iconography had a much larger repertory of images and might occur in other contexts, including altarpieces. This astounding alabaster depicts one of the fifteen signs believed to precede the Last Judgement and was designed to be accommodated as part of a series within a wooden tabernacle. The omens were drawn from the book of Revelation and the teachings of St Jerome and were elaborated upon in *The Golden Legend*, a thirteenth-century collection of stories associated with the liturgical calendar compiled by Jacobus de Voragine (d. 1298). Among the fearful warnings itemized were dramatic events such as mountains crashing to the ground, tidal waves, stars falling from the sky, earthquakes and heaven and earth burning.

The tenth sign, shown here, describes how men shall emerge from the caves into which they have retreated, demented and unable to speak. The confusion of the characters is reflected in their hands, raised helplessly, or resting upon a shoulder for guidance, and, most powerfully, by the directionless orientation of their heads, which expresses total bewilderment. The alabaster carver has met the challenge of depicting an intangible psychological state in a masterly way rarely achieved in the sculpture of any period. For the literate, an angel unfolds an explanatory scroll above the scene. The painted inscription is now lost, along with almost all the paint that originally covered the surfaces of this remarkable composition.

15th century

France

Given by H. Boone

HEIGHT: 33.5 cm

P&E 1857,0218.1

ALABASTER FIGURE OF A WEEPER FROM A TOMB

The fashion in courtly funerary art to place figures known as 'weepers' in niches around a tomb was customary from the thirteenth until at least the last quarter of the sixteenth century. This powerful and poignant image of mourning found its most celebrated expression in the tomb of Philip the Bold, Duke of Burgundy (d. 1404), which incorporated forty-one alabaster figures of weepers. The figures are thought to reflect the various orders of mourners present at Philip's funeral and are characterized by an individuality and naturalism suggestive of portraiture. The monument's artistic merits were rapidly assimilated by sculptors and it had a profound effect on the design of subsequent tombs.

This lone alabaster weeper from an unknown tomb shares the same concern for understated naturalism. The translucent sheen of alabaster was greatly valued, and, unlike other stone, it appears not to have been highly painted in this context. Elements of selectively applied gilding were simply employed to enhance details of dress. The costumes very often help to identify the status of the weepers, who are frequently drawn from the rank and file of court culture. There is little specific about the dress of this figure to provide any means of identification. The hood, used as a sign of mourning, obscures any headdress that might have provided a clue. Significantly not all the figures arranged around tombs in the attitude of weepers appear to be in mourning, a fact that has challenged the traditional interpretation that they are meant to represent those present at the funeral procession. One possibility is that the figures function as part of a memento mori, a reminder of the inevitability of death. Such schemes frequently used figures from a courtly context to signify the vanity and transience of life. That this might be the case is indicated by possibly the earliest surviving instance of weepers on a tomb at Las Huelgas, near Burgos in Spain. The tomb, commissioned by Alphonso VII and Eleanor Plantagenet, was probably made for their son, Prince Sancho. It is dated 1194 in an inscription that anticipates a sentiment that did not become current in medieval Europe until the fourteenth century: 'Whoever you are, you will fall into death, so take heed and weep for mine. I am what you will be and was what you are now. I beg you to pray for me.'

ALABASTER WITH THE RESURRECTION

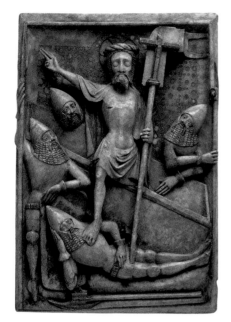

Late 14th century
England
HEIGHT: 43 cm
WIDTH: 29.3 cm
P&E 1905,0522.1

Resurrection scenes are among the most numerous of the surviving alabaster panels produced in England from the fourteenth to the early sixteenth century. The subject's popularity is undoubtedly connected with the importance of Easter and its arrangement may have been influenced by the mystery plays that were performed in celebration of the feast. From the earliest representations, Christ is shown stepping from the tomb on to the body of a recumbent soldier, an iconographic feature that seems to be peculiar to English art. A stage direction in the Chester mystery play issues the instruction, 'Jesus rising, crushes the soldier with his foot'.

The soldier who receives the foot of Christ in this alabaster is the only one of the four who appears securely asleep; the other three seem to be in a state of confused half-sleep. One leans on his shield and appears to direct his gaze to the risen Christ, another rests his chin dozily on the side of the sarcophagus, while the fourth expresses bewilderment through the tilt of his head and his unfocused stare. Christ emerges triumphant with an emphatic gesture of benediction from his dramatically extended right arm. In his left hand he holds the cross-staff and pennant that symbolize his victory over death. Of his wounds, only the gash in his side is visible; the holes in his hands and foot and the blood that issued from the wound caused by the crown of thorns would originally have been painted on, but have now been lost. Pigment remains mainly in areas that are less exposed or offer greater adhesion, such as the textured surface of the soldiers' mail collars, their drooping moustaches and Christ's hair and beard.

The economy of design, the neatly chamfered edges that frame the composition and the details of the soldiers' armour indicate a date in the late fourteenth century. The careful ordering of the figures and the management of perspective in the sloping form of the sarcophagus make this one of the most satisfying of all the Resurrection alabasters. Especially pleasing is the way in which the lance of the soldier on the left and the battle axe of the soldier on the right form part of the frame and curl discretely around the edge.

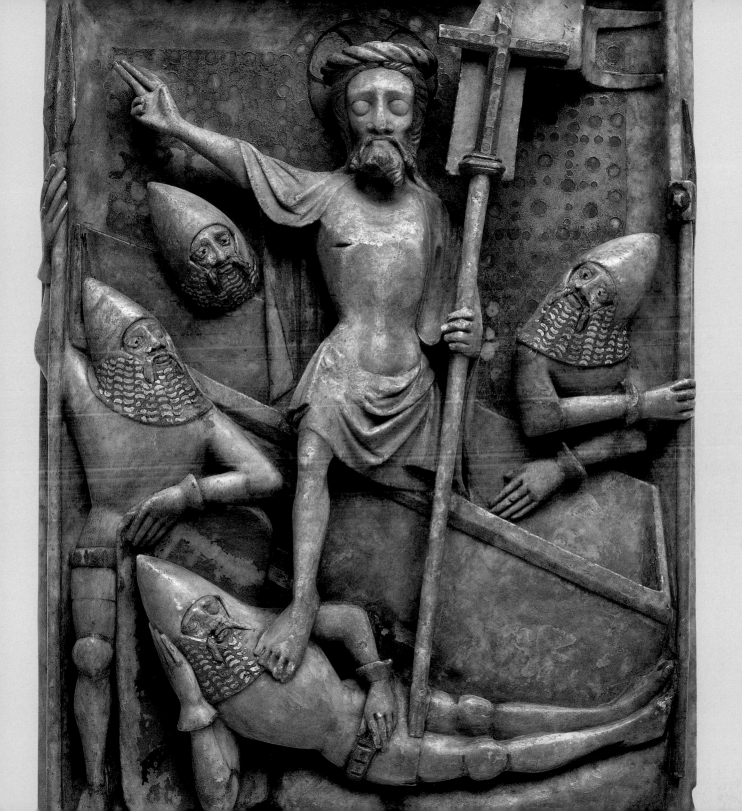

PAIR OF ALABASTERS SHOWING THE BLESSED AND THE DAMNED

Early 15th century

England

HEIGHT: 28 cm (Blessed);
30 cm (Damned)

P&E 1872,0520.31 (Blessed);
P&E 1872,0520.32 (Damned)

Alabaster altarpieces with the 'Doom' or Last Judgement as their subject are known from records describing them at the Guild of St Mary in Boston, Lincolnshire, and the church of St Mary the Great in Cambridge. Sometimes of quite extensive proportions, they could include as many as fifteen scenes of the warnings believed to predict the Second Coming (see pp. 150–1). Central to images of the Judgement was the weighing of the souls by St Michael, whereby those heavy with sin would tip the scale to the left and those heavy with virtue would tip it to the right. Through this process the blessed were destined to gain access to the gates of heaven, while sinners were dragged to the jaws of hell.

Both scenarios are detailed by these two panels, which once formed part of a much larger scheme of the Last Judgement. They are not entirely complete: the crenellated cornice, which helps date them to the first quarter of the fifteenth century, is only partly intact in the alabaster of the blessed entering heaven. The scene is beautifully choreographed as three chosen souls, naked and sexless, are arranged in perfect synchronization as they step forward with their left legs. The first greets St Peter with a raised hand; the two who follow join their hands in prayer. They stand on a green ground studded with daisies, characteristic of the majority of English alabaster panels. St Peter, however, stands larger than life in a different firmament beyond the golden arch that defines heaven. A scroll unfurls above the heads of the fortunate few and would originally have carried an inscription describing the scene.

The harmony and space that dominate the heavenly domain are replaced by confusion and panic as the damned twist away uncomfortably from their fate. A lone female figure is already consigned to the flames of hell, which lick around her waist and legs as Satan drags a huddle of distraught souls to join her. They are ensnared by a chain around their waists, which the devil pulls over his shoulder as he turns to survey his catch. The two foremost figures turn to each other in distress, one hand raised to their chests, the other helplessly gripping the chain.

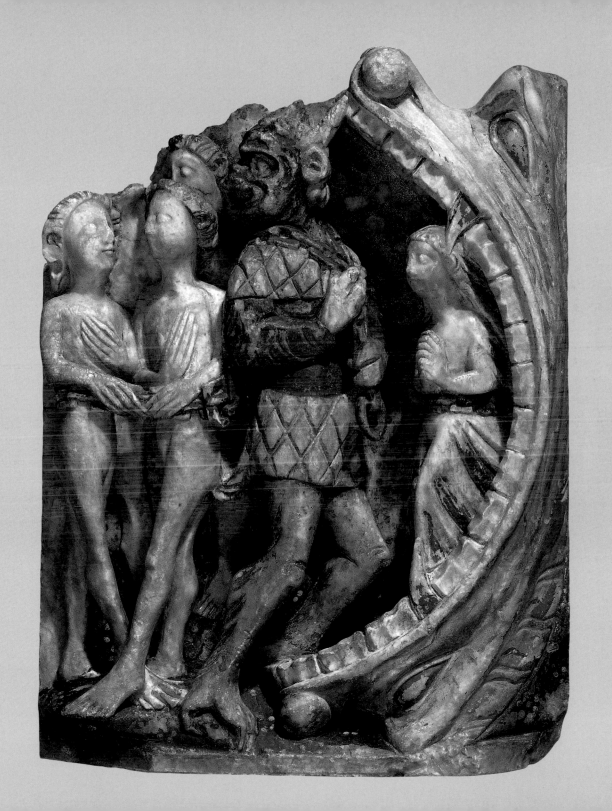

DOORKNOCKER IN THE FORM OF A LION'S HEAD

Many medieval church doors were originally equipped with bronze door-knockers, though few are retained. They performed a critical role in the ancient law of Sanctuary, wherein the Church offered refuge for criminals who knocked on a church door. They were allowed to remain unmolested within the confines of a sacred environment for up to forty days, after which they were compelled to submit to the law or renounce the realm and leave the country. The law was revised with considerable restrictions in the reign of Henry VII and was finally repealed in the seventeenth century. This change may account for the scant survival of doorknockers, as they were inevitably removed and melted down.

This impressive example must have belonged to a church of some importance. It was produced by the ancient process of sand-casting whereby a mould was made in two parts, one slightly larger than the other, from a clay-like mixture of sand, straw and manure. One part was placed inside the other, leaving a cavity into which the molten bronze was poured. The mould was packed around with sand and left to cool. The technique is intricate and time-consuming and, as the mould cannot be reused, the resulting product remains unique. This doorknocker is modelled into the shape of a lion's head with very pronounced features. The mane is arranged in double rows of coiled locks, which extend across the base-plate at equal intervals; the eyes are prominent and well defined with incised pupils and heavy eyebrows; the flaring nostrils have great depth; and a curly moustache emphasizes the mouth, which grips the ring, a later replacement. Style and symmetry dominate; there is little attempt at naturalism. The principal source for representations of lions was medieval Bestiaries, manuals of mythical and exotic animals, which endowed creatures with sacred significance. They contested that lion cubs were born dead and revived after three days by the male lion, clearly echoing Christ's resurrection. Lions were the favoured form for doorknockers: two others survive at York and many more in continental Europe. The attribution of this piece to an English workshop has been debated but it is likely that it was made in York in imitation of doorknockers produced in Germany in the second half of the twelfth century.

About 1200

England

DIAMETER: 37.2 cm

P&E 1909,0605.1

2 SOCIETY

Survivals of secular medieval art are relatively rare. Despite the ravages of religious reform and periodic iconoclasm, devotional art has frequently been saved by the sacred nature of its subject matter and the physical protection offered by church sanctuaries. Medieval royal palaces invariably experienced extensive refurbishments to update them in the course of their long histories. The Palace of Westminster in London, home to the medieval English monarchy, retained something of its former splendour until it was devastated by fire in the nineteenth century. Documentary evidence remains in the form of royal accounts and inventories and in the valuable drawings and descriptions of antiquarian scholars. English kings from Henry III (r. 1216–72) onwards developed Westminster in conscious competition with the palace of the kings of France on the Île de la Cité in Paris. Consequently, St Stephen's Chapel was conceived as a two-storey elevation in direct reference to the French royal chapel of Sainte-Chapelle. Similarly, Henry spent vast amounts of money on the refurbishment of Westminster Abbey to create a royal mausoleum to rival that at St Denis.

Sadly nothing remains of the secular subjects that once decorated the English royal palaces and much must be left to speculation. Henry III's love of romance literature and history subjects undoubtedly influenced his choice of decorative schemes. It is known, for example, that the Antioch chamber at Clarendon Palace was painted with the mythical combat of Richard I and Saladin and it has been suggested that the very fine tiles found at Chertsey Abbey showing the same scene may have been intended for the Palace of Westminster. Tiles of comparable

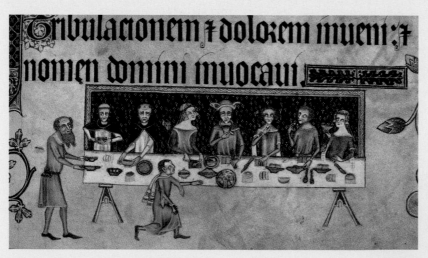

Detail from the Luttrell Psalter, showing Sir Geoffrey Luttrell at table. England (East Anglia), c. 1325–35. British Library, Add.42130, f. 208.

quality detailing the romance of Tristram and Isolde, also found at Chertsey, may also have been destined for one of his royal palaces.

Romance subjects were generally popular with an educated, wealthy elite, who were able to buy expensive items made of enamelled metalwork or ivory. The importance of Cologne as a production centre for ivory carving was eclipsed in the fourteenth century by Paris, which became the principal city for the manufacture of luxury goods. Ivory combs, caskets, writing tablets and mirror cases were made in abundance and decorated with scenes that had particular appeal to a courtly audience. Paris also excelled as a centre for goldsmiths, who included among their patrons the influential Jean, duc de Berry. His commissions of the Royal Gold Cup and the Holy Thorn Reliquary illustrate the very high level of skill that was available in the city. The Holy Thorn Reliquary carries an important indication of the duc de Berry's patronage in the heraldic plates which decorate its base.

The development of a system of heraldry was a purely medieval achievement. From the thirteenth century it represented an established pictorial code, which proliferated on a wide variety of objects, often as a sign of ownership. It was characteristically employed to announce status and to advertise lineage and was, therefore, frequently used to express marriage ties. A number of beautifully crafted objects incorporating heraldic devices exist, ranging from horse furniture, seal-dies and jewellery to fine tableware. Colour is an extremely important element in decoding heraldry and was normally applied to metal items in the form of enamel. Other materials such as leather, ivory and wood might be painted with a coat of arms. Elaborate wall hangings were woven or embroidered with emblems, as shown in the Luttrell Psalter, painted between about 1325 and 1335. Sir Geoffrey Luttrell was lord of the manor at Irnham in Lincolnshire and is shown at a feast with his guests seated against a tapestry showing his arms of silver martlets on a blue ground. This marginal illustration is one of a series of remarkable genre scenes that decorate the Psalter and provides detailed information about the protocol and furnishings of a medieval feast.

BRASS OF JOHN LANGSTON

About 1506

Probably made in London, England

Given by Sir Augustus
Wollaston Franks

HEIGHT: 69.5 cm

P&E 1861,0304.1

Memorial brasses presented a cheaper alternative means of commemorating the dead than tomb effigies, which were the privilege of the very wealthy. They are made from latten, a type of brass, and the details of their designs were picked out by a black inlay creating a very attractive colour contrast. Though occasionally monumental in size, the majority were small and were easily accommodated within the increasingly cramped confines of a church. Their use began in France and Germany in the thirteenth century and spread rapidly to the Low Countries and England where the pastime of taking brass rubbings was established by the seventeenth century. This recreational occupation acquired greater appeal in the age of antiquarian research when the details of memorial brasses were avidly recorded. It is owing to the survival of a rubbing at the Society of Antiquaries in London that we know the identity of the knight commemorated by this brass. It was taken at Caversfield Church, Oxfordshire, in 1821 and shows John Langston with his wife, Amice Danvers, and their twenty-two children.

Brasses, unlike tomb effigies, did not develop a system of portraiture but rather represented social types such as bishops, knights or merchants. The Langston family is shown dressed in the high fashion of the day to signify its social status. John Langston's fine brass depicts him as the embodiment of the chivalric, knightly virtues still current in the sixteenth century. His anatomy conforms to notions of how an ideal knight ought to look, which were well established in the fifteenth century. In the 1430s the standard bearer of the Spanish knight Don Pedro Niño described him in the following way:

> This knight was fair to see, of heavy build, neither very tall nor very short, and well formed: he had wide shoulders, a deep chest, hips high on his body, thighs thick and strong, arms long and well made, thick buttocks, a hard fist and well turned leg and a slim, delicate waist.

MASTERPIECES OF MEDIEVAL ART *163*

SIGNET RING WITH A LION

This finely engraved heavy gold signet ring has a compelling historical association. It was found on the site of the famous Battle of Towton, North Yorkshire. The battle was fought in extreme weather conditions on 29 March 1461 and is credited with being the largest and most violent engagement of the Wars of the Roses. It proved a pivotal victory for the Yorkist forces in the conflict and established Edward IV as king. Among the vanquished Lancastrians, Henry Percy, 3rd Earl of Northumberland, was mortally wounded in the battle. The Percy family is known to have used the badge of a lion in the sixteenth century and it has long been considered likely that this high-status aristocratic ring belonged to Henry.

The ring shows a lion standing squarely on all fours, poised to pounce, with its mouth slightly open. Its shaggy mane and thick tail, which curves across its back, are equally expressive of vitality. The motto 'now ys thus' is inscribed from the lion's head to its rump. Familial and political ties were routinely expressed through the deployment of badges and mottoes by the aristocracy (see pp. 172–3). However, in this instance there is currently no evidence to attach this phrase to the Percy family with any certainty. The signet ring was a masculine accessory that enabled the relatively rapid sealing of closed correspondence. Since the survival of medieval documents has relied heavily on those retained historically in the archives of Church and State for the purposes of law, few examples of personal correspondence with seals relating to signets are known to exist.

Late 15th century

England

Given by Sir Augustus
Wollaston Franks

DIAMETER: 2.9 cm

P&E AF.771

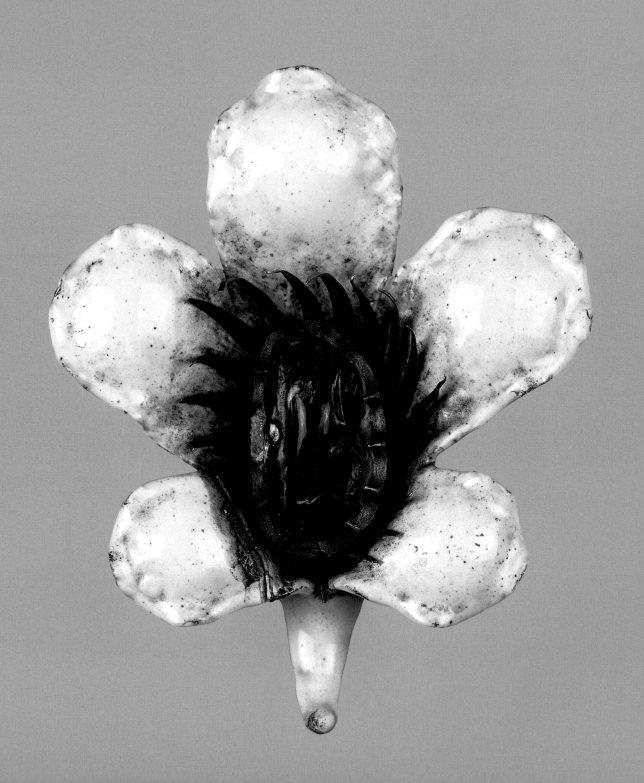

THE ALL SOULS JEWEL

A taste for ornament based on nature was very much a feature of aristocratic fashion in the late fourteenth and early fifteenth century. It corresponded with technical developments in the jeweller's craft that enabled greater three-dimensionality of form. This was effected chiefly by the invention in Paris in the mid-fourteenth century of enamelling in the round, known as *émail en ronde bosse*. *Ronde-bosse* enamel fuses to all the surfaces of the metal and was highly favoured for figurative works such as the Dunstable Swan Jewel (pp. 172–3) and the Waddesdon Holy Thorn Reliquary (pp. 86–7). Along with these outstanding examples, the All Souls Jewel is a rare survival of extant *ronde-bosse* enamel. Its preservation is almost certainly due to the fact that from a very early point after its manufacture, it was retained by All Souls College, Oxford. Records show that it was at the college in the time of John Stokes, the fifth Warden of All Souls, between 1466 and 1494.

The jewel is a brooch made from a single sheet of gold and shaped into a five-petalled flower covered in opaque white enamel. In the centre is an elongated, roughly oval, pale pink gemstone. Analysis has identified this as a pink tourmaline, a stone that did not appear in Europe in great quantities much before the nineteenth century. It is framed by a fringe of thick-cut, curled gold foil, which simulates the flower's stamens. It is likely that it came from the east, possibly Sri Lanka, and that its rarity was appreciated by its original owners. In the fifteenth century it was an established practice among the wealthy elite to set highly prized jewels in the centre of a flower. The custom was international in its appeal and remained current for much of the century. The settings that were chosen are frequently recorded as brooches and may have been worn by men or women. White flower jewels with central coloured stones, similar to the All Souls Jewel, are set into the splendid coronets of two of the three magi in Benozzo Gozzoli's *Adoration*, painted for the chapel in the Palazzo Medici-Riccardi in Florence between 1459 and 1460.

15th century

France or England

On loan from The Warden and Fellows of All Souls College, Oxford University

LENGTH: 5 cm
WIDTH: 4.1 cm

THE SHIELD OF PARADE

Late 15th century

From Flanders or Burgundy

Given by the Revd J. Wilson

HEIGHT: 83 cm

P&E 1863,0501.1

A knight's accomplishments might be demonstrated equally at battle or in tournament and both occupations could be deadly. This painted shield is a rare survival and illustrates the ubiquitous presence of death, even in the most courtly of contexts. The left half shows a fashionably dressed standing woman, while her suitor, clad in armour and pressed forward by the skeletal figure of Death, kneels on the right. Above the knight's head a scroll unfurls, which reads '*Vous ou la mort*' (You or death): the knight would rather die than prove unworthy of his lady's affection.

The lady appears on the shield as an idealized object of desire, whereas the representation of the knight is more individualized and may be a portrait of the patron. The spectre of death hanging over the knight gives the shield the air of a memento mori. Knights appear frequently in the iconography of the Three Living and the Three Dead, a popular late medieval motif that illustrates the invincibility of death by juxtaposing three cadavers with three figures emblematic of youth. As the dead face the living they deliver the sobering sentiment, 'As you are now, so once were we; as we are now, so shall ye be'.

The shield is painted to a high standard and is made from a wooden core covered with hardened leather like a conventional battle shield. However, it was not designed to be used in combat but was created as a display piece, possibly as a prize in a tournament or for use in a parade. Tournaments were bloody affairs and were periodically forbidden by the Church as early as the twelfth century. French kings such as Philip II (1180–1223) argued against them on practical grounds as a waste of resources in terms of both men and horses, and in 1295 the Statuta Armorum in England attempted to establish ground rules to lessen their brutality. A trend for setting tournaments to an Arthurian theme emerged in the thirteenth century as a way of regulating behaviour. They were known as Round Tables and took part on a circular field using only weapons of courtesy, i.e. blunted weapons. The fashion for this type of tournament was still current at the end of the fifteenth century, when *Le petit formulaire* was compiled as a reference guide to staging tournaments in the Arthurian manner.

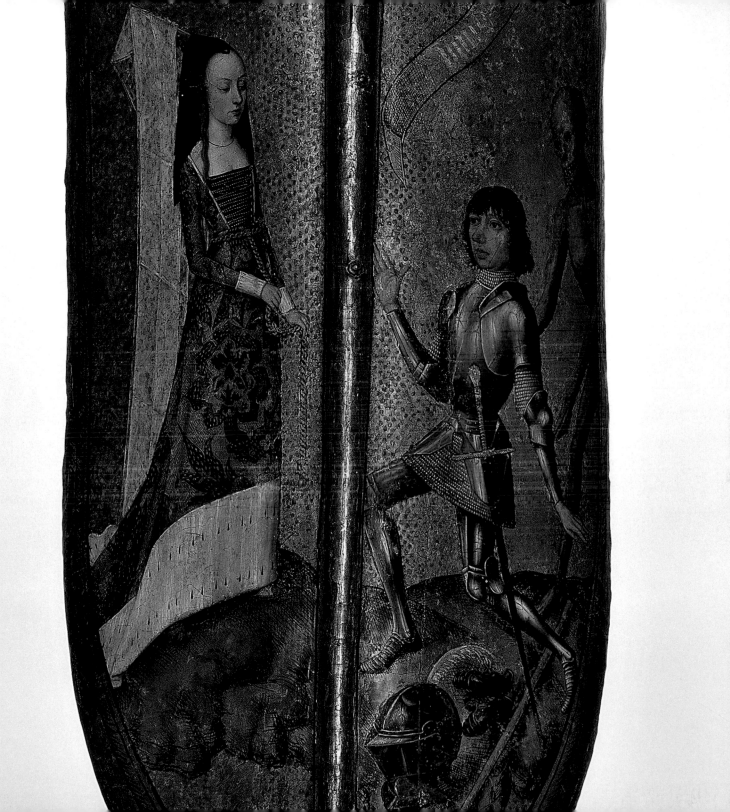

SWORD OF STATE

About 1473–83
Germany and England
LENGTH: 182.3 cm
WIDTH: 40.6 cm (quillons)
P&E SL.17537

Ceremony and ritual were important tools in creating the mystique of medieval royalty. Public appearances were shrouded in a level of pomp commensurate with the presence of the monarch, and appropriate accessories were wielded. This Sword of State is of a size that would always have commanded a response of awe and wonder. Its steel blade was commissioned from Germany, probably at Passau or Sollingen, and bears two marks of a small running wolf. Its hilt is made of copper alloy, which was originally gilded so that the sword would have had a sleek appearance of silver and gold. The quillons, grip and pommel are engraved with black-letter inscriptions along their edges, which are extremely abraded and largely undecipherable. What can be made out is a repeated invocation to the Virgin Mary, which may have been intended as a protective charm. The octagonal pommel contains in its centre a roundel enamelled with the cross of St George; the corresponding cavity on the reverse has lost its setting.

Other surviving champlevé enamels that decorate the grip stand out boldly in red and white and are designed to be viewed with the blade held upright. They are used to denote specific coats of arms among a number that comprise on one side the arms for a Prince of Wales supported by angels, with the arms for the ancient kingdom of north Wales and those for the Duchy of Cornwall; on the other side, arms for the earldoms of March and Chester are juxtaposed with a third shield, as yet unidentified. The heraldry signifies only two possible owners. The first is Edward, Prince of Wales, son of Edward IV, who was made Earl of Chester in 1473, and the second is Edward, son of Richard III, who was given the same titles in 1483. It has been maintained that since the entitlement to use the Sword of State was intimately connected with the role as ruler of the Palatinate of Chester, the sword must relate to that office. It seems not impossible to suppose that this very sword was held aloft before the future Edward V when he visited Chester in 1475.

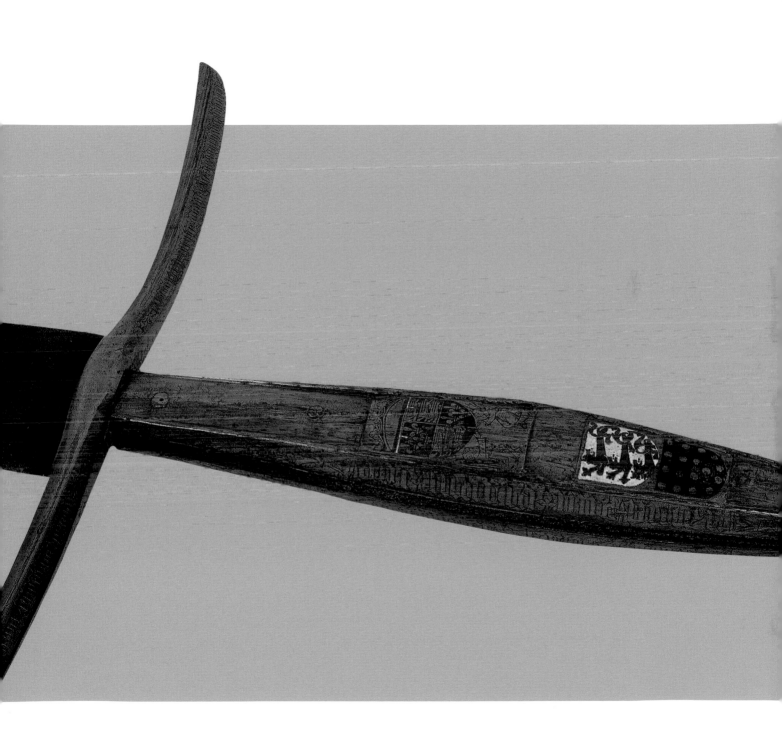

THE DUNSTABLE SWAN JEWEL

Swans were regarded as noble creatures in medieval Europe. When Edward I made an oath on two swans that he would conquer Scotland, he was undoubtedly appreciative of this quality. He may also have been prompted by the story of the Swan Knight of literary romance. Confusion between history and myth reigned in an age that saw, for example, King Arthur included in Geoffrey of Monmouth's *History of the Kings of Britain* (*c.* 1136). Many noble families were eager to demonstrate their descent from the Arthurian knights and other notable mythical heroes such as the enigmatic Swan Knight, who rescued a damsel in distress in his boat drawn by swans.

The Dunstable Swan Jewel was found on the site of a Dominican friary at Dunstable, Bedfordshire. It is likely to have been lost by someone of high status, possibly associated with the De Bohun family or the House of Lancaster. The rich and powerful De Bohuns used the swan as their symbol, and when Henry of Lancaster married Mary de Bohun in 1380 it was adopted by his family. Such jewels were livery badges, which, when worn, would broadcast both familial and political allegiance. Less finely crafted badges would be distributed to all members of the household, including servants. Laws existed to prevent the abuse of livery, which in its worst manifestation could result in the formation of private armies, who behaved little better than brigands. Disputes over the wearing of livery badges erupted during the reign of Richard II (1366–99), whose supporters were accused of being intimidatory and lawless. Richard's symbol was the white hart, the most elaborate representation of which survives on the Wilton Diptych at the National Gallery in London. A description in an inventory of the Treasures of Richard II describes a jewel that resembles the painted example very closely. The same inventory identifies Richard as the owner of a swan jewel too. Richard's swan jewel was smaller than the Dunstable Swan but it was also made of gold, covered in white enamel and with a gold chain around its neck.

The opaque white enamel that covers the Dunstable Swan is known as *émail en ronde bosse*. This technique, which allowed objects to be enamelled in the round by fusing molten glass on to gold, was perfected in Paris around 1400.

Around 1400

France or England

Purchased with contributions from the Art Fund, the Pilgrim Trust and the Worshipful Company of Goldsmiths

HEIGHT: 3.3 cm

WIDTH: 3.5 cm

P&E 1966,0703.1

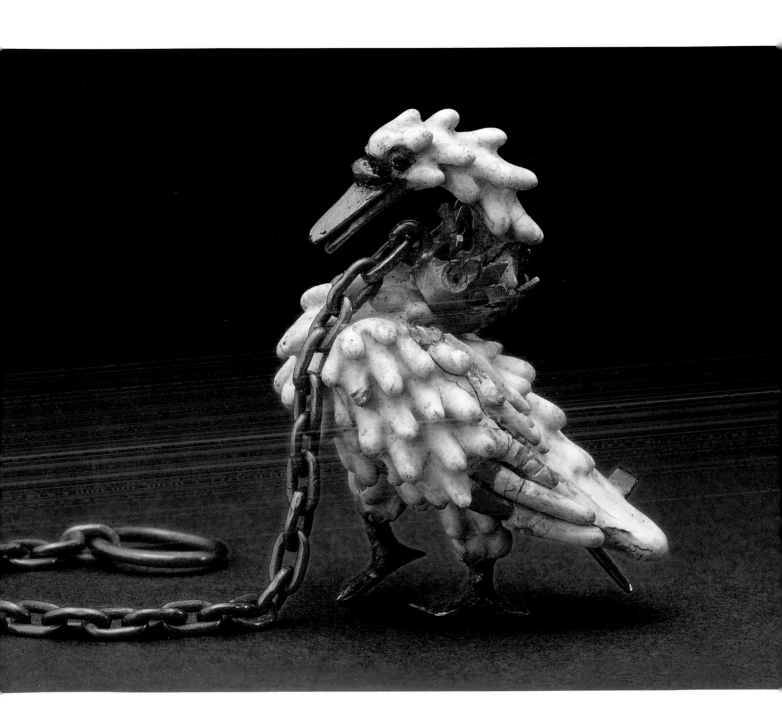

FOUR IVORY TABLEMEN

Tablemen were used in a game resembling backgammon that was popular among the nobility between the mid-eleventh and the thirteenth centuries. Large numbers of expensive tablemen were produced from walrus ivory carved with popular subjects including biblical or mythical scenes, the symbols of the zodiac or representations of animals ranging from the domestic to the exotic and the fabulous.

These tablemen are from a related group formerly owned by the famous Gothic enthusiast and collector Horace Walpole. They were all carved, characteristically, in sunken relief to allow them to be stacked without damaging the detail. There may have been some unity in the subjects chosen for different sets or different sides. This group of tablemen contains real rather than mythical beasts, for instance, with the singular exception of the grotesque hybrid (seen here at bottom right) comprising two winged creatures with faces on their tails, conjoined at the neck by the mask of a man with a heavy moustache. A number of the other tablemen show animals suckling their young: a cow and a calf, a sow and a piglet, a hare and leverets, a mare and a foal, and, shown here (at top right), a goat and a kid. In medieval Bestiaries, the goat's moral value lay in the fact that it was driven always to graze in higher pastures and that it could distinguish between good and bad grass. Here it chews on the vine, which has obvious Eucharistic connotations. No other clear sub-category that could indicate an opposing side emerges from the group. The only conflict-based image is the spirited representation of a cat attacking a rat (top left). The cat's exposed claws and teeth and the twisted sinews of its neck provide the rat with a fierce adversary. There is little hope of escape as its tail is pinned down by one claw and the cat rears up to clench it in its forepaws. The observed naturalism in the depiction of the cat is contrasted with one of the few exotic animals in the group, the elephant (bottom left). The elephant is shown with a howdah containing four people, and is recognizable from this and from its impressive tusks and trunk. Its feet, hindquarters and tail and its minuscule ears, however, confirm the unsurprising certainty that the animal was carved from written or verbal descriptions.

Late 12th century

Cologne, Germany

Given by Sir Augustus Wollaston Franks

DIAMETER: 5.9 cm

P&E 1892,0801.36; 38; 43; 46

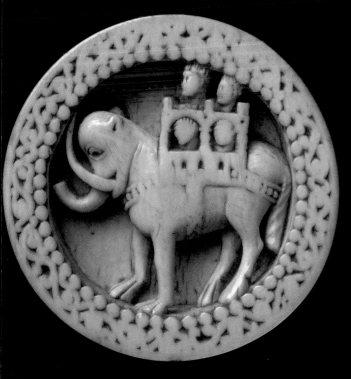
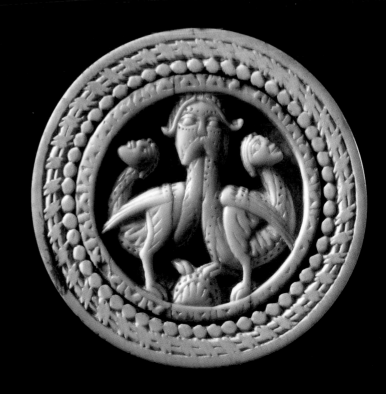

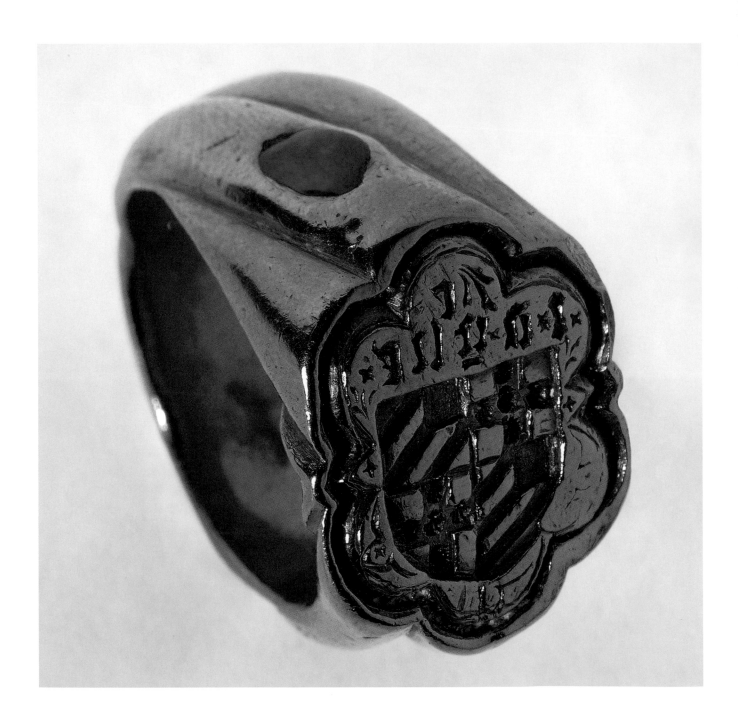

GOLD SIGNET RING WITH THE DE GRAILLY ARMS

The massive proportions of this gold signet ring, combined with the elaborate sexfoil bezel, the heavily wreathed hoop and the rubies set into each shoulder, create what amounts to a high-status statement piece, confirmed by the complex heraldry engraved into the sealing surface of the bezel. Above a shield of arms, individual letters, punctuated by simply engraved crosses, spell out 'e + i + d + g r e'. Read with the heraldry, which relates to the De Grailly family, this has been interpreted as an abbreviation for 'est + Iohannis + de + Gre' ('it is [the seal of] John de Grailly').

Sir John de Grailly, Vicomte de Benanges et Castillon and Captal de Buch, was immensely well connected and enormously wealthy. The captalate of Buch was a title associated with a small town close to Bordeaux, which was considered to be of strategic military importance and was closely allied to the English cause against France. John de Grailly was one of the founders of the Order of the Garter in 1348 and companion in arms of the Black Prince, with whom he fought at Poitiers in 1356 and on expedition in Spain in 1367 (see pp. 196–7). The splendid qualities of this signet ring reflect both the social position of the De Grailly family and the complexities of estate administration. Signet rings proved a valuable tool in sealing private correspondence and in the rapid transactions of business made inevitable by military campaigns.

Late 14th century

France

DIAMETER: 2.5 cm

P&E 1982,0501.1

A GREAT BACINET

Now corroded and missing vital elements of its protective covering, this great bacinet is a fascinating survival of a type of armour that was once both life-saving and cutting-edge. From the early fifteenth century great bacinets were associated with fully articulated plate armour. Mail had provided the predominant means of protection in combat for hundreds of years and could resist the blow of a sword adequately well. However, it was not so effective against the longbow, which shot arrows at such speed that they could pierce the rings forming the fabric of the mail shirt (known as a hauberk). The development of the crossbow signalled the end of mail armour as its bolts achieved speeds four or five times greater even than the arrows of the longbow. The articulated suits of armour were built of separate sheets, each one closely measured and modelled carefully to fit every part of the body. Usually made of steel, the plates were designed to deflect weapons from their glancing surfaces. The great bacinet was originally fitted with a rounded visor, pierced with holes for ventilation and visibility. A keyhole slot at the apex of the skull may have been the means of affixing a crest to the top of the helmet.

That great bacinets enjoyed immense popularity in England is shown by their appearance on a large number of church monuments and brasses. They were worn in battle at least until the end of the Hundred Years War (1337–1453), whereupon they were increasingly used for foot combat in tournaments. Although once considered to be an English product, it is now felt that great bacinets were probably imported from continental Europe. This example has been described as Italian or French, a French origin being argued partly from its unusual findspot of Kordofan, Sudan. French trading interests in the Levant were developed by the celebrated merchant Jacques Coeur, who was arrested on a series of charges in 1451. Among the crimes listed was that of selling arms to the infidel, the Khalif of Egypt. It is not impossible that a transaction of this sort was responsible for the great bacinet's exotic journey. French merchants, however, were also trading in widely exported Italian armour and the most probable place of manufacture for this piece remains Italy.

Around 1430
Possibly Italy
Given by Henry Christy
HEIGHT: 43 cm
WIDTH: 24.5 cm
DEPTH: 26.5 cm
P&E OA.2190

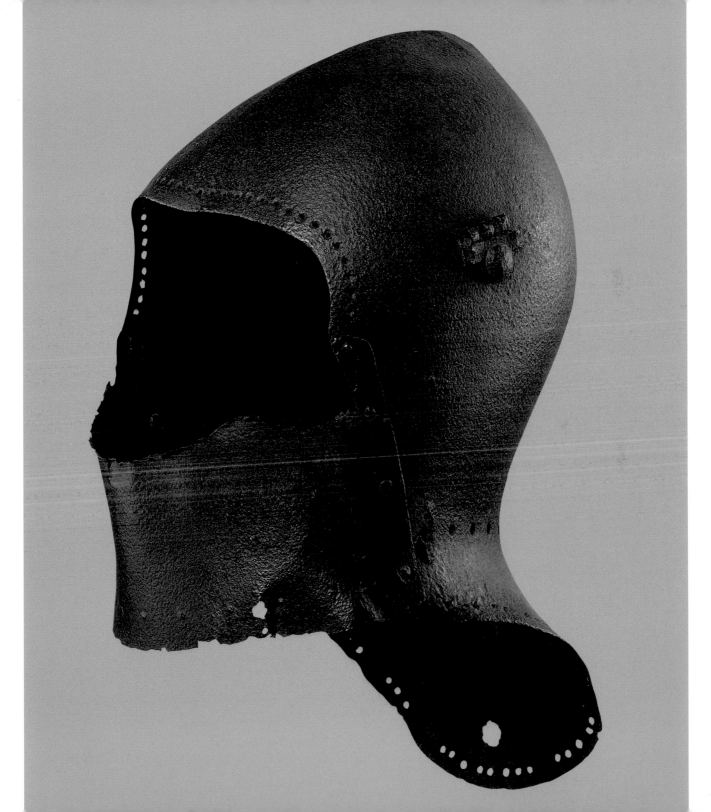

COIN PENDANT USING A GOLD RYAL (ROSE NOBLE) OF EDWARD IV, KING OF ENGLAND

In medieval Europe large and attractive coins were occasionally converted into jewellery. Often the impetus seems to have come from a religious element in the design, since a prominent cross is a feature of so many medieval coins. The significance of the cross is shown by how the coin is set in the mount containing it or by the relevant side of a silver coin being gilded, demonstrating that this was to be the side on view.

This coin pendant appears to be different. The coin it uses was issued by Edward IV in the years 1464–70. Edward became king in 1461, dethroning Henry VI and establishing the Yorkist dynasty, the first fundamental regime change of the Wars of the Roses. Once in power, Edward instituted an overdue coinage reform. Among his changes were alterations to the long-lasting noble, introduced in 1344, with its design of a king holding a shield and sword standing in a ship: 'For foure things our noble sheweth to me / King, ship, and sword and power of the sea', ran a fifteenth-century rhyme. Edward IV enhanced its value from the traditional half a mark (6s 8d) to ten shillings to take account of shifting gold prices. He also amended the design, adding prominent badges of the new Yorkist dynasty he represented: a rose on the ship's side on the front and on the back he virtually obliterated the cross by superimposing a blazing sun and another Yorkist rose to accompany the traditional royal emblems of crown, lion and fleur-de-lis. It was known as the rose noble or ryal.

The new coin was not revived in 1471, when Edward returned after the brief restoration of Henry VI in 1470, but the existing stocks of the coin were popular in England, which the conversion of this example into a pendant seems to reflect. The positioning of the suspension loop is notable. If it were suspended with the reverse showing, the design would be distinctly askew. If the front of the coin were to be on show, it would be upside down. The position of the loops seems to suggest that it was placed so that the coin could be raised up to the face by its wearer. Is it conceivably the memento of a devoted supporter of the Yorkists in general, or of Edward IV personally?

About 1464–83

England

DIAMETER: 4 cm

P&E AF.2772

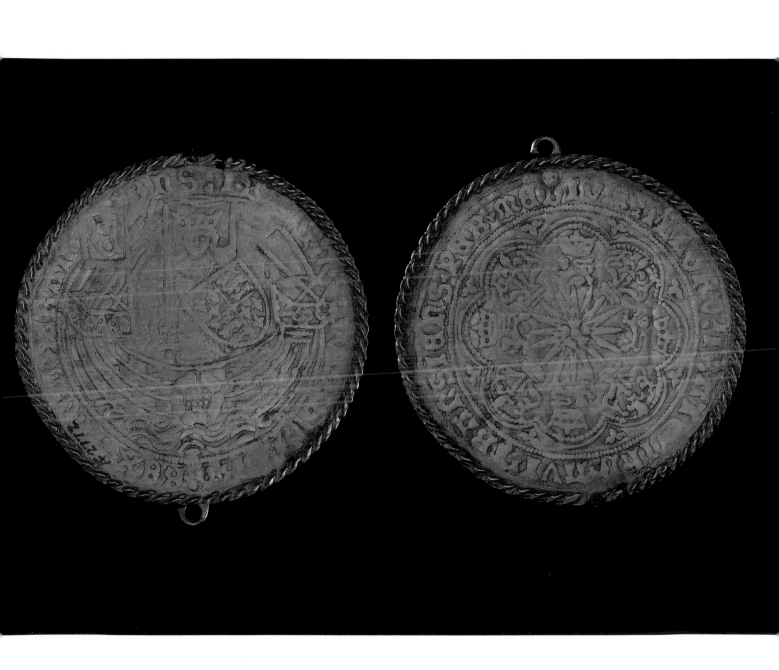

THE KING'S PAVEMENT

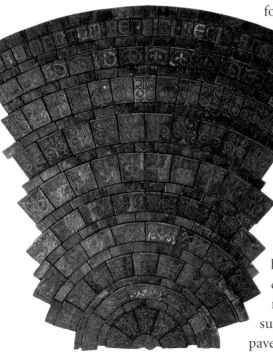

The magnificent large circular tiled floor now known as the King's Pavement originally paved the private chapel built for Henry III at the favourite royal residence and hunting lodge Clarendon Palace. A major new extension was built between 1234 and 1237 for Henry III by the king's master mason, Elias of Dyrham, which included private apartments for the king and queen and a chapel for the king's personal use. On 14 March 1244 a pavement of tiles was ordered 'for the king's own chapel'. The tiles were produced on the site and fired in a kiln that was built nearby specifically for the commission.

The pavement formed the central feature of the chapel floor, and was originally around four metres in diameter. It consists of concentric bands of alternately plain narrow green-glazed tiles and brown tiles decorated with yellow inlaid designs in the form of stylized foliage and fleurs-de-lis. The original inscription around the outermost decorated band is unknown, as fewer than half the letter tiles were found; it has been reconstructed to read 'Pavimentum Henrici Regis Anglie' ('The pavement of Henry, King of England').

The chapel itself was on the upper floor. Many of the tiles were found during excavations near the site of the building in which it was located, and had probably fallen from the first floor when the building eventually collapsed. This segment was assembled from loose tiles augmented by a number of plaster casts. The original innermost decorated band does not survive; that shown is a reconstruction based on a tile from another circular pavement, probably made for Salisbury Cathedral. A piece of plain tile has been used to form the centre of the pattern, as the original roundel does not survive.

The pavement illustrates the importance of royal patronage in the fashion for decorated paved floors in the medieval period. Tiled floors had previously been laid mainly in monastic buildings. The expert tilers who produced this pavement probably came from Normandy, where similar large circular pavements survive from the thirteenth century. They later made circular pavements elsewhere in England and influenced the production of decorated pavements over a wide area.

Around 1244–5
Clarendon Palace, Wiltshire
Given by Major S.V. Christie-Miller
LENGTH: 2250 cm
WIDTH: 2110 cm
DEPTH: 29 cm
P&E 1957,1006.various

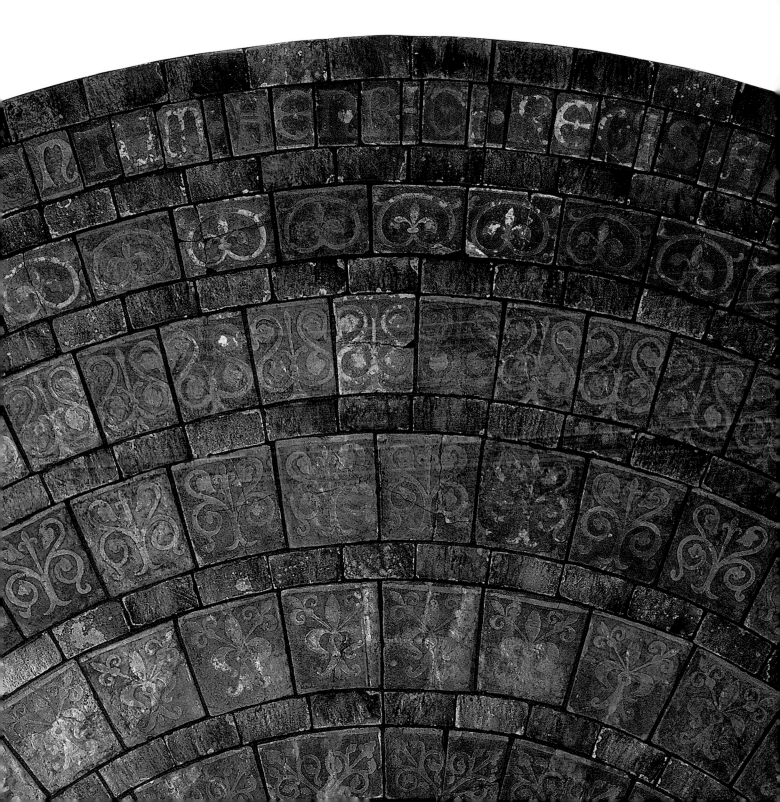

WALL PAINTINGS FROM ST STEPHEN'S CHAPEL, PALACE OF WESTMINSTER

About 1349–62

England

Gift of the Society of Antiquaries of London

HEIGHT: 49 cm (Job);
76.3 cm (Tobit)

WIDTH: 93 cm (Job);
49 cm (Tobit)

P&E 1814,0312.2

'Every part of [St Stephen's] chapel except the polished marble columns and shafts of pedestals was painted and gilded', observed the antiquary Frederick MacKenzie, ten years after the chapel was devastated by fire in 1834. The detailed record made by antiquaries such as MacKenzie allows us to reconstruct some of the chapel's splendour. Their descriptions and engravings are reinforced by these rare survivals of wall paintings, removed from the chapel during building works in 1800, which testify to the superlative quality of the original decoration.

St Stephen's was the royal chapel at the Palace of Westminster. Begun during the reign of Edward I it was deliberately modelled on Sainte-Chapelle in Paris, which it sought to excel in terms of beauty and extravagance. Like Sainte-Chapelle, it was constructed on two levels, the ground floor being used by the royal household and court and the upper floor reserved for the royal family and clergy. The upper chapel was mostly completed under Edward III, who saw it decorated between about 1349 and 1362. The fragments that survive depict scenes from the Books of Job and Tobit. They were arranged in two tiers of four scenes as part of an extensive narrative positioned below the windows of the side walls. Each image is accompanied by a Latin inscription, which explains its significance and identifies its audience as literate and learned.

Expensive pigments such as ultramarine and vermilion were used in the execution of the Italianate-influenced paintings. The dramatically staged destruction of Job's children at a banquet (Job 2:18–19) demonstrates a skilful manipulation of *trompe l'œil* in the slender colonnades that divide the scene to give it depth. An attempt at perspective is also made in the treatment of the table and the objects that furnish the feast. These remarkable fragments are scant survivals of a decorative scheme that may have numbered as many as 160 narratives, accompanied by large-scale figures of angels holding lengths of richly decorated textiles, the imposing figures of thirty-two military saints and representations of the royal family beneath an extensive depiction of the Adoration of the Magi.

PANEL PAINTINGS FROM THE PALACE OF WESTMINSTER

About 1263–66

England

Purchased with the aid of grants
from the National Heritage
Memorial Fund and the Art Fund

HEIGHT: 45.3 cm
(including frame)
WIDTH: 43 cm

P&E 1995,0401.1 & 2

Henry III's state bedchamber at the Palace of Westminster was justly famous in its day. Measuring over twenty-four metres in length by almost eight metres in width, with a ceiling height of around ten metres, it was lavishly decorated and became known by the fourteenth century as *camera depicta*, the Painted Chamber, for the paintings that covered every conceivable surface. The chamber had been gutted by fire in 1263 and Henry set about refurbishing it with gusto. Three hundred oak trees from the royal parks were felled for the repairs and provided material for the reconstruction of the ceiling, which was achieved with great rapidity. Household accounts indicate that it was in place by 1266. These two panel paintings date from this period of activity. They show a prophet with a scroll and a six-winged seraph and were designed to be placed on the ceiling in an ambitious scheme of half figures. The plan may have proved too ambitious since it was never completed and the panels were covered over with the paint barely dry. They remained hidden until revealed by restoration work in 1816. At this time they were removed along with representations of two other prophets: had this not happened, they would have perished in the fire of 1834. The whereabouts of the panels showing the two prophets remain unknown, if indeed they survive.

The rediscovery of the panels established them as probably the earliest existing examples of English panel painting. They are wonderfully well preserved and painted to the exceptional standard appropriate to a royal commission. It has been argued that two hands worked on the panels and that they demonstrate a shift in personnel at the Palace from the court painter William of Westminster to Walter of Durham. The panels certainly convey different emotional qualities: the prophet appears suitably stern with deep creases in his furrowed brow, while the angel beams benignly with the unambiguous curl of a smile about its lips. Henry, it seems, entertained specific views on how an angel ought to be seen, stipulating in 1240 that two sculpted seraphim destined for the chapel of St Peter ad Vincula at the Tower of London should have 'cheerful and joyous countenances'.

SEAL-DIE FOR THE TOWN OF BOPPARD AM RHEIN

The increasing political power of towns in the twelfth century is reflected in the emergence of town seals that imparted some degree of self-governance. In the German territories, the Holy Roman Emperor extended his influence by creating free towns, which were not governed by feudal or ecclesiastical overlords. The legend on this seal for Boppard am Rhein declares it to be a free imperial town. Seals communicated the might of towns in different ways. The importance of sacred benefaction, for instance, figures heavily in the late twelfth- or early thirteenth-century seal for the city of London, which shows, on one side, an over-sized figure of St Paul standing above the London skyline, and, on the other, a representation of St Thomas Becket. Other seals used images of architectural fortification in an unmistakably emphatic way or might employ the device of a ship if the town were also a port. The seal for Boppard uses a number of these conventions to create an image of outstanding beauty.

Architectural seals may additionally offer a recognizable glimpse of the medieval townscape. Boppard's excellently engraved bronze seal-die provides a more or less realistic view of its Romanesque cathedral as it still stands today. The cathedral's ethereal presence appears to soar above the city walls, which recede away into a sketchily defined silhouette. The engraver's management of perspective is admirable as he expresses recession by removing the details of the brickwork in the walls behind the cathedral. However, the fabric of the walls is allowed to dominate the foreground, where it serves as a display of physical strength. The city walls are pierced by a round-arched doorway, which contains a diminutive representation of Boppard's patron saint, St Severus. His name also appears on the walls of the cathedral, which was dedicated to him, confirming the spiritual credentials of the city. On the cathedral's roof an impressive imperial eagle with outstretched wings also broadcasts the town's status.

1228–36
Germany
DIAMETER: 9 cm
P&E 1842,0926.6

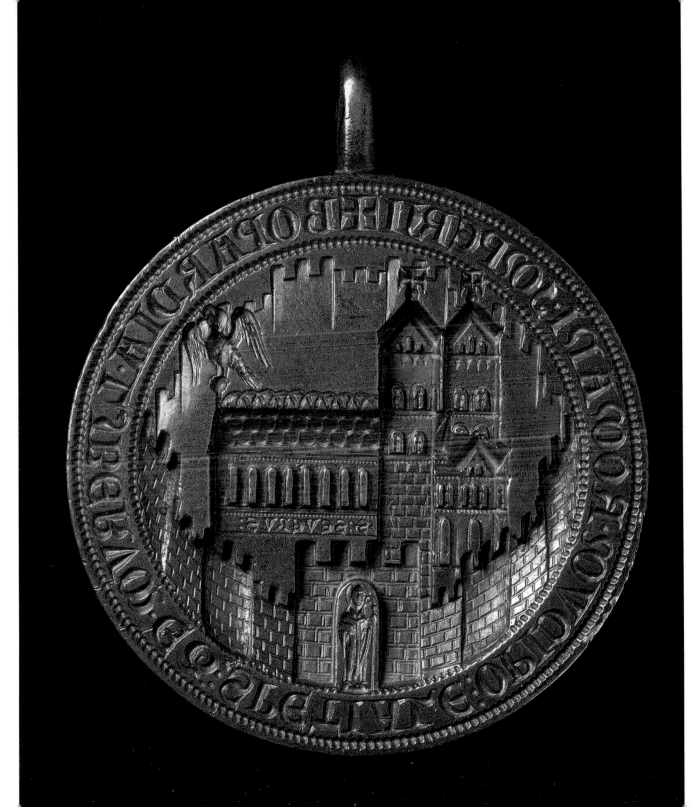

GOLD PAVILLON OF EDWARD THE BLACK PRINCE AS PRINCE OF AQUITAINE

1362–72

Minted in Aquitaine (modern France)

Bequeathed by T.B. Clarke-Thornhill

DIAMETER: 3.3 cm

CM 1935,0401.6560

European coinage was principally silver until the later thirteenth century, when gold reappeared as a monetary metal in Italy. Its use spread along the trade routes of Europe and the major western kingdoms adopted it in the fourteenth century, a trend set by France. In the 1340s it was introduced both in England itself and its territory of the duchy of Aquitaine, centred on Bordeaux.

These gold coins were large and impressive, in part owing to the fact that the English monetary units of pound and penny were unusually high value in European terms. However, there was another factor. Long-standing disputes between the English and French kings over exactly how Aquitaine fitted into both their kingdoms came to a head in the 1330s. An exasperated Edward III put forward his claim to the French throne, which had been in the air following the extinction of the direct French royal line in 1328. This was potentially a way of solving the Aquitaine issue, as a negotiating tool if not a realistic ambition. His splendid gold coins of the 1340s in England and Aquitaine proclaimed his new title: 'King of England and France'.

Few would have foreseen the resulting conflict turning into the Hundred Years War (1337–1453). After one of the great English triumphs, the Battle of Poitiers, brought John II of France into English hands, a new settlement was negotiated. An expanded Aquitaine no longer owed any allegiance to the French king. In 1362 Edward III invested his son Edward the Black Prince, victor of Poitiers, with Aquitaine. He issued a range of coins in his own name, of which the pavillon was the most common as well as the most magnificent, due to its large size and intricate design. The inscription names the prince as 'Firstborn son of the king of England' (P[RIM]OG[E]N[ITUS] REG[IS] ANGL[IE]) and 'prince of Aquitaine'. The coin's name arises from the image of the prince standing beneath a Gothic portico or canopy. He holds a sword in one hand, and points at it with the other, while two heraldic English leopards rest at his feet. In the background are four ostrich feathers, formerly the emblem of King John the Blind of Bohemia, and reputedly adopted by the Black Prince after the former's heroic death fighting on the French side at the Battle of Crécy.

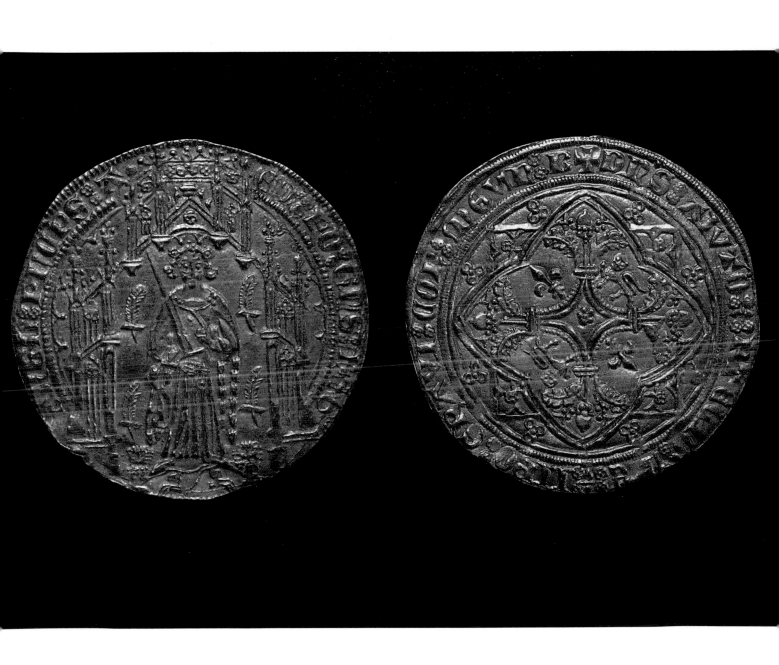

SEAL-DIE OF ISABELLA OF HAINAULT

Medieval royal seal-dies rarely survive, as it was customary to destroy them upon the death of a monarch for reasons of security. Seals represented financial power and were generally attached to documents relating to the disposition of land or wealth. An alternative way of voiding the seal-die was to inter it with the owner. This extraordinarily beautiful seal-die was buried with its owner, Isabella of Hainault, when she died in childbirth in 1190 at the age of twenty-one. It was discovered in her coffin during building works at the cathedral of Notre-Dame in Paris in 1858. Isabella was the wife of Philip II of France (r. 1179–1223), whom she married at the age of eleven, when he was fifteen. In her short life Isabella's seal had little opportunity to see much use, but she would have employed it in the despatch of affairs connected with her household.

Queens and noblewomen were generally represented on their seals as standing figures. This convention dictated the form of the seal, which is usually a pointed oval, known as a vesica. The iconographic model used was adapted from that of the Virgin Mary. Marian worship was influenced by notions of medieval queenship. The Virgin Mary was perceived as maid, mother, consort and queen. As queen of heaven she set the standard for royal behaviour. The intercessory role of medieval queens was undoubtedly inspired not just by the diplomatic nature of their marriages but by the sacred model presented by the Virgin Mary. Here Isabella stands crowned, holding a sceptre in one hand and a fleur-de-lis in the other. The fleur-de-lis is at once a symbol of France and the Virgin Mary. The engraving is of the highest quality and shows a masterly approach to the modelling of anatomy and drapery. Isabella's cloak is drawn tightly around her to reveal a knee brought forward as her stance assumes a gentle, if not entirely convincing, contrapposto, which may be as classically inspired as the robes she wears.

1180–90

Paris, France

HEIGHT: 9.6 cm

P&E 1970,0904.1

SILVER-GILT CASKET WITH THE ARMS OF ISABELLA OF FRANCE

The miniature dimensions of this elegant casket appear at odds with its status as an object loaded with regal significance. However, its size is entirely in keeping with the nature of the gift it constituted. The heraldry on the front of the sloping roof of the casket belongs to Isabella of France, daughter of Philip IV and wife of Edward II. Isabella was betrothed to Edward in 1303 when he was Prince of Wales and she was a child of about seven years old. Their betrothal was a purely political affair and was conceived as a double union to forge a lasting peace with France. As part of the process, Edward I had married Margaret, the half-sister of Philip IV, in 1299. The arms on the other side of the casket belong to Margaret. The choice of heraldry and its positioning suggest that the casket may have been given to Isabella by Margaret at the time of her betrothal or on the occasion of her marriage, which took place at Boulogne in 1308. When Isabella married she was still only twelve years old. The small scale of the casket is perfectly suitable for a gift to a child bride.

The casket is made of silver-gilt and takes the house-shaped form favoured by shrines and reliquaries. This architectural element is amplified by the lancet windows decorating the sides. The exterior surfaces, beautifully sober as they appear now, would probably have been richly enamelled. The application of colour would have provided a jewel-like preciousness to the casket but would have also made the heraldry fully understandable. Inside the casket are marks left by the removal of two inserts, which would have created three separate compartments. This arrangement is most usually made for the containment of holy oils in chrismatories and the casket may have served this purpose. Equally it may have contained the precious gifts that were routinely passed within and between aristocratic families. Tiny rings and brooches survive in sufficient numbers to indicate that expensive gifts of jewellery to children were not uncommon. Such items are of a size that would be comfortably accommodated in this diminutive casket.

About 1303–8

England

HEIGHT: 6.9 cm
LENGTH: 8.3 cm
WIDTH: 4 cm

P&E 1872,1216.1

FUNERARY BADGE OF EDWARD THE BLACK PRINCE

In its manufacture, this badge relates closely to those produced as souvenirs of pilgrimage at different sites throughout medieval Europe. However, it was made not to commemorate a pilgrimage, but as a memento of a very specific event. In 1376 the heir to the English throne, Edward of Woodstock, Prince of Wales, died prematurely at the age of forty-five. Edward is more famously known as the Black Prince, a military hero and a paragon of chivalric virtue. In 1344 his father, Edward III, named his young son one of the founding members of the Order of the Garter. Edward went on to distinguish himself in campaigns in France, most notably at the Battle of Crécy in 1346, when he was only sixteen years old, and in 1356 at Poitiers, where he captured the French king John II. However, Edward died not on the field of battle but at the Palace of Westminster from an unidentified sickness, which he may have contracted nine years earlier while on expedition in Spain.

Edward stipulated in his will that he wanted to be buried at Canterbury Cathedral, a place made sacred by the shrine of St Thomas Becket. The veneration of Becket at Canterbury stimulated the production of an unparalleled variety of souvenirs and it is extremely likely that badges for Edward's funeral were made there. The badge represents Edward kneeling before an image of the Holy Trinity. Above his head, an angel emerges holding a shield bearing his arms while another angel stands behind with his leopard-crested helm. The composition is framed by a representation of the Garter, which is inscribed 'hony sout ke mal y pence' ('honi soit qui mal y pense'). This motto, meaning 'shame on he who thinks evil of it', refers to the validity of English claims to territories in France. The Order of the Garter was founded principally as a means of upholding these claims through an allegiance of powerful magnates, although it was propelled by a notional desire to revive the tradition of a noble order of knights first established by the mythical King Arthur.

Around 1376
England
LENGTH: 13 cm
WIDTH: 8.6 cm
P&E OA.100

THE RICHARD II QUADRANT

Richard II's use of the white hart badge is famously documented in the chronicle *Historia Vitae et Regni Ricardi Secundi*, which attributes its adoption to the Smithfield tournament in October 1390. It is most strikingly represented in the Wilton Diptych at the National Gallery, London, but it was used widely by Richard as a mark of ownership on other objects such as the Asante Jug (pp. 242–3) and this quadrant. The white hart is engraved in a roundel on the front of the quadrant, where it is shown couchant with its customary coronet and chain around its neck.

A quadrant such as this would have been a prestigious object for a king or nobleman, combining practical utility with an attractive design. It is one of a group of three closely comparable instruments, one of which, at the Dorset County Museum in Dorchester, is dated 1398 and is likely to have been owned by John Holland, half-brother of Richard II. This instrument is dated 1399, the year of Richard's untimely death. Indeed, a surviving inventory of the treasure at the Tower of London compiled in November 1399, after Henry IV had taken the throne, contains a reference to a horary quadrant, specifying its weight as '5 troy ounces', which is very close to the weight of this instrument.

A horary quadrant enabled its owner to tell the time from the altitude of the sun, and this quadrant, like the 1398 one, features a table of solar altitudes calculated for latitude 52 degrees, or around London. In addition there is a table of Dominical Letters, which mark the first Sunday in the year and are used to calculate the date of Easter. Further significance relating to Easter is seen in the enigmatic inscription ':pri .3. di .3. pascha fi:', a mnemonic for finding the date of that feast, the full version of which usually reads 'Post . Epi . pri . pri . pri : dy . dy . dy . pascha fi'. When expanded this reminds the reader that Easter is the third Sunday after the third new moon after Epiphany.

1399
England
RADIUS: 9 cm
P&E 1860,0519.1

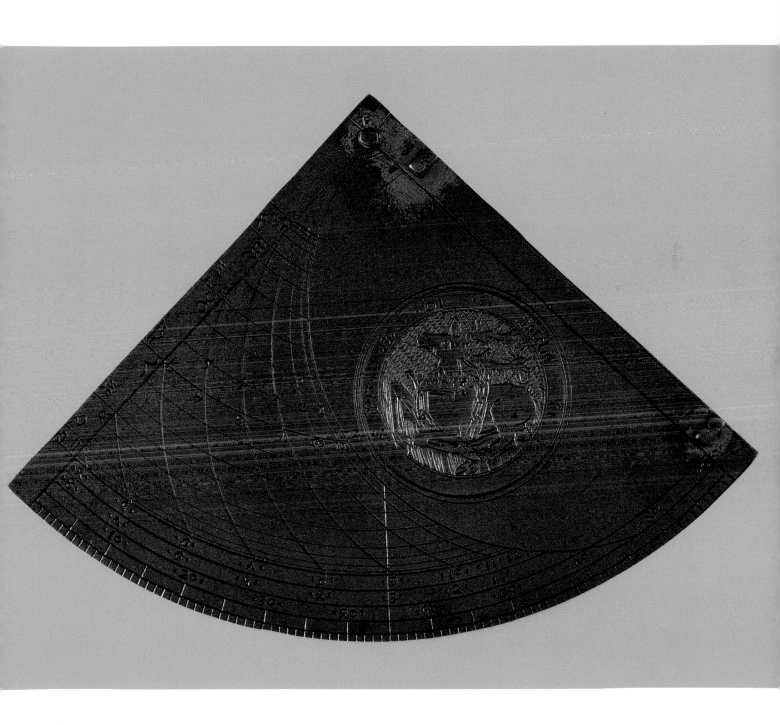

THE 'TALBOT' CASKET

When new, the embossed surfaces of this leather casket were painted so that its dense design was clearly legible. Inserted in its base is a painted silk showing the 1st Earl of Shrewsbury, John Talbot, and his wife in 1470. The casket derives its name from this nineteenth-century painting, but there is no firm evidence to suggest that it was associated with the family before 1860. Remarkably the casket combines, without any apparent tension, scenes of a sacred and secular nature. Its exterior surfaces are alive with incised scrollwork, enigmatic hybrid creatures and cavorting lovers. Six figures on the lid disport themselves in a game known as 'hot cockles', whereby a willing victim was vigorously spanked until identification of the attacker released him from his plight and rewarded him with a kiss (see pp. 226–7). To modern sensitivities this seems strangely at odds with the representation of the Annunciation that decorates the inside of the lid.

The Annunciation is undoubtedly the chief glory of the casket. Its preserved paint picks out the subtle design in red, green, yellow and blue. The surrounding marginal scrollwork occupied by birds is graceful while the management of perspective is masterly. The tiled floor on which the Virgin stands, the recently vacated chair and the elaborate architecture of the canopy equally testify to the leatherworker's skill. The archangel Gabriel approaches through a porch, the speed of his arrival expressed by his wings and his bent right leg, which both intrude into the margin. The placement of this scene inside the casket offers it separation from the romantic activities illustrated on the external surfaces.

However, the veneration of the Virgin functioned convincingly within the conventions of courtly romance, and the inclusion of this sacred scene was undoubtedly meant to heighten the courtly appeal of the casket rather than to supply any negative comment on the nature of love. A further allusion to the Annunciation is made by the Latin inscription that surrounds the lid, which is taken from the salutation of Gabriel, a popular charm recited as protection against thieves.

Late 14th century

Flanders

Purchased with donations from the Pilgrim Trust and the Art Fund

HEIGHT: 12.5 cm
LENGTH: 25.5 cm
WIDTH: 19 cm

P&E 1977,0502.1

A PAIR OF WRITING TABLET COVERS

From the first quarter of the fourteenth century, a large number of luxury goods was produced in the ivory workshops of Paris. Over the preceding century the artists responsible for caskets, combs, mirror cases, knife handles and writing tablets had become well versed in their skills through the carving of religious scenes on diptychs and triptychs. The subject matter that decorated these new products was predominantly secular and was drawn from Romance literature, exotic and ancient fables or daily aristocratic pursuits (see pp. 206–7 and 216–17).

Ivory writing tablets were accommodated in leather cases, which contained a cavity for a stylus. They were usually bound between two carved covers and were recessed on both sides to receive a wax coating into which writings or sketches could be incised with the stylus. The reverse sides of the covers were recessed in a similar way for the same purpose. The usual means of connecting the separate leaves was by the use of a thong threaded through holes in the corner of the panels. This pair of writing tablet covers is not pierced, however, and was probably bound by a glued parchment spine, a technique employed in a set of tablets at the Victoria and Albert Museum, London. They are carved with activities exclusively enjoyed by the courtly elite. On the left panel, a couple enjoys the intimacy of falconry, a sport that had strong romantic connotations in the medieval calendar as the occupation for the month of May. This is a stage in courtship that precedes the next scene and may have been intended to serve as the front cover. The panel on the right shows an exchange of favours as the couple decorate crowns with roses, the flower of submission. The lover kneels before his lady and hands her a rose, which she accepts. In the background a squirrel, a symbol of lust, scampers along the branch of a tree and may serve as a further indication of the advanced state of the relationship (see pp. 218–19).

Early 14th century

France

HEIGHT: 11.5 cm

WIDTH: 10.6 cm

P&E 1856,0509.2

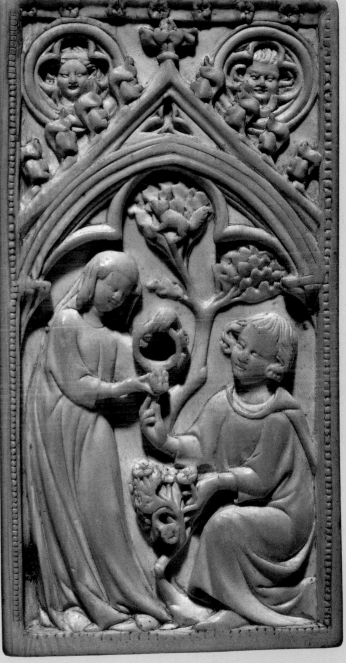

TRISTRAM AND ISOLDE TILES

The tale of the adulterous love between the knight Tristram and his uncle's wife Isolde (see pp. 208–9) was immensely popular at the English court. The elaborate series of floor tiles decorated with scenes from the story was found in the Chapter House at Chertsey Abbey, but was probably commissioned originally for one of the royal residences of Henry III, possibly the Palace of Westminster, and only afterwards used at Chertsey. The tiles depict the story in more than thirty scenes, emphasizing the knight's heroic exploits. This scene shows the crowned figure of King Mark kissing his nephew, Tristram. The image is a dramatic illustration of the bestowal of the feudal kiss, a symbolic ritual signifying an oath of fidelity sworn to the lord by the vassal under his protection. However, in this context it also foreshadows Tristram's eventual betrayal of Mark, through his illicit love for Isolde, and the final tragic outcome.

The story depicted on the Chertsey tiles corresponds to an early version of the romance by the Anglo-Norman poet Thomas of Erceldount, composed between 1170 and 1200. It is likely that the pictures were based on cartoons or drawings by one of the king's painters, probably derived from manuscript illustrations. The circular band surrounding the roundels contained either dragons, as seen here, or inscriptions relating to the narrative. The names of Tristram, Mark, Morhaut and Morgan, all characters in the story, appear on some of these tiles, and would have identified many of the scenes. The inscriptions are in French, in an English or Norman dialect, and were intended for a literate audience at the court of Henry III.

The inlaid decoration on the Chertsey tiles is the most beautiful and elaborate to survive from the medieval period, and was carried out with superlative skill. The Tristram tiles were probably made slightly later than the combat series (see pp. 266–7), as the complexity of manufacture has been reduced. The roundels were fired in one piece rather than four, and were set into square frames fired in four sections, rather than a mosaic background. Artistically and technically, the tiles are remarkable, and are superior to the work of any other medieval tilers known in either France or England.

About 1260s–70s

Chertsey Abbey, Surrey

Given by Dr H. Manwaring Shurlock

HEIGHT: 41 cm
WIDTH: 41 cm

P&E 1885,1113.8903 and various

IVORY MIRROR-BACK

In the late medieval period hunting was a central feature of aristocratic identity. It was an exclusive activity, which provided a forum for flirtation and romance. May was the traditional month for lovers and hunting scenes were generally chosen to illustrate that month in the medieval calendar. Falconry was practised by both sexes and the intimacy it invited is demonstrated by this ivory mirror-back carved with the scene of a couple out hunting. They ride side by side filling most of the frame as their two horses overlap in a jumble of legs. A valet with a spear follows behind on foot. However, the focus of the composition is not the hunt itself but rather the implicit communication between the two lovers,

About 1325–75
Paris, France
DIAMETER: 9.7 cm
P&E 1856,0623.103

who gaze intently at each other. Their physical proximity is emphasized by the overlapping forms and by the constrained space they inhabit. The fashionable hunting clothes they wear and the falcons they hold are mere accessories in their pursuit of love.

Mirror cases were among the luxury items produced by the ivory workshops of fourteenth-century Paris. They were made in pairs, which were hinged and operated in a way similar to the modern compact. The enthusiasm of nineteenth-century collectors meant that most were separated for sale and it is rare for a complete mirror case to survive. The reflective surface that was inserted into recesses on the internal face of the mirror was made of polished metal rather than glass. They were produced for the same privileged, aristocratic market that enjoyed the pleasures of the hunt and their iconography drew upon the leisured activities of the nobility or the world of literary romance. Four floppy-eared wyverns travel in rotation around the edge of this mirror case, effectively serving as marginal decoration. Other mirror cases use grotesques or lions to provide the same contrast with the scenes of elegance and beauty that they surround.

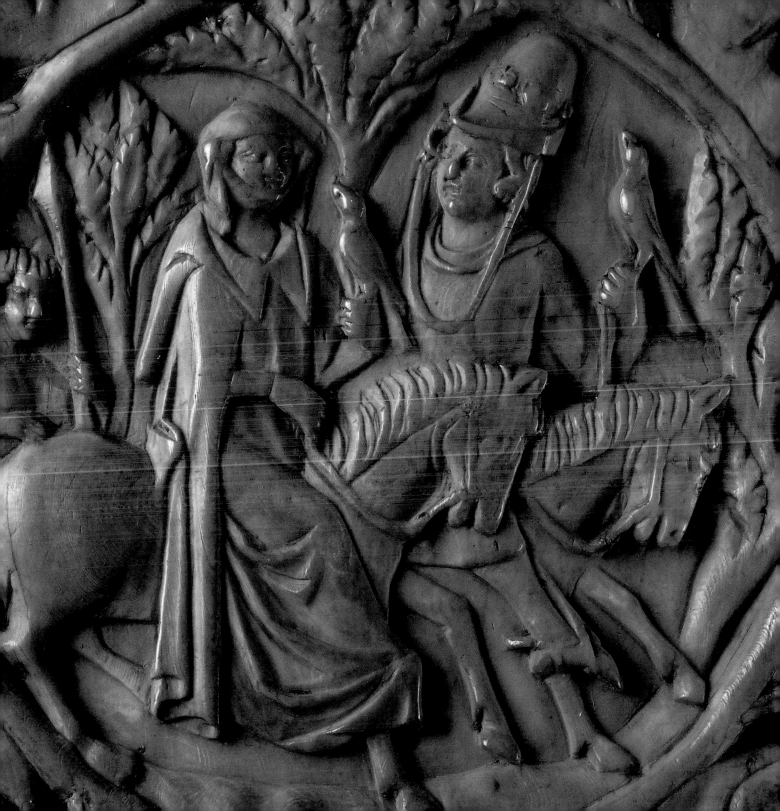

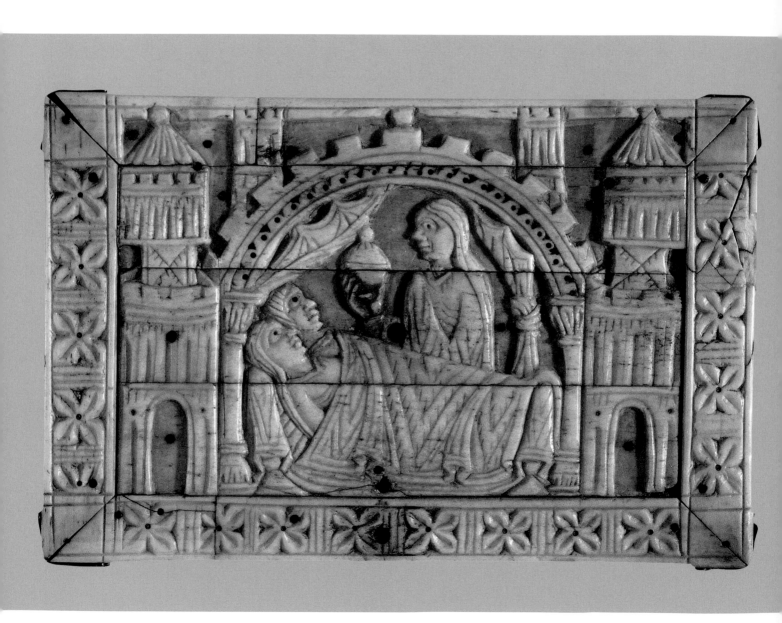

BONE CASKET CARVED WITH SCENES FROM TRISTRAM AND ISOLDE

1180–1200

Probably from Cologne, Germany

Given by the Art Fund

HEIGHT: 9.3 cm
LENGTH: 14.3 cm
WIDTH: 9.5 cm

P&E 1947,0706.1

One of the greatest dilemmas of the medieval chivalric code is perfectly encapsulated by the tragic story of Tristram, an exceptionally virtuous and accomplished knight, who falls in love with his uncle's wife, Isolde. His uncle is Mark, King of Cornwall, who deserves Tristram's fealty on both a familial and a feudal level, while Isolde is a woman eminently worthy of a knight's amorous attentions. Andreas Capellanus, writing around the time this casket was made, recommended that a male lover should seek the favours of a socially superior woman, since it would debase him to love an inferior. He added that true love could only exist out of wedlock because a married woman loves her husband solely from duty. The tensions and dramatic consequences of the pursuit of this philosophy are developed in several Romance stories from the eleventh century onwards.

Oral versions of the story of Tristram and Isolde were probably recounted long before it was committed to writing. Scenes omitted from the manuscript sources may have been selected to decorate parts of this casket as only the carving on the lid can be linked with any certainty to the narrative. The two ends appear to convey elements of the story with the figures of Tristram and Isolde on the right end and Mark and Isolde on the left. The front shows two sets of couples within arches and the back shows knights in a similar arrangement. The scenes were probably

chosen to balance one another in the development of a theme, perhaps the power of love. The knights act as an embodiment of military strength but are typically powerless in love. Isolde knows it is her duty to love Mark but is irresistibly drawn to Tristram. The futility of resisting their attraction to one another is compounded by the accidental consumption of a love draft. On the lid of the casket, Isolde's maid, Brangwain, is shown with a covered cup that contains the potion as Tristram and Isolde lie in bed. The circumstances around this fateful mistake vary from story to story but the detail helps to exonerate the lovers in their plight as helpless victims while, at the same time, sealing their destiny.

CASKET WITH TROUBADOURS

Dancers, musicians, hybrid beasts and lovers populate the surfaces of this remarkable casket, the earliest surviving secular piece produced by the enamel workshops of Limoges. The front of the casket is charged with sexual imagery drawn from medieval love poetry and fuelled by the revealing fashions of the day. The tight costumes of the couples cling to their thighs, arms and breasts in a way that would have been highly provocative to a medieval audience. Flowers and birds punctuate the proceedings and suggest that the season is Spring, the time for love. The flowers, turgid with expectancy, are all still in bud, with one exception which bursts into bloom between the pair on the right. This may express the advanced state of their relationship as the gesture that defines them implies: the male figure, in a pale blue tunic, kneels in submission to the female who wears a green robe; she restrains him with a leather halter, normally used in falconry, while he joins his hands in the traditional pose adopted by a vassal to his lord; in her other hand she carries a falcon, a symbol of the lover's desire, making clear the control she exerts in the game of love.

The seductive power of the male appears on the left of the casket as a man in a green tunic plays a rebec and a woman dances to his tune. The bird that flits between them sports the same colours worn by the woman and, according to poetic convention, expresses the male's sexual longing. The fact that the two dominant figures on both sides of the casket wear green may also be significant. Green was the colour associated both with springtime and with hunting and may be used here to express the power of nature.

A fifth, enigmatic figure occupies the centre of the casket, dividing the pairs of lovers. He undoubtedly participates in the programme of sexual symbolism as he positions himself beneath the clasp, holding a key to the lock in one hand and a sword in the other as if prepared to defend the casket's contents. The horn he wears around his neck equips him with the means of sounding the alarm if his charge is endangered.

About 1180

Limoges, France

HEIGHT: 11 cm
LENGTH: 21.1 cm
WIDTH: 15.6 cm

P&E 1859,0110.1

THE LOVERS' BROOCH

Sapphires and rubies are set alternately on this beautifully textured brooch to create a pleasingly controlled colour combination of reds and blues against gold. The spaces between the gems are decorated in a similarly alternate fashion with punched crosses and Lombardic letters. The letters are not easily legible but read '++++I O S ++++V I I ++++ E N ++++ I E'. Their mysterious meaning is perhaps revealed when the brooch is turned over. On its reverse is an inscription written in Old French and inlaid with niello: 'IO SVI ICI EN LIV DAMI AMO', which may be translated as 'I am here in the place of a friend I love'. The two inscriptions share enough letters in the same sequence to express the same sentiment. The version on the front of the brooch is either abbreviated or it was a mistake which the goldsmith tried to cover up by camouflaging the letters with the punches that surround them. Through its inscriptions, the brooch speaks ('I' the brooch 'am here' etc.) and is placed firmly in the context of romantic love. This charming convention is a characteristic of medieval jewellery, which in the case of lovers' tokens brings with it a certain implication of intimacy. The inscription is secret, not visible to the onlooker, and is worn against the lover's breast.

The giving of gifts was an important aspect of aristocratic love making. One of the most influential love theorists of the medieval period, Andreas Capellanus, writing in the late twelfth century, itemized what was appropriate for a woman to receive from her lover, including 'a handkerchief, a hairband, a circlet of gold or silver, a brooch for the breast'. The exchange of gifts indicated a serious attachment and sometimes had serious consequences: in 1314 Isabella, the young wife of Edward II, was called as a witness in the trial of her three sisters-in-law. Gifts which she had made to them, and which were passed by them to their lovers, were cited as evidence of adultery. The three women were found guilty and imprisoned; their lovers were publicly disembowelled.

13th century

England

Bequeathed by Sir Augustus Wollaston Franks

DIAMETER: 3.8 cm

P&E AF.2683

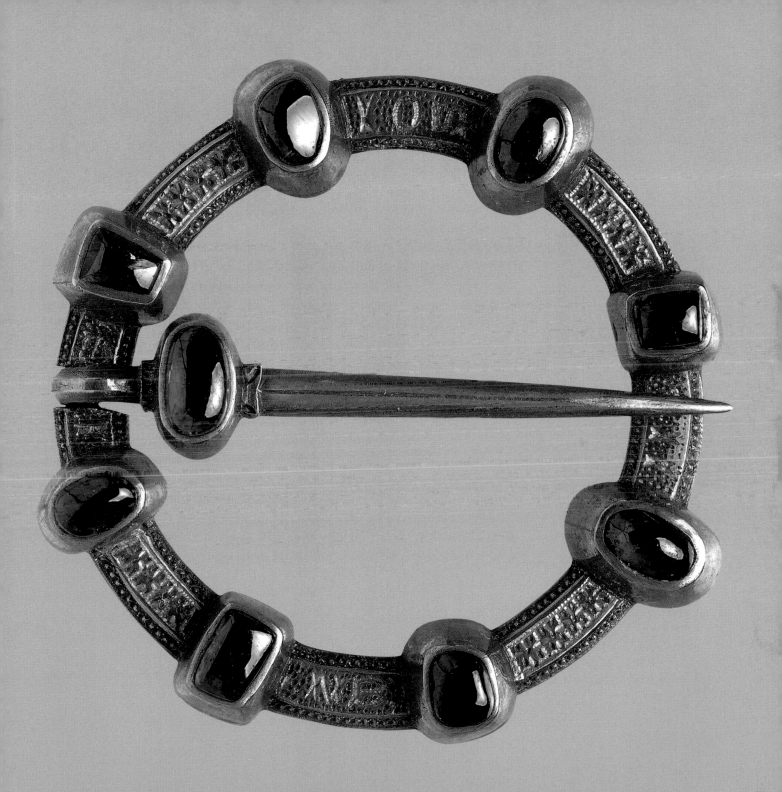

CITOLE

1280–1330

England

Purchased with the assistance
of the Art Fund and the
Pilgrim Trust

LENGTH: 61 cm
WIDTH: 18.6 cm
DEPTH: 14.7 cm

P&E 1963,1002.1

Music occupied an extremely important place in medieval religious worship. Evidence of the hymns that were sung at Mass survives in beautifully illuminated manuscripts of sheet music. However, the music that was enjoyed by the wealthy as part of their daily ritual of pleasure is barely known to us. The citole is a rare survival and offers a unique insight into the splendour that surrounded musical performances in a secular setting. Details of the court of Edward II, King of England from 1307 to 1327, reveal how much he delighted in the company of minstrels and it is tempting to identify this regal instrument with his reign. It may certainly have been commissioned by a king or queen and may have remained in royal ownership until the time of Queen Elizabeth I (1558–1603). A silver plate above the peg-box is engraved with the arms of Elizabeth and her lover, Robert Dudley, Earl of Leicester. At this time it was converted to use as a violin with the addition of a new soundboard.

The citole was made as a strumming instrument to provide rhythm and was usually played with other instruments, probably in the performance of love ballads. The images that decorate its sides, neck and part of the back are redolent of medieval adventure. The denseness of the deep, dark forest is picked out with remarkable regard to detail. Oak, hawthorn, vine and mulberry leaves are all identifiable. Miniature hunting scenes animate the body of the citole as men and dogs give chase to rabbits, foxes and deer. The observation of the known world is combined with a record of the imaginary. A centaur joins in the hunt with other hybrids while the forest scene itself seems to spring from the mouth of a dragon that curls around the finger hole.

Hunting was generally associated with the month of May, which was considered a time for lovers. However, the citole offers an alternative season in the figure of a swineherd knocking down acorns to feed his pigs. This was the traditional labour for November and December as the animals were fattened for Christmas. Both points in the calendar afforded plenty of opportunity for feasting and musical celebrations.

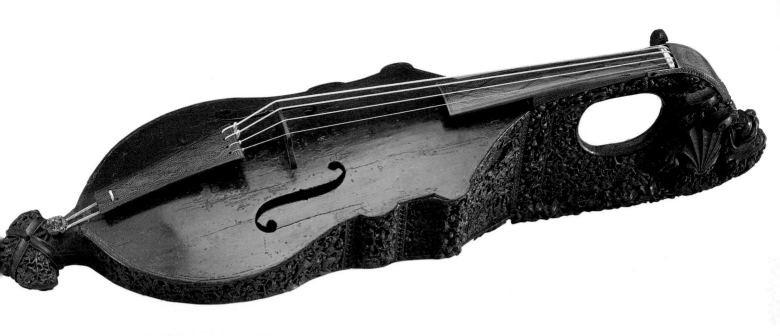

IVORY CASKET WITH SCENES FROM THE ROMANCES

The dominant image on the lid of this casket is a joust. However, in the background a castle is besieged by knights and protected by maidens, who attempt to repel them with roses, the flower of submission. The episode is known as the Assault on the Castle of Love and first appears in pictorial form in the Peterborough Psalter (1299–1328). The scenes that decorate the casket are drawn from a repertory of Romance tales designed to instruct and amuse an aristocratic audience. Themes such as lust and chastity, folly and wisdom are juxtaposed in a series of non-connected scenes.

The story of Aristotle and Phyllis appears on the front of the casket. The Greek philosopher Aristotle warns the young Alexander the Great to beware of women and to concentrate on his studies. However, when Aristotle meets Phyllis, the object of Alexander's affections, he falls in love with her too. She rejects him but asks to ride around the court on his back, like a horse. He complies and Alexander witnesses the humiliation. This scene is paired with the Fountain of Youth, which

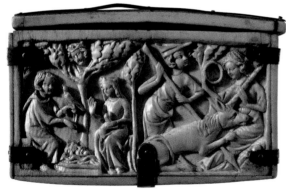

1325–50
Paris, France
HEIGHT: 7.3 cm
LENGTH: 21.2 cm
WIDTH: 12.7 cm
P&E 1856,0623.166

shows the elderly bathing in a magical fountain to have their youth restored. The two scenes operate as a joke on age and desire. On the left side of the casket, Tristram and Isolde are spied upon by Isolde's husband, King Mark. Seeing his face reflected in a fountain, they change their conversation and escape detection. This scene is combined with an image of the unicorn and the maiden, placing lust alongside chastity. Unicorns were believed to surrender to virgins, allowing hunters to trap them. On the right end, in an isolated scene, Galahad the virgin knight receives the key to the castle of maidens.

The reverse of the casket is decorated with tales of Gawain and Lancelot. Interestingly the carver has made a mistake. When Gawain occupies the magic bed, spears rain down on him and he protects himself with his shield. However, in this instance, the spears also rain down on Lancelot as he crosses the sword bridge. Since the same mistake occurs on more than one casket it may suggest that the craftsmen were not completely familiar with the stories.

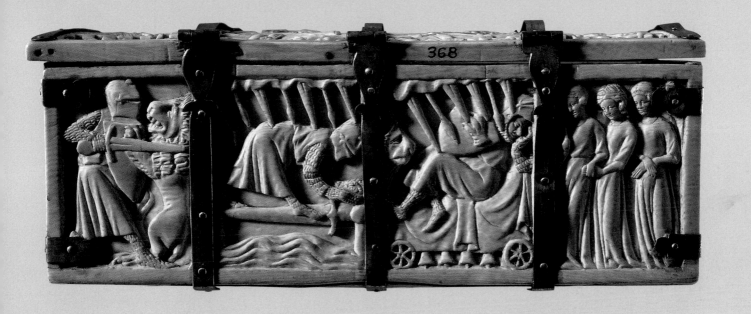
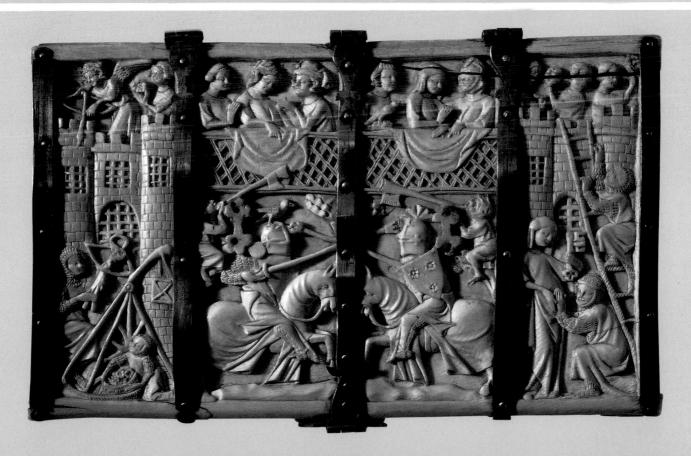

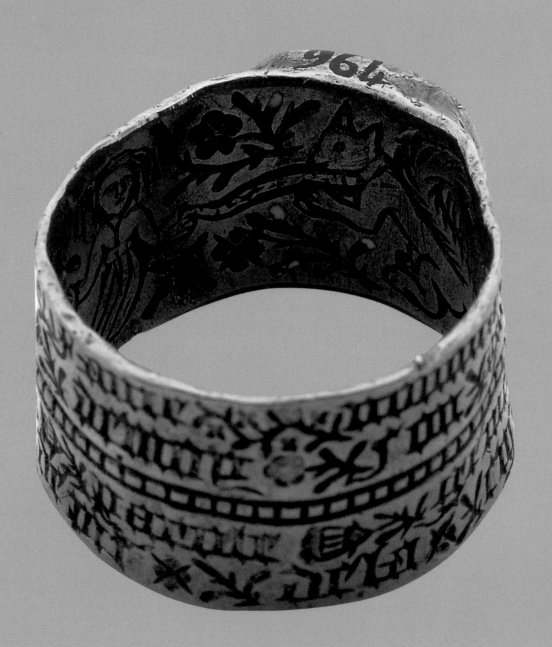

GOLD AND SAPPHIRE RING WITH AN INSCRIPTION

15th century

France

Bequeathed by Sir Augustus
Wollaston Franks

HEIGHT: 1.1 cm
DIAMETER: 1.7 cm

P&E AF.1077

This complex and clever ring plays a puzzling grammatical game in the inscriptions that cover the external and internal faces of its broad band. The inscription is interspersed with delicate sprays of foliage, the whole inlaid with black enamel which, where it survives, stands out boldly against the gold background. It is written in French and reads, on the outside: 'UNE FAME NOMINATIVE A FAIT DE MOY SON DATIFF PAR LA PAROLE GENITIVE EN DEPIT DE LACCUSSATIF'. It translates as: 'a woman in the nominative has made me her dative by the genitive word despite the accusative.' In this inscription, the voice is ostensibly that of the ring, which has been accepted reluctantly as the possession of the woman in question, undoubtedly as a love gift. That this is true is made clear in the secret inscription inside the band: 'SRS AMOUR EST INFINITI[V]E DE VEU ESTRE SON RELATIFF' ('[?] love is infinite that wants to be her relative'). This latter part of the inscription has been interpreted variously but seems to mean that the lover's desire to be related (i.e. married) to the woman is borne of infinite love.

The overtures of affection offered by this sentiment have led to suggestions that it may have been made as a wedding or betrothal ring. Its flirtatious game is extended to the imagery concealed inside the band. This shows a woman holding a squirrel on a leash in one hand and a bunch of flowers in the other. Squirrels were tamed as pets for ladies in the Middle Ages and, possibly as a consequence of the proximity they enjoyed in the laps of their owners, they acquired sexual significance as representative of the penis. 'To crack a nut', the squirrel's undisputed skill, became an established metaphor in poetry for sexual intercourse and was clearly understood by the grammatically adept giver of this ring. The ring's sexual secrets are well hidden behind a wall of text and the strangely inappropriate choice of a sapphire for its setting. The sapphire was celebrated for its magical power both to make men chaste and to cool the blood.

IVORY CASKET WITH THE CHÂTELAINE DE VERGI

About 1320–40

Paris, France

Given by Sir Augustus
Wollaston Franks

HEIGHT: 9.7 cm
LENGTH: 22.6 cm
WIDTH: 10.8 cm

P&E 1892,0801.47

This wonderfully animated casket serves as a tightly packed visual account of a popular narrative poem penned in the mid-thirteenth century. It relates the tragic tale of the Châtelaine de Vergi, a story apparently founded in fact, although inevitably romanticized to conform to chivalric values. The events depicted are propelled by love, jealousy, deceit, dishonour and revenge.

On the left side of the lid (illustrated at bottom right), within pairs of sharply defined quatrefoils, a love story unfolds. The top two scenes show the châtelaine being wooed by a knight of the court of Burgundy and accepting his advances. In the bottom two scenes she instructs her lapdog to give him a signal of her availability and they meet for their secret liaison in her bedchamber. On the right side of the lid, the plot becomes complicated by the desires of the duchess of Burgundy, who attempts to seduce the knight in a dancing scene that takes place in her chamber. She chucks his chin as a sign of her amorous intent. The knight, of course, rejects her in favour of his lady and the duchess falsely accuses him of propositioning her to the duke. In the bottom two scenes, the angry duke unsheathes his sword and threatens to kill the knight but fails to do so when he hears of the knight's true love. On the reverse of the casket, the duke observes the lovers together to confirm their story and pledges to keep their secret. However, he is coaxed into revealing it to the duchess, who, on the left side panel (illustrated at top left), whispers her knowledge of it to the châtelaine at a feast. On the front of the casket (illustrated at top right), the distressed young woman dies of shame, and is discovered by her maid. The knight then draws his sword and kills himself, and, in a breathless whirl of continuous action, the duke withdraws the sword from his dead body and goes in search of his treacherous wife. The urgency of the action is conveyed as the duke leans from one scene into the next, pressing his hand against the dividing strip that originally held a silver mount. On the right side (illustrated at bottom left), the duchess still dancing with her ladies, is executed by the duke.

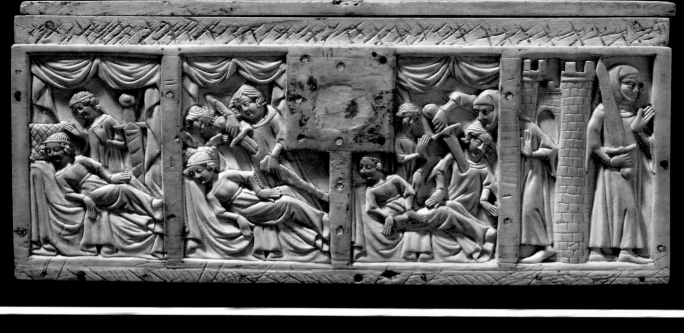
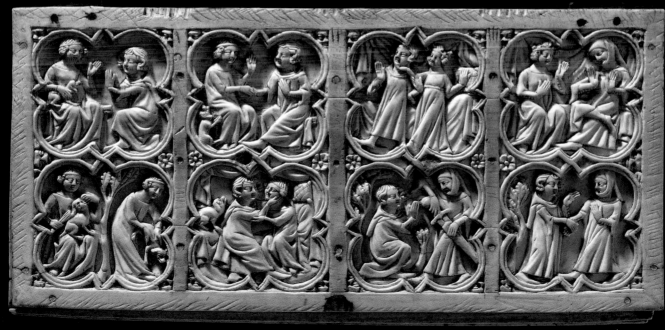

GOLD BROOCH WITH INSCRIPTION

From the thirteenth century, romantic inscriptions on medieval rings and brooches abound in huge numbers, evidence of the currency of love culture in aristocratic society. They were mostly coined in French and were frequently formulaic, including dedications such as '*de bon cuer*' ('from a good heart') and '*mon cuer avez*' ('you have my heart'). The most popular Latin phrase, '*amor vincit omnia*' ('love conquers all'), is engraved, interestingly, on a brooch worn by Chaucer's prioress Madam Eglantine in *The Canterbury Tales* and taken as an indication of her worldliness. Longer inscriptions, however, may have even been unique compositions (see the ring on pp. 218–19) and demonstrate greater imagination and humour. The inscription that covers both sides of this simple gold brooch takes the form of a rhyming couplet in French, which reads on the front '*Ieo sui fermail pur garder sein*' and on the reverse '*ke nu svilein nimette mein*'. This may be translated as 'I am a brooch to guard the breast / so that no rascal may put his hand therein'. The second part of the couplet was not visible when the brooch was worn and serves as a witty aside to the sentiment on show.

Wandering hands may have been a just cause for concern to virtuous ladies, but it was a source of anxiety for their sometimes absent husbands. The ability of a brooch to act as a physical and symbolic defence is expressed by Jean de Hauteville, writing at the end of the twelfth century:

> My bride shall wear a brooch, a witness to her modesty and a proof that hers will be a chaste bed. It will shut up her breast and thrust back any intruder . . .

Robert de Blois reinforces the value of protective jewellery in his *Advice to Ladies* composed around the middle of the thirteenth century:

> Take care not to allow your breast / To be felt, fondled or caressed /
> By any hands save those that might. / For, true it is, when one first thought /
> Of fashioning the clothing clasp, / It was to keep man's lustful grasp /
> From woman's bust, which should be known / To husband's hands and his alone.

13th century
France or England
DIAMETER: 2 cm
P&E 1929,0411.1

HEART PENDANT

The symbol of the heart widely recognized today seems to have become familiar from the fourteenth century, when it was circulated on everything from jewellery to manuscript illuminations and seals. By the time this expensively crafted jewel was made in the fifteenth century, the heart was a universally acknowledged sign of passion, courage and devotion. The peculiarly poetic qualities of the pendant derive from a very particular combination of word and image. Its front surface is literally encrusted in tears, the droplet form almost as readily understandable as the heart symbol itself. That these are tears rather than drops of blood is clear from the French inscription on the reverse – '*tristes en plaisir*' or 'sadness in pleasure' – which evokes feelings of sorrow and plays on the bittersweet element of romantic attachment exploited as late as the sixteenth century by Shakespeare. In the fifteenth century the poet Charles d'Orleans expressed the same melancholy of the lover:

> Dedens mon Livre de Pensée
> J'ay trouvé escripvant mon cueur
> La vray histoire de douleur
> De larmes toutes enluminée
> (In the book of my thoughts / I have found written on my heart /
> The true history of sorrow / Illuminated with tears.)

A luminous quality to the pendant's tears was achieved by setting them against an enamelled background. The enamel is now lost, along with the pearls that were originally suspended from the three chains that hang from the base of the heart. White enamel was frequently used for this purpose and would have supplied a suitable colour combination. The inscription on the reverse was also intended to accommodate enamel, probably black. The inscription surrounds an engraved ivy leaf, keyed to take green enamel. The ivy leaf was used as part of an extensive reference of flower symbolism to signify constancy. Expensive love jewels were exchanged as tokens of affection between wealthy lovers, with men as likely as women to wear such items.

15th century
France or England
HEIGHT: 4.1 cm
P&E 1979,1103.1

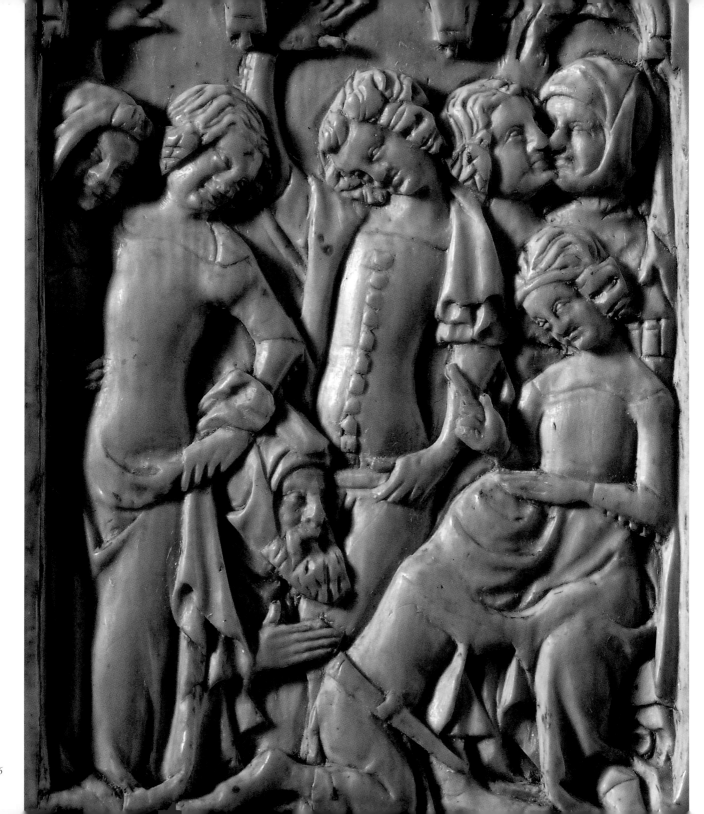

IVORY WRITING TABLET COVER
WITH A GAME OF FORFEITS

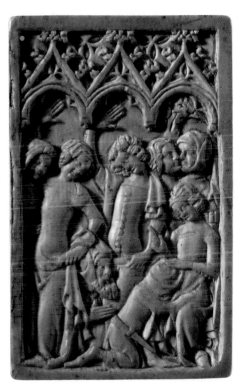

14th century

Paris, France

Given by Sir Augustus
Wollaston Franks

HEIGHT: 8.3 cm

P&E 1888,1217.1

The pursuits of the leisured classes formed the subject matter for an assortment of luxury goods made from ivory and produced in Paris in the fourteenth century. The refinement of courtly life was detailed on objects such as mirror-backs (pp. 206–7) and writing tablet covers (pp. 202–3). This cover to a set of writing tablets depicts a party game that has significantly more potential for lewdness. Four couples are arranged beneath three pointed arches surrounded by foliage that appears partly architectural and partly natural. The encroaching natural world may be an indication of the season, likely to be Spring, the time traditionally given over to lovers' pastimes. The densely crowded scene enforces physical intimacy between the figures who overlap in their enthusiasm to participate in a game known in English as 'hot cockles'.

'Hot cockles' was essentially a slapping game whereby a blindfolded male victim was slapped by female assailants until he identified correctly the hand striking him. The reward for recognition was a kiss, which is being administered in the top right corner of this panel. Below, a man obscures his face and hands under the skirts of a seated lady, who raises an admonitory index finger. Meanwhile two other ladies extend their arms fully in unison to deliver a resounding blow. A kneeling male figure, his hands joined in eager supplication, squeezes between them as next in line for the same treatment. The scene is loaded with erotic imagery, heightened by the tightly buttoned bodices that each lady wears, which is given extra emphasis by the two standing female figures who hitch their skirts more closely around their hips. The game, not surprisingly, was international in its appeal. In the Germanic territories it was known as 'Schinken klopfen' ('bottom slapping') and it seems to have enjoyed popularity in different forms until as late as the eighteenth century.

THREE BROOCHES

Around 1420–50

Probably Burgundian

Given by Sir Augustus
Wollaston Franks

HEIGHT: 4.2 cm (AF.2768)
DIAMETER: 3 cm (AF.2769)
DIAMETER: 1.9 cm (AF.2770)

P&E AF.2768, 69 & 70

An abundance of flowers set with gems gives these shimmering brooches a feeling of sensual luxury. All three brooches were found together in the river Meuse and were probably lost by the same owner. The second largest is set with a central spinel with a diamond above it. The buds that encircle the frame contain spheres with white enamel sprinkled with gold. At the centre of the smallest brooch is a garnet, which is surrounded by closely packed foliate forms of different heights. The stones are cut and polished to allow the maximum refraction of light. Their imagery is informed by the symbolism and sensations associated with the rituals of love. Gardens were considered especially appealing locations for the pursuit of love and flowers were endowed with specific meanings related to romantic sentiment. Gems too were equipped with qualities that had particular significance for lovers. The combination of a diamond and a sapphire with three rubies and pearls (now missing) on the largest of the brooches was intended to signal certain values. The diamond, placed above the other stones, represented constancy, while the ruby's warmer hue was suggestive of passion. The female figure in the middle of this brooch was once enamelled white on its face, where traces remain, and on the hands that gently frame the centrally placed sapphire. Her gown was probably also enamelled in blue, the favoured colour to express constancy in love.

The heavily textured three-dimensionality of the piece is created by layers of decoration, which include the scalloped edges of the figure's sleeves and veil and the floral crown that she wears. All around her are gold beads on high stems that provide extra depth and movement to the composition. The popularity of figurative brooches with flowers is well understood from documentary sources and from other rare survivals such as the brooch with lovers in a garden, in the Kunsthistorisches Museum, Vienna. That this fashion was international is clear both from inventories and from a portrait of Bianca Maria Visconti by Bonifacio Bembo in the Pinacoteca di Brera, Milan. Bianca is painted wearing a brooch very similar to this example on her shoulder, which may have been an expensive import or was perhaps produced by an Italian goldsmith working in the same tradition.

BRONZE PURSE FRAME

A great number of purse frames survive from the medieval period. Most of them were mass produced and follow a predictable formula that frequently includes a rudimentary inscription on the purse bar, most commonly 'Ave Maria Gracia Plena'. Architectural purse frames are a much rarer commodity, particularly in England where very few survive. This remarkable example was found on the Thames foreshore in London, close to Cannon Street Station. It demonstrates an outstanding degree of preservation and an unequalled level of technical excellence.

The purse frame is cast in bronze and consists of an ornate openwork structure from which are suspended two loops, one larger than the other, with stitching holes for the attachment of fabric. The architectural details include elaborate window tracery in the French Flamboyant style on two loosely articulated side panels that may have been designed to secure a cover, perhaps fitted with a clasp. Three towers are arranged along the top of the bar; the largest, in the centre, is made to accommodate a swivel, which would have fixed the purse to a belt. The precision of the openwork places the purse frame in a category of fine metalwork closely associated with medieval scientific instrument- and clock-makers. Strong parallels to the micro-architecture employed on the purse frame are offered by a Burgundian clock currently on loan to the British Museum from the Victoria and Albert Museum, London (M.11-1940).

The fabric of purses is usually lost because of its vulnerability but would normally have been silk or linen. From representations in panel paintings, sculpture and funerary monuments, it is clear that, with their fabric in place, the purses could achieve quite expansive proportions. They were made to contain more than just money and were worn by men as an attribute of business, wealth and generosity. Joseph of Arimathea, for example, is most frequently shown wearing a purse to signify not only his prosperity but also the fact that he gave selflessly. This purse frame was probably an import from France or the Netherlands, or it may have been lost by a foreign merchant in transit or resident in London.

Around 1450

France or The Netherlands

Acquired with donations from the British Museum Friends, Mr Sam Fogg and the Art Fund

LENGTH: 20.5 cm

WIDTH: 11 cm

P&E 1998,1001.1

COVER FOR A NAUTILUS SHELL

About 1297

Paris, France

LENGTH: 9.8 cm

WIDTH: 9.2 cm

On loan from the Wardens
and Fellows of All Souls
College, Oxford

Nautilus shells were highly prized as exotic table ornaments in the Middle Ages. Their rarity and value was amplified by decorative elements that transformed them into elaborate ceremonial drinking cups. The distinctive horseshoe shape of this cover, with its slight kink on the right-hand side, suggests that it was almost certainly designed to seal the opening of a nautilus shell. It is made from silver-gilt and gold and covered in enamels laid with incredible sharpness and precision. The enamel comprises three different techniques, champlevé, cloisonné and translucent, the last two combining to form what is known as *émail de plique*.

Émail de plique is a rare variety of cloisonné enamel consisting of cells built up from extremely thin sheets of gold bent into delicate heart-shapes, trefoils and quadrilobes filled with opaque white, yellow and red enamel. The cells are characteristically set into a background of deep translucent green enamel to give a gem-like appearance. The technique emerged in the late thirteenth century and seems to have been associated with the goldsmiths of Paris. It is used on this nautilus shell cover to divide five fields of heraldic decoration, the dominant device being that of Philip IV of France. The side panels show the arms of Hainault and Clermont-Nesle, generally accepted to signify Raoul de Nesle, Constable of France, who married Isabella of Hainault in 1297. The vivid colour combinations, their different textures, the beaded borders and the elaborate knop arranged with enamels to form a six-pointed star all contribute to the splendour of the piece, which was probably the result of a royal commission. The most likely meaning of the dense display of heraldry is that Philip IV gave Raoul de Nesle a mounted nautilus shell as a wedding present. An inventory of Raoul's wealth of precious goods tells us that he owned a shell 'garnished' with gold, and it is tempting to associate the description with this piece.

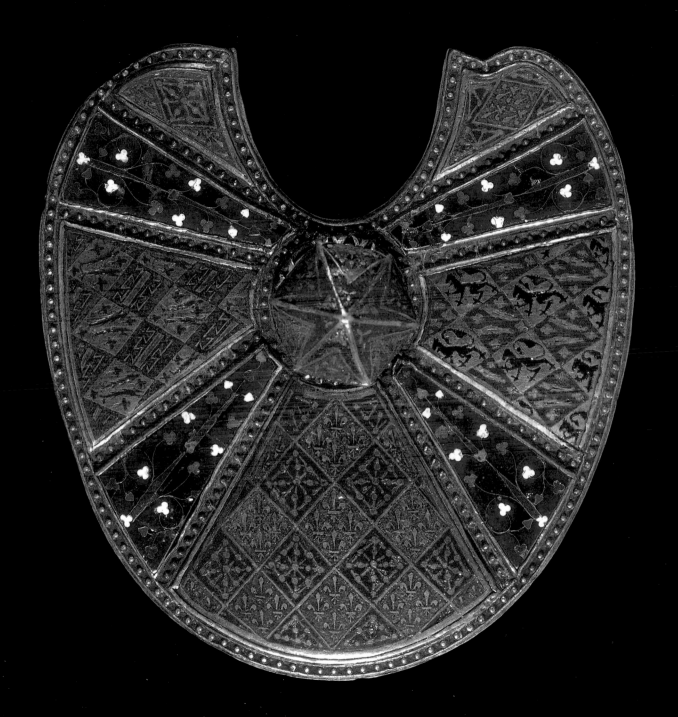

SILVER-GILT AND ENAMEL SPOON

Medieval spoons might be made of wood, pewter or horn. The finest examples were made of silver or silver-gilt and were so highly treasured that they frequently became heirlooms and were passed from one generation to another. The characteristic form of a medieval spoon is pear-shaped with a long stem terminating in a decorative finial. Very often at the junction of the bowl with the stem there is the head of a grotesque, which appears to grip the bowl in its mouth. This spoon at once corresponds to each of these standard features and transcends them. Its highly decorative appearance is achieved by the use of translucent enamel, which is applied in thin layers to allow the reflection of light from the metal beneath. Much of the enamel is lost but it would originally have covered the first half of the stem as well as both sides of the bowl. The design enlivened by the enamel is a delicate arrangement of flowers and leaves, which on the front of the bowl encircles the words 'ave Maria' ('Hail Mary'), enamelled in black.

The most extraordinary feature of the spoon is the fact that it comes apart to fit into a miniature travelling case. Travelling sets of spoons and knives were not unusual (see pp. 254–5) and occasionally more than one spoon might be inserted into a single case of not remarkable size. Richard Whittington, Mayor of London, owned four silver spoons in their own specially designed case, which still survives in the possession of the Worshipful Company of Mercers, London. The cases were generally made of *cuir bouilli*, leather hardened to the density of wood by repeated folding and boiling. The leather cases were usually painted, sometimes with heraldic devices that served as ownership marks. The owner of this spoon may have enjoyed amusing his fellow diners by keeping the spoon's structure a secret and challenging them to fit it back into its case.

15th century
Flanders
Donated by Max Rosenheim

LENGTH: 18 cm (spoon); 9.5 cm (case)
WIDTH: 5 cm (spoon); 7 cm (case)
P&E 1899,1209.3 & 4

LION AND RIDER AQUAMANILE

Aquamaniles were used in the ritual washing of hands at mealtimes or by the celebrant during Mass. The name derives from the Latin words 'aqua' for water and 'manus' for hand. Of the many surviving examples, the majority take the form of a lion and are almost universally made of brass. Documentary evidence from inventories indicates that gold and silver aquamaniles were not uncommon, though none is known to survive. This aquamanile is one of a large number thought to originate in north Germany, where there was a long-established metalworking presence that was extremely strong throughout the thirteenth and for much of the fourteenth century.

It shows a naked man riding a lion. He clings to it by its ears and bends his short, thin legs to press his feet against its neck. The handle of the aquamanile takes the customary shape of a grotesque, in this instance an elongated bird-like creature, which grips the man by the shoulders and turns its beaked head over its back. It seems to emerge from the lion's tail, which is little more than a curly lock. The aquamanile was designed to take water through a square opening in the lion's head and to distribute it through a spout that emanates from its mouth. The spout is disguised as a tiny figure who appears to resist being swallowed by the lion by pushing against its open jaws with both hands. The positioning of the spout means that the aquamanile had to be lifted by its handle and tilted to be used. However, later examples dating from about 1400 were equipped with a spigot, which was applied as low as possible at the front of the aquamanile and allowed the water to be released at will. The hole in the chest of this lion may suggest that it was modernized by the insertion of a spigot at some point after the original date of manufacture.

13th century

Germany

HEIGHT: 32.5 cm

LENGTH: 34 cm

P&E 1851,0412.1

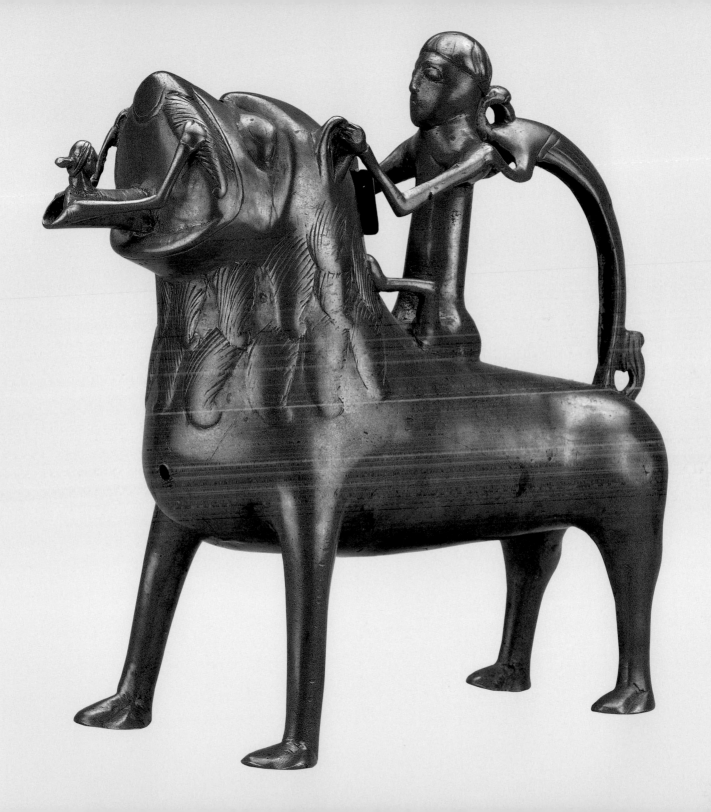

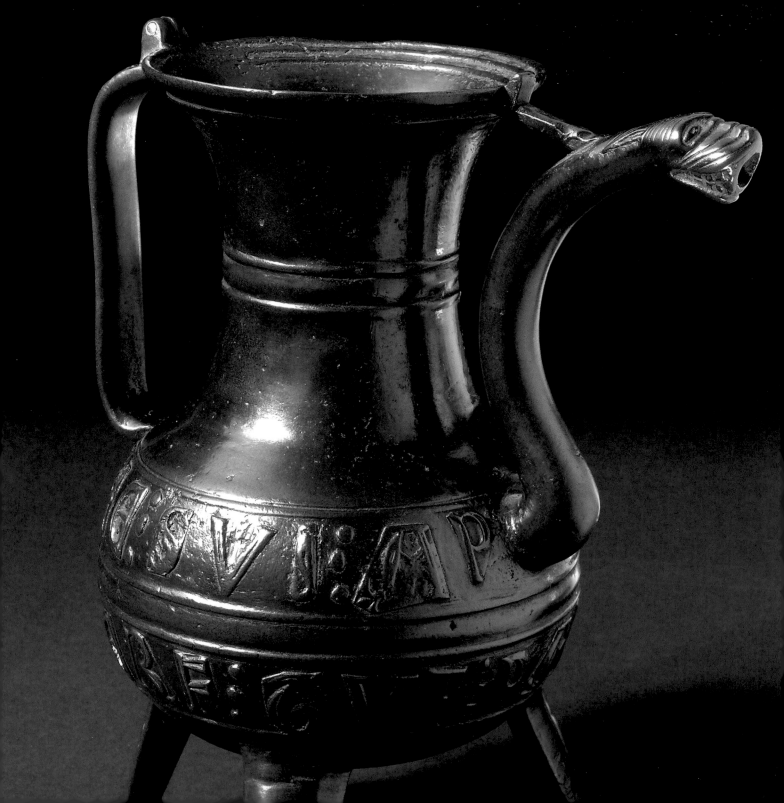

BRONZE LAVER WITH INSCRIPTION

14th century

England

HEIGHT: 25.8 cm

WIDTH: 11.5 cm

P&E 1975,1001.1

Bronze vessels were used by at least the moderately wealthy, poorer tables being furnished by less expensive items of pottery or wood. This tripod pitcher, known as a laver, has slightly mannered proportions in its nipped-in neck and sinuous spout, which terminates in a dragon's head, and it was probably designed to serve an elegant table. Additional evidence for the status of the owner is offered by the fact that it carries an inscription in French, implying that it belonged to someone who was certainly literate and probably fashionably educated.

The inscription reads: 'IE SUI APELLE LAWR IE SERF TUT PAR AMUR' ('I am called a laver, I serve all with love'). A laver was a vessel used specifically for washing and takes its name from the French verb 'laver', meaning 'to wash'. They were normally used in conjunction with large bronze bowls. Frequent washing of hands was a feature of medieval dining since the general practice was to eat without utensils such as knives and forks. Good table manners were seen as a sign of breeding. Consequently, Chaucer's refined prioress in *The Canterbury Tales*, written in the late fourteenth century, serves as an exemplar of social etiquette and escapes mealtimes without a spot of grease upon her lips. In the fifteenth century a number of manuals on courtesy and manners emphasized the importance of cleanliness. William Caxton's *Book of Courtesye* advises:

> Washe with water your hondes so cleene
> That in the towel shal no spotte be sene
> (Wash with water your hands so clean,
> that on the towel no spot [of dirt] shall be seen).

The hospitality of the host was also considered a virtue and the generous sentiment of this inscription carries with it a sense of equanimity and warmth. Other inscriptions on bronze jugs advertise ownership and occasionally act as warnings against theft. The Asante Jug (see pp. 242–3) broadcast its owner's identity through a display of heraldry and badges and reserves the inscription to impart proverbial wisdom.

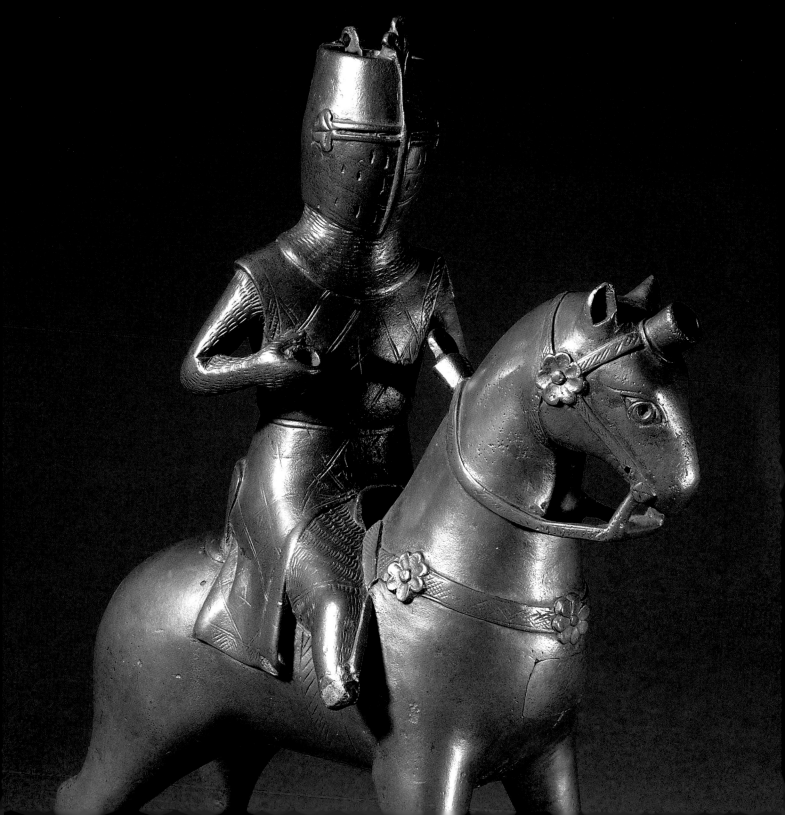

KNIGHT ON HORSEBACK AQUAMANILE

Late 13th century
England
HEIGHT: 33 cm
P&E 1853,0315.1

The word 'aquamanile' describes a category of object from the medieval period essential to both table etiquette and religious ritual (see pp. 236–7). Aquamaniles were used for the washing of hands, an absolute necessity at mealtimes in an age when most diners used their fingers for eating. The celebrants of Mass also washed in an act of public cleansing, which was a mark of respect for the Eucharist.

Aquamaniles were crafted in the lost-wax method of bronze casting, a technique inherited from ancient Greece and Rome, and brought to medieval Europe through the agency of Islamic metalworkers. The vessels produced by this process took a variety of forms, usually animals, such as lions, horses and unicorns. This beautifully modelled example takes the shape of a knight on horseback. Its function is almost concealed by its form. An opening at the top of the knight's helmet allows it to be filled with water which would then be poured out through a spout on the forehead of the horse. From the numbers that survive, horse and rider aquamaniles seem to have been very popular. They were sufficiently appealing to the aspiring classes for cheaper versions to have been made in pottery. Pottery vessels imitating metal originals were very often given a dark green glaze to simulate the patina of bronze.

This aquamanile was found in the river Tyne, near Hexham, where it probably sustained the damage that saw the loss of its lance and shield and part of the knight's legs. However, the quality of its craftsmanship is a strong indication that this was a prestigious commission for a wealthy client.

THE ASANTE JUG

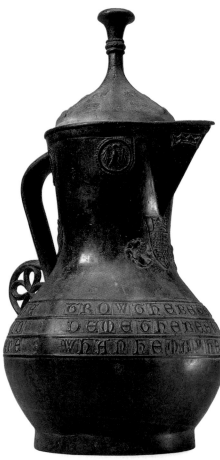

About 1390–1400

England

Found in the Asante kingdom
(modern Ghana), West Africa

HEIGHT: 62 cm (approx.)

P&E 1896,0727.1

This remarkable fourteenth-century English bronze vessel takes its name from the intriguing circumstances of its discovery in 1896 in the Asante kingdom on the west coast of Africa. So far no evidence has come to light to indicate how or when it travelled there. It is the largest in a series of surviving jugs probably cast by a London bell founder. The related examples are at the Victoria and Albert Museum, London, and the Luton Museum, Hertfordshire. Dating evidence is supplied for all three in the form of the royal arms of England, which are used to decorate the bodies of the vessels, and suggest a date of 1340–1405. The Asante jug is the only example to retain its lid, which offers additional evidence for its production date. The facets of the lid carry the white hart emblem adopted by Richard II from 1390 to 1399.

The three jugs may have been made for display rather than use. Their size and capacity render them difficult to handle. However, while proverbial inscriptions occur on the bellies of the jugs at the British Museum and the Victoria and Albert Museum, the Luton jug's simple dedication to 'my lord Wenlok' throws into doubt the question of a convincing connection between them. The first Lord Wenlock's dates (c. 1400–70) are at odds with those normally attached to the other jugs. This discrepancy may be the consequence of the reuse of fourteenth-century moulds by a foundry in the fifteenth century or it may be that the term 'Lord Wenlok' is being used informally to describe William Wenlock, the uncle of the first Lord Wenlock, who died in 1391. The second possibility could even suggest a production date of 1390–91 for all three vessels.

Part of the charm of the Asante jug lies in the avuncular wisdom of its inscription, which offers kindly advice against a lack of frugality that could well have been directed at Richard II himself, a monarch infamous for his extravagance:

He that wyl not spare when he may	(He that shall not save when he can
He shal not spend when he would	Shall not spend when he wants to.
Deme the best in every dowt	Suppose the best in every fear
Til the trowthe be tryid owte	Until the truth is known)

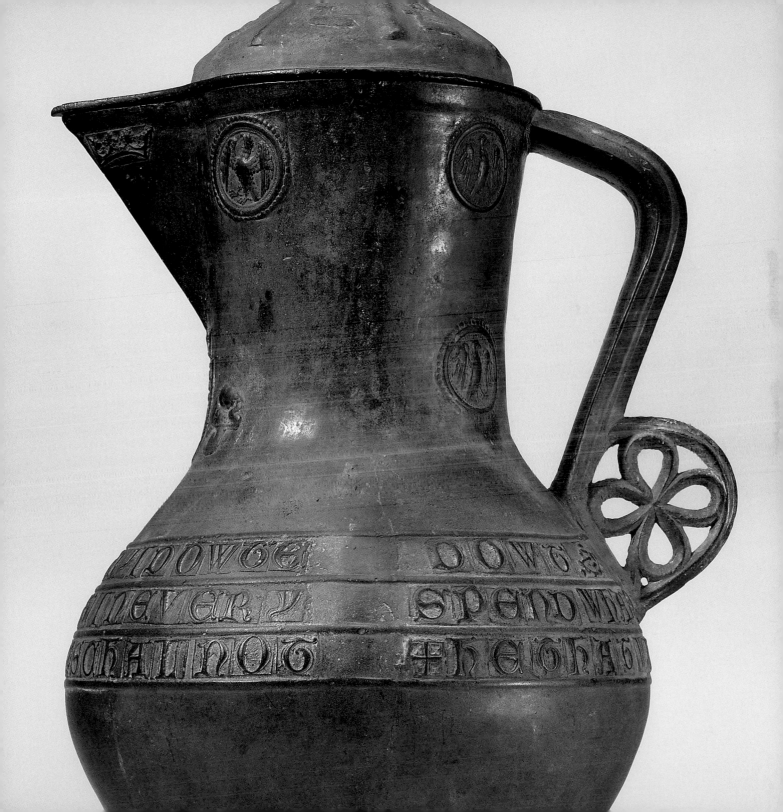

JUG MADE AT KINGSTON-UPON-THAMES

A rich palette of red, yellow and green animates the surface of this lively jug, which is given textural strength from the application of low-relief grotesques set into lozenges. The different coloured glazes are created by the addition of iron (red), copper (green) and lead (yellow). The four-legged grotesques resemble dragons and appear to leap energetically across the belly of the jug. They are divided by a register of inverted dark green chevrons, creating a pseudo-heraldic effect.

Contemporary depictions of feasts do not show jugs of this size as tableware and it is likely that they were set to one side and used for serving. The decorative detail of this example suggests that it was relatively expensive and must certainly have received a degree of attention as a display piece. It is a wheel-thrown vessel manufactured from the white clay characteristic of products from Kingston-upon-Thames in Surrey. Kingston-type wares enjoyed great popularity with Londoners who, between the thirteenth and fourteenth centuries, provided the Surrey potters with their largest market. Their great selling point was their white fabric gained from clays which were transported to Kingston, probably from Farnham in Surrey, by boat along the Thames. The pottery produced there took many different forms and included cooking pots, condiment dishes, drinking horns, money-boxes and urinals and was usually given a characteristic glossy green glaze. This jug is an exceptionally elaborate product in its combination of colours and its extravagant relief decoration.

Late 13th century

Kingston-upon-Thames,
Surrey, England

HEIGHT: 28.5 cm

P&E 1856,0701.1566

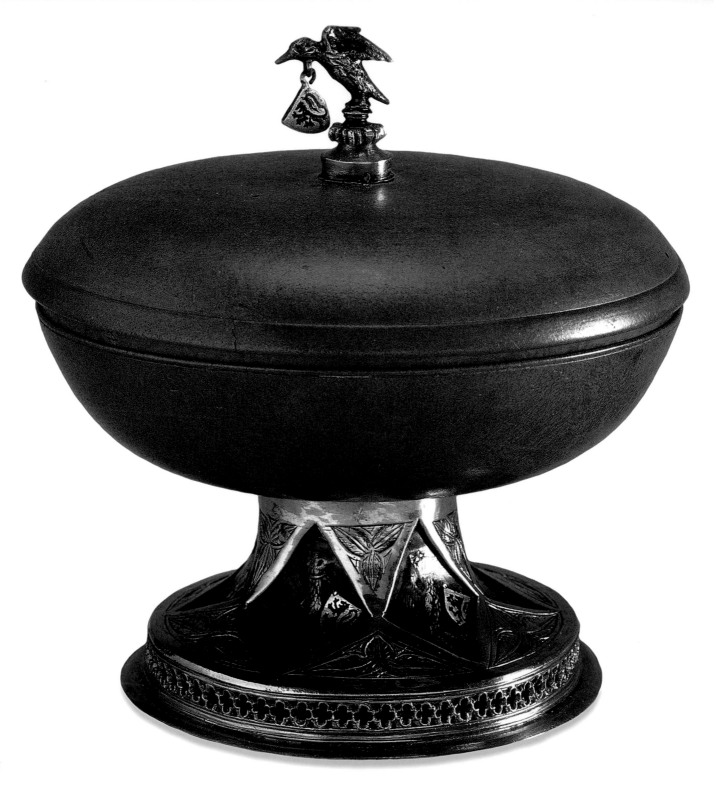

MAZER AND COVER

Mid-14th century

Flanders

Bequeathed by Sir Augustus
Wollaston Franks

DIAMETER: 14.5 cm

P&E AF.3116

Wooden vessels were much more common in the medieval period than their survival rate suggests. They were generally used by the less elevated sections of society as a cheap alternative to metal or pottery. Mazers were a specific type of wooden drinking cup often used communally by hospitals, guilds, corporations and other societies. They usually had a reinforced metal rim, which might carry a motto, and could contain a medallion in the base of the bowl, which might be engraved with a devotional image. Their name derives from the Old High German word 'másá' meaning 'a spot' since they were frequently made from a speckled wood known as bird's eye maple. However, de luxe versions of mazers made for personal use were not unknown and are represented by this highly individualized example.

It stands on a silver-gilt foot, which is decorated with lozenge-shaped translucent enamels of a green-winged silver bird, which carries a shield from its neck. The same silver bird perches on the cover of the mazer, modelled in the round with some vestiges of the green enamel that once covered its wing feathers, and bearing an armorial shield from a suspension loop under its beak. The shield shows the arms of Flanders but provides insufficient evidence for the identity of the original owner. However, the leather case that was used to protect the mazer in transit remains intact and supplies further information. It is decorated with the arms of Flanders combined with those of Ghistelles and probably alludes to the marriage of Louis de Flandres, the illegitimate son of Louis de Mâle, Count of Flanders from 1346 to 1384, to Mary de Ghistelles. In order to render the heraldic decoration understandable, the leather case would have been painted. Colour is an important element in interpreting armorial bearings, which would have been more readily identifiable for a medieval audience accustomed to displays of heraldry in all manner of contexts from the battlefield to the dinner table.

TWO GEMELLIONS

The word 'gemellion' derives from the Latin 'gemellus', which means 'twin'. It describes pairs of shallow basins used by the wealthy in the Middle Ages in the ritual of washing before meals. Such ablutions were considered extremely important, and architecturally integrated wash basins and cisterns occasionally survive in monasteries or great houses as evidence of this provision made for guests. Equally, hospitality might be extended by a servant offering to pour running water over the hands of diners. Warmed, scented water was poured from one gemellion over the hands, and received in another placed beneath it. The pouring gemellion was equipped with a spout, which survives on this pair in the form of a lion's head. The water drains through the spout by seven holes which are pierced into the side of the basin.

Few pairs of gemellions survive. That these gemellions constitute a pair is clear from their identical design. The only significant point of departure is the arrangement of the heraldic shields, which alternates differently between the two. The reverse decoration of an engraved lion set into a shield within concentric planes creating a ten-pointed star is also common to both; each point terminates in an elegant fleur-de-lis. The basins of the gemellions are engraved with fabulous beasts and enamelled. In the central medallion two hybrids, resembling Harpies, confront one another with shield and sword against a design of swirling tendrils. The same creatures are involved in combat with lions and dragons in four surrounding scenes set within overlapping arcs picked out in white enamel. The impact of the white enamel is greater than it would have been originally when the red and blue enamels were equally as vivid.

Around 1250–75

Limoges, France

Given by Major General A. Meyrick

DIAMETER: 22.7 cm

P&E 1878,1101.11 & 12

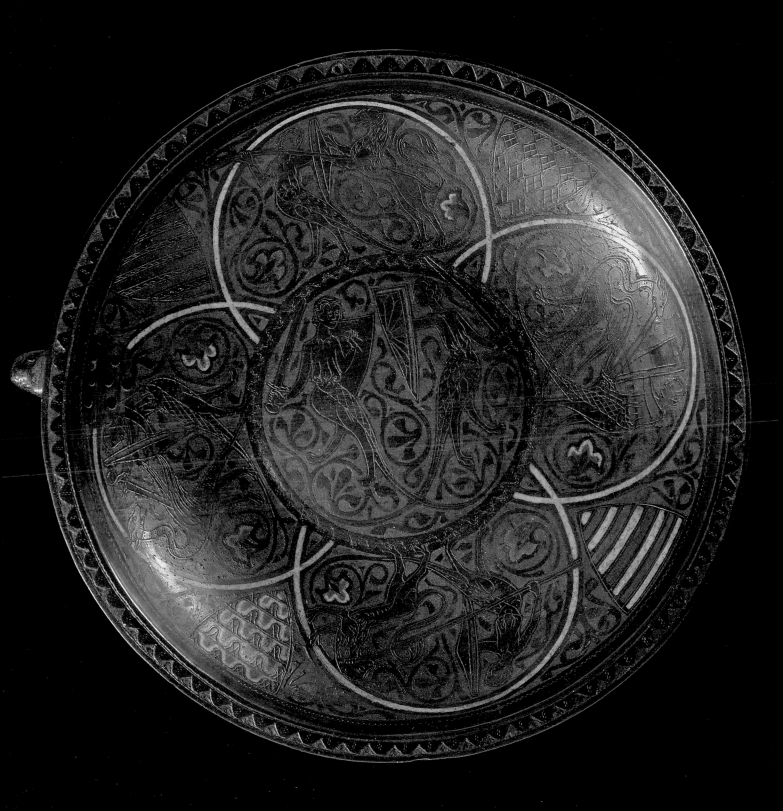

THE ROYAL GOLD CUP

About 1370–80

Paris, France

Acquired with contributions from HM Treasury, the Worshipful Company of Goldsmiths, Sir Augustus Wollaston Franks and others

HEIGHT: 23.6 cm (with cover)
DIAMETER: 17.8 cm

P&E 1892,0501.1

This priceless, peerless object made from solid gold and decorated with translucent enamels passed from one royal pair of hands to another until it disappeared into obscurity in seventeenth-century Spain. It was commissioned by Jean, duc de Berry, probably as a birthday gift to his brother, Charles V of France. Charles died before the gift could be made and the cup went instead to his son, Charles VI. Through the agency of the Hundred Years War, it came into the possession of John, Duke of Bedford, brother of Henry V of England. In the sixteenth century it is recorded in the household of Henry VIII; it remained in English royal hands until James I presented it to the Spanish ambassador who negotiated peace between Spain and England in 1604.

The cup bears the marks of its illustrious past in two bands inserted in its stem, one carrying the Tudor roses of Henry VIII and the other an inscription commemorating the peace with Spain. Other changes to its appearance include the removal of a collar of pearls from the rim of the cover, which would also have been crowned with a decorative knop. Alterations aside, the cup remains a breathtaking survival of the medieval goldsmith's craft. The gold is pounced with delicately rendered foliate motifs inhabited by birds, designs that are all but invisible to the naked eye, which is drawn instead to the wonder of the enamels. These are skilfully laid in extremely shallow fields, allowing the light of the gold to shine through. Gradations of light and shade are introduced to the coloured enamels with an ease that defies explanation but provides depth and movement to the composition. The costumes reveal coloured linings, sleeves and stockings in an effortless display of technical virtuosity. The enamels depict scenes of the martyrdom of St Agnes, who refused the advances of the pagan Procopius and suffered the consequences. That her feast day, 21 January, coincides with the birthday of Charles V no doubt prompted the choice of subject matter. The religious nature of the cup is amplified by the signs of the evangelists that decorate the foot and by a medallion of Christ in Majesty, placed inside the cover directly above another in the bowl depicting St Agnes receiving instruction. However, the religious imagery belies the cup's emphatically princely and secular original function.

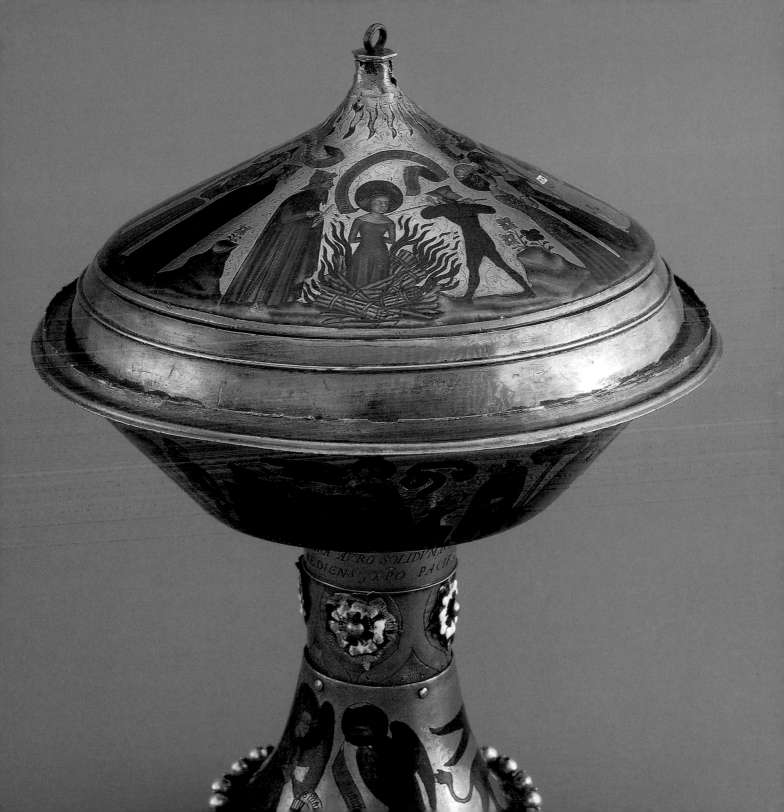

SILVER-GILT CUP AND COVER

Gold and silver vessels furnished the grandest tables at medieval feasts, which were occasions for ritualistic displays of wealth and hospitality. Few examples survive because they were frequently melted down either for their bullion value or to suit the dictates of changing fashions. This outstanding silver-gilt cup and cover survives partly because its simple form and capacious dimensions corresponded to the needs and tastes of the post-Reformation Church in England. It was preserved unaltered for use as a communion chalice, a function it performed at the parish church of St Cyriac's in Lacock, Wiltshire, until relatively recently. Such cups – known as 'chalice cups' because of their shape – were in use from around the thirteenth century onwards and are distinguished from chalices by their size and the addition of a lid for a cover; a medieval chalice would be smaller and was usually covered by a paten.

Cups were used to serve wine and ale but splendid examples such as this may have had a more ceremonial function. They were displayed in cupboards or arranged on sideboards known as buffets and may have been placed beside the host at the centre of the feast for the dispensation of drink to his principal guests. Cups were usually shared, a fact which accounts for the voluminous forms of the very few that survive. The table was organized according to a strict hierarchy, reflected in the utensils used. Drinking cups of pewter, pottery and wood would have been present at the same feast and many of the diners would bring their own in leather containers. Feasts were not called routinely but were usually connected with a specific event, such as a marriage or a date in the Church calendar.

This cup is distinctively plain in a period when many high-status cups were embellished by enamels or gems. The sober use of gilding on the foot, cresting and finial creates a pleasing contrast of colour heightened by the discreet use of ornament. The cresting is applied to the foot at the base, at the junction with the bowl, where it is inverted, and along the rim of the cover. It is combined with lengths of ropework, supplying a subtle textural richness against the smooth silver. Ropework also encircles the fabulously proportioned finial which perches precariously on the summit of the cover's vertiginously sloping sides.

About 1430–50

England

HEIGHT: 35 cm
DIAMETER: 13.8 cm

On loan from St Cyriac's Church,
Lacock, Wiltshire

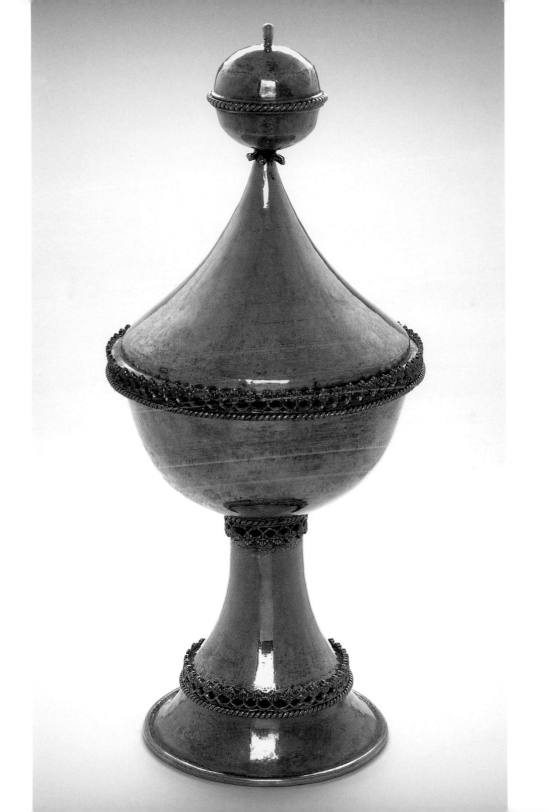

Probably around 1406

Dijon or Paris, France

LENGTH (MAX.): 38.6 cm

WIDTH (MAX.): 5.6 cm

P&E 1855,1201.118

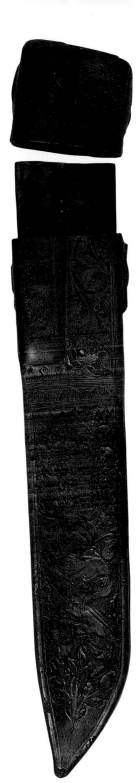

SET OF KNIVES WITH A LEATHER SHEATH

The protocol of dining and entertaining in the Middle Ages determined specific practices. It was quite usual, for instance, for guests to bring their own implements to a feast and so leather cases were designed for their transportation. This leather sheath was used to accommodate four knives, each one highly decorated with a display of heraldic devices, inscriptions and floral motifs. The wooden handles are furnished with silver-gilt mounts enamelled with the arms of Hainault and Holland. The date of the knives is established by the heraldry. It relates to Jean, duc de Touraine, the son of Charles VI of France, who married Jacqueline de Hainault in July 1406. The heraldry and the inscriptions are executed in translucent enamel, which shines brightly in a range of colours. The inscription, probably devised to commemorate the wedding, runs the full length of both sides of the handles and reads 's'il plaist a dieu' ('if it pleases God'). The leather sheath would have revealed an equal measure of colour as it was almost certainly painted to make its complex design vividly legible.

The sheath is embossed with a monogram consisting of the intertwined letters 'Y' and 'O'. This has been thought to relate to the marriage of Ysabel, the daughter of John the Fearless, Duke of Burgundy, to Olivier de Blois, which also took place in 1406, and could indicate that this splendid set of knives was a wedding present from Ysabel and Olivier to Jean and Jacqueline. However, there is no substantive evidence for this. The monogram is placed next to a representation of a watering pot, which sprinkles droplets of water on to the vegetation below. This intriguing imagery developed associations with grieving in the early fifteenth century but may have been employed here as a symbol of fertility. In the bottom half of the sheath, a peasant, fully equipped for work, walks beneath the words 'J'endure' ('I keep on going' or 'I continue'). The toiling peasant may signify the enduring relationship between man and nature to reinforce the message conveyed by the watering pot.

THE FISHPOOL HOARD

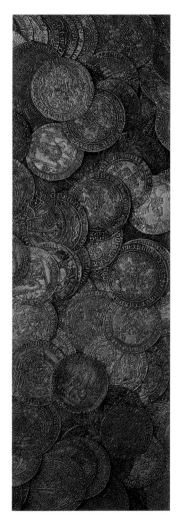

Mid-15th century

Made in England and Flanders

P&E 1967,1208.1–9

CM 1968,0412.1–1135

The Fishpool hoard is distinguished by the fact that it consists entirely of gold and comprises the biggest single find of medieval gold coins ever made in Britain. Discovered in 1966 during building works in the village of Fishpool, Nottinghamshire, the hoard consists of 1,273 coins, four finger rings, three pendants, a brooch and two lengths of chain. The coins provide evidence for the circumstances of their deposition, and include English nobles, half-nobles and quarter-nobles dating from the time of Edward III (r. 1327–77) to Edward IV (r. 1461–83). The latest coins were issued between 1460 and August 1464, suggesting the hoard might have been hidden between these dates. During this period England was rocked by civil war as the dynastic disputes of the houses of Lancaster and York raged in what was termed the Wars of the Roses. From 1461 to 1463 Margaret of Anjou, the wife of the deposed Lancastrian king Henry VI, had been actively fundraising in support of her husband in Scotland, France and the Netherlands. Coins from all these countries were found in significant numbers among the English coins.

Interestingly, most of the inscribed items of jewellery carry an amatory phrase and it is tempting to view them as additional evidence of Margaret's involvement. A ring engraved with the image of St Katharine has the motto '*en bon cuer*', which occurs in a different form on the signet ring as '*de bon cuer*', meaning 'in/of good heart'. The miniature enamelled padlock reads on one side '*de tout*' and on the other '*mon cuer*' ('of all my heart'). The heart brooch crystallizes the intimate nature of the jewellery through its shape and the inscription on its reverse, which reads '*je suys vostre sans de partier*' ('I am yours wholly'). The benevolent sentiments of the love jewellery are reinforced by the ring set with a turquoise, believed to protect its wearer from poison, drowning or from riding accidents.

The hoard was probably deposited during a Lancastrian rebellion against Edward IV, possibly after the Battle of Hexham in May 1464. Its value when buried amounted to around £400, which corresponds to about £300,000 today and may indicate that the hoard originally formed part of the Lancastrian royal treasury.

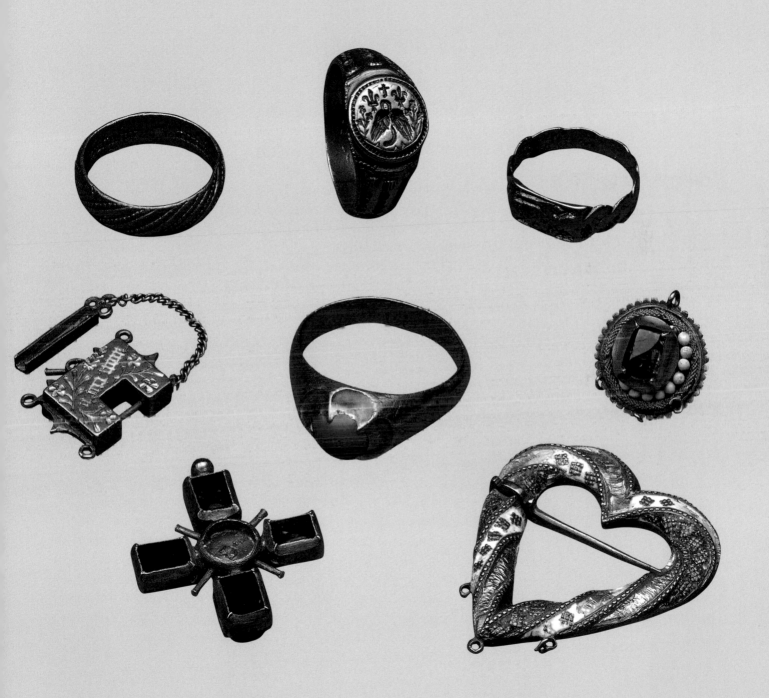

SEAL-DIE OF ROBERT FITZWALTER

Equestrian seals operated as an expression of masculine valour. They were the conventional way for noblemen to represent themselves in England from the time of William the Conqueror and remained a salient feature of seal-die design until a preference for heraldry and lineage exhibited itself in the fourteenth and fifteenth centuries.

Robert Fitzwalter's seal-die combines a self-confident depiction of his military prowess with a display of his social standing, communicated partly through the heraldry he employs to advertise his familial and political ties. The caparisons of Fitzwalter's horse and his shield both bear the chevrons of his family while another shield, occupying the only space that might accommodate it, under the horse's muzzle, is engraved with the voided lozenges of the De Quincy family. The Fitzwalters and the De Quincys were close political allies and fearsome opponents to King John (r. 1199–1216), who was said to hate three men above all others: Archbishop Stephen Langton, Robert Fitzwalter and Saher de Quincy. The seal of Saher de Quincy also includes a two-legged dragon, or wyvern, cowering below the horse, to indicate the triumph of virtue over evil in an image suggestive of St George. However St George, who became a popular military saint after the First Crusade (1095–99), was not adopted as England's national saint until the fifteenth century.

The majority of seal-dies were made from bronze since this was hard-wearing, inexpensive and yielded a sharp impression. Silver was used less frequently and rarely in the quantity required to make the Fitzwalter seal. Fitzwalter had the means to invest in a seal of outstanding quality and clearly selected one of the finest goldsmiths to engrave the die. The result is a tour de force of seal-die engraving, which conveys a variety of different textures with equal conviction, from the scales of the dragon to the almost transparent caparisons of the horse and the agitated folds of Fitzwalter's surcoat.

About 1213–19
England
DIAMETER: 7.4 cm
P&E 1841,0624.1

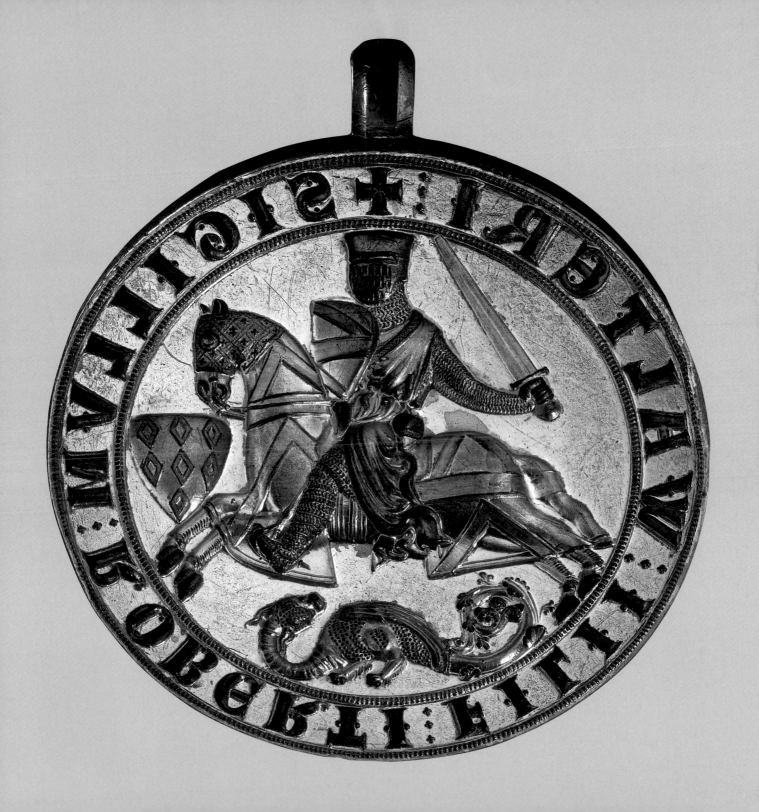

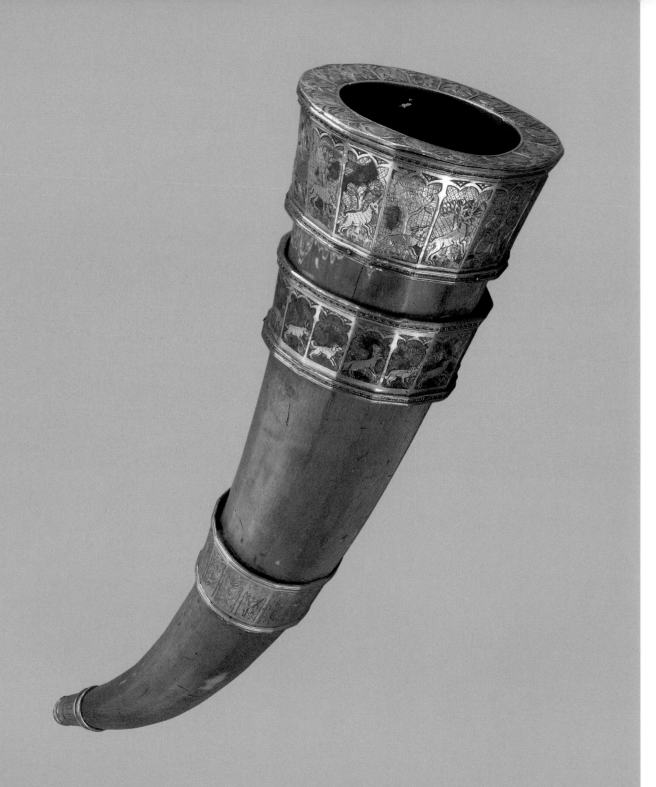

THE SAVERNAKE HORN

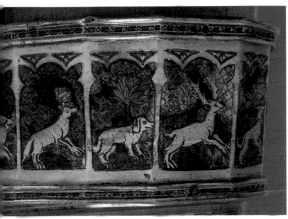

At more than twice the size recommended for a good hunting horn, considered by medieval authorities to be around thirty centimetres in length, this horn was probably conceived with a ceremonial purpose in mind. This theory is borne out by the extraordinary nature of the raw material, an elephant tusk, and by the enamelled silver-gilt mounts that surround its mouth.

The tusk itself was a very expensive and treasured commodity; this one predates the enamels that decorate it by one or two centuries and was clearly preserved for its value. The mounts, arranged in two parallel bands, date from the second quarter of the fourteenth century. The silver mouthpiece and central mount date from the eighteenth century, when the horn was still sounded periodically. Its association with Savernake forest in Wiltshire dates from at least the sixteenth century, when William Camden noted that it was owned by the Seymour family, descendants of the Sturmy family, wardens of Savernake from the reign of Henry II (r. 1154–89). Given the date of the tusk, it is possible that the horn was originally fashioned at this time and decorated with mounts in the fourteenth century to mark a special event.

The central panel of the upper mount shows a seated king in conversation with a bishop on his right. To his left stands a forester in a short tunic, holding his attribute of a horn. These figures could signify a forestry agreement between the king and a bishop. In England, from the time of the Norman Conquest, hunting was made the prerogative of a noble elite. Consequently settlement, cultivation and hunting in the forest were subject to rigorously enforced regulations. Hunting dogs and forest creatures inhabit the remaining arcaded panels of both mounts, while around the rim sixteen falcons are shown preening in a variety of attitudes. Although much of the enamel is lost, all were originally reserved in silver-gilt against a lush background of translucent blue and green enamel representing the forest. The animals include a lion and a unicorn, neither of which was to be routinely encountered in a forest but both firmly perceived within the noble order of beasts in the medieval imagination.

About 1325–50

England

Purchased with assistance from the Art Fund, the Pilgrim Trust and the Worshipful Company of Goldsmiths

LENGTH: 63.5 cm (along line of horn)

P&E 1975,0401.1

SEAL-DIE OF ELIZABETH OF SEVORC

The imagery used on aristocratic seals was meant to personify wealth and pedigree. Noblemen showed themselves on horseback to emulate representations of the king (see pp. 264–5). The conventional mode of portrayal for high-born ladies referred in part to royal female seals, which ultimately derived from the iconography of the Virgin (see pp. 198–9). From the late twelfth century, they are generally shown standing in a simple gown, their hair loose, holding a lily – a direct allusion to the Virgin – in one hand and a hawk – signifying social status – in the other. Since the flower and the bird were equally synonymous with springtime and youth, they also carried a strong romantic resonance.

These romantic associations apply to the glamorous representation of a wealthy woman on this gilt-bronze seal-die. The legend describes the seal's owner as 'Elizabeth, Lady of Sevorc' in letters given an appropriately elaborate flourish. 'Sevorc' denotes Sebourg, near Valenciennes in northern France, an area from which seals of equestrian women are unusual but not unknown. The highly fashionable Elizabeth flaunts her privilege by adopting hunting imagery, which carries with it an element of sexual allure. Hunting served as an occasion for flirtation and romance; women, meanwhile, were compared favourably with falcons owing to their beauty and their need of careful handling. Elizabeth's social self-confidence is palpable as she perches sidesaddle on her frisky mare with barely a touch of the reins. Her elegantly clad outstretched arm holds in its gloved hand an eagle's claw, while her other hand secures her falcon by thin straps. The wonderfully detailed depiction is invested with a degree of naturalism in the movement of the horse, whose tail and hind legs encroach lightly into the space reserved for the legend, and in the fall of drapery into folds around Elizabeth's raised legs and feet. The rich surviving gilding suggests that the seal-die would have appeared convincingly to be made of gold when it was new. It was designed to make an impact as powerful as any seal engraved for a male of equivalent standing and it has been suggested that seals of equestrian women imply independent wealth.

Late 13th or early 14th century
France
DIAMETER: 6.3 cm
P&E 1987,0103.1

3 INTERNATIONAL INFLUENCES

The medieval view of the world with Jerusalem at its centre is illustrated by the Psalter Map, painted in London around 1262. This convention was drawn from the Biblical commentaries of Jerome, who connected the words in Psalm 73, describing God's work of salvation as happening in the 'middle of the earth', with a passage from Ezekiel 5:5: 'I have placed Jerusalem in the middle of the peoples, and around her the lands.' The map is rendered as a cosmological diagram and was never intended to serve any navigational need. The world is represented as a circle, above which Christ gives his blessing between two censing angels. Medieval maps generally formed part of larger Latin texts probably produced for a monastic readership and they may have served as

World Map, from a Psalter Map Manuscript. England (London?), after 1262. British Library, Add. 28681, fol. 9.

contemplative aids for those whose vows prevented them from actively making a pilgrimage. Pilgrimage, trade, dynastic marriages, monastic foundations, the movement of bishops, international conflict and occupation were the principal means by which people and ideas circulated the medieval world. Significant cities for the ferment of ideas included Constantinople, Venice, Salerno, Palermo and Toledo, along with university cities such as Paris and Bologna.

The militant pilgrimages known as Crusades were first preached by Pope Urban II in 1095 as a consequence of the Seljuk capture of Jerusalem from the Fatimid caliphs of Egypt in 1071. The Seljuk regime's less tolerant attitude towards Christian pilgrimage provided the impulse for a military campaign that changed the political map of the eastern Mediterranean for almost two hundred years. The process of settlement that followed the Christian victory in 1099 was critical to the flow of Islamic influences to the west. Christian ivory carvings, textile design, glass manufacture, ceramic production and architecture were all enriched by Islamic forms and technologies. The Crusades were ultimately to have a disastrous effect on the Byzantine

Empire, which suffered a tremendous humiliation during the Fourth Crusade. For complex reasons, the Republic of Venice influenced the course of the Fourth Crusade and directed the might of the crusaders not against the Islamic territories, but against their Christian allies in Constantinople. The city fell in 1204 and remained under Latin rule until 1261 when it was won back by the Byzantine Emperor, Michael VIII Palaeologos. In the interim, Constantinople had been denuded of much of its treasures as sacred relics and artworks were transported in huge volumes to Venice from whence they were traded to the rest of Europe.

The cultural exchange encouraged by cohabitation was more influential in the relatively harmonious society fostered by Roger II of Sicily (r. 1130–54), whose court was built on the spirit of tolerance established by the Muslim occupation of the island that invited scholars of all faiths to congregate there. Palermo, along with Toledo in Spain, was established as an influential centre of translation, which exposed the Latin west to the scientific achievements of the Greeks and Muslims.

An enthusiasm for classical learning was an abiding characteristic of the medieval period, which saw both the translation of major classical works and their assimilation into Christian thought. Representations of mythological subjects decorate a wide variety of objects ranging from twelfth-century ivory counters and bronze bowls to fourteenth-century ivory writing tablets and caskets. From the mid-eleventh to the early fourteenth century there was a tremendous vogue among the wealthy and learned for collections of classical intaglios, which were often set into gold or silver mounts to serve as seal-dies or used to ornament portable altars, book covers and reliquaries. Occasionally medieval intaglios were carved in direct imitation of a classical model. The most exceptional example of a medieval artist working successfully in the classical style is certainly the Noah Cameo, which is generally attributed to the court of Frederick II Hohenstaufen, Holy Roman Emperor and King of Sicily. Frederick's court maintained the cosmopolitan flavour encouraged by his Norman predecessors and remained a hub of intellectual activity. Frederick's personal infatuation with Roman history influenced his policies and his personal imagery.

RICHARD AND SALADIN TILES

About 1250–60

Chertsey, England

Given by Dr H. Manwaring
Shurlock

LENGTH: 17.1 cm
WIDTH: 10.4 cm
DIAMETER: 1.6 cm (roundels)

P&E 1885,1113.9051–60; 9065–70

Richard I and Saladin were famous adversaries during the Third Crusade (1189–92) but they never met. The conflict shown on the tiles as Richard drives his lance through the sorry-looking Saladin is complete fiction. They were designed as part of a series of combat tiles made at Chertsey Abbey in Surrey, each one intended to reflect the glory of Richard I, also known as Richard the Lionheart. All the other tiles show lions in combat with men and act as an obvious play on words.

The tiles are among the finest medieval inlaid tiles in existence and demonstrate superlative technical skill and artistry. The figures of Richard and Saladin are beautifully rendered with a freedom that denies the restrictions of working in clay. The expressive qualities brought to the composition by the contrasting forms send a clear message to the onlooker: Richard is victorious; Saladin is vanquished. Richard's horse seems to pounce out of the frame, while Saladin's crumples beneath him. The tiles are the only ones in the combat series which carry the action from one roundel to another. This is done by the ingenious device of extending Richard's lance from one scene to the next as its point emerges from Saladin's back.

Restoration work subsequent to excavation and remounting has resulted in some changes to the original scheme. The roundels are set into mosaic tiles of foliate design and have a border of small tiles with crowns. The latter are unlikely to have been the original surrounds since there is a number of segmental tiles from the same site with individual letters which may have been used, like the legends in seal design, to identify the protagonists. The tiles almost certainly decorated an interior used by a literate audience. The subject of Richard and Saladin had enormous appeal for English kings and Henry III had it painted on the walls of the Antioch Chamber at Clarendon Palace. The subject matter and the quality of these tiles suggest they were intended to furnish a royal palace.

ICON WITH ST GEORGE AND THE YOUTH OF MYTILENE

The period of conflict and occupation caused by the Crusades saw large areas of Syria and the Holy Land fall under the control of the Latin west throughout the twelfth and much of the thirteenth century. The movement and settlement of the crusaders brought with it an inevitable cross-cultural exchange whereby ideas, technologies and styles travelled from east to west and vice versa. The resultant fusion of influences can often complicate the question of artistic attribution. This remarkable icon has been the subject of much speculation in this respect.

St George is shown not in the customary act of slaying the dragon (see pp. 24–5), but astride his nubile white horse with the miniature figure of a young boy behind him. At its least palatable level the icon functions as a piece of anti-Muslim propaganda to serve the crusading ideal. It relates the legend of a Christian slave compelled to serve Saracen masters on the island of Crete. Through the miraculous intervention of St George, the slave is rescued at the precise moment when he is serving a glass of wine to one of his captors and is transported back to his home in Mytilene. The event is drawn from a Greek text on the miracles of St George and was believed to have occurred in the tenth century. The subject is given a relief background modelled in gesso which was originally silvered to create the impression of precious metal, characteristic of icons painted in Cyprus. However, although the source of the text, the Greek inscription that identifies the saint and the treatment of the gesso all suggest familiarity and fluency with Byzantine culture, the icon may not be a purely Byzantine product. It has a number of distinctly western features, such as a certain rotundity of form, particularly around the eyes, and a Gothicizing sway to the figures. Also, scientific analysis has revealed the presence of oil in the tempera, seemingly an exclusively western practice. Recent research has attached the icon to a body of work with overtly French features and associations, including icons at the monastery of St Catherine in Sinai. One example there, showing Sts George and Theodore, has the same motif on its reverse – the True Cross in red with the sacred monogram for Jesus in Greek – as the Museum's icon. It has been suggested accordingly that these works were produced by a French artist working in the Levant.

Mid-13th century
Probably the Levant
HEIGHT: 26.8 cm
WIDTH: 18.8 cm
P&E 1984,0601.1

ICON WITH ST JEROME

15th century

Crete

Donated to the National Gallery
by Alfred de Pass, transferred
to the British Museum in 1994

HEIGHT: 34.5 cm

WIDTH: 27 cm

P&E 1994,0501.1

In 1204, after the sack of Constantinople by the participants in the Fourth Crusade led by the Venetians, huge areas of the eastern Mediterranean were placed in turmoil. The island of Crete fell from Byzantine control into the hands of the Venetians from 1210 until 1669, when it became a Turkish possession. Despite a degree of religious repression under the Venetian Republic, Crete prospered, not least through its artistic output, notably through icon painting. Indeed it has been judged that Crete was of critical importance in the continuing production and development of icons. Many that were painted in this period remained faithful to Byzantine conventions; however, others represented a fusion of Byzantine and particularly Italian Renaissance art. The combination of these two stylistic elements has helped to determine the attribution of this icon as Cretan.

It depicts St Jerome in the robes of a western cardinal, calmly extracting a thorn from the paw of an obedient lion. This legendary act of kindness secured for him the loyalty of the lion, which became one of his iconographic attributes. He is seated on an elaborate bench, itself a very non-Byzantine exercise in perspective, before a lectern, which indicates his position as a learned Church father. As he turns away from his text, freshly written, the open page reveals the following words of guidance in Latin: 'Overcome anger through patience; rejoice in the knowledge of the scriptures and you will disdain the sins of the flesh.' Jerome's role as a desert ascetic is established by the arid landscape that surrounds him. The landscape and the architectural elements it incorporates help to place this icon in the Cretan tradition. The three-aisled basilica, though deeply Italianate in style and in its appreciation of perspective, is a frequent feature in Cretan icons. The wood on which the icon is painted also fixes this panel to the Byzantine world: it is painted on cypress, used widely for Greek icons, rather than poplar, which was generally favoured by Italian panel painters.

ICON WITH ST GEORGE SLAYING THE DRAGON

Byzantine artists had a profound impact on the development of devotional art in Russia, particularly after the Russian conversion to Christian Orthodoxy in 988. The prolific use of painted icons in Orthodox worship rapidly spread to Russia, where influential centres of icon production were established in areas such as Novgorod and Pskov in the north-west. It was in a small village in north Russia in 1959 that this remarkable icon was discovered functioning as the shutter of a barn window. Successive layers of paint had been applied to the surface and it was only after painstaking conservation that the beauty of the original painting was revealed. The icon had been constructed in the conventional way, the artist having applied cloth and gesso to a piece of limewood to receive the paint. After conservation a stylistic judgement could be made about the identity of the artist, who was probably a painter from the northern Novgorod province.

Known popularly as the 'Black George' because of the distinctive black horse that St George rides, it depicts the saint in the act of slaying the dragon. The vigorous strength of the saint is shown in striking opposition to the serpent-like dragon, which recoils beneath the thrust of the bright red spear. Elements of the painting are picked out in the same red, binding the composition and directing the eye across the picture plane. In this way the vertical axis provided by the spear finds a horizontal axis in the red straps that form the trappings of the horse. Meanwhile the billowing red cloak of St George throws his halo into sharp contrast and serves to emphasize his sanctity. The emphasis is reinforced by the Cyrillic inscription – also painted in red, alongside the cloak – which spells out his name.

Around 1400–50

Northern Novgorod
province, Russia

HEIGHT: 77 cm
WIDTH: 57 cm

P&E 1986,0603.1

GOLD PENDANT (KOLT)

The survival of significant pieces of fine jewellery from Kiev, the ancient capital of the Slav state of Kievan Rus', reflects the prestige and magnificence that surrounded the Kievan court in the late eleventh and early twelfth centuries. Archaeological evidence suggests that it was served by a network of jewellers' workshops closely associated with it. This exceptional gold and enamel kolt, possibly designed to be suspended from a headdress, was originally fashioned as one of a pair. The kolt would have been worn at official ceremonies by a woman of considerable social standing. Four loops around the edge were designed to support a string of pearls, now missing, and its hollow interior was probably intended to contain aromatic herbs. What remains is of outstanding quality. The cloisonné enamel is set into cells formed by gold strips to create opulent patterns. On the reverse, a quatrefoil within a circle is placed between two stylized crescents. On the front, two birds turn to confront one another over a central roundel. Their tail feathers and general demeanour suggest that they are probably meant to portray doves; they may carry Christian significance as symbols of the Holy Spirit. The cloisonné enamels show the influence of Byzantine art and technology while the decoration suggests a fusion of Christian and oriental impulses. It is highly likely that the kolt was separated from one of the hoards found in the city in the nineteenth century (see pp. 276–7).

Late 11th–early 12th century
Kievan Rus' (modern Ukraine)
Bequeathed by William Burges
HEIGHT: 4.1 cm
P&E 1881,0802.3

A BRACELET AND PENDANT FROM THE KIEV HOARD

Between the tenth and thirteenth centuries, the city of Kiev, in the present-day Ukraine, was the capital of an expansive and powerful Slav state known as Kievan Rus'. Little material evidence survives of the wealth and sophistication of the culture that it produced, but significant assemblages exist in the National Museum of Ukraine and the Museum of Historical Treasures of Ukraine in Kiev and at the Armoury Museum in Moscow. In addition, the Metropolitan Museum of Art in New York was gifted two groups of gold and enamel jewellery dating from the eleventh and twelfth centuries by the eminent collector J. Pierpont Morgan. The material came from hoards discovered in Kiev in 1842 and 1906. Pierpont Morgan separated the silver and niello jewellery from the 1906 hoard found at Trekhsvyatytelska Street (the Street of the Three Saints) and donated it to the British Museum. The complete hoard consisted of more than seventy pieces of fine jewellery and coins with two silver ingots.

The two examples featured here are selected to demonstrate the stately splendour of the find. The bracelet is made of hammered sheet silver. It opens by a hinge on one side and is closed by a removable pin on the other. Its surface is divided into six arcades engraved with the figures of birds and large foliate motifs. The design was originally entirely inlaid with niello, which now only partially survives. It would have been a high-status piece and was probably produced by a workshop attached to the ruling dynasty in Kiev. The birds engraved on the bracelet have been interpreted as the symbols of this princely family. The pendant is an example of female court regalia and may have been worn as an earring or suspended from a ceremonial headdress or crown. In its centre is a representation of a griffin set against a nielloed ground. The decorative openwork border is constructed of filigree wires enclosed by a beaded wire rim. When found, the hoard was contained in a lead box and was probably concealed at the time of the Sack of Kiev by Tartar forces around 1240.

Late 11th or 12th century

Kievan Rus' (modern Ukraine)

Gift of J. Pierpont Morgan

DIAMETER OF BRACELET: 6.9 cm

DIAMETER OF PENDANT: 5.2 cm

P&E 1907,0520.1 (bracelet);

P&E 1907,0520.13 (pendant)

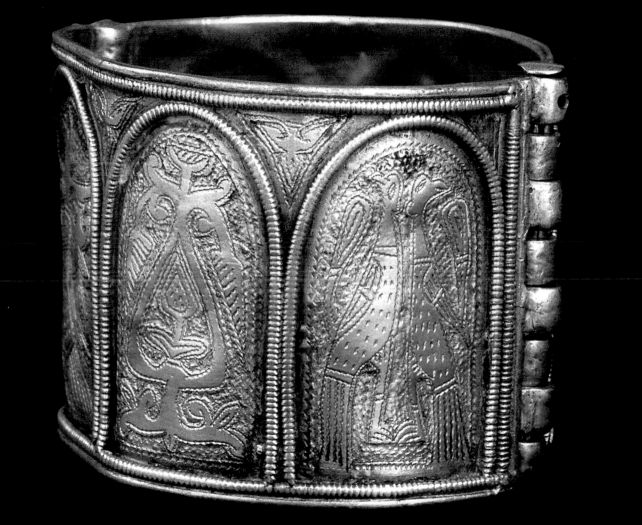

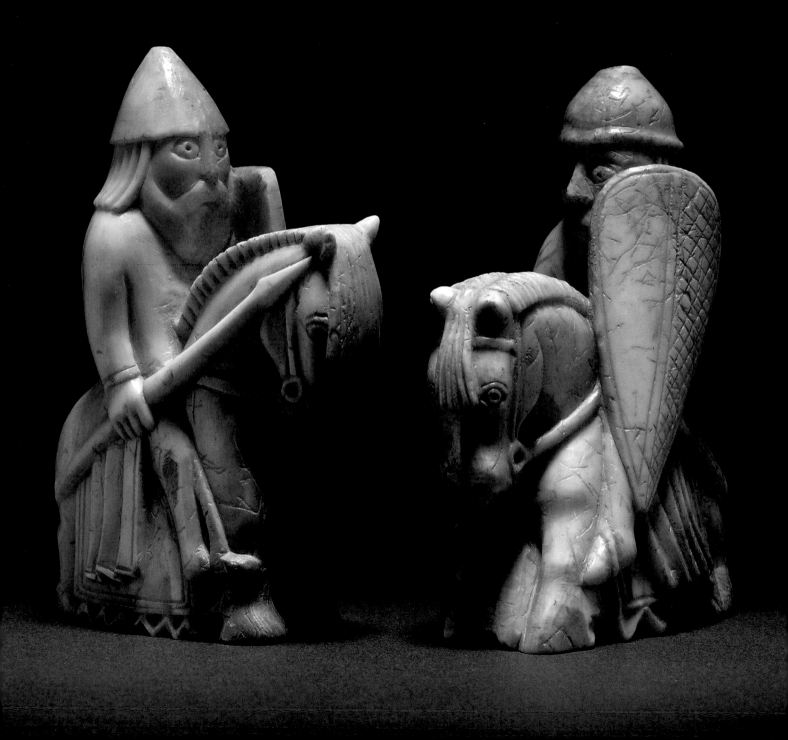

THE LEWIS CHESSMEN

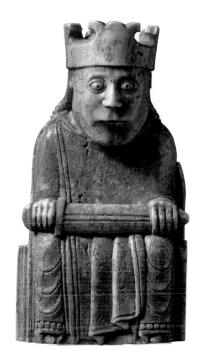

The Lewis chessmen are possibly the most famous items in the medieval collection at the British Museum. Made from walrus ivory, they were found with an intricately carved, ivory belt buckle and fourteen ivory counters in the vicinity of the bay of Uig on the Isle of Lewis. No one can be sure when or why they were deposited there, and the circumstances of their discovery are equally mysterious. What is certain is that they were found before 11 April 1831, when they were first exhibited at the Society of Antiquaries for Scotland in Edinburgh.

The chessmen are a rare survival of secular twelfth-century culture and act as a measure of the luxury that enveloped the aristocratic circles of northern Europe. Seventy-eight pieces survive (sixty-seven at the British Museum and eleven at the National Museum of Scotland in Edinburgh). The principal pieces of king, queen, bishop, knight and rook exist in sufficient numbers to suggest as many as four original complete sets. The fact that such a quantity was found along with other items carved from walrus ivory might imply that they were the valuable stock-in-trade of a travelling merchant who was forced to store them on the island in an emergency and was fated never to return.

Originating in sixth-century India, the game of chess came to Europe ultimately through the Islamic territories of southern Spain and Italy. In Europe it retained its character as a war game designed to develop strategic thinking and was seen as one of the seven knightly accomplishments.

The distinctive pose of the queen in the Lewis chessmen probably excites more interest in modern audiences than any almost other aspect of the assemblage. Her sullen looks are, in fact, probably an expression of contemplation or grieving taken from contemporary images of the Virgin Mary. The thrones of the queens, kings and bishops, which are individualized in a style that incorporates zoomorphic decoration, geometric interlace and architectural motifs, help to fix the chess pieces stylistically to the walrus ivory workshops of Scandinavia, and, most probably, Norway.

About 1150–1200

Probably made in Norway

Found on the Isle of Lewis, Outer Hebrides, Scotland

HEIGHT: up to 10.3 cm

P&E 1831,1101.78–159

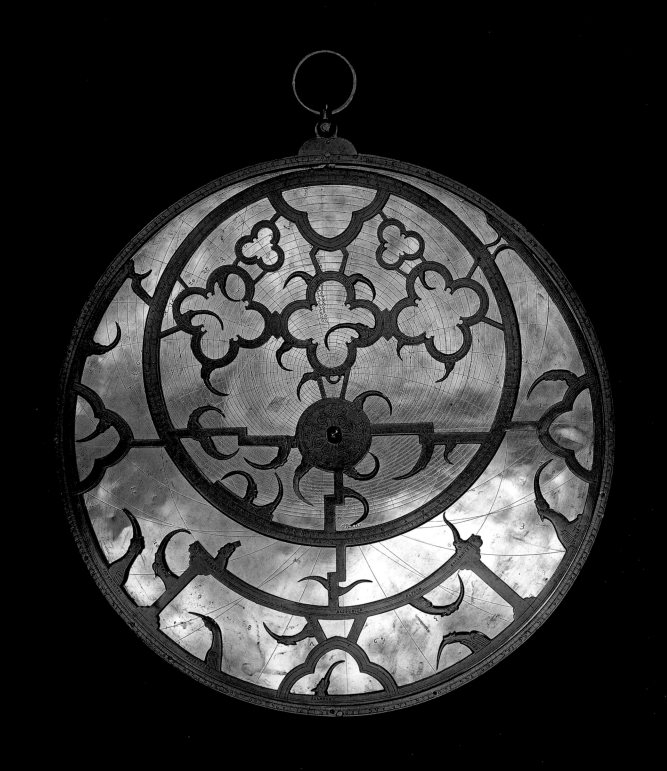

THE SLOANE ASTROLABE

The so-called Sloane Astrolabe is one of the oldest and most enigmatic mathematical instruments in the medieval collection of the British Museum. Its size and stunning design, encompassing animals and mythical beasts of delightful detail, make it intriguing to behold before one even considers its function.

Astrolabes are basically two-dimensional maps of the three-dimensional celestial sphere, meaning that the most important stars and the main celestial circles such as the tropics, the ecliptic and the celestial equator have been projected onto a flat plane. This construction process, which was known to the ancient Greeks, is similar to that used in the production of a map. Astrolabes are among the most sophisticated instruments made before the invention of the computer, enabling the user to determine the time in different hour-systems at day and night, to establish heights and angles, and to facilitate the casting of horoscopes. As the astrolabe is capable of determining the time of prayer according to the rules that guide every Muslim, it was particularly popular in the Islamic world.

This astrolabe was named after Sir Hans Sloane as it formed part of his collection, which became the basis of the British Museum in 1753. The object is made of brass, but the application of lacquer at some point in the past has resulted in the darker colour of most of the components. Every astrolabe can be used at a variety of latitudes for which the inlaid flat discs, the so-called 'plates', are engraved. The Sloane Astrolabe has three plates that are laid out for six different latitudes between 48 degrees 30 minutes and 54 degrees, i.e. for most of Europe. Only one city is mentioned: Lundoniarum (London) on the plate for 52 degrees. The back is highly decorated with interwoven mythical animals and foliate scrolls. Engraved on it are several calendrical scales which enable the user to calculate the dates of the movable Christian feasts, and to read off the names of forty-eight saints. The presence of the names of three saints of particular English significance – Dunstan, celebrated 19 May; Augustine of Canterbury, 26 May; and Edmund, 20 November – together with the plate marked for London, and the overall design make an English origin most likely. Sadly, the Sloane Astrolabe is now incomplete: the ruler needed to take readings is missing.

Around 1300
England
Bequeathed by Sir Hans Sloane
DIAMETER: 46 cm
DEPTH: 1.2 cm
P&E SLMathInstr 54

THE CHAUCER ASTROLABE

Inscribed 1326, this is the earliest dated European astrolabe; we know little about instrument-making in England before that date. The saints' days marked on the back of the astrolabe clearly indicate its English origins, and one of the plates is marked for the latitude of Oxford. The other plates are marked for Jerusalem, 'Babilonie', Rome, Montpellier and Paris, but this does not necessarily imply that the owner of this instrument travelled to those places, since an astrolabe could be used for calculations as well as for observations. Another important English astrolabe in the British Museum's collection is inscribed 1342 and is signed by its maker, the otherwise unknown Blakene (P&E 1853,1104.1).

During the fourteenth century, there were several different texts circulating on the construction and use of the astrolabe, usually in Latin. They were widely copied by monks and scholars, and are frequently listed in library booklists of the period. Towards the end of the century, Geoffrey Chaucer (c. 1342–1400) prepared the first English-language treatise on the astrolabe, dedicated to his son Lewis but intended for a much wider readership. This text survives in more than thirty manuscript copies, some of which are illustrated with diagrams. The text describes and depicts the parts of an astrolabe very similar to this one, with a Y-shaped rete, a dog-shaped pointer for Alhabor (the 'dog star' now known as Sirius) and other star-pointers in the shape of birds. These similarities meant that this instrument came to be known as the 'Chaucer Astrolabe', and it provides valuable evidence of the kinds of instruments around in England when Chaucer was compiling his *Treatise on the Astrolabe*, a text that still provides a useful manual for how to observe and calculate with the instrument.

There is another group of astrolabes, including one in the Museum's collection (P&E 1914,0219.1), which bear even stronger similarities to the description and illustrations in Chaucer's text; some have even been claimed to be Chaucer's own astrolabe. Close examination of the manuscripts and texts shows, however, that most of these were made after Chaucer's death – perhaps linked to his increasing posthumous fame and his growing reputation as a polymath as well as a poet – and should be considered an astrolabe just like Chaucer's, rather than Chaucer's own.

1326

England

DIAMETER: 13.2 cm
DEPTH: 1 cm (mater)

P&E 1909,0617.1

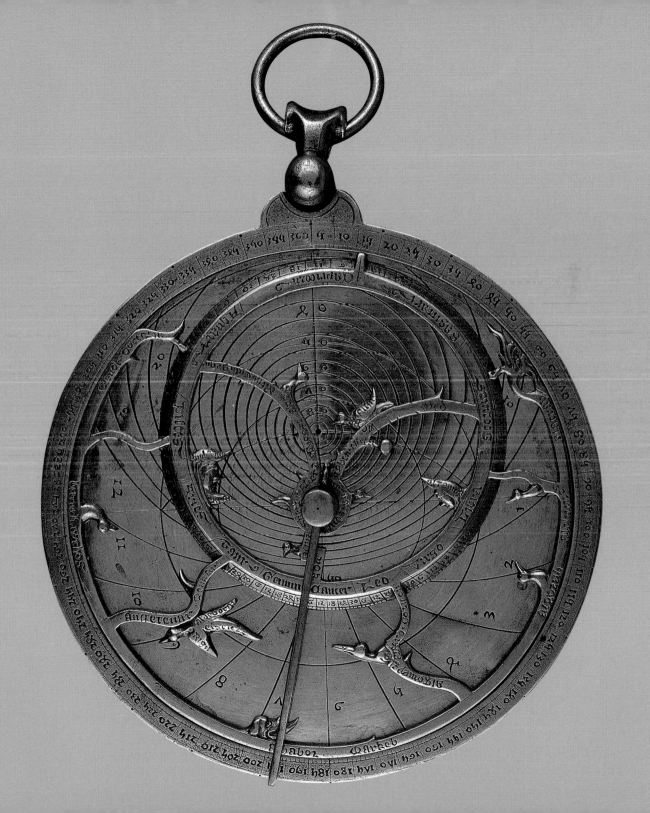

MARBLE SLAB FROM A TRANSENNA

10th century

Probably from Constantinople
(modern Istanbul, Turkey)

HEIGHT: 92 cm
LENGTH: 245 cm

P&E 1924,1017.1

The military successes of the Middle Byzantine Macedonian dynasty led to a period of affluent artistic development generally termed the 'Macedonian Renaissance'. New churches were constructed, free from the constraints of iconoclasm (see pp. 48–9), and a new style of ecclesiastical architecture evolved. The classical basilica-style church gave way to a more compact, cruciform structure around a central dome, which saw a greater use of architectural sculpture.

This commanding marble relief is likely to have served as an enclosure screen, or transenna. Its bold forms display images that must have held specific symbolic significance for a Byzantine audience. In the centre is an imperious eagle, depicted as if floating rather than airborne, with a snake in its talons. The snake is not submissive but rises up to confront the eagle. To either side is a representation of another eagle, each descending on the more passive prey of a hare. The treatment of the central eagle is distinctively different. Its plumage is denser, covering its breast and neck, and the treatment of the profile is emphatically crisp. The whole scene is rather static, although the extended wings of the eagles convey the impression of impending flight. Further meaning may be intended by the inclusion of foliate motifs in the form of vine scrolls, which divide the panel. The motif of an eagle with a hare or a snake occurs in other examples of Middle Byzantine sculpture and may take its inspiration from Near Eastern art, perhaps as a consequence of Byzantine military activity in Anatolia in the tenth century.

THE BORRADAILE OLIPHANT

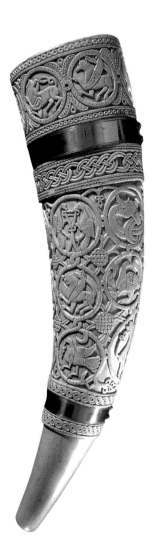

An oliphant is a large hunting or sounding horn, its name derived from the Old French word for 'elephant' to describe the fact that it is made from an elephant tusk. These exotic objects were made in large numbers in the eleventh and twelfth centuries and represent something of a puzzle. They demonstrate a mixture of Islamic and Christian elements but survive only in the West and are considered to have been produced exclusively for European consumption. A number of examples exist in European cathedral treasuries with firm medieval provenances. The long established view is that they were produced in southern Italy, where Byzantine and Islamic influences flourished, although recent speculation has suggested that they were made in Fatimid Egypt purely for export.

The Borradaile Oliphant, named after the collector who bequeathed it to the British Museum, is a particularly fine example of robust proportions with an impressive degree of preservation. The carving remains crisp and the ivory brilliant. It is decorated with a series of connected roundels, which relate to Islamic textile designs, highly prized at the time. Each circle is separated either by leafy fronds, in the top band, or by stylized clusters of grapes along the body. They contain animals such as griffins, lions, snakes, peacocks and pairs of confronting eagles. The arrangement is very close to that adopted by Islamic horns but the treatment is markedly different and certain motifs such as the peacock drinking from a chalice is derived from late antique art.

11th century
Possibly southern Italy
Bequeathed by Charles Borradaile
LENGTH: 54.9 cm
P&E 1923,1205.3

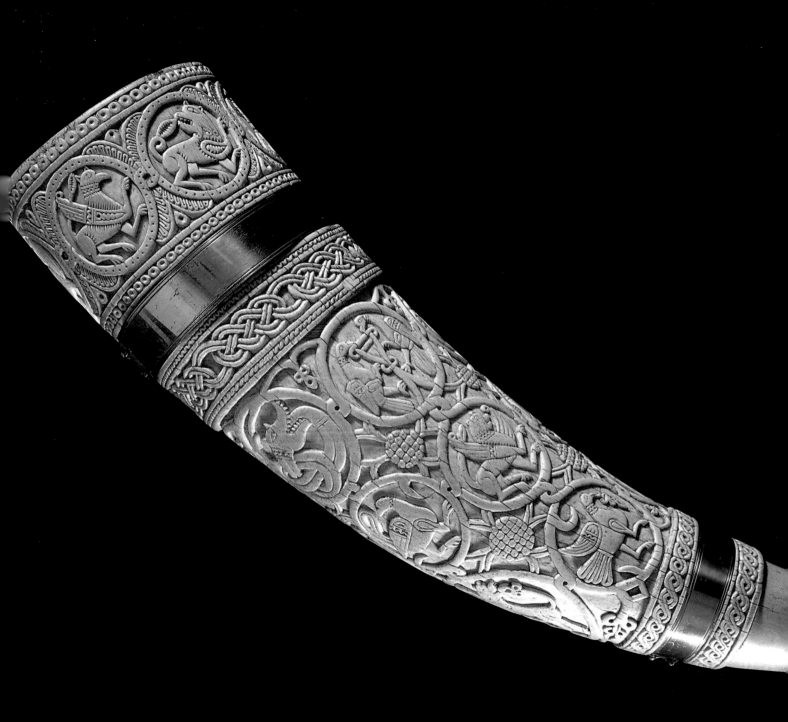

THE NOAH CAMEO

Carved from onyx, this rare medieval cameo depicts the dramatic moment when Noah and his family emerge from the ark. The scene is largely static, a frozen moment in time. However, each small gesture is psychologically significant in communicating a sense of liberation. Birds reaccustom themselves to the air with a flurry of agitation on the roof of the ark, outstretching their wings and preening; a stallion stamps his foot on the ground; the dogs sniff the earth. The cameo carver shows great skill and sensitivity in the way that he manipulates both his subject and his medium. The natural discolouration of the stone is used to describe the plumage of a pair of birds. The use of light and shade is masterly, creating a sense of space as the animals in the foreground are rendered systematically lighter than their partners who fall into shadow. The animals appear in miniature but are perfectly proportioned as pairs.

Very few medieval cameos survive and they rarely achieve the level of sophistication and skill offered by this one. It attests to the continuing production of extremely high quality cameos long after the fall of the Roman empire. Its exceptional qualities suggest that it may have been produced at the court of the king of Sicily, the Holy Roman Emperor Frederick II (1194–1250). The intellectual and artistic tenor at this time of the south of Italy and Sicily, where Catholic and Orthodox Christians, Jews and Muslims all lived in relative harmony, contributed to a movement in Europe termed the twelfth-century Renaissance. The cameo's classical influences include the treatment of drapery, which adheres to the anatomy in the style of the late antique. The male nude in the centre of the family group displays a physique that is equally classical in inspiration.

Highly prized from the moment it was created, the cameo continued to attract the attention of art lovers. It received a gold mount in the fifteenth century and passed into the hands of the Medici of Florence, where it is described in a collection inventory in 1465. Lorenzo de' Medici (1469–92) clearly had a particular love of the piece since he had his name, 'LAVR MED', engraved on one of the doors of the ark.

1200–50
Sicily or southern Italy
LENGTH: 5.3 cm
P&E 1890,0901.15

THE CLEPHANE OLIPHANT

The Clephane Oliphant takes its name from the family reputed to have owned it in the Middle Ages. Its traditional home was Carslogie Castle in Fife, the historic seat of the Clephane family. Famously, Sir Walter Scott described the oliphant being used to sound the alarm from the battlements of the castle. Although no documentary evidence supports the assertion of its existence in medieval Britain, the attraction of the oliphant as a collection piece for a wealthy pilgrim or a crusader and the possibility that it may have been formally gifted through an unknown transaction cannot be entirely discounted. The uncertain history of the oliphant is compounded by the question of which centre of production was responsible for making these fabulously exotic objects. Scholarly opinion on the issue has wavered but the general consensus has been that all oliphants were made in southern Italy, where the cultural mix of strong Christian and Muslim populations would account for the fusion of Byzantine and Islamic elements in their design. A further possibility, recently raised, is that the source for the oliphants may be Fatimid Egypt, where they were produced for an elite export market.

The Clephane Oliphant is a complete elephant tusk carved in relief with fabulous beasts and luxurious foliate motifs. Vegetal scrolls decorate two bands that originally would have framed a silver mount close to its mouth. The space in which the mount was positioned is left blank to accommodate it. A similar blank space occurs at the narrow end, where a second mount was fitted to enable the oliphant to be worn by suspension from a shoulder strap. This space is encircled by stiff acanthus leaves, which have strong classical associations. An interest in classical antiquity is given greater prominence on the body of the tusk, which carries scenes from the Hippodrome. Charioteers drawn by four horses race around the top register and staged hunting events with wild and domestic animals are arranged beneath it. A judge occupies a space at the bottom, equipped with palm fronds to give to the winners.

11th century

Possibly southern Italy

LENGTH: 57.5 cm
WIDTH: 11.5 cm

P&E 1979,0701.1

GOLD AUGUSTALE OF EMPEROR FREDERICK II AS KING OF SICILY

Frederick II, King of Sicily (r. 1198–1250) and Holy Roman Emperor (from 1220), was born into the princely German house of Hohenstaufen and was destined to rule over an empire more vast than any since the days of imperial Rome. He inherited the Norman kingdom of Sicily, which he ruled from Palermo, establishing a court that became a centre for international intellectual activity. Frederick's fascination with ancient Rome was expressed through his particular admiration of the Emperor Augustus. His *Liber Augustalis* (Book of Augustus) expounded his political belief in an absolutist state and his military victories were marked with triumphal processions.

He placed a great deal of confidence in the ability of art to act as propaganda and had himself portrayed in the manner of a Roman emperor on this gold coin. The coin was produced in 1231 and served as a novel power statement. Known as an *augustale*, it was modelled on the Roman soldus and shows Frederick in profile, crowned with a laurel wreath and wearing a Roman-style breastplate. On the reverse is the imperial eagle. The coin was struck in high relief to give a powerful impression and, significantly, it was made of gold. Few countries in Western Europe were in a position to mint a gold coinage. Sicily, Spain and the crusader states, however, were able to exploit supplies of the metal from sub-Saharan Africa. The resulting coins were heavily influenced by Islamic designs. Frederick's innovation was to produce a self-consciously classical-style coin. The emphatic design was part of a more integrated policy to portray Frederick as an all-powerful Caesar and to challenge the authority of the papacy. The *augustale* was widely circulated in Italy and was largely responsible for the revival of gold coinage in Western Europe from the 1250s.

1231–50
Sicily
Gift of Dr F. Parkes Weber
DIAMETER: 1 cm
CM 1906,1103.3558

THE CADMUS BOWL

The Cadmus bowl was almost certainly designed as a partner for the Scylla bowl (see pp. 296–7). They were found in June and July 1824 by workmen constructing a bridge over the river Severn between Tewkesbury and Gloucester. The proximity of the Priory of Deerhurst could explain the loss of these highly literary utensils, although they may have been used in either a sacred or a secular setting. This bowl takes its name from the central representation of Cadmus, King of Thebes, credited as the mythological inventor of the Greek alphabet, who is shown accordingly seated at a lectern writing in a book. A surrounding Latin inscription explains the scene's significance. Six other episodes are arranged within semicircular inscriptions around the bowl. Above the central scene is the birth of Hercules, followed by the first of the hero's legendary displays of strength: the goddess Hera, provoked by jealousy, sends two serpents to destroy the infant Hercules, which he kills by strangulation. The remaining roundels are devoted to a seemingly random selection of the Labours of Hercules, some conflated into two scenes by the Latin hexameters that describe them. Hercules fights the dragon that guarded the apples of the Hesperides; next he assails Geryon, the three-headed monster, who is shown here as a conventional king. The surrounding verse also alludes to the death of the hydra. The same narrative technique is applied to the next scene, showing the defeat of Cacus but referring also to the overthrow of Cerberus. The final scene depicts the death of the hero. Overcome by the poisoned garment given to him by his jealous wife Deianira, Hercules places himself on his funeral pyre (see detail at left). As the flames lick around him, he sits passively accepting his fate, his club rendered useless against death, propped against a clump of trees.

The subjects of Cadmus and Hercules may have been used here because of the association of classical mythology with Christian themes; thus Cadmus prefigures the Evangelists, particularly St John whose opening verse affirms, 'In the beginning was the Word'. Hercules, meanwhile, the only mortal to achieve divine status, may be seen as a precursor to Christ, his Labours an anticipation of the Passion.

12th century

Probably German

Given by Joseph A. Gardiner

DIAMETER: 26 cm

HEIGHT: 4.6 cm

P&E 1921,0325.1

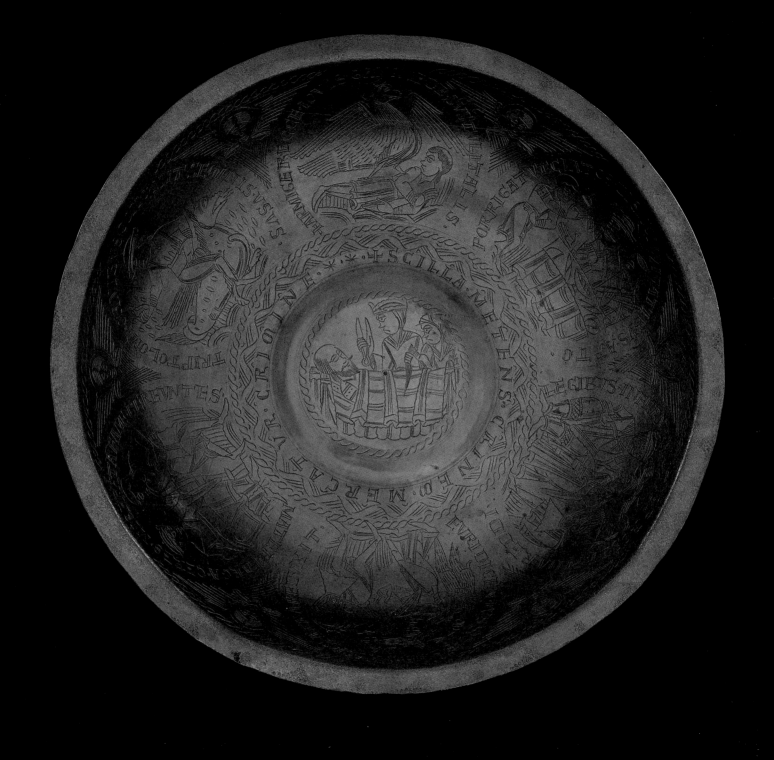

THE SCYLLA BOWL

12th century

Probably Germany

Given by Miss Lawrence in memory of Walter Lawrence

DIAMETER: 25.8 cm
HEIGHT: 4.6 cm

P&E 1925,1008.1

A large number of hammered copper-alloy bowls survives from different contexts around Europe and beyond. They are usually associated with speculative areas of production in Germany, but their wide distribution has thus far made any convincing attribution elusive. England, Scandinavia and the Low Countries have also been suggested as potential places of manufacture for some of the bowls, which were clearly widely traded. All follow roughly the same formula of a central depiction around which are grouped individual scenes identified by Latin inscriptions. They are generally characterized by a relatively uniform depth and by the construction of a flat, narrow rim, frequently engraved with hatched triangles.

This bowl takes its name from the engraving in the central roundel, which depicts Scylla stealing away with a lock of her father's hair. Scylla was the daughter of Nisus, King of Megara, who tragically fell in love with her father's enemy, King Minos. In order to gain the favour of Minos, who was laying siege to the city, she secured for him the lock of hair on which the power of her father depended. This done, Minos was victorious and killed the defeated Nisus. However, so disturbed was he by the treachery of Scylla that he set sail without her and she was drowned trying to pursue him.

The significance of the scene is not entirely clear but the bowls operated in a didactic way, combining the utilitarian act of washing with education. They are laden with text – composed in debased hexameters – and were undoubtedly intended to be read. The other six scenes are arranged in pairs and relate to the stories of Orpheus and Eurydice, Ganymede and Ceres and Triptolemus. The common source for the myths was probably Ovid's *Metamorphoses*, which was immensely popular in the Middle Ages, not only a source of classical learning but also of Christian instruction. Mythological scenes were routinely given a range of Christian meanings by ecclesiastical scholars. There is convincing evidence that the bowls were used in pairs and the thematically compatible Cadmus bowl (see pp. 294–5), of close proportions, was found on the same site a month before the Scylla bowl.

IVORY TABLEMAN WITH THE BIRTH OF HERCULES

The ivory workshops of Cologne enjoyed a brisk international trade in the twelfth century utilizing supplies of walrus tusks which arrived from Scandinavia to supplement the scant availability of elephant ivory. Among the city's celebrated products were fine quality tablemen, used in a game similar to backgammon, which took as their subjects stories from the Bible, classical mythology and astrology, among others (see pp. 148–8 and 174–5). The adventures of Hercules were an extremely popular choice among the carvings, reflecting an enthusiasm for classical learning that is one of the distinctive qualities of the twelfth century, when numerous translations of classical texts were made available. Hercules represented extreme valour and perseverance and was understood as a personification of virtue by medieval commentators. He enjoyed the unique privilege of being the only mortal in classical mythology to be made a god and his various triumphs over evil were seen as an anticipation of Christ's victory over sin and death (see pp. 294–5).

An episode connected with the birth of Hercules is represented by this expertly executed tableman. The complex treatment of the narrative makes for a packed composition, which the ivory-carver handles with great confidence. The naked figure on the right, grappling with two serpentine monsters, is the infant Hercules, who fends off the two serpents sent to destroy him by the jealous goddess Hera. He is shown here in the act of strangling the beasts. The seated female figure on the left is probably the goddess herself, who is shown in a scene of continuous narrative releasing the two beak-headed serpents from the container she holds on her lap.

Around 1150
Cologne, Germany
DIAMETER: 6 cm
P&E 1929,0604.1

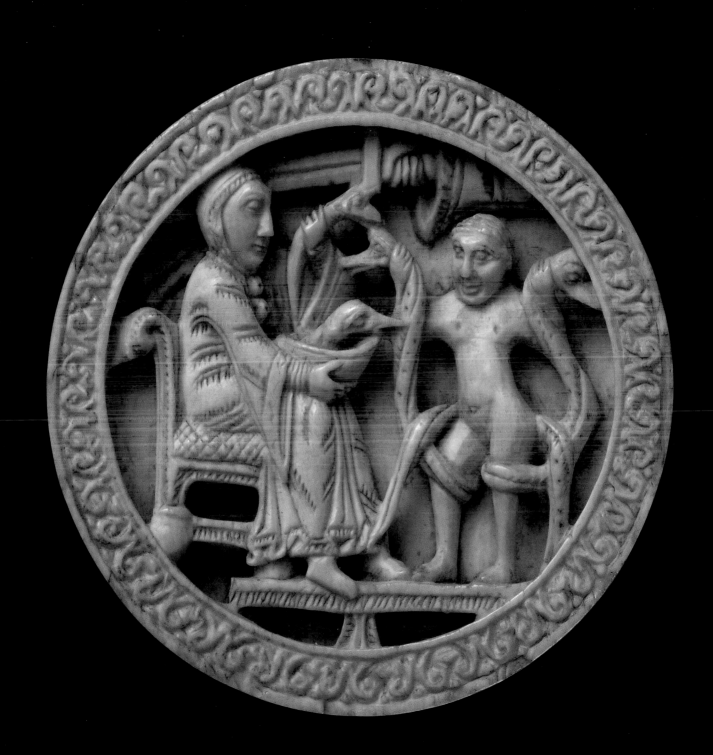

GOLD SEAL-DIE WITH A JASPER INTAGLIO

An interest in classical culture was a pervading characteristic of medieval intellectual life. From the twelfth to the fourteenth century this was given prominent expression by the widespread use of ancient Greek and Roman intaglios in the sealing of documents. Their scale made them best suited for use as counter-seals or private seals and they were generally set into oval gold or silver mounts or signet rings which were engraved with legends. The legends sometimes identified their owners, but more frequently they announced the seal as 'sigillum secreti', a secret seal, or referred to the iconography in a knowing or playful way. Consequently a seal set with a late imperial intaglio of Hercules has the French legend 'QVI ME PORTE SIEST LE MVS' ('Who carries me fares best') in an obvious allusion to the mythical strength of the classical hero.

The question of how adept the audience for these gems was at interpreting their subjects has been a matter of some debate. However, it is now generally accepted that the desire to collect them was prompted by knowledge, and that ownership of such a seal demonstrated taste, education and wealth. The artistic merits of the intaglios occasionally led to medieval imitations of the classical stones. This remarkable red jasper gem set into a gold mount reveals a familiarity with classical female portrait busts, and, specifically, with representations of the Roman goddess Ceres, who was associated with corn and fertility. It shows a young woman wearing a fashionable headdress tied under her chin, her hair piled up in a coiled plait drawn from classical prototypes. The sprig of foliage that she confronts seems to be influenced by representations of Ceres such as that on a nicolo set into an early fourteenth-century gold signet ring (Dalton 224, illustrated at left).

The classical inspiration may not be intended to convey more than an appreciation of a beautiful woman, the spray of flowers endowing the image with the scent of spring and connotations of love. The legend is in Latin and means 'I cover the enclosed secrets', making it clear that the seal was used in closed correspondence. The need for secret or 'privy' seals became more intense as the administrative pressures on large estates grew and personnel expanded.

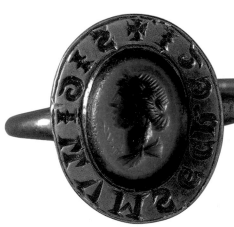

Early 14th century
England
HEIGHT: 2.5 cm
WIDTH: 2.2 cm
P&E 1881,0312.1
(Tonnochy Catalogue 705)

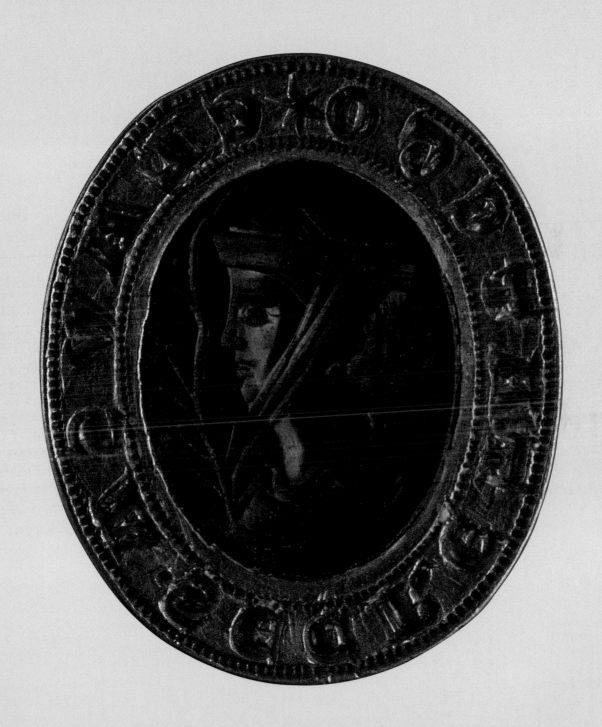

RELIQUARY CASKET OF ST THOMAS BECKET

The shrine of St Thomas Becket at Canterbury was the most visited in England and one of the four most popular pilgrim destinations in Europe, along with Rome, Santiago de Compostela and Cologne. The wealth of the shrine and the riches that furnished it were legendary.

The front of this enamel reliquary depicts the events of the night of 29 December 1170, when four knights – Reginald FitzUrse, Richard le Bret, Hugh de Moreville and William de Tracy – stormed Canterbury Cathedral (see pp. 112–13). There they found Becket, praying before an altar, and brutally slew him. On this casket Becket is seen accepting his fate passively, with head bowed. The knights, however, are in a flurry of agitation and hesitation. The drapery of the knight dealing the fatal blow billows at its hem to express violent movement. The second knight turns rapidly to unsheathe his sword, while the fourth grasps the arm of the third in a gesture that suggests restraint. The whole scene is choreographed with remarkable skill to suggest an act of haste with the hint of repentance. In the upper register, the funeral of Becket is depicted with due solemnity.

After the death of Becket, Henry II was publicly penitent. Becket was canonized in 1173 and the Plantagenet family promoted his veneration through donations at his shrine and by making gifts of his relics to religious houses and churches throughout Europe. The relics were contained in reliquaries such as this one, made at Limoges in south-west France, then part of the English duchy of Aquitaine. This reliquary is among the finest of more than forty that survive. It was collected by Sir William Hamilton (1730–1803) while he was travelling in Naples and may have found its way there through the influence of Joanna, daughter of Henry II, who married William the Good of Sicily in 1177.

12th century

Limoges, France

On loan from the Society of Antiquaries of London

HEIGHT: 15.5 cm
LENGTH: 21 cm
WIDTH: 9.5 cm

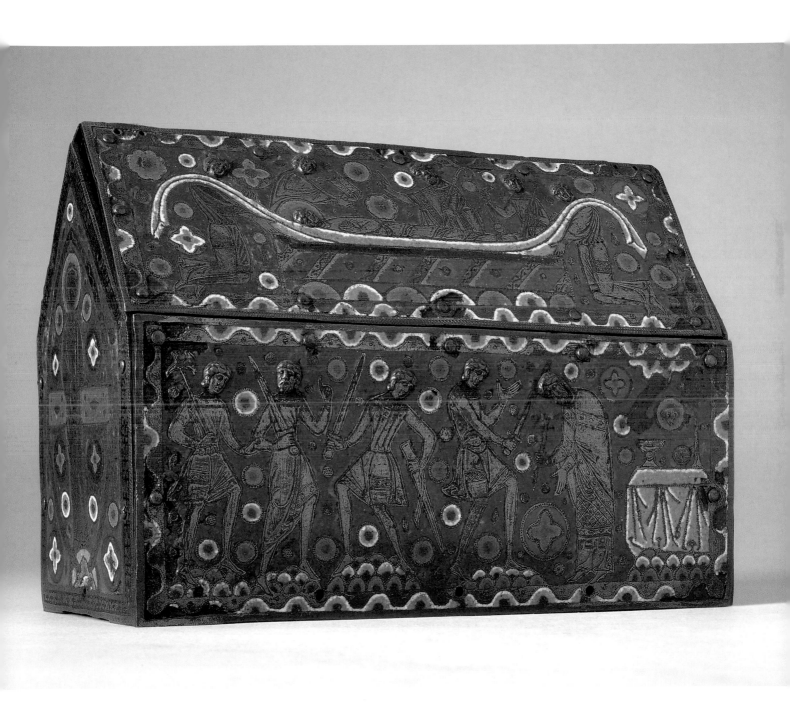

GOLD SALUTO OF CHARLES I OF ANJOU, KING OF SICILY

Religious images such as crosses and patron saints proliferated on medieval coins. Much rarer, however, were narrative scenes from the Bible or lives of saints. An unusual and attractive exception is the Annunciation, described in Luke 1:26–38, when the archangel Gabriel announces to the Virgin Mary that she will conceive the Son of God. Two important gold coins utilize this scene, one being the saluto of Charles I of Anjou, King of Sicily.

Charles of Anjou (r. 1266–85), the younger brother of Louis IX (St Louis), King of France, took power in the kingdom of Sicily as the pope's nominee, following a long struggle between the papacy, as overlords of Sicily, and the Hohenstaufen emperors, who inherited the kingdom. King Manfred, son of Emperor Frederick II, was killed by Charles's armies at the Battle of Benevento in 1266 and the emperor's grandson Conradin was captured and executed in 1268.

During his reign Charles brought Sicilian coinage into line with contemporary western developments by introducing a new coinage of virtually pure gold. Rare evidence survives of the king's direct and personal involvement in the design of this coinage, with its elegantly balanced scene: Gabriel and the Virgin stand to either side of a flowering lily, one of the Virgin's main symbols. Charles's personal religion seems to have been very conventional and shows no especial devotion to the Virgin. It is possible that the use of the scene should be read as a propagandist indication of a new dispensation in the kingdom, in opposition to the allegedly schismatic and treacherous Hohenstaufen.

The other side of the coin reflects Charles's ambitions in the eastern Mediterranean. He worked relentlessly to overthrow the restored Byzantine empire and the coin design shows another direction of his endeavours, depicting a shield with the conjoined arms of the kingdoms of Sicily and Jerusalem, as he purchased a claim to the latter in rivalry to the kings of Cyprus. These ambitions led to his greatest setback. In the Sicilian Vespers of 1282, the inhabitants of Sicily rebelled, with aid from Byzantium and Aragon, whose king was married to the daughter of King Manfred. The Aragonese took over Sicily, and at his death Charles only remained in control of the mainland part of the kingdom around Naples.

1266–85
Sicily
DIAMETER: 2.3 cm
CM C.2775

HÉDERVÁRI CRUCIFIX

The traditional iconography of this exquisitely fashioned processional cross is given a courtly character by the heraldic devices which are set around its knop. These offer extremely valuable clues to the period of its manufacture and the details of its commission. The coat of arms of Hungary and the insignia of the Hédervári family indicate that it was made during the reign of Charles I of Hungary (1288–1342). An outstanding act of heroism connected the life of Charles I to the Hédervári. In 1330 the noble Desso Hédervári sacrificed his own life by dressing in the king's armour, allowing Charles I to escape a Romanian ambush. It is a firm possibility that this regal cross was commissioned by his family to commemorate the event.

It appears that little expense was spared in the commission. The uncompromisingly high standard of the metalwork suggests that a goldsmith of some considerable standing was involved in its production. The dazzling translucent enamels have a distinctly Italian appearance and this has led to the opinion that a Sienese goldsmith, Peter Gallicus, was most probably responsible for the cross. Peter Gallicus was working in the Hungarian court in the 1330s and, if not personally responsible for its execution, he must certainly have influenced its design and enamelling technique. The enamels are predominantly deep blue in colour and contain representations of the Virgin and St John the Evangelist (to each side of the figure of Christ) with an image of Christ in Majesty at the top and the figure of Adam emerging from his tomb at the bottom. According to Christian mythology, the site of the Crucifixion was coincidentally the burial place of Adam. This divine placement of the Crucifixion gave very physical expression to Christ's atonement for Adam's sin. Christ's sacrificial qualities are expressed further on the reverse where the central image, between the symbols of the four evangelists, is the Agnus Dei, a symbolic representation of Christ as the Lamb of God taken from the teachings of St John the Baptist. The spaces between the principal enamel plaques are filled with smaller quatrefoils enamelled with stylized floral motifs and birds.

Around 1330
Hungary
Bequeathed by
Charles Borradaile
HEIGHT: 56.9 cm
P&E 1923,1205.10

THE RUSPER CHALICE

Chalices enjoyed a special status in the performance of the Liturgy in the medieval period. Eucharistic doctrine promulgated at the Fourth Lateran Council in 1215 stated that through the miracle of the Mass, the consecrated wine actually became the blood of Christ. Concerns about the sacredness of the sacrament prompted periodic stipulations on the suitability of materials in the manufacture of chalices. From the thirteenth century gold and silver were felt to be the only appropriate metals for the reception of the Eucharist. Chalices made to be interred with a priest upon his death were exempt from this ruling and could be made of tin. The Rusper chalice survives as another exception to the rule. It is made of gilt-copper alloy decorated with champlevé enamels in the Limoges tradition. It was found in 1840 in the grave of a nun at Rusper near Horsham in Sussex. However, it may not have been made purely as a funerary chalice since the Church decreed that gilt Limoges enamel chalices could also, exceptionally, be used in the Mass. This remarkable statement reinforces the very high value that was placed upon Limoges enamelled liturgical vessels.

Regrettably, the chalice has suffered some considerable deterioration from its time in the ground. The surface is pitted and corroded and the enamels lack their original lustre. However, enough remains to give an indication of how splendid it must have once appeared when brightly gilded with its rich palette of white, yellow, green, turquoise, blue, pink and red. The chalice's proportions are perfectly balanced, the radius of the foot corresponding exactly with that of the bowl. Its curved surfaces are enamelled on the bowl with the figures of God the Father and three angels, and, on the foot, with the half figures of four saints. All are contained within semicircular units that expand into exuberant foliate motifs which separate each figure.

Although the findspot of the chalice is not sufficient to argue convincingly that it was an English product, there is every possibility that Limoges craftsmen were active in England at this time. Equally, however, the trade in Limoges enamel was vigorous by the third quarter of the twelfth century and the chalice may have been an expensive import commissioned by a wealthy prioress of Rusper.

Around 1200

Limoges, France, or England

Acquired with donations from the Art Fund and the National Heritage Memorial Fund

HEIGHT: 13.1 cm
DIAMETER: 10.3 cm

P&E 1996,0610.1

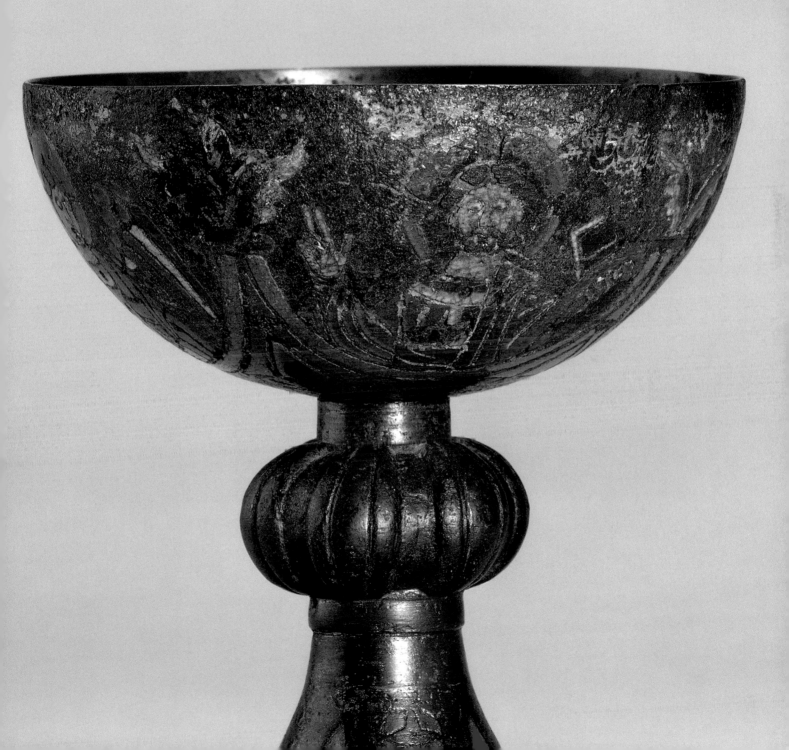

ALTAR FRONTAL SHOWING THE BETRAYAL OF CHRIST

This beautifully preserved fragment from an altar frontal was made at the height of the golden period for the embroidery known as *opus anglicanum* ('English work'; see pp. 120–21), which enjoyed greater international prestige than any other artistic product from England throughout the thirteenth and fourteenth centuries. The fragment displays a painterly fluency that belies the difficulty of rendering naturalistic forms in thread and delights in gently swaying figures, softly undulating drapery and dramatic groupings. The full scheme probably depicted the Passion of Christ. It opens with Christ's Charge to St Peter (Matthew 16:18–19), when Christ's divinity is revealed to Peter, who is entrusted to found the Christian Church. The event is pivotal in the Passion narrative as it precedes Christ's revelation to the disciples of his fate (Matthew 16:21). This unfolds in the next scene, which shows the kiss of Judas amid the violence of Christ's arrest. The action occurs in one continuous movement as a soldier raises a lantern so that Christ can be identified by Judas, who recognizes him with a kiss. As Judas lunges forward, Christ retreats slightly but engages him with a knowing look. With one hand he tries to prevent Peter from injuring the servant Malchus and with the other he pacifies a soldier who grips him by the wrist. The subsequent scenes are lost, but the partial survival of a scourge suggests that the Flagellation of Christ followed.

The two scenes are divided by a slender column with a foliate capital, on which is embroidered the inscription 'MCCCXC [1390] Rome'. The papal appreciation of *opus anglicanum* is well documented and this highly valued altar frontal was clearly in Rome some fifty years or so after it was made. The possibility that it was originally a papal commission is reinforced by the choice of subject: the Charge to St Peter is unique in English embroidery and uniquely relevant to the Papacy.

Around 1300–50

England

Given by Sir Augustus
Wollaston Franks

HEIGHT: 51 cm

WIDTH: 60 cm

P&E 1884,0606.6

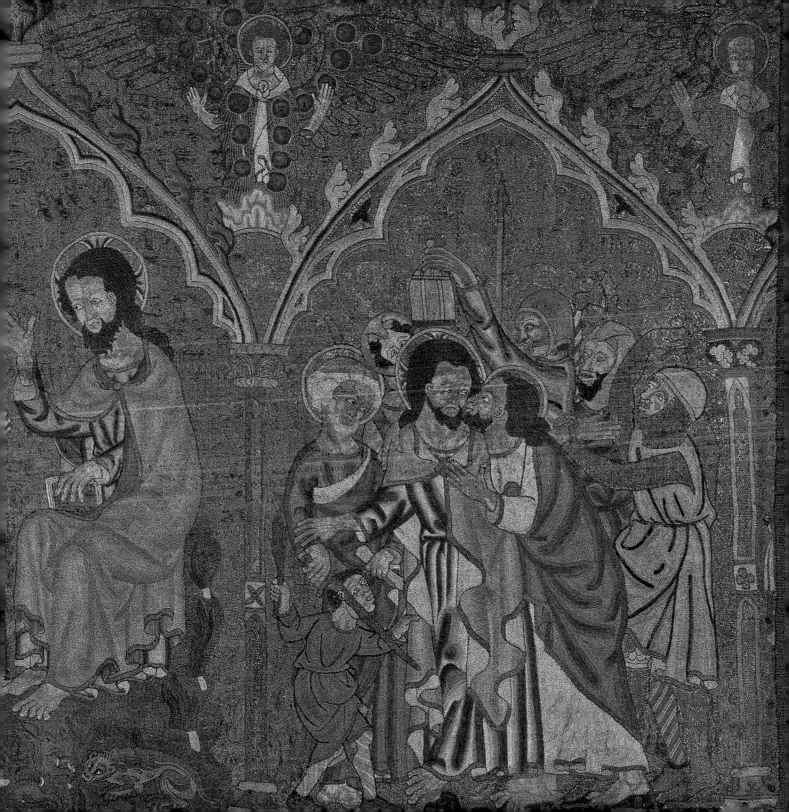

ALABASTER OF THE ANNUNCIATION

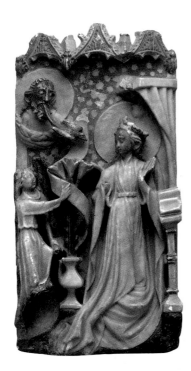

The survival rate of carved alabaster panels depicting the life of the Virgin that furnished altars dedicated to her offers material evidence for a cult that dominated late medieval Christianity. The Annunciation, when Mary first receives word that she has been chosen to be the mother of Christ, was an episode of fundamental importance to narratives relating to both the Virgin and Christ.

There were five recognizable stages of the Annunciation, which ranged from astonishment to acceptance. These were articulated expressly for audience identification with the emotional state of the Virgin. By the mid-fifteenth century, when this panel was carved, a predilection for portraying astonishment characterized the work of artists in alabaster. This stage in the Annunciation story had great dramatic impact: the Virgin, disturbed at prayer, turns in amazement at the salutation from the archangel Gabriel. Gabriel is shown in mid-flight, pointing to a scroll that unfurls around a lily in a vase. The scroll was originally painted with the Latin words 'Ave Maria Gracia Plena' ('Hail Mary, full of grace'), while the lily is a standard iconographic attribute symbolizing the Virgin's purity, its three blooms offering additional representation for the Trinity. Two manifestations of the Trinity are unambiguously evident in the figure of God the Father, who emerges from a cloud in the top left corner, and the Holy Spirit, in the form of a dove that issues from his mouth and flies towards the Virgin. The third member of the Trinity, Christ, will by implication soon be present in the Virgin's womb.

Of the remaining alabasters of the Annunciation from this period, this example is one of the most refined. The artist has resisted the temptation to fill the space with extraneous detail, a compulsion that becomes characteristic of alabasters at this time. The paint that survives on this panel, including the beautifully rendered wings of the archangel Gabriel, made to resemble peacock feathers, is entirely original.

The international nature of the cult of the Virgin, along with the successful export of vast numbers of alabasters to every corner of the known world, ensured the widest possible audience for such products.

About 1440

England

Given by Sir Augustus
Wollaston Franks

HEIGHT: 35 cm
WIDTH: 18 cm

P&E 1879,0710.8

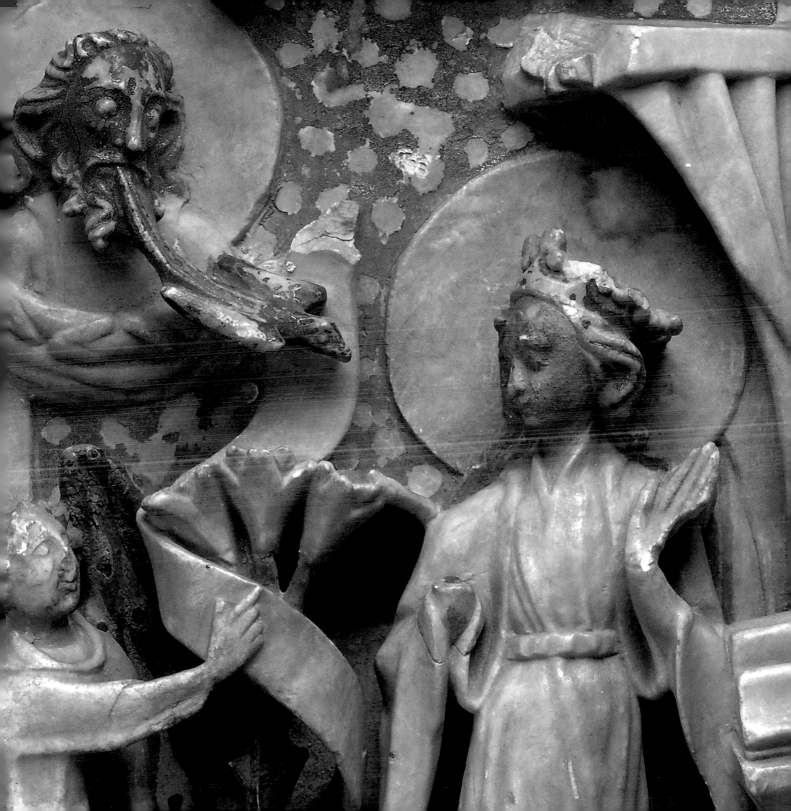

THE ALDREVANDIN BEAKER

Around 1330

Venice

HEIGHT: 13 cm
DIAMETER: 10.9 cm

P&E 1876,1104.3

The anonymity of artists and craftsmen in the medieval period is one of the era's abiding frustrations. Documentary references to individuals by name are rare at a time when the concept of an artist's signature did not really exist. A common way for an artist to signify his identity was to endow the object itself with a voice. Thus the Latin inscription on this delicate glass beaker declares boldly: 'MAGISTER ALDREVANDIN ME FECI[T]' ('Master Aldrevandin made me'). Aldrevandin was probably active in Venice, where the early glass industry profited enormously from contact with the Byzantine and Islamic worlds. The names of as many as five glassmakers appear in Venetian documents between about 1280 and 1351, but Aldrevandin is not among them. However, his name has been attached posthumously to a group of glass vessels and fragments which appear to be closely related, stylistically and technologically, to this beaker. The distribution of these associated pieces ranges widely throughout Europe and suggests a vigorous trade network.

The inspiration for the Aldrevandin-style glass came from the Islamic tradition of enamelled and gilded glass. However, there are significant differences in both form and treatment. Islamic glass tended to have a different shape for beakers, for example, which would taper out from the base to the rim, creating a graceful profile with an exaggerated, flared mouth. The Aldrevandin beaker is virtually cylindrical with a more modestly flared lip and rather stunted proportions. The paint and gilding was also applied distinctively to the exterior of Islamic glass vessels, whereas the Aldrevandin beaker is painted on its internal and external surfaces and uses yellow paint instead of gold. The body of the beaker is painted with three heraldic shields: two are yellow, one with three blue antlers and the other with three red keys, and the third consists of black and white horizontal bands. The shields are probably exploited purely for their decorative appeal rather than signifying a specific commission. They are embellished by white spots of paint that surround them and are separated by trefoil and heart-shaped leaves in red, green, yellow and cobalt blue balanced precariously on slender white stems.

FURTHER READING

John Blair and Nigel Ramsay (eds), *English Medieval Industries*, Hambledon Press, London, 1991

Michael Camille, *The Medieval Art of Love*, Abrams, New York, 1998

John Cherry, *Medieval Love Poetry*, The British Museum Press, London, 2006

John Cherry, *Medieval Craftsmen: Goldsmiths*, The British Museum Press, London, 1992

John Cherry, *Medieval Decorative Art*, The British Museum Press, London, 1991

Dominique Collon (ed.), *7000 Years of Seals*, The British Museum Press, London, 1997

Robin Cormack, *Icons*, The British Museum Press, London, 2007

Kate Giles and Christopher Dyer (eds), *Town and Country in the Middle Ages*, Society for Medieval Archaeology, Leeds, 2005

Chris Given-Wilson (ed.), *An Illustrated History of Late Medieval England*, Manchester University Press, 1996

P.D.A. Harvey and A. McGuinness, *A Guide to British Medieval Seals*, British Library and Public Record Office, London, 1996

Malcolm Jones, *The Secret Middle Ages*, Sutton Publishing, Stroud, 2004

James Robinson, *The Lewis Chessmen*, The British Museum Press, London, 2004

Veronica Sekules, *Medieval Art*, Oxford University Press, 2001

Jennie Stopford, *Medieval Floor Tiles of Northern England. Pattern and Purpose: production between the 13th and 16th centuries*, Oxbow Books, Oxford, 2005

Neil Stratford, *Catalogue of Medieval Enamels in the British Museum*, Vol. II, The British Museum Press, London, 1993

H. Tait (ed.), *7000 Years of Jewellery*, The British Museum Press, London, 1986

EXHIBITION CATALOGUES

Jonathan Alexander and Paul Binski, *Age of Chivalry: Art in Plantagenet England 1200–1400*, Royal Academy of Arts, London, 1987

Peter Barnet (ed.), *Images in Ivory: Precious Objects of the Gothic Age,* Detroit Insitute of Arts, 1997

Peter Barnet and Pete Dandridge, *Lions, Dragons and other Beasts: aquamanilia of the Middle Ages*, The Bard Graduate Center, New York, 2006

David Buckton (ed.), *Byzantium: Treasures of Byzantine Art and Culture*, British Museum, London, 1994

Danielle Gaborit-Chopin, *L'art au temps des rois maudits. Philippe le Bel et ses fils 1285 – 1328*, Grand Palais, Paris, 1998

Danielle Gaborit-Chopin, *La France romane*, Musée du Louvre, Paris, 2005

Timothy Husband, *The Treasury of Basel Cathedral*, The Metropolitan Museum of Art, New York, 2001

Richard Marks and Paul Williamson, *Gothic: Art for England 1400–1547*, Victoria and Albert Museum, London, 2003

Elisabeth Taburet-Delahaye (ed.), *Paris 1400: Les arts sous Charles VI*, Musée du Louvre, Paris, 2005

George Zarnecki (ed.), *English Romanesque Art 1066–1200*, The Arts Council of Great Britain, London, 1984

OTHER COLLECTIONS

Peter Barnet and Nancy Wu, *The Cloisters: medieval art and architecture*, The Metropolitan Museum of Art, New York, 2005

John Cherry and John Lowden, *Medieval Ivories and Works of Art in the Thomson Collection*, The Art Museum of Ontario, 2008

Danielle Gaborit-Chopin, *Ivoires médiévaux*, Musée du Louvre, Paris, 2003

Holger A. Klein (ed.), *Sacred Gifts and Worldly Treasures: Medieval Masterworks from the Cleveland Museum of Art*, The Cleveland Museum of Art, 2007

Richard H. Randall, *Masterpieces of Ivory from the Walters Art Gallery*, The Walters Art Gallery, Baltimore, 1985

Paul Williamson (ed.), *The Medieval Treasury: the art of the Middle Ages in the Victoria and Albert Museum*, Victoria and Albert Museum, London, 1998

WEBSITES

The Cistercians in Yorkshire:
www.cistercians.shef.ac.uk

Lewes Priory research:
www.cluniac-priory-st-pancras-lewes-de-warenne-foundation-research.co.uk

The Corpus of Romanesque Sculpture in Britain and Ireland:
www.crsbi.ac.uk

Richard II's Treasure:
www.history.ac.uk/richardII

Intute (web resources for education and research):
www.intute.ac.uk

INDEX